EMPERORS' TREASURES

EMPERORS' TREASURES

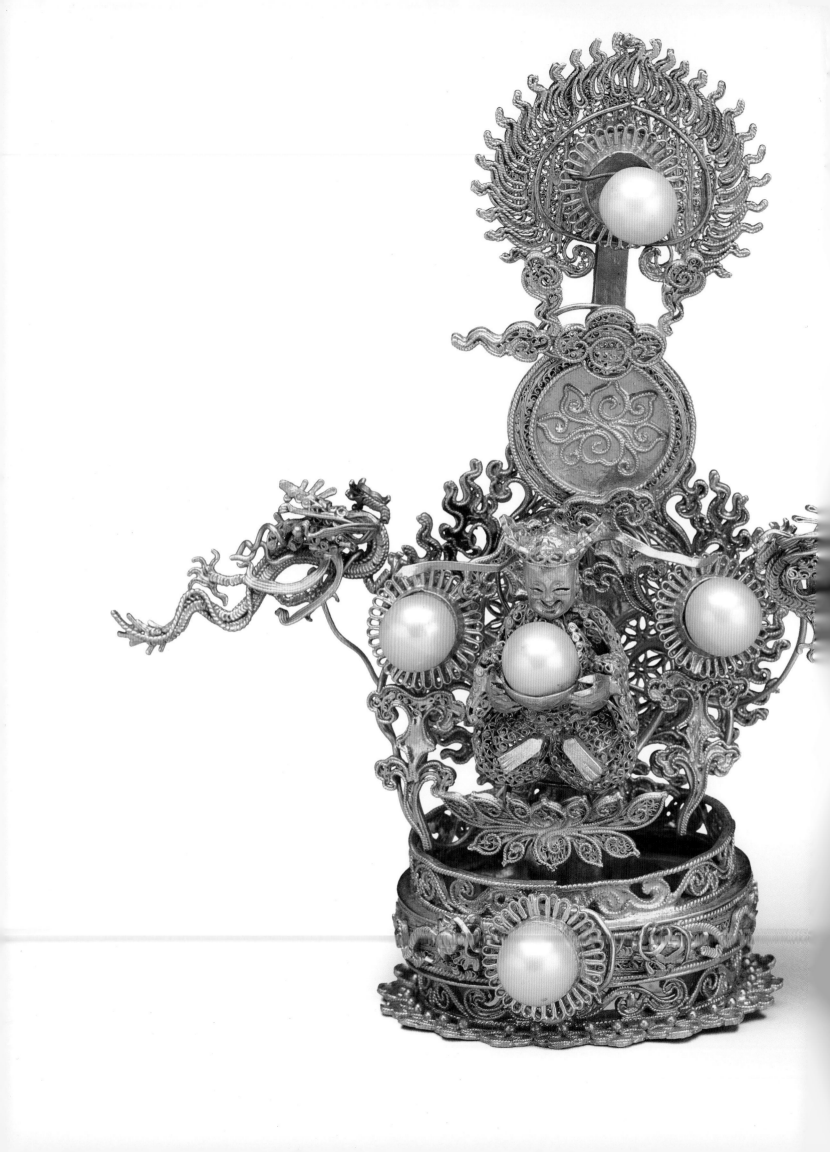

EMPERORS' TREASURES

Chinese Art from the National Palace Museum, Taipei

EDITED BY

Jay Xu and He Li

WITH CONTRIBUTIONS BY

Jay Xu, Fung Ming-chu, Ho Chuan-hsin, Alfreda Murck, Tianlong Jiao, He Li, and curators from the National Palace Museum, Taipei, and the Asian Art Museum of San Francisco

Asian Art Museum
San Francisco

◥ Asian

Published by
Asian Art Museum—Chong-Moon Lee Center for
Asian Art and Culture
200 Larkin Street
San Francisco, CA 94102
www.asianart.org

Library of Congress Cataloging-in-Publication Data
Names: Xu, Jay, editor. | He, Li, 1950- editor. | Asian
 Art Museum of San Francisco, organizer, host
 institution.
Title: Emperors' treasures : Chinese art from the
 National Palace Museum, Taipei / edited by Jay Xu
 and Li He ; with contributions by Fung Ming-chu,
 Jay Xu, Ho Chuan-hsin, Alfreda Murck, Tianlong
 Jiao, He Li, and curators from the National Palace
 Museum, Taipei, and the Asian Art Museum.
Description: First edition. | San Francisco : Asian
 Art Museum, 2016. | Includes bibliographical
 references and index.
Identifiers: LCCN 2015043289|
 ISBN 9780939117734 (hardback) |
 ISBN 9780939117741 (paperback)
Subjects: LCSH: Art, Chinese—Exhibitions. |
 Art—Taiwan—Taipei—Exhibitions. | Guo li gu
 gong bo wu yuan—Exhibitions. | BISAC: ART /
 Asian. | ART / Collections, Catalogs, Exhibitions
 / General. | ANTIQUES & COLLECTIBLES /
 Porcelain & China.
Classification: LCC N7342 .E47 2016 | DDC
 709.51/07451249—dc23
LC record available at http://lccn.loc.
gov/2015043289

The Asian Art Museum–Chong-Moon Lee Center for
Asian Art and Culture is a public institution whose
mission is to lead a diverse global audience in discov-
ering the unique material, aesthetic, and intellectual
achievements of Asian art and culture.

*Emperors' Treasures: Chinese Art from the National
Palace Museum, Taipei* is co-organized by the Asian
Art Museum of San Francisco and the National Palace
Museum, Taipei. This exhibition is supported by an
indemnity from the Federal Council on the Art and the
Humanities.

Exhibition Dates
ASIAN ART MUSEUM OF SAN FRANCISCO
June 17–September 18, 2016
THE MUSEUM OF FINE ARTS, HOUSTON
October 23, 2016–January 22, 2017

Produced by the Publications Department, Asian Art
 Museum, Clare Jacobson, Head of Publications

Design and production by Amanda Freymann and Joan
 Sommers, Glue + Paper Workshop, LLC
Edited by Tom Fredrickson
Proofread by David Sweet
Indexed by Theresa Duran
Color separations by Professional Graphics, Inc.,
 Rockford, IL
Printed and bound in China by Asia Pacific Offset

Distributed by:
North America, Latin America & Europe
Tuttle Publishing
364 Innovation Drive
North Clarendon, VT 05759-9436 U.S.A.
Tel: 1 (802) 773-8930; Fax: 1 (802) 773-6993
info@tuttlepublishing.com
www.tuttlepublishing.com

Asia Pacific
Berkeley Books Pte. Ltd.
61 Tai Seng Avenue #02-12
Singapore 534167
Tel: (65) 6280-1330; Fax: (65) 6280-6290
inquiries@periplus.com.sg www.periplus.com

Front cover: Half-portrait of Emperor Gaozong, Zhao
 Gou (detail), Southern Song dynasty (1127–1279),
 cat. 4.
Back cover: Vase with revolving core and eight-trigram
 design, approx. 1744, Qing dynasty (1644–1911), reign
 of Emperor Qianlong (1736–95), cat. 144.
Page ii: Gold Buddha for the front of a summer court
 hat, approx. 1790, Qing dynasty (1644–1911), reign of
 Emperor Qianlong (1736–95), cat. 162.
Page v: Flowers and insects (album leaf; detail), Yuan
 dynasty or Ming dynasty (1271–1644), cat. 40.11.
Page vi: Vase with scenes of children playing, Qing
 dynasty (1644–1911), reign of Emperor Qianlong
 (1736–95), cat. 146.
Page xiv: Perfumer with lotus scrolls, Ming dynasty
 (1368–1644), reign of Emperor Xuande (1426–35),
 cat. 73.
Page 31: Vase with flower designs, Ming dynasty (1368–
 1644), reign of Emperor Yongle (1403–24), cat. 60.
Page 242: *Marvelous Scripture of the Lotus Sutra*, 1419,
 Ming dynasty (1368–1644), reign of Emperor Yongle
 (1403–24), cat. 53.

All images courtesy the National Palace Museum,
 Taipei, except for the following:
Pages 15, 55: Photography by Asian Art Museum of San
 Francisco
Page 21: Museum of Fine Arts, Boston, Maria
 Antoinette Evans Fund, 33.364
Page 23: Metropolitan Museum of Art, Bequest of John
 M. Crawford Jr., 1988, 1989.363.12
Page 24: Metropolitan Museum of Art, 1980.276
Page 25: Freer Gallery of Art, Smithsonian Institution,
 Washington, DC: Purchase—Freer Endowment and
 Friends of Freer and Sackler Galleries, F2015.2a–b
Page 29: Courtesy of Hu Chui
Page 57b: Henan Provincial Institute of Cultural Relics
 and Archaeology
Page 127b: Jingdezhen Museum of Ceramic History
Pages 136–37: Wikimedia Commons / Public Domain
Page 138: Cleveland Museum of Art, John L. Severance
 Fund 1969.31
Page 139: © Victoria and Albert Museum, London
Page 140: Freer Gallery of Art and Arthur M. Sackler
 Gallery Archives, FSA A.13 SC-GR-249
Page 233b: Courtesy of Andrew Siu
Page 237b: Freer Gallery of Art and Arthur M. Sackler
 Gallery Archives, FSA A.13 SC-GR-252

Everywhere under Heaven
Is no land that is not the king's
To the borders of all those lands
None but is the king's subject

—*Shijing* (*Classic of Poetry*)

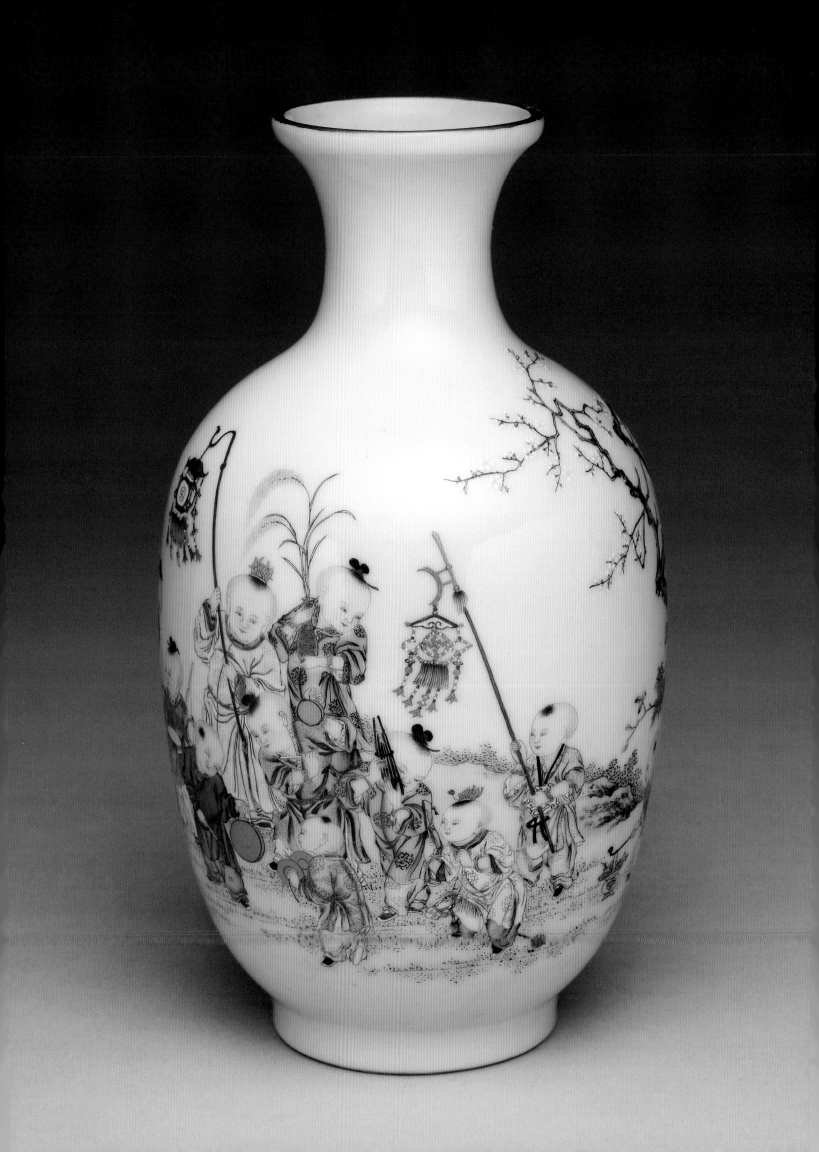

CONTENTS

 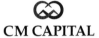

n collaboration with the Asian Art Museum and the National Palace Museum, Taipei, The Robert H. N. Ho Family Foundation is honored to sponsor *Emperors' Treasures: Chinese Art from the National Palace Museum, Taipei.*

In the decade since my father, Robert H. N. Ho, established our family foundation, we have twice successfully collaborated with the Asian Art Museum, and so we are particularly proud to support this cornerstone exhibition of the museum's fiftieth anniversary year. A key mission of our foundation is to promote Chinese culture and the arts to a Western audience so as to increase understanding of and appreciation for this ancient legacy. Nowhere does the 5,000 years of Chinese history manifest itself more beautifully and comprehensively than in the exquisite imperial collection that has been lovingly conserved and displayed at the National Palace Museum, Taipei.

Emperors' Treasures spans the period from the Song dynasty, an important era in the development of sophisticated culture and taste, to the Qing dynasty, when more dramatic events of history marked the end of imperial China. The treasures on display in this exhibition give us unique insights into Chinese life, culture, and history through the eyes and tastes of the absolute rulers of China from the twelfth through the early twentieth century. Most objects in this unique exhibition of paintings, calligraphy, bronze vessels, ceramics, lacquerware, jades, textiles, and documents—including thirty extremely rare masterpieces—are making their debut in the United States. We are deeply grateful to the National Palace Museum, Taipei, for its generous loan of these treasures.

I hope that American audiences will gain a deeper understanding of China's vibrant culture, an important aspect often overlooked with today's overwhelming emphasis on geopolitics and the economy. There is much to be learned from the ageless beauty on display, and The Robert H. N. Ho Family Foundation is proud to contribute to this wonderful exhibition.

PRESENTING
SPONSOR'S
STATEMENT

Robert Y. C. Ho
Chairman
The Robert H. N. Ho Family Foundation

何 鴻 毅 家 族 基 金
THE ROBERT H. N. HO FAMILY FOUNDATION

Jay Xu
Director
Asian Art Museum of San Francisco

A porcelain vase. A jade belt ornament. A silk scroll. Chinese emperors' treasures—unlike the artistic works commissioned by Egyptian pharaohs or Roman Caesars—were not outward expressions of power and wealth. Rather these exemplars of technical brilliance and artistic taste were meant for personal pleasure and cultivation behind palace walls. A masterful calligraphic album, a jewel-studded hairpin, or a cloisonné enamel ewer might be displayed on a special occasion or for a lucky visitor, but treasures like these were otherwise kept away from the damaging sun and the eyes of the curious. Even emperors' portraits, unlike their larger-than-life counterparts of Egyptian and Roman statuary, were not shown in public. Owning such treasures, it seems, was more important than displaying them, as ownership signified possessing culture and political legitimacy.

Emperors' Treasures brings out more than 170 Chinese masterworks for public appreciation in the United States. The exhibition and this catalogue display a trove of paintings, calligraphy, bronze vessels, ceramics, lacquerware, jades, textiles, and historical documents that once rested in imperial hands. At the same time, it explores the identities of eight rulers—seven emperors and one empress—who left their aesthetic mark on their times. During the 800 years covered in this catalogue, dynastic tastes ranged from the dignified Song (960–1279) to the bold yet subtle Yuan (1271–1368) and from the brilliant Ming (1368–1644) to the final, dazzling Qing period (1644–1911). The rulers expressed their artistic inclinations in varied ways: collecting art, commissioning new works, and even personally creating artworks. While they might not have actively cultivated a specific aesthetic for their subjects to follow, they exerted profound influence on the development of Chinese art. We can now identify their unique tastes, just as we can the style of Louis XIV or Elizabeth I.

The work featured in *Emperors' Treasures* comes from one exceptional museum, the National Palace Museum, Taipei, which houses a significant portion of the Chinese imperial collection. In 2008, soon after I assumed the position of director of the Asian Art Museum, I developed an idea for an exhibition including works from the museum. In January 2014 the Asian Art Museum and the National Palace Museum reached agreement for each institution to host an exhibition from the other; a memorandum of understanding to that effect was officially signed in March 2014.

This year, during the Asian Art Museum's fiftieth anniversary, I am thrilled to be able to bring so many masterworks from Taipei to San Francisco. *Emperors' Treasures* is an ideal vehicle with which to celebrate the museum's anniversary, as both exhibition and institution exemplify the richness, variety, and personality of Asia. I am delighted that the exhibition will then travel to the Museum of Fine Arts, Houston.

I am indebted to all the people who made this book and exhibition possible. I would like to thank, first and foremost, the staff at the National Palace Museum, Taipei, for their collaboration on this project. Special thanks to Director Fung Ming-Chu, whose leadership was instrumental in realizing this work. I am grateful to Ho Chuan-hsin, deputy director, for his support and his essay in this book. Thanks to more than two dozen National Palace Museum staff members who worked on the exhibition and wrote the source texts for the objects in this catalogue. I wish to

extend my appreciation also to Gary Tinterow, director of the Museum of Fine Arts, Houston, and his able staff for their support and participation.

Here at the Asian Art Museum, I would like to express my gratitude to the staff who participated in the organization of the exhibition under an extraordinarily tight timetable and especially to He Li, associate curator of Chinese art, who co-curated the exhibition and coedited this catalogue. Thanks to Tianlong Jiao, former curator of Chinese art, who assisted with the exhibition and authored an essay in this volume. Thanks to Jamie Chu, curatorial project assistant, who helped to organize the exhibition and the catalogue. And I acknowledge Pedro Moura Carvalho, former deputy director, for his help in focusing the theme of the show. Countless other staff in the Asian Art Museum's education, museum services, marketing, public relations, and development departments made sure that this exhibition and catalogue met the highest standards and reached the largest number of people.

Finally, I would like to thank all the sponsors whose generous support made possible this landmark exhibition. I'd especially like to thank our exhibition presenting sponsor, The Robert H. N. Ho Family Foundation; our exhibition sponsors, the Henry Luce Foundation, East West Bank, Robert and Vivian Tsao, and Diane B. Wilsey; and our catalogue presenting sponsor, the Bei Shan Tang Foundation; along with the many others whose generosity has made this exhibition and publication possible.

As you read through this catalogue, may you share my excitement in bringing so many treasures to light.

FOREWORD

Fung Ming-Chu
Director
National Palace Museum, Taipei

The National Palace Museum (NPM) was founded on October 10, 1925, in the Forbidden City in Beijing. The core of its collection was shipped to Taiwan in 1949. In 1965 a new museum designed to house these works was established in Waishuangxi, Taipei, and merged with the Preparatory Office of the National Central Museum. The new museum was then named the "National Palace Museum." The NPM houses the former Qing imperial collection compiled over the past centuries and includes the best works of Chinese art. The entire collection comprises 696,344 pieces, and the NPM is among the most popular museums in the world.

The touring exhibition *Emperors' Treasures: Chinese Art from the National Palace Museum, Taipei* will be presented at the Asian Art Museum of San Francisco and then travel to the Museum of Fine Arts, Houston, between June 2016 and January 2017. The successful establishment of this exhibition is the result of the enthusiastic undertaking of these two museums' directors, especially Director Jay Xu of the Asian Art Museum. Since 2009, Director Xu visited the NPM every year to express his desire to collaborate on an exhibition and to discuss possible themes. It was not until October 2013, after he visited our exhibition *The All Complete Qianlong: A Special Exhibition on the Aesthetic Tastes of the Qing Emperor Gaozong*, that he decided on the theme of the emperors' tastes and to hold the exhibition in commemoration of the Asian Art Museum's fiftieth anniversary in 2016. Director Xu pointed out that this exhibition would be the first major exhibition from the NPM since *Possessing the Past: Treasures from the National Palace Museum, Taipei* in 1996, which toured the four largest cities in the United States. He welcomed the prospect that a new generation of American youth would be exposed to Chinese culture and would learn about the NPM through the exhibition. His aspirations struck a chord with our museum and, thus, *Emperors' Treasures* is scheduled to debut on June 17, 2016, at the Asian Art Museum of San Francisco.

The exhibition will then continue on with a slightly different selection of artworks to the Museum of Fine Arts, Houston, on October 23, 2016. On January 2, 2014, the museum's director, Gary Tinterow visited me and brought with him the catalogue *Masterworks of Pre-Columbian, Indonesian, and African Gold* to demonstrate his wish to provide the splendid gold objects in his museum's collection for a future exchange exhibition at the NPM so that artworks from the NPM's collection could be shown in Houston. Apart from Director Tinterow's aspirations, our decision to collaborate with the Museum of Fine Arts, Houston, was based on the fact that the two previous traveling exhibitions from the NPM to the United States (in 1961 and 1996) were only shown in Washington, DC, New York, Boston, Chicago, and San Francisco. As Houston is the fourth-largest American city with a large Chinese population, we approved with pleasure Director Tinterow's request, deciding to make the Museum of Fine Arts, Houston, the second stop of the *Emperors' Treasures* exhibition.

After the exhibition dates and venues were confirmed, the two museums' curatorial teams were in discussion for more than a year and decided to focus on four dynasties and eight rulers: Emperor Huizong of the Northern Song dynasty (with reference to Emperor Gaozong of the Southern Song dynasty), Kublai Khan

of the Yuan dynasty, Emperors Yongle and Xuande of the Ming dynasty, Emperors Kangxi, Yongzheng, and Qianlong of the Qing dynasty, and Empress Dowager Cixi of the late Qing dynasty. These eight representative rulers comprise the core of the exhibition.

The 178 exquisite treasures selected for the exhibition span 1,000 years of development and introduce the changes of taste and achievement in Chinese art. In accordance with Director Xu's suggestion, the title of the exhibition changed from *Emperors' Tastes* to *Emperors' Treasures* to better accommodate the American public. The catalogue entries were written by the curators from the NPM, while curators from the Asian Art Museum of San Francisco not only translated but also revised many of the entries to better suit the museum's audience. The Asian Art Museum's curators and exhibition team were in charge of the exhibition layout and chose the eight rulers to lead the exhibition's sequence. By examining each figure's time period and background, political convictions, religious beliefs, cultural education, and individual personality, this exhibition aims to explore the development of each ruler's artistic tastes and their impact on the style and artistic achievements of his or her time and on later generations.

One feature that distinguishes this exhibition is that the eight figures around which it is organized include rulers of Han, Mongol, and Manchurian ethnicities that reflect the uninterrupted development of Chinese culture under rulers of different backgrounds. Furthermore, the exhibition explores imperial art from a female perspective through the figure of Empress Dowager Cixi, who lived through the end of the nineteenth and the beginning of the twentieth century. To conclude, the entire curatorial team hopes that *Emperors' Treasures* will have a deep impact, appeal to a broad audience, foster new perspectives on historical objects, and provide inspiration.

On behalf of the NPM, I would like to thank both Director Jay Xu and Director Gary Tinterow for their dedication to having art objects from the NPM's collection travel to the United States once again and for contributing to the cultural exchanges between our two countries. I would also like to thank both museums' curatorial teams for their endless hard work and detailed planning to make this a wonderful exhibition. My gratitude also extends to the prominent Chinese art historian James C. Y. Watt for his assistance and kind affirmations, which greatly motivated everyone working on this project and strengthened their confidence.

Lastly, I would like to sincerely congratulate the Asian Art Museum of San Francisco on its fiftieth anniversary. I express my deepest wishes for the long-term prosperity of the museum and the success of this exhibition.

Fung Ming-chu

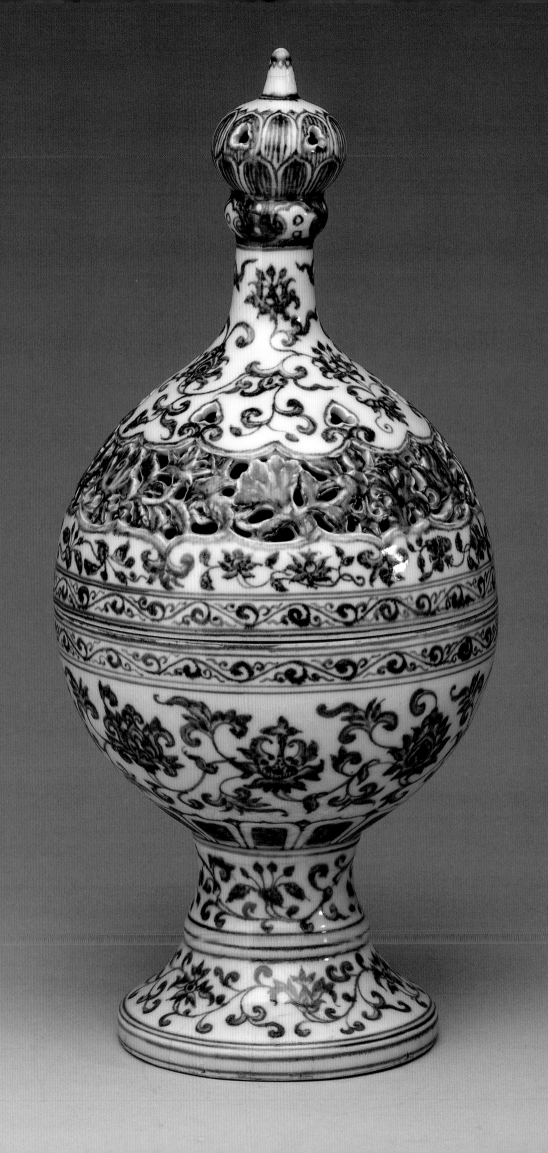

would like to express my gratitude to all those involved in this catalogue for their invaluable work and assistance. Special thanks to the staff of the National Palace Museum, Taipei: Ho Chuan-hsin, Deputy Director; Yu Pei-chin, Deputy Chief Curator in the Department of Antiquities; Tung Wen-e, Associate Research Fellow in the Department of Painting and Calligraphy; and Lisette Lou, Senior Executive Officer of International Affairs in the Office of the Director.

Special thanks must also be given to Terese Bartholomew, Curator Emeritus in the Department of Himalayan Art and Chinese Decorative Art at the Asian Art Museum; Li Jian, Curator of East Asian Art at the Virginia Museum of Fine Arts; Hou-mei Sung, Curator of Asian Art at the Cincinnati Art Museum; So Kam Ng Lee, Professor of Art History at De Anza College; Yvonne Kong; and Andrew Siu for their effort and time on the exhibition catalogue. Thanks to Amanda Freymann and Joan Sommers of Glue + Paper Workshop for their work shepherding and designing this book, and editor Thomas Fredrickson for his patience and commitment to this project. Additional appreciation goes to Clare Jacobson, Head of Publications of the Asian Art Museum.

I would also like to thank my colleagues at the Asian Art Museum who worked countless hours to make the *Emperors' Treasures* exhibition a success. I am grateful to Jamie Chu, Curatorial Project Assistant, for her invaluable help with the exhibition and catalogue; and to Cathy Mano, Associate Head of Registration; Mark Fenn, Associate Head of Conservation; Shiho Sasaki, Paintings Conservator; and Vincent Avalos, Mountmaker, for their dedication to the artwork. Thanks to Kim Bush Tomio, Director of Museum Services; and Jen Schauer, Museum Services Coordinator, for managing the correspondence between the Asian Art Museum, the National Palace Museum, Taipei, and the Museum of Fine Arts, Houston. Thanks to Jonathan Bloom, Image Services Manager, for coordinating catalogue photography; John Stucky, Library Director, for his research assistance; Marco Centin, Exhibition Designer; and the entire exhibition and preparation teams for their contributions to the layout of the show.

ACKNOWLEDGMENTS

He Li
Associate Curator of Chinese Art
Asian Art Museum of San Francisco

approx. 6000–2000 BCE	Neolithic
[approx. 2100–1600 BCE]	Xia
approx. 1600–1050 BCE	Shang dynasty
approx. 1050–256 BCE	Zhou dynasty Western Zhou (approx. 1050–771 BCE) Eastern Zhou (approx. 771–221 BCE) Spring and Autumn Period (771–approx. 480 BCE) Warring States Period (approx. 480–221 BCE)
221 BCE–206 BCE	Qin dynasty
206 BCE–220 CE	Han dynasty Western (Former) Han (206 BCE–9 CE) Xin (Wang Mang Interregnum) (9–23) Eastern Han (25–220)
220–419	Three Kingdoms and Jin
420–589	Northern and Southern dynasties Southern dynasties (317–589) Northern dynasties (386–581)
581–618	Sui dynasty
618–907	Tang dynasty
907–960	Five dynasties
907–1125	Liao dynasty
960–1279	Song dynasty Northern Song (960–1127) Southern Song (1127–1279)
1115–1234	Jin dynasty
1271–1368	Yuan dynasty
1368–1644	Ming dynasty
1644–1911	Qing dynasty

CHRONOLOGY OF
DYNASTIC CHINA

SONG DYNASTY (960–1279)

Northern Song (960–1127)

POSTHUMOUS TEMPLE NAME / REIGN DATES

Taizu / 960–976

Taizong / 977–997

Zhenzong / 998–1022

Renzong / 1023–1063

Yingzong / 1064–1067

Shenzong / 1068–1085

Zhezong / 1086–1100

Huizong / 1101–1125

Qinzong / 1126–1127

Southern Song (1127–1279)

POSTHUMOUS TEMPLE NAME / REIGN DATES

Gaozong / 1127–1162

Xiaozong / 1163–1189

Guangzong / 1190–1194

Ningzong / 1195–1224

Lizong / 1225–1264

Duzong / 1265–1274

Gongzong / 1275

Duanzong / 1276–1277

Di Bing / 1278–1279

YUAN DYNASTY (1271–1368)

POSTHUMOUS TEMPLE NAME / KHAN NAME / REIGN DATES

Shizu / Kublai / 1271–1294

Chengzong / Temür / 1295–1307

Wuzong / Khaishan / 1308–1311

Renzong / Ayurbarwada / 1312–1320

Yingzong / Shidebala / 1321–1323

Taidingdi / Yesün Temürv / 1324–1328

Wenzong / Tugh Temür / 1328–1329;
 1330–1332

Mingzong / Kusala / 1329

Ningzong / Irinjibal / 1332

Shundi / Toghon Temür / 1333–1368

MING DYNASTY (1368–1644)

POSTHUMOUS TEMPLE NAME / REIGN TITLE / REIGN DATES

Taizu / Hongwu / 1368–1398

Huidi / Jianwen / 1399–1402

Chengzu / Yongle / 1403–1424

Renzong / Hongxi / 1425

Xuanzong / Xuande / 1426–1435

Yingzong / Zhengtong / 1436–1449

Daizong / Jingtai / 1450–1456

Yingzong* / Tianshun / 1457–1464

Xianzong / Chenghua / 1465–1487

Xiaozong / Hongzhi / 1488–1505

Wuzong / Zhengde / 1506–1521

Shizong / Jiajing / 1522–1566

Muzong / Longqing / 1567–1572

Shenzong / Wanli / 1573–1620

Guangzong / Taichang / 1620

Xizong / Tianqi / 1621–1627

Sizong / Chongzhen / 1628–1644

QING DYNASTY (1644–1911)

POSTHUMOUS TEMPLE NAME / REIGN TITLE / REIGN DATES

Shizu / Shunzhi / 1644–1661

Shengzu / Kangxi / 1662–1722

Shizong / Yongzheng / 1723–1735

Gaozong / Qianlong / 1736–1795

Renzong / Jiaqing / 1796–1820

Xuanzong / Daoguang / 1821–1850

Wenzong / Xianfeng / 1851–1861

Muzong / Tongzhi / 1862–1874

Dezong / Guangxu / 1875–1908

Puyi / Xuantong / 1908–1911

* restored to throne

EMPERORS OF THE SONG, YUAN, MING, AND QING DYNASTIES

動常恐長蔹戟勢⋯⋯動視

幾層蒼檜遠凝嵐四撿老

松園若封三品非無美蔭

羽曾令壯奮起

HO CHUAN-HSIN

Imperial Art Collections and Transitions in China

Throughout history Chinese emperors have esteemed classical works of calligraphy and painting. These two types of art fulfilled many functions during the imperial era, including the transmission of political intent, the propagation of morals, and the edification of ministers and subjects alike. Among these were also purely aesthetic aims or the emulation of ancient ways in the establishment of aesthetic paragons.

Calligraphy, in particular, played a major part in the cultivation and education of the ancient gentry. According to traditional calligraphic theories, writing not only recorded and transmitted information but also displayed the concrete signs of an individual's learning, cultivation, character, and conduct. The calligraphic traces of worthy emperors, ministers, and statesmen—as well as those of talented and virtuous men of ancient times—served as models from which later generations could learn. As with paintings and other precious artifacts, these works of calligraphy possessed significance in terms of cultural orthodoxy and inheritance. Hence, they became the principal objects of pursuit and collection for emperors who valued cultural accomplishments and enlightenment. Many emperors were deeply fond of calligraphic creations, which they deployed to manifest their personal attainments in letters and culture. An emperor's personal taste directly influenced the court and guided trends in contemporary artistic creations in calligraphy and painting. Therefore, the collection and appreciation of calligraphy and painting at the court, the taste of the emperor, and the painting academies based in the palace were all interconnected. They constitute a major element in the development of the art of China.

CALLIGRAPHY FROM THE EMPEROR'S HAND

Historical accounts frequently relate how a certain emperor would, in addition to administering the empire, turn his attention to calligraphy and practice the art with the imperial hand; these calligraphic works were then bestowed upon worthy ministers and bureaucrats. This practice was praised as an expression of cultivation.

Extant works by Emperor Taizong (reigned 626–49) of the Tang dynasty reveal his esteem for the calligraphy of Wang Xizhi (approx. 303–61), also known as the Sage of Calligraphy, who, with his son Wang Xianzhi (344–86), brought new life and spirit to the development of calligraphy. Taizong's establishment of a classical paradigm influenced the course of imperial calligraphy thereafter. The sixth emperor of the Tang dynasty, Xuanzong (Li Longji; reigned 712–56), is best

Grotesque Stones in the slender-gold style (detail), Northern Song dynasty (960–1127), reign of Emperor Huizong (1100–25), cat. 1.

FIGURE 1

Ode on Pied Wagtails. By Li Longji (Emperor Xuanzong, 685–762). Tang dynasty (618–907), reign of Emperor Xuanzong (713–75). Hand scroll, ink on paper.

remembered for his cultural and military accomplishments and his adroit employment of virtuous and capable scholars to govern the empire—indeed, he is credited with initiating an age of peace and prosperity. Yet his talent for calligraphy was also highly esteemed. In *Rhapsody on Calligraphy* (*Shushu fu*) the theorist of calligraphy Dou Ji (active 742–55) floridly praised Xuanzong's skills: "An utmost vigor of character carved on the monumental stone; a mind like a spring which spouts a phoenix, a brush like the sea which swallows the whale." Song-era art critics pointed out that Xuanzong's calligraphy had a huge influence on his contemporaries; his running, clerical (*bafen*), and cursive scripts were widely emulated.[1]

A calligraphic scroll by Xuanzong in the collection of the National Palace Museum is titled *Ode on Pied Wagtails* (*Jiling Song*; fig. 1). A long preface to the work by the emperor relates how he recalled his far-flung brothers to posts in the capital so that they might join him in the palace, "extending friendship . . . often reciting poetry together" and partaking in the joy of familial love. One autumn day as the brothers gathered, a thousand wagtails happened to fly by and rest on the trees in the Hall of Holy Virtue (*Linde dian*). When they flew away, the birds called to each other as though they were caring for each other like brothers. Observing this sight, the brothers were moved to summon the learned official historian Wei Guangcheng (active 710–50), who may have helped Xuanzong finish the ode. The emperor inscribed his initial at the end of the scroll, indicating imperial authorship. This is the earliest extant example of an emperor personally inscribing a poem.

In the colophon panel of *Ode on Pied Wagtails* the Qing-era calligrapher Wang Wenzhi (1730–1802) added a postscript: "With the calligraphy of emperors and kings, their texts are endowed with the poise of dragons and the bearing of phoenixes, inimitable by their subjects or common people. Observing this ode makes one want to see the sagacious unsurpassed brilliance of the Kaiyuan era [713–41]." Wang notes how the emperor's calligraphy fuses masculine vim and vigor with feminine reserve and observes that the qualities of the calligraphy itself suggest Xuanzong's wise and exceptional abilities in governance. Many similarities exist between *Ode on Pied Wagtails* and Wang Xizhi's legendary work *Preface to the Orchid Pavilion* (*Lanting Xu*): in the attack, sustain, and syncopation of the brush; in the way the tip of the brush is rotated in order to vary the momentum of the characters; and in the sheer beauty of the characters, there indeed is a line of descent from Wang Xizhi

to Xuanzong. Juxtaposing the two works, however, one can easily observe that the earlier text is slender while the later text is plump, demonstrating how the style of calligraphy, as guided by emperors, evolved after the mid-Tang era.

Even before ascending to the throne, Emperor Taizong of the Song dynasty (reigned 977–97) was interested in calligraphy and highly valued the collection of ancient calligraphic traces. After becoming emperor, Taizong frequently studied calligraphy in his leisure time. He was proficient in all types of calligraphy, including seal, regular, running, "flying-white," and clerical scripts, excelling especially in cursive script. His *Thousand-Word Classic* in cursive script was engraved on a stele placed in the Imperial Archives in the capital Chang'an, Shaanxi province. He also wrote the same text in the small-seal script and large texts in the flying-white style, which he bestowed on ministers.[2] The Song-era writer and calligrapher Huang Tingjian (1045–1105) said that after Taizong pacified the realm, he practiced martial arts, excelled in literature, became interested in painting, and mastered various calligraphic styles; contemporary elites were honored to receive instruction from the emperor.[3] In his *History of Calligraphy*, the Northern Song calligrapher Mi Fu (1051–1107) mentioned that all the ministers in Taizong's court studied the work of classical calligraphers Zhong Yao (151–230) and Wang Xizhi in order to cater to the emperor's taste.[4] Records from the Southern Song dynasty (1127–1279) mention how Taizong often summoned the calligraphers of the scholarly institution known as the Hanlin Academy to practice the calligraphy of Zhong and Wang.[5] Following the example of Taizong, who revered the tradition of Wang, it was common for official-scholars to practice the earlier masters' calligraphy at court.

Song emperors learned and practiced calligraphy and were influenced by respected scholars. During the reign of Emperor Zhezong (1086–1100), Huang Tingjian instructed the children in the royal household. This perhaps explains why the early calligraphy of Zhezong's son, Huizong (reigned 1101–25), shows Huang's influence. Huizong also studied the Tang calligraphers Xue Ji (649–713) and Zhu Suiliang (596–658) and went on to create what is known as the "slender-gold" style of calligraphy,[6] which combined delicate, vigorous brushstrokes, momentum, and compact character forms. His "*Grotesque Stones* in the slender-gold style" (cat. 1) is an example of this style. It features a "seven-character" poem that describes the protrusions and hollows of an unusual rock: it looked, he wrote, like a beast about to pounce or a dragon about to soar, with dark green junipers growing out of the cracks. Huizong also cited a legend about the heroic general Li Guang (died 119 BCE) shooting an arrow into the rock—further heightening the mythic stature of this peculiar stone. The subject of this poem may have been in the imperial rockery called the Program of Flora and Stone (*Huashigang*) in Bianjing, constructed during Huizong's reign. In praising and poetizing the fabulous form of rocks, the emperor fused calligraphy, poetry, and natural scenery into a single work of art.

After the Jurchens conquered the northern part of the empire, the Song court moved south to the Jiangnan region. The unfamiliar culture and geography of this region had a strong influence on Chinese painting and calligraphy. Emperor Gaozong (reigned 1127–62; see cat. 4), son of Huizong, inherited his father's artistic talent and interests and likewise studied Huang Tingjian in his youth: a few steles featuring calligraphy made when he was about twenty years of age still remain and clearly show the veneration Gaozong had for Huang's style. The emperor also studied Wang Xizhi, collecting his *Preface to the Orchid Pavilion* and other works, and emulated calligraphic styles from the Wei and Jin dynasties (220–419). In a style of dignified elegance and charm, he copied classic texts or bestowed poems and texts in

the imperial hand. More than a personal expression of style, Gaozong's calligraphy deeply influenced the art in the Southern Song court.

The first few emperors of the Ming dynasty (1368–1644) followed imperial tradition and took pains to cultivate skill in and appreciation of calligraphy in their children. Emperor Yongle (reigned 1403–24) wrote poems and texts in calligraphy on exquisite paper in order to bestow them on favored ministers. Emperor Renzong (reigned 1425) was skilled with ink and brush, granting his copy of the *Preface to the Orchid Pavilion* to officials. Critics praised the vigorous spirit and excellent style of Renzong's calligraphy, saying it exceeded even that of Emperor Taizong.[7] In 1416 Prince Xian of Zhou (died 1439) assembled exemplary calligraphic works from the Song and Yuan periods (960–1368) and published them in *Model Calligraphies from the Imperial Archives of the Chunhua Era* (*Chunhua getie*) and *Calligraphies from the Imperial Archives* (*Mige xutie*) and reengraved *Model Calligraphies Assembled in the Hall of Eastern Study* (*Dongshutang jigu fatie*). Unfortunately, few of these works have survived.

Emperor Xuande (reigned 1426–35) continued his ancestors' admiration for the art of calligraphy. He appreciated the ancient masters and amused himself with poetry, calligraphy, and painting, producing works in his own hand as gifts for members of the court. The album "Harmonious pair of painting and calligraphy" (cat. 63), a precious relic, was inscribed "Playfully written by the Emperor" by Xuande in 1428. The first spread opens to a painting in ink of a bamboo tree and two birds, with other leaves featuring a series of lyric verses in running script that describe a woman leading a lonely life and reminiscing about her former lover. The diction of the verse is genuine and the emotions sincere, demonstrating Xuande's interest in this literary genre. The calligraphy is carefree, and the manipulation of the brush is firm and handsome. Xuande's calligraphy was influenced by the brothers Shen Du (1357–1434) and Shen Can (1379–1453), who were early Ming court calligraphers (see cat. 54). Their style can be traced back to Zhao Mengfu (1254–1322), who in turn was influenced by Wang Xizhi. The influence of this lineage—a style of vigorous elegance—is evident in this work by Xuande.

Though the first few emperors of the Qing dynasty (1644–1911) were Manchus, they were deeply influenced by Han Chinese culture. Like the emperors of the Song and Ming dynasties, they valued the practice and study of calligraphy. In *History of Calligraphy from the Imperial Qing* (*Huangqing shushi*; 1924) author Li Fang listed forty-three Qing emperors, princes, and royal clansmen adept in calligraphy. Among them were four emperors—Shunzhi, Kangxi, Yongzheng, and Qianlong—who had a marked influence on the formation of stylistic trends in court calligraphy. Their calligraphic traces were carefully recorded in the catalogue of the Qing imperial collection, *Treasured Splendors from Stone Canals* (*Shiqu baoji*).

Emperor Kangxi (reigned 1662–1722) believed that practicing calligraphy "fostered virtue and benefited the body and mind." He frequently discussed the calligraphy of ancients with courtiers, bestowed his own imperial calligraphy on ministers, and left inscriptions at famous temples.[8] In his youth he was guided by Shen Quan (1624–84), whose calligraphy was modeled on the style of the Ming elite Dong Qichang (1555–1636). Kangxi therefore developed a passion for Dong's calligraphy, searching out his works and collecting them in the Secret Pavilion in the palace. Dong was already an influential figure, and with Kangxi's praise his reputation only grew, and his style became the standard against which all calligraphy was measured.

Kangxi was fond of copying ancient calligraphic models. He claimed to have copied or examined the vast majority of the palace collection. In 1690 he commanded Shen Quan and others to gather the ancient model books and the palace collection to be copied and engraved in the twenty-four volumes of *Calligraphic Works from Palace of Diligent Assiduousness* (*Maoqin dian fatie*). Kangxi's own copies were sometimes attached to the calligraphic texts, attesting to his interest in the ancient classics. *Treasured Splendors from Stone Canals* records about 300 copies from Kangxi's hand: classics of Confucianism, Buddhism, and Daoism; ancient poetry; copies of ancient calligraphy; and his own poems, odes, essays, commemorating words carved on stone steles, letters, prefaces, and postscripts. "Calligraphy in running script by Emperor Kangxi" (cat. 83) was a work that was bestowed on a favorite official. The calligraphy, on smooth speckled-gold paper, inscribed Tang-era poetry.[9] The force of the brush is steady, the strokes are even and rounded, and the forms of the characters are very balanced. Only in certain connected dots is there any evidence of the speed of the brush, displaying a flexible movement. This sensitive lightness amid dignified elegance is part of a tradition stretching from Wang Xizhi to Zhao Mengfu and Dong Qichang.

Emperor Yongzheng (reigned 1723–35) began practicing calligraphy as a prince (see cat. 106). He was praised for having "fused the charm of master calligraphers since the Jin, Tang, Song and Yuan" periods and left behind a rich trove of calligraphy: poetry, odes, epigraphs, and copies of ancient works as well as inscriptions on steles and tablets in famous mountains and temples. In 1738 ministers and officials assembled examples of his calligraphy and published them as *Calligraphy Models of Recitation Pavilion* (*Langyinge fatie*).

Emperor Qianlong (reigned 1736–95) continued to promote traditional Confucian culture advanced by his grandfather, Kangxi, and his father, Yongzheng. He especially adhered to the traditions of the Tang and the Song dynasties, which valued the cultivation of the humanities and literary arts as well as the promotion and practice of the art of calligraphy. Qianlong pursued calligraphy throughout his entire life, with the copying of texts being his main mode of practice. The comprehensive and systematically organized collection of classics in the palace profoundly influenced the development of calligraphy from the early Qing onward, encouraging an appreciation for tradition and an integration of the styles of ancient and modern masters. As a result, the art of calligraphy reached a peak of refinement and excellence during the Qing dynasty.

IMPERIAL PAINTERS

While many emperors in Chinese history embraced the art and discipline of calligraphy, few were adept at painting—perhaps because that art demands time-consuming training and technique incompatible with the demands of administration and governance. Emperor Huizong of the Song dynasty was an exception. By the time he was sixteen or seventeen years of age and still known as Prince of Duan, he had demonstrated a pronounced interest in calligraphy and painting. In contrast to his brothers, who indulged in luxury, he preferred to practice these arts. He spent time with Wang Shen (1036–93) and Zhao Lingrang (active 1067–1100), both members of the Song imperial household who appreciated poetry and painting. The bird-and-flower painter Wu Yuanyu (active approx. 1050–1100) frequented royal estates

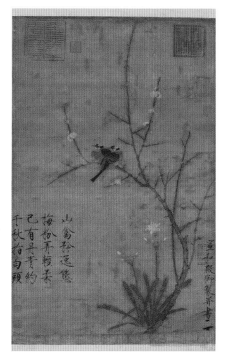

FIGURE 2
Wintersweet Blossoms. By Zhao Ji (Emperor Huizong, 1082–1135). Northern Song dynasty (960–1127), reign of Emperor Huizong (1100–25). Hanging scroll, ink and color on silk.

and influenced Huizong's paintings in that genre. Huizong's *Wintersweet Blossoms* (*Lamei Shanqin*; fig. 2) in the National Palace Museum collection is one such work. His gentle touch with the brush, which nevertheless contains a steady and even forceful sensitivity, marks out the plum blossoms and the branches and a pair of plum starlings huddled close by. Even without detailed portrayal of these subjects, the work conveys an intensely lively impression, revealing how Huizong's excellent brush techniques contribute to a subtly poetic work. On it Huizong inscribed in his distinctive "slender-gold" script a poem of his own composition, the last lines of which read: ". . . to the blue-green—I already promised we will spend a thousand years together until white hair." He also wrote "Produced and written by the Emperor in Xuanhe Palace," signing it, "Premier in the World" (*Tianxia yiren*). It is evident that he was proud of his artistic accomplishments.

Emperor Xuande of the Ming dynasty was also devoted to the art of painting, and the early Qing critic Xu Qin (1626–83) praised his talent. Painting as he pleased, Xuande reached a very high standard,[10] and some critics believe that his artistic accomplishments compared with Huizong's.[11] Most of Xuande's extant works are flower-and-bird paintings or portrayals of animals. The fauna that are the main subjects of these works are executed in a style similar to the meticulous realism of Song academic painting. They are set against backgrounds of flowers, trees, bamboo, and rocks that display the "freehand" (*xieyi*) style of the Yuan and the early Ming eras. One example is "Cats in a flower-and-rock garden" (cat. 64). The soft texture of the cats' fur is rendered in faint dark ink and ink wash with a few touches of the brush, while in the background a sculptural rock and wild chrysanthemums are precisely outlined with a fine brush. Thus, two different styles of painting are merged in one work.

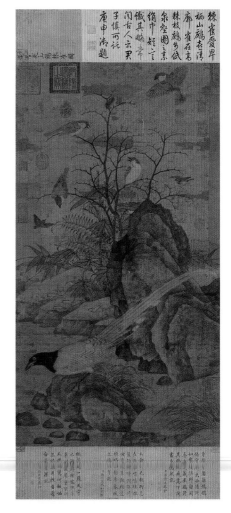

THE IMPERIAL PAINTING ACADEMY

Throughout Chinese history, the court recruited gifted painters to serve in the palace for all sorts of practical and aesthetic goals. From the Han dynasty in the second century BCE to the Tang dynasty in the eighth century CE, the process remained more or less the same: Professional artists would be commanded by the emperor to create a painting to decorate the palace or promote enlightenment. These painters were not a part of a formal institution or system, nor did they have an official studio. Some of them did assume official duties, taking up the position of "Academician Awaiting Orders" (*Hanlin Daizhao*) in the Hanlin Academy in the central government. *Hanlin*, meaning "forest of brush tips," was a common designation at the Institute of Academicians from the Tang through Qing dynasties.

It was not until the tenth century that an official painting academy was set up in the palace. The Imperial Painting Academy, established at the Northern Song court, attracted specialists in painting from all over the empire. Modern scholars have determined that 168 painters served in the academy in the early years of the Northern Song dynasty, with 70 court painters active in the late Song and the Southern Song courts.[12] Posts in the Imperial Painting Academy included "usher" (*zhihou*), "Academician" (*Yixue*), and "Academician Awaiting Orders" (*Daizhao*).

Painters in the academy followed the wishes of the emperor, who commissioned paintings of figures, landscapes, flower-and-bird subjects, animals, and Daoist and Buddhist themes, among others. The style of these paintings shifted according to the emperor's taste.[13] For instance, the Academician Awaiting Orders

FIGURE 3
Blue Magpie and Thorny Shrubs. By Huang Jucai (born 933). Northern Song dynasty (960–1127). Hanging scroll, ink and color on silk.

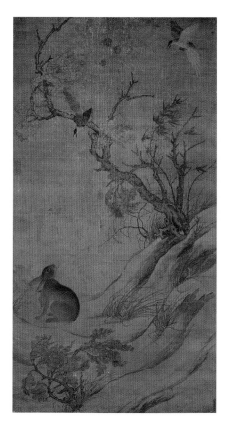

FIGURE 4
Magpies and Hare, dated 1061. By Cui Bai
(active approx. 1050–1100). Northern Song
dynasty (960–1127), reign of Emperor Renzong
(1023–63). Hanging scroll, ink and color on silk.

Huang Jucai (born 933) produced murals and screen paintings for the halls of the palace on themes mainly concerned with the precious and strange fauna of the Imperial Garden. His style (and that of his father, Huang Quan [approx. 903–65]) became the standard by which other painters were judged,[14] and Emperor Taizong honored Huang Jucai with an important position at court. By the time of Emperor Shenzong (reigned 1068–85), Cui Bai (active approx. 1050–1100), Wu Yuanyu, and others had developed a new style of painting that became the fashion at the academy. In Huang Jucai's *Blue Magpie and Thorny Shrubs* (fig. 3), the partridge had been depicted with detailed brushwork to which fine coloring has been added. In Cui Bai's *Magpies and Hare* (fig. 4), the background plays a more prominent role in the composition, showing the slope of a hill, a withered tree, and bamboo. These elements, along with the hare and the partridge in the mountain stream, are rendered in delicate and rough brushstrokes and all work in concert. The artist attempted to create a mood beyond the realism of the image. Such styles presaged developments in painting under the next emperor, Huizong.

Huizong's interest in the arts was reflected in reforms enacted at the Imperial Painting Academy. In 1104 he established two separate curricula: "Study of Painting" and "Study of Calligraphy" at the School for Sons of the State (*Guozi xue*), one of several capital schools under the Directorate of Education. This was the first time that a government had established art education as a specialized field of training aimed at nurturing scholars. In 1110 the two departments were reorganized into the Hanlin Writing Art Bureau (*Hanlin shuyi ju*) and the Hanlin Painting Bureau (*Hanlin tuhua ju*). Students in painting chose one of six specialties: Buddhism and Daoism, figures, landscapes, birds and animals, flowers and bamboo, or architecture. They were given fundamental instruction in the classics and studied characters, seal script, and accuracy in imagery; they were tested on their knowledge of classical texts and the expression of "painterly" and "poetic" intent. Students in calligraphy were to "cultivate virtue [and] pursue traditional schools, in order to integrate the studies of the world." The academy defined the curriculum and outlined paradigms worthy of emulation. Aside from learning calligraphic techniques, they studied classical texts in order to understand the principles of construction in ancient writing and to be proficient in the Confucian classics. The evaluation of calligraphy followed certain principles:[15] characters should be appropriately square, round, flat, or slender; strokes should be vigorous, clear, and elegant; the work should manifest painterly and poetic intent. These curricula would define the standards of painting and calligraphy in the Southern Song court.

When the Southern Song established its capital in Hangzhou, Zhejiang province, the painting academy moved there as well. Under the guidance of the imperial household, court painters undertook decorative paintings for palace temples, murals and partitions in government offices, screens, and others commissions. They built on the achievements of the Northern Song artists, developing a more delicate style of painting rich in poetic sentiment. Ma Yuan (active approx. 1160–after 1225) and his son Ma Lin (active 1180–after 1256) were important academic painters active in the middle part of the Southern Song dynasty. In "Walking on a path in spring" (cat. 8), Ma Yuan depicts a scholar who seems to have barged into a secluded and placid world of animals and plants and creates a subtle, sensitive picture of the relationship between humans and nature. Emperor Ningzong (reigned 1195–1224) added a poetic inscription to the painting, establishing a new model of collaboration between Southern Song emperors and academic painters. Ma Lin's *Spring Fragrance, Clearing after Rain* (cat. 9) conveys a similar mood and theme. The

poetic depiction recalls a verse by poet Su Shi (1037–1101): "Few peach blossoms can be seen beyond the bamboo grove; ducks feel the warm water of spring before all others." To Ma Lin's signature Emperor Ningzong appended the painting's title in calligraphy and a seal mark used by Empress Yang Meizi (1162–1232), establishing the collective nature of the work.[16]

After founding the Ming dynasty, Emperor Hongwu (reigned 1368–98) emulated the Song and established a painting academy, summoning painters from around the empire to take up positions in the palace. These professional painters were usually recommended to the capital by local officials. Hangzhou and the neighboring Fujian area had produced many talented painters since the Southern Song era, as had Guangdong, Shandong, Suzhou, Nanjing, and other places. These artists brought a wealth of regional styles to court painting. Painters serving the court congregated in the Hall of Benevolent Wisdom (*Renzhi dian*), the Hall of Military Eminence (*Wuying dian*), and the Hall of Literary Glory (*Wenhua dian*). Painting flourished during the reigns of Xuande (1426–35), Chenghua (1465–87), and Hongzhi (1488–1505); between 1400 and 1529 the number of court painters increased from 211 to 1,700.

Li Zai (died 1431) was a court painter accomplished in two styles of landscape: one "fine and glossy," modeled after the Northern Song court painter Guo Xi (active approx. 1050–1100); the other "bold and unconstrained," following the Southern Song court painters Ma Yuan and Xia Gui (active 1195–1224). "Mountain villa and lofty retreat" (cat. 65) belongs to the former category and portrays the secluded world of a hermit living in the mountains. Particularly eye catching are the towering ridges and peaks jutting above the mist and the exaggerated, twisted trees—features similar to those in Guo Xi's masterpiece *Early Spring* (fig. 5). These resemblances suggest that in copying Guo Xi, Li Zai's style had become a set formula—one loved by Emperor Xuande. We can easily imagine viewers seeing the painting on the wall of the palace and entertaining the fantasy of being detached from the mortal world.

Court painting reached its pinnacle during the Qing dynasty. In the early Qing, the Studio of the Wish-Granting Wand (*Ruyi guan*) was set up within the Imperial Workshop (*Zaoban chu*) under the Imperial Household Department in the northwestern part of the Forbidden City. Painters were either recommended by ministers or local officials or summoned by the emperor to serve in the palace. Their service was assessed—and rewarded or punished—depending on the emperor's likes and interests. Painters were divided into three ranks and paid accordingly. In order to control the content and quality of the paintings, emperors frequently reviewed drafts submitted by the painters; only when the emperor had approved a draft would painting begin. Important large-scale works were produced collaboratively, with labor divided according to each painter's expertise.[17] Paintings covered a broad range of themes and content, always with the aim of enlightening the populace. Among the most popular were paintings of activities related to the solar calendar, auspicious tidings at the New Year, religious subjects, the glorious feats of the imperial household, and rare animals from foreign nations. The production of paintings in the Qing court was not limited to professional painters. The palace was home to many imperial clansmen who were skilled in painting and to major ministers in key positions who obeyed orders to create paintings to suit the needs of a particular situation.

The Qing court painters of the orthodox school revered the old masters' views of nature and techniques. In his inscription on the painting *Whiling Away the Summer in a River Village* (cat. 84), Wang Hui (1632–1717) described a work of the

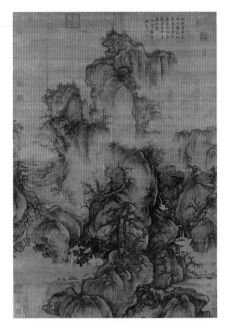

FIGURE 5
Early Spring. By Guo Xi (active 11th century). Northern Song dynasty (960–1126). Hanging scroll, ink and color on silk.

same title by the great Yuan-era official-scholar Zhao Mengfu, calling it "extremely beautiful and vigorous, with an extraordinary intent. He . . . delivered the mysterious charm of the ancients." Exactly what he meant by Zhao's "intent"—the quality that made Zhao worth emulating more than any single feature—can perhaps be gleaned from Wang Hui's depiction of this calm and ordinary scene: a smooth stream with shallow inlets, a crooked path with willows on the bank, village huts, wild egrets, and flying swallows. The willow groves on the near shore are sparse and delicate. The pale green ink wash on the mountain rocks creates a contrast that conveys a clear, carefree atmosphere. This painting was later collected by Emperor Qianlong and was included in his catalogue compiled between 1791 and 1793.

Wang Yuanqi's "Peaks emerging from spring clouds" (cat. 86) is a pleasant scene with a strong decorative flavor; the work was well suited to being hung in a formal hall. Wang Yuanqi's color scheme, his solid strokes, and the winding-dragon arrangement are indicative of the Qing goal of "imitating the ancients" while achieving an "overall synthesis"—of looking back to classical masters while incorporating new styles of such Ming masters as Dong Qichang and Wang Shimin (1592–1680). This painting was a work Emperor Qianlong particularly appreciated, bringing it with him during a trip to the Mountain Villa for Summer Retreat in Chengde.

Leng Mei (1662–after 1742) and Jiao Bingzhen (active 1689–1726) each created paintings appreciated by the Qing emperors, though they clearly belonged to different schools (see cats. 88 and 90). Differences in regional background, lineage, and upbringing produced a wide range of styles in painting by the literati.[18] Indeed, this diversity is one of the distinctive qualities of Qing painting. All painters—professional or talented officials, Han or Manchu, Confucian or Jesuit—were welcome; all styles—meticulous or carefree, traditional or innovative—were valued by the Qing emperors.

NOTES

1. Ho Chuan-hsin 1992.

2. Zhu Changwen 1970.

3. Huang Tingjian 1967, 31.

4. Mi Fu 1966.

5. Wang Yinglin 1983, 775.

6. Cai Tao 1991. Tao Zongyi 1993, 43.

7. Zhu Mouyin 1983–86, 140.

8. Liu Jiaju 1992. Zhuang Jifa 1992. Li Fang (1924) 1986.

9. Lin Lina 2002.

10. Xu Qin 1993, 5.

11. Lin Lina 1994.

12. Ho 1980.

13. Guo Ruoxu (1074) 1993.

14. *Xuanhe huapu* (1119–25) 1993, 122–23.

15. Tuo Tuo (1345) 1969, vol. 6, chap. 157, 4853.

16. Wang Yaoting 1995.

17. Nie Chongzheng 1996.

18. Chou Ju-shi 1985.

TIANLONG JIAO

Exceptional Emperors: The Antiquities Collections of Huizong and Qianlong

For millennia Chinese emperors collected luxurious goods, arts, and antiquities. These treasures are usually characterized by their extraordinary splendor, beauty, and richness, representing the highlights of Chinese artistic accomplishments. The fact that the emperors built these collections and that these objects were rarely seen outside the court created a mysterious aura around the artworks and fascinated people at the time and since. The course of imperial collecting and the development of the collections are closely intertwined with the political and cultural history of China. The often-violent transition from one dynasty to another led to the dispersal or destruction of many treasures. The odyssey of how these imperial collections evolved and survived is key to understanding their significance.

Given the nature of imperial power, any treasures in the emperors' possession were in one way or another inevitably tied to statecraft. Art historian Lothar Ledderose has argued that imperial collecting was an integral part of Chinese rule, with the treasures seized from conquered rivals serving as symbols of dynastic legitimacy.[1] This view has been endorsed by those who have found political symbolism in the imperial collections throughout Chinese history.[2] Patricia Ebrey has observed that imperial collecting habits during the Northern Song dynasty (960–1127) served as a way to awe the scholar-official class: "In Song times, collecting and writing about books, art, and antiquities became an arena in which the educated elite and the throne subtly competed for cultural leadership" (see fig. 1).[3] However, there are others who argue that it is too simplistic to tie the act of imperial collecting exclusively to politics—that in reality the motivations behind the emperors' collecting were complex, and that the messages their activities generated are subject to specific historical context. In order to understand Chinese imperial collecting, therefore, one must study the religious, psychological, and social-cultural aspects of the relevant emperor-collector.[4]

It is also important to acknowledge that collecting antiquities and gathering or commissioning contemporary arts and crafts were seen as separate activities. Most, if not all, Chinese emperors indulged themselves with contemporary or exotic luxury goods, but few were passionate about antiquities. There are two notable exceptions to this rule: Emperor Huizong (reigned 1101–25) of the Northern Song dynasty and Emperor Qianlong (reigned 1736–95) of the Qing dynasty (1644–1911). Both emperors amassed a huge number of antiquities, indulged themselves with their collections, and more importantly, published their collections in a series of catalogues. Their collecting and connoisseurship had an enduring effect on the development of the study of antiquities in China. Most of Huizong's collections were

Tibetan-style ewer, Qing dynasty (1644–1911), reign of Emperor Qianlong (1736–95), cat. 140.

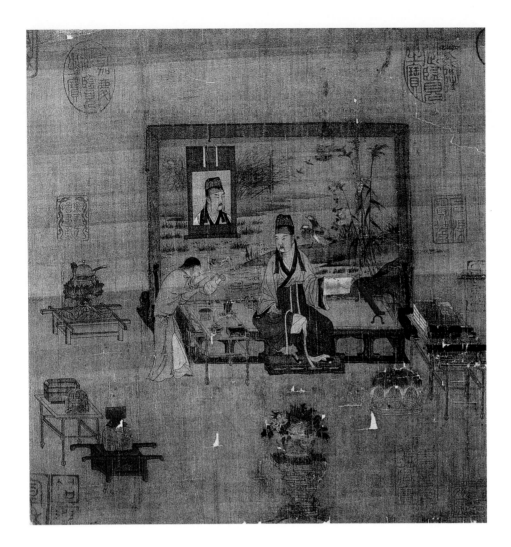

tragically lost after the Northern Song dynasty was invaded by the Jin army in 1127, but the majority of Qianlong's collections have survived despite the fact that they also went through a series of violent wars. The National Palace Museum, Taipei, has one of the largest holdings of Qianlong's antiquities, and many of these objects are featured in this exhibition.

SYMBOLS OF PRESTIGE AND POLITICAL LEGITIMACY

The roots of collecting luxurious goods can be traced back to the remote prehistory of China. Archaeological discoveries have demonstrated that the elites in prehistoric China fully understood the power of prestigious goods. Starting around 3000 BCE tombs furnished with goods made of jade or ivory appeared in many regions of China, indicating that the beginning of hierarchical societies was associated with the possession of prestigious objects by a small number of elites. The collecting of antiquities, however, seems to have been a much later phenomenon. Although a number of ancient objects were found in tombs from the Shang dynasty (approx. 1600–1050 BCE) and the Eastern Zhou period (approx. 771–221 BCE), it was not until the Western Han dynasty (206 BCE–9 CE) that antique collecting became an important endeavor among royalty, as indicated by recent archaeological discoveries. Many of the tombs or mausoleums of the Han royalty excavated so far have contained antiquities. One example is the tomb of King Liu Fei of the Jiangdu kingdom (reigned

153–128 BCE): Among its more than 10,000 objects are a number of antiquities, including a jade halberd from the Shang dynasty, a bronze basin from the Spring and Autumn period (771–approx. 480 BCE), and a bronze bell from the Warring States period (approx. 480–221 BCE).[5] Although we do not know how the king acquired these antiquities, the fact that they were buried in his tomb clearly indicates that they were regarded as precious. There are also cases of antiquities that were refitted for different uses. In the tomb of King Liu Sheng of the Zhongshan kingdom (died 113 BCE), for instance, a prehistoric Liangzhu culture (3400–2250 BCE) jade *cong* tube was refitted to be part of a jade suit.[6] Another Liangzhu-era jade *cong* tube was given a silver base for the pleasure of a Han dynasty lord whose tomb was located at Sanlidun, Lianshui county, Jiangsu province.[7] This tomb also held a number of bronze vessels and statues that date to the Warring States period, clearly indicating that this Han royal enjoyed ancient artifacts.

During the Western Han dynasty, some antiquities held exceptional spiritual and political value, most notably ancient bronze tripods. The appearance of ancient bronze tripods was regarded as an auspicious sign for the dynasty, establishing a connection with the legendary "Nine Tripods" that had been regarded as a symbol of kingship since the Xia dynasty (approx. 2100–1600 BCE). According to legend, the first ruler of the Xia dynasty, King Yu, cast a set of nine tripods to symbolize his authority to rule. When the Xia fell, the tripods were handed down to the Shang dynasty and later, in turn, to the Western Zhou dynasty. They were lost before the founding of the Qin empire (221–206 BCE), an inauspicious sign for that short-lived dynasty. Historical texts state that when a large bronze tripod was found in the Fen River in 116 BCE, Emperor Wu (reigned 141–86 BCE) made a special journey to see it. Indeed, the appearance of this ancient bronze artifact was thought to be so auspicious that Wu subsequently changed his reign title to *Yuanding* ("Original Tripod"). To the Western Han emperors, the possession of these ancient bronze tripods clearly symbolized a divine mandate to rule China.

We do not know whether this kind of politically motivated collecting of antiquities continued after the Han dynasty. During the many centuries of turmoil that followed the collapse of that dynasty, such collecting was not a priority for most emperors. By the Tang dynasty (618–907 CE), China once again entered a peaceful and prosperous period when there was a distinct resurgence in collecting antiquities, though the notion of collecting to legitimize rule greatly changed. It is recorded that Emperor Taizong (reigned 626–49) was an avid collector of the calligraphy of Wang Xizhi (approx. 303–61). However, he was motivated by his personal zeal to possess all of Wang's works, nearly 2,300 pieces, and not by the empire's political needs. After enjoying them, he eventually had them buried in his tomb. His infatuation with these ancient works shows how imperial taste could affect the transmission of Chinese cultural heritage to later generations.

COLLECTING ANTIQUITY ON AN UNPRECEDENTED SCALE

The Northern Song dynasty represents a turning point in the appreciation of Chinese antiquities, as the collecting of ancient objects became a nationwide pursuit on an unprecedented scale. The imperial family and scholar-officials were all actively engaged in collecting antiquities. Ancient bronzes, jades, rubbings of stone steles, and books all became highly valued collectibles. More importantly, the study

of antiquities reached a new level of sophistication. Emperors and officials alike researched and published their collections. This connoisseurship had a great influence on the development of antiquarianism and initiated a field of research called *Jin Shi Xue* that has continued to the present day in China. This passion for antiquities was driven by court policy. After seizing the throne in a military coup, the Song emperors resolved to restore traditional ritual systems to stabilize their rule. Antiquities, particularly bronzes and books, were regarded as important resources for promoting ancient rituals and wisdom. From the time of Emperor Taizong (reigned 977–97), the Song court made a conscious effort to collect antiquities, and emperors rewarded worthy officials by allowing them to view their collections.

This kind of political favoritism shaped the practices of Emperor Huizong (reigned 1101–25), the most avid emperor-collector of the Northern Song dynasty. Even as a prince, Huizong was a passionate lover of antiquities and arts. After he became emperor, he made it clear to his court that he wished to collect antiquities to decorate the many halls in his palaces. His officials responded with an enthusiastic pursuit of ancient artifacts and arts for the emperor. It is recorded that Huizong's collection of ancient ritual vessels quickly grew from 500 pieces to more than 6,000 pieces within the first ten years of his reign.[8] He rewarded people who submitted antiquities to him with money or promotion to a higher rank. These policies not only drove up the price of antiquities, they also had a devastating effect on many ancient tombs. Recent archaeological excavations reveal evidence of looting during the Northern Song period, which was likely the first large-scale destruction of ancient tombs in Chinese history.

As a result, it did not take long for Huizong to build up an impressive collection of antiquities. By 1113 his collections had grown so large that he had to construct a special building for them. It is recorded that Huizong not only filled this building with precious ancient bronzes, jades, and crafts, he also named the rooms with titles such as "Searching for Antiquity," "Pursuing Antiquity," "Honoring Antiquity," "Examining Antiquity," "Creating Antiquity," "Transmitting Antiquity," "Broad Manifestations of Antiquity," and "Inner Secrets of Antiquity."

Emperor Huizong enjoyed studying his collections and would invite trusted officials to join him. A number of scholar-officials—such as Cai Jing (1047–1126)—helped Huizong study the collections and authenticate objects when necessary. Huizong also made his ownership of the objects visible by writing inscriptions and putting his seals on paintings and calligraphy. And yet, as we shall see, his assertion of ownership was far less invasive than that of Emperor Qianlong of the Qing dynasty.

The exact number of antiquities in Huizong's collections is unknown. First compiled in 1107–10 and expanded and revised in 1119–25, *Antiquities Catalogue of Xuanhe* (*Xuanhe bogutu*; fig. 2) describes about 840 works—though it is reasonable to believe that the actual size of Huizong's bronze collection was in the thousands. About 6,400 paintings are listed in *Painting Catalogue of Xuanhe* (*Xuanhe huapu*; compiled 1119–25), and about 1,200 works were illustrated in the *Calligraphy Catalogue of Xuanhe* (*Xuanhe shupu*; also published 1120). However, these catalogues do not list the complete inventory of Huizong's collections. Research has shown that they are very selective, reflecting Huizong and his curators' views on specific artworks.[9] And while the catalogues focus on ancient (pre–Song dynasty) artists, they also include contemporary artworks.

These catalogues established Huizong as the first Chinese emperor to publish his collections. The taxonomic system employed in these catalogues had an enduring

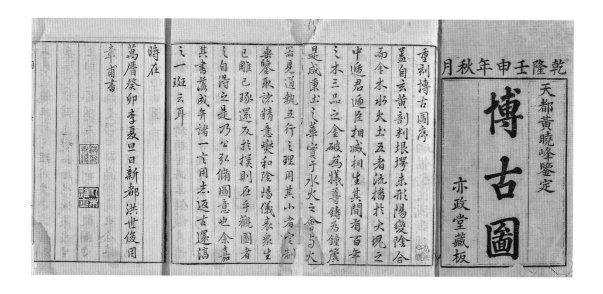

effect on the study of Chinese art and antiquities. The calligraphy catalogue was divided into eight categories: emperors' calligraphy, seal script (*zhuan shu*), clerical script (*li shu*), regular script (*zheng shu*), running script (*xing shu*), cursive script (*cao shu*), clerical script (*bafen shu*), and imperial and government documents (*zhizhao gaoming*). The painting catalogue grouped paintings into ten genres: religious, figure, architecture, foreigners, dragons and fish, landscape, animals, birds and flowers, ink bamboo/small scenes, and vegetation. While the compilers of the calligraphy and painting catalogues might have adopted terminology from earlier treatises, the antiquities catalogue was truly a pioneering work of scholarship that established a format for describing bronzes: a combination of line drawings of the object, facsimiles of inscriptions, and written descriptions of the physical appearance and dimensions of the work. This catalogue established the nomenclature for most ancient bronze vessels, based primarily on inscriptions, that are still in use today.

Huizong and his scholar-officials went beyond just describing and naming the ancient bronzes; they also studied their history and use. The Song dynasty scholar-official Lu Dalin (1040–92) wrote that the objective of compiling the catalogue was "to search for the origins of [ritual] institutions, to fill the lacunae in the classics and their commentaries, and to correct the errors of the [classical] scholars of the past."[10] Their methodology and scholarship marks the beginning of the academic study of antiquities in China.

In 1127 the Northern Song capital of Kaifeng was ransacked by the invading Jurchen army. Huizong, who had abdicated the throne the previous year, and his son Emperor Qinzong (reigned 1126–27) were both taken prisoner. Huizong's collection of art and antiquities, along with other imperial treasures, were taken away by the invading army. With no appreciations for these objects, the Jurchen rulers gave many artworks away as rewards to generals and officials. In 1158 the Jurchen ruler Wan Yanliang (reigned 1149–61) ordered the destruction of all ancient vessels taken from the Song court. Those objects that survived faced many similar threats and ordeals in the subsequent cycles of turmoil in China, and most works that once resided in Huizong's collection were eventually lost; it is estimated that fewer than 100 objects survive today.[11] The fate of the Northern Song dynasty gave Huizong a reputation as an emperor more interested in the arts than statecraft, and he was routinely cited as a cautionary example by later imperial advisers who wanted to persuade their emperors not to delve too deeply into the arts.

The Qing dynasty was established in 1644 by invading Manchus from the northeast. As a minority population, these conquering Manchu rulers were conscious of the need to legitimize their rule to the Chinese majority. In doing so, they developed a deep appreciation for Chinese culture. In the early years of the dynasty, the emperors' interest in and patronage of Chinese culture succeeded in establishing acceptance of their governance. Emperor Shunzhi (reigned 1644–61) was a gifted painter in the traditional Chinese style who particularly admired Emperor Huizong's patronage of art. Emperor Kangxi (reigned 1662–1722) engaged Chinese artists in painting, architecture, and ceramic manufacturing projects for the court and demanded that artists portray him as a Chinese scholar. Emperor Yongzheng (reigned 1723–35) likewise supported Chinese arts. By the time Emperor Qianlong took the throne in 1736, the Qing dynasty was in its most stable and prosperous period. This allowed Qianlong to indulge his own taste for collecting, making him the most prolific emperor-collector of all.

In quantity and quality, Qianlong's collection was the richest in Chinese history, surpassing even Emperor Huizong's in almost all categories. He commissioned a series of catalogues documenting his collections of bronzes, paintings, calligraphy, seals, and books. These catalogues were organized according to the halls in which his collections were housed. For instance, 1,529 ancient bronzes were recorded in the *Antiquities of Western Clarity* (*Xiqing gujian*; published 1749); 1,235 works of calligraphy and paintings were listed in the *Imperial Archives with Gems* (*Midian zhulin*; 1744), 200 inkstones were recorded in *Inkstone Catalogue of Western Clarity* (*Xiqing yanpu*; 1778). Revised editions of these catalogues recorded Qianlong's ever-growing collections, even after his abdication in 1795, but by no means did they represent his entire collection. On the contrary, they were highly selective, with decisions about which objects to include made by scholar-officials under Qianlong's supervision. For example, most of Qianlong's collections of Song and Ming porcelains were not recorded. In terms of the format and taxonomic system of his catalogues, Qianlong followed Emperor Huizong's example.

Scholars have attempted to estimate the total number of works in Qianlong's collections, but there is no agreement so far.[12] Patricia Ebrey has argued that there were 3 million works in the collection—though this number is likely too high.[13] According to Tsai Mei-Fen, the chief curator of the Object Division of the National Place Museum, 608,985 works from the former Qing palace were shipped from mainland China to Taiwan at the end of the civil war in 1949, including 46,100 objects; 5,526 paintings and works of calligraphy; and 545,797 books and documents from the former Palace Museum; and 11,047 objects; 477 paintings and works of calligraphy; and 38 books and documents from the former Central Museum. "About 80 percent of these works were collected by Emperor Qianlong," says Tsai, putting the total number of works from Qianlong's collections in the National Palace Museum, Taipei, at about 490,000 pieces. Because Qianlong collected both antiquities and contemporary arts, we do not know the exact number of antiquities in his collections. Given the fact that a good portion of the Qing imperial collections are still in mainland China, it is reasonable to believe that Qianlong amassed more than half a million antiquities throughout the sixty years of his reign.

With his absolute power over the empire, Qianlong had the means to amass all the antiquities he wished to possess. A good portion of them were inherited

from his ancestors and from previous dynasties, but tributes from officials were another major source of acquisitions. Qianlong lived into his eighties and enjoyed many lavish birthday celebrations and national ceremonies, all of which provided plentiful opportunities for officials to pay tribute to the emperor. Qianlong also used his inspection trips to the south to gather antiquities and arts from local collectors.

Qianlong obviously derived deep pleasure from his collections. He studied them with great interest and had no hesitation about leaving visible marks on almost all of the pieces he liked. His connoisseurship was expressed through poems, inscriptions, colophons, as well as seals—some of them so excessive that they have profoundly altered the original appearance of the artworks. In his later years Qianlong proclaimed himself the "Old Man of Ten Perfections" (*Shi quan laoren*), a title that referred to his successful military exploits and accomplishments in collecting art and antiquities.

A BLESSING FOREVER

Imperial collecting in China is as complex as Chinese history itself. Emperors collected for different purposes and in different patterns. What these collections shared was the fact that they were amassed for the exclusive enjoyment of the emperors, their families, and a close circle of officials. They were "forbidden" to the dynasty's subjects.

It was common for the founding emperors of new dynasties to seize the previous dynasty's treasures to legitimize their rule. The two great emperor collectors, Huizong and Qianlong, were exceptions to this rule. By the time they took the throne, their dynasties were already well established and enjoying periods of stability and prosperity. Although the need to sustain their dynasties was always paramount, there was no urgent reason to legitimize their rule through the collecting of antiquities. Therefore, their collecting passions and habits were more personal matters. And they shared a goal held by other emperors: they collected for the express benefit of the present members and future generations of the imperial family. Emperor Qianlong made an explicit statement of this goal by stamping onto many artworks a seal that read "Bless the sons and grandsons forever" (*Yi Zi Sun*).

The Qing dynasty came to an end in 1911, and after decades of turmoil, the collections of Emperor Qianlong and his descendants were once again dispersed. Some of these works were destroyed, but fortunately most of them have survived. Today these "forbidden" treasures are mostly housed in three museums, of which the National Palace Museum, Taipei, is one. These treasures are viewed and enjoyed by millions of visitors from all over the world every year—a "blessing" very different from that originally bestowed by Emperor Qianlong and other Chinese emperors.

NOTES

1. Ledderose 1978–79.
2. Elliot and Shambaugh 2005.
3. Ebrey 2008, 17.
4. Wang Cheng-hua 2010.
5. *Kaogu* 2013.10, pp. 3–68.
6. *Kaogu* 1972.2, pp. 39–47.
7. *Kaogu* 1973.2, pp. 80–87.
8. Ebrey 2008.
9. Ibid.
10. Chang 1986, 8.
11. Ebrey 2008.
12. He 2004, 95.
13. Ebrey 2008.

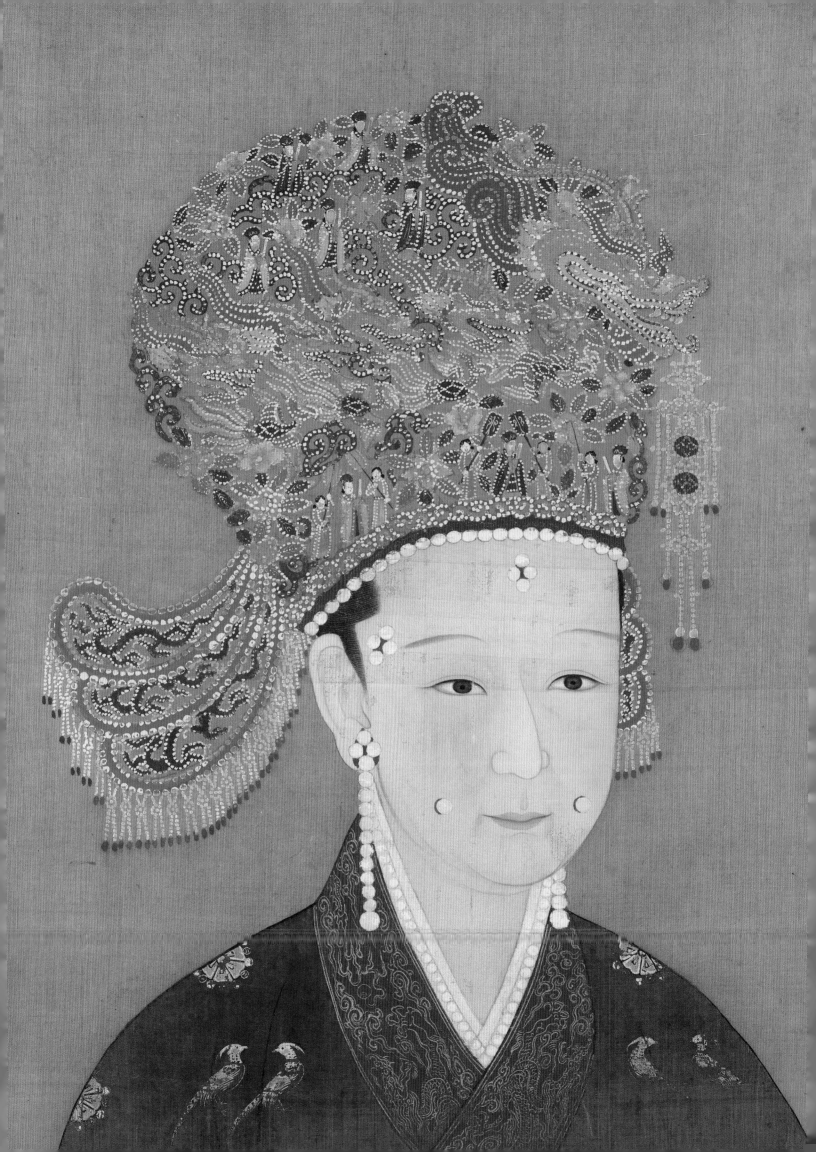

ALFREDA MURCK

A Millennium of Imperial Collecting and Patronage

During the nine and a half centuries of the Song, Yuan, Ming, and Qing dynasties, well-regarded sovereigns sponsored cultural projects that balanced military prowess with civilian luster. Courts that boasted collections of antiquities, calligraphy, and painting attracted talent, inspired confidence, and provided a model for wider society.

These collecting practices had compelling ancient precedents. The earliest palace collections were closely tied to the belief that heaven rewarded virtuous rulers with numinous objects such as ritual bronze vessels, charts, diagrams, and registers. In 219 BCE, when the First Emperor of Qin failed to retrieve nine bronze tripods from a river, it was interpreted as heaven withholding favor. Over time, magical artifacts were supplemented by art objects chosen for aesthetic appeal.[1]

Although the concept of royal art patronage often refers to financial and material support that monarchs bestow on artists—including calligraphers, painters, poets, and musicians—this essay approaches patronage in the broader sense of objects collected by emperors as well as things produced by and for royal courts by builders, kilns, and craftsmen of every description.

Drawing on generous state resources, imperial families commissioned palaces, libraries, ancestral shrines, Daoist halls, and Buddhist temples. They configured gardens, built tombs, and constructed villas for relatives and favorite officials. These architectural wonders in turn required furnishings such as screens, altars, textiles, sets of sacrificial vessels, religious icons, incense burners, thrones, dishes, lanterns, and wall decorations. Imperial courts organized processions with as many as 20,000 uniformed participants.[2] Aiming to inspire awe and respect, these spectacles required the manufacture of ceremonial robes, chariots, horse trappings, uniforms, helmets, insignia, canopies, banners, flags, drums, bronze bells, and gongs. Although not all goods produced for royal consumption—whether quotidian, religious, or ceremonial—qualify as high art, there is no question that today even fragments of such objects are prized.

NORTHERN SONG DYNASTY (960–1127)

Founding emperors were never great collectors. Although they contributed to the dynasty's patrimony by confiscating collections from their defeated enemies, their priorities were elsewhere: securing territory and populations; setting a new calendar; and establishing altars to heaven, ancestors, earth, and grain. The founding emperor of the Song dynasty, Zhao Kuangyin (reigned 960–76; also known as

Half-portrait of Empress Wu, Southern Song dynasty (1127–1279), cat. 5.

Taizu), hired experts for the task of setting standards for ritual and culture guided by ancient texts and recent precedents.

The Song dynasty's second emperor, Taizong (reigned 977–97), reputedly gained the throne through fratricide and, thus, was understandably eager to demonstrate his command of both culture and the bureaucracy.[3] During his reign he oversaw the establishment of norms for architecture, literature, painting, and historiography. Taking a personal interest in calligraphy, he brushed showy pieces in "flying-white" script and gave them to officials. Meanwhile, clerks and courtiers were instructed to practice the writing style of canonical fourth-century paragons of calligraphy Wang Xizhi (approx. 303–61) and his son Wang Xianzhi (344–86). In promoting the style of the Two Wangs, Taizong associated himself with the glories of the earlier Tang dynasty (618–907). Emperor Taizong of the Tang dynasty (reigned 626–49) so prized *Preface to the Orchid Pavilion* (*Lanting Xu*), which he promoted as Wang Xizhi's undisputed masterpiece, that he had it entombed with him. He left behind various manuscripts and stone-cut copies that were then recopied in ink or recut into stone and wood; these, too, were copied, generating many subtly different versions.

The attention to calligraphy, the most prestigious of all the arts, was not a trivial aesthetic issue. The written word represented a connection to the origins of civilization and transmitted the guiding precepts of China's foundational thinkers. Furthermore, calligraphic characters—whether carved into bone or stone, brushed on paper or silk, or written in sand—were often felt to have a numinous power in communing with spiritual forces. Brush writing was examined for revelations of the personality and moral stature of the calligrapher.[4] In 992 Emperor Taizong established calligraphy standards through a compendium called *Model Calligraphies from the Imperial Archives of the Chunhua Era* (*Chunhua getie*) that was distributed in the form of ink rubbings. Students and scholars were instructed to follow these examples, with the primary model being the balanced yet flexible style of the Two Wangs.

In the eleventh century unintended consequences resulted from the recruitment of officials through a new competitive examination system. Freshly minted scholar-officials included some strong, independent minds who challenged the dominant norms set by the court. The leading intellectual of the era, Ouyang Xiu (1007–72) (cat. 2), had studied the Two Wangs' calligraphy but favored the sturdy, upright style of the heroic Tang dynasty scholar-official Yan Zhenqing (709–85), arguing that it was the moral character of a model that mattered most. Ouyang Xiu and luminaries such as Su Shi (1037–1101) and Huang Tingjian (1045–1105) esteemed the uncalculated spontaneity of Yan Zhenqing's calligraphy in "Letter on the Controversy over Seating Protocol."[5]

The cultural competition between the educated elite—commonly called the literati—and the imperial court played out in painting as well. Royal courts sponsored paintings that pictured a prosperous and harmonious world in which color played a positive role. The court's preference for meticulous, polychrome painting was grounded in the belief that what you see is true, or could come true. The educated elite favored understated paintings in ink monochrome that were an extension of the writing brush. Scholar-painters prized authenticity, in the sense of psychological truth over verisimilitude, and sometimes obliquely referred to perceived injustices and flaws in the social order in their works. These two approaches to painting broadly define court and literati styles, yet the distinction is not absolute: the two methods overlapped and borrowed from one another, and a painter could

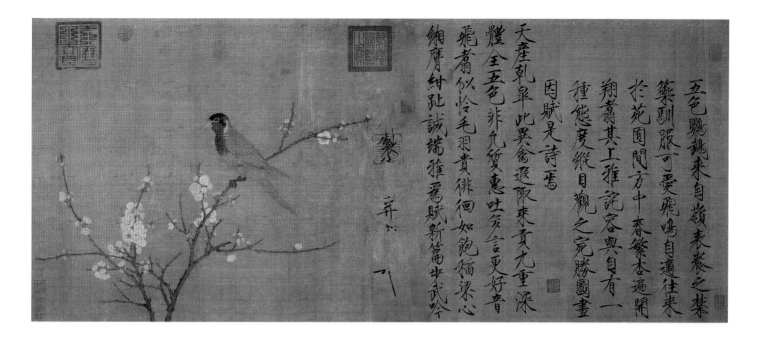

五色鸚鵡來自嶺表養之禁
籞馴服可愛飛鳴自適往來
於苑囿間方中春繁杏遍開
翔蕭其上雅詫容與自有一
種態度縱目觀之宛勝圖畫
因賦是詩焉

天産乾皐此異禽遐陬來貢尤重深
體全五色非凡質惠吐多言更好音
飛翥似憐毛羽貴徘徊如飽稻粱心
緗膺紺趾誠端雅為賦新篇步武吟

FIGURE 1

*Five-Colored Parakeet and Imperial
Calligraphy*. Attributed to Zhao Ji (Emperor
Huizong, 1082–1135). Northern Song dynasty
(960–1127), reign of Emperor Huizong
(1101–25). Hand scroll, ink, and color on silk.
Photograph © 2016 Museum of Fine Arts,
Boston.

switch styles depending on the message he wanted to send. In the late eleventh
century the new ink painting informed by personal commentaries was generating
discussion and followers.

Soon after Emperor Huizong (reigned 1101–25) ascended the throne, he
asserted the court's authority to propagate cultural standards. The paintings pro-
duced at his court established new, refined models. Of the few surviving works from
his quarter-century reign, *Five-Colored Parakeet and Imperial Calligraphy* (fig. 1)
superbly represents the "magic realism" of Huizong-era court painting. In calligra-
phy, Huizong developed a distinctive hand that came to be called the "slender-gold"
style and which can be seen next to the parakeet in the painting.[6] Huizong had
official declarations carved into stone in this unmistakable style in the conviction
that instructions written in his own hand would carry more authority.[7] *Five-Colored
Parakeet* is also an example of the "three perfections": the combination of poetry,
calligraphy, and painting in one work. In this Huizong, who was one of the most
literate of emperors, was taking a page from the late-eleventh-century educated
elite who had integrated the three arts with less polish but with arguably greater
emotional impact.

In addition to regarding antique objects as signs of heaven's favor, Huizong
collected art with a passion rivaled only by the eighteenth-century Manchu emperor
Qianlong.[8] The core of the Song imperial collection was formed by the dynasty's
founder Taizu, who confiscated books and art from defeated rival states. Huizong
expanded the collection by purchase and by generously rewarding donations.
Huizong's imperial catalogues indicate the scope of his collections: *Antiquities
Catalogue of Xuanhe* (*Xuanhe bogutu*) included 840 items; the *Calligraphy Catalogue
of Xuanhe* (*Xuanhe shupu*) contained 1,220 items; and the *Painting Catalogue of
Xuanhe* (*Xuanhe huapu*) documented almost 6,400 works.[9]

The vast collections that Huizong had assembled were largely lost in 1126
when the Song capital, Kaifeng, was sacked by Jurchen troops. The Jurchen car-
ried off thousands of carts of loot and imperial regalia. The loss of life was worse.
Thousands died during the siege of the capital. The Jurchen took prisoner 11,635
women; the retired emperor, Huizong; the just-deposed emperor, Qinzong (reigned
1126–27), and their consorts; and several thousand others, including officials,

attendants, eunuchs, craftsmen, and servants. Taken north to the home region of the Jurchen, most of the captives perished in the first two years.[10] Thousands who evaded capture braved the dangerous journey south pursued by Jurchen troops.

SOUTHERN SONG DYNASTY (1127–1279)

"Crossing to the south" (*nan du*) euphemistically encapsulates the chaotic events that demarcate the Northern Song from the Southern Song dynasty. The experience of crossing to the south informs two categories of objects in *Emperor's Treasures*: pottery and painting.

In central Jiangxi province, the kilns at Jizhou produced a range of black and brown glazed wares from about the ninth century into the Ming dynasty. The most celebrated are the Southern Song "falling-leaf" bowls, in which one or two desiccated leaves contrast with a dark glaze (see cat. 28).[11] Although falling leaves were a well-established metaphor for people returning to their roots, far more common in poetry was the image of leaves being swept up by the wind, flying, and scattering uncontrolled. Why such drama around a leaf? Annotations to an early poetry anthology equated falling leaves with worthy men being cast aside.[12] In the twelfth century, when the leaf bowls began to be produced at Jizhou, the imperial family and much of the capital's population were refugees for whom metaphors of dislocation and grief were fitting. Those who had survived escape from the Jurchen and reached the south were temporarily housed in Buddhist monasteries and government buildings. Buddhist temples in Jiangxi and Zhejiang provinces held tea ceremonies during which dried tea leaves were powdered and then whipped into a frothy, pale green infusion. Clan members no doubt cupped "falling leaf" bowls, felt the warmth of the tea, inhaled the grassy fragrance, and meditated on family and friends who had been lost and their own chance survival.[13]

Crossing to the south also highlights the relative importance of paintings—especially portraits of past emperors. These were vital in demonstrating continuity at the reconstituted court and in asserting legitimacy through venerating ancestors and displaying filial piety. In terms of dynastic preservation, famous masterpieces were far less important than anonymous ancestral portraits. For example, when the Jurchen sacked the Song capital, Empress Meng (1073–1131) was staying in a temple and so eluded capture. Critical to the dynasty's survival, she accompanied the new, self-declared Emperor Gaozong (reigned 1127–62) to the "temporary capital" of Lin'an (now Hangzhou) in the southern province of Zhejiang. In 1129, as the Jurchen threatened the new capital, Gaozong feared being captured. Apparently to maintain two sources of dynastic legitimacy, Gaozong sent the imperial portraits under guard with Empress Meng west into Jiangxi. En route to Jizhou, the empress encountered several hundred soldiers who were planning to become robbers. After being shown the portraits of Huizong and Qinzong and told that loyalty to the Song would be more remunerative than robbery, the potential brigands swore allegiance to the emperor.[14]

Since Emperor Huizong's passion for art and luxury was largely blamed for the fall of the Northern Song dynasty, Gaozong chose an ostentatiously somber approach for painting at his court. At least for a few decades, painting themes focused on stories of dislocation, reunions, rectitude, loyalty, and classical learning.[15]

Gaozong himself transcribed each of the 305 poems in the early anthology *The Book of Odes* and enlisted the minor official Ma Hezhi (active twelfth century) to paint interpretations on blank silk to the left of each poem.[16] *The Book of Odes* had an impeccable pedigree as it was said to have been edited by Confucius, the revered patriarch of learning. This cycle of poetry and paintings was far more proper than the light-hearted poems that were the inspiration for paintings at Huizong's court. As generations passed, the court relaxed into a comfortable life in the south. Painting subjects moved on to gardens, flowers, and misty landscapes, but the art of the Southern Song court remained more restrained, intimate, and melancholy than that of its predecessor.

In all periods, imperial women played a role in commissioning art for home, temple, and private enjoyment. Particularly outstanding was Yang Meizi (1162–1232), consort to Emperor Ningzong (reigned 1195–1224). She rose spectacularly from child entertainer of uncertain parentage to lady's maid in the palace to a beautiful and politically savvy young woman who outmaneuvered rivals to become empress in 1202.[17] Educated in the palace, Yang collaborated with some of the greatest artists of the dynasty. Ma Yuan (active approx. 1160–after 1225) and his son Ma Lin (active 1180–after 1256; see cats. 8 and 9, respectively) both painted flowers and landscapes to complement poems that she transcribed. A poem she wrote on an album leaf (fig. 2) was likely paired with a painting that is now lost, but the calligraphy displays her neat, accomplished hand. The poem reads:

> My makeup worn and faded, only the scent lingers;
> Still I shall enjoy Spring's beauty before my eyes
> Once you said to me how a year blooms quickly and as quickly dies!
> Might we now forsake worldly splendors for the land of wine?

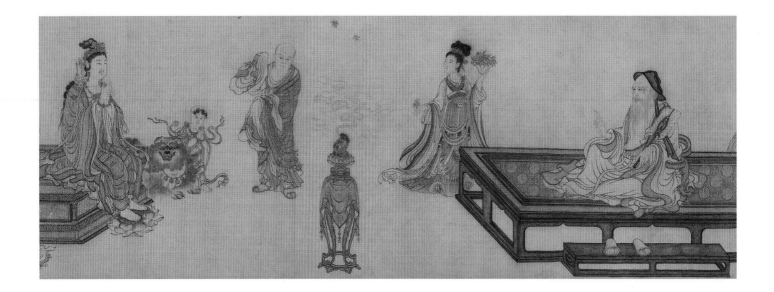

An influential figure until her death, Yang in this quatrain adopted the trope of the neglected palace woman. Spring's renewal reminds her of her fading beauty. The elegiac tone is mitigated in the last line with an invitation to indulge in wine.

In all periods, cultivating good behavior in boys and women was addressed through text and image. Court-sponsored didactic paintings and woodblock prints instructed children in filial behavior and women in proper decorum. For women there were versions of *Admonitions of the Imperial Instructress* and *Ladies' Classic of Filial Piety*.[18] For children, especially heirs to the throne, there were moral lessons on obedience, diligence, and self-sacrifice.[19]

MONGOL YUAN DYNASTY (1271–1368)

The earliest Mongol leaders of the brief Yuan dynasty did not learn Chinese. By the third generation, however, children were being taught Chinese language, calligraphic technique, and the classics. Grand Princess Sengge Ragi (approx. 1283–1331) and her two brothers were given an education that instilled an appreciation of Chinese culture, and Sengge went on to become the greatest collector of the Yuan dynasty. Her brothers, both of whom rose to be emperor, gave Sengge generous stipends that facilitated her acquisitions.[20] A fourteenth-century record of her impressive collection lists more than forty items, and her seals appear on another fifteen distinguished works.[21]

Instead of instituting a formal painting academy of the kind organized by Huizong, the Mongols established a painting service that sent artisans out to decorate palace halls.[22] The court also commissioned works from outstanding artists. A brilliant scholar and the finest calligrapher of the age, Zhao Mengfu (1254–1322; see cat. 42) served as a minor official at the Mongol court. He was continually in demand for his calligraphic inscriptions and paintings. In 1298 Emperor Chengzong (reigned 1295–1307) commissioned him to Beijing to join a team of calligraphers to transcribe the entire canon of Buddhist sutras. Zhao is said to have outdone them all, daily writing 10,000 perfect characters.[23]

He Cheng (active late thirteenth–early fourteenth century) and Wang Zhenpeng (approx. 1275–1330) produced fine-line paintings for the court,[24] and Princess Sengge owned a version of Wang's crisply drawn *Dragon Boat Festival*.

FIGURE 3
Detail of *Vimalakīrti and the Doctrine of Nonduality*, dated 1308. By Wang Zhenpeng (active approx. 1275–1330). Yuan dynasty (1271–1368), reign of Emperor Wuzong (1308–11). Hand scroll, ink on silk.

In 1308 her brother, the future Emperor Renzong, commissioned Wang to paint *Vimalakīrti and the Doctrine of Nonduality* (fig. 3). In a note on the scroll, the artist wrote that the picture was a draft based on a painting by Ma Yunqing (active approx. 1230), which was in turn a copy of a version by the scholar-painter Li Gonglin (1049–1106). The popularity of *Vimalakīrti-nirdeśa* with Buddhist laymen is not surprising since the sutra celebrates the layman's astuteness in debating Mañjuśrī, the bodhisattva of wisdom. Vimalakīrti outshines his opponent on every point despite his wealth and lay status. When pressed to explain nonduality, he remained quiet. His "thunderous silence" overwhelmed Mañjuśrī, for it perfectly illustrated the doctrine of nonduality by refusing to make distinctions.

Controlling territories that spanned Asia, the Mongol court tolerated Nestorian Christians, Daoists, Jews, and Muslims. While allowing all sects of Buddhism, Kublai Khan (reigned 1271–94) had a particular liking for Tibetan Buddhist practice, which was more colorful and more engaged in politics than other sects. He generously funded repair of old monasteries and construction of new ones.[25]

MING DYNASTY (1368–1644)

After years of hard-fought battles, Zhu Yuanzhang (reigned 1368–98) founded the Ming dynasty in 1368, taking the imperial title Hongwu, and restored Chinese rule. For his capital he chose Nanjing, just south of the Yangtze River and roughly at the center of his empire. With his many consorts, he sired twenty-six sons. Keeping the heir apparent with him in Nanjing, the emperor posted the other twenty-five in key locations around the empire, making each a prince of a fiefdom. These regional courts with their grand palaces and entourages were intended as a protective fence and screen for the court.[26] In locations as distant as Beijing in the north and Guizhou in the south, the princes, who had generous stipends and land for food and income, enjoyed the power and privilege that came with imperial blood. Their villas were filled with furnishings from around the empire. Some of the 443,500 pieces of porcelain requisitioned by the court in 1433 from Jingdezhen[27] were possibly used by the regional courts.

With this magnitude of imperial patronage, Jingdezhen, which had already been producing superb blue-and-white wares in the Yuan era, flourished in the Ming dynasty. At the beginning of the dynasty it was decreed that all vessels used on imperial altars should be monochrome porcelains. They would replace the motley assemblage of metal and ceramic imitations of antique bronze vessels. During the reign of Emperor Xuande (1426–35), copper-red glaze was perfected (fig. 4). The Ming "sacrificial red glaze" was named after its use in rites at the Altar of the Sun. Because the imperial family name, Zhu, means "red," the court no doubt prized the rich red glaze for symbolic as well as aesthetic reasons. Notoriously difficult to control, the intense color results from a combination of a minute amount of finely ground copper oxide in the glaze and carefully controlled high kiln temperatures.[28] The resulting soft, sensuous surface—it has been likened to plush velvet—is one of the triumphs of Ming court patronage.

The red-inked seals that collectors and connoisseurs impressed on scrolls are valuable in establishing their ownership over the centuries. The *siyin* half seal has long been misidentified as an early Ming dynasty court seal for objects acquired from the Yuan imperial collection. But the seal is now recognized as one used by

FIGURE 4
Dish. Ming dynasty (1368–1644), reign of Emperor Xuande (1426–35). Porcelain with copper-red glaze.

registry offices (*Jingli si*) located all over the empire when cataloguing confiscated art and household effects. The seal's full legend reads "Seal of registry office" (*Jingli siyin*). The left half with *siyin* characters was impressed on the right edge of an artwork while the right half of the seal was simultaneously imprinted on a registry book. The *siyin* seal can be seen in the exhibition on the right edge of "Ancient temple in a mountain pass" by Jia Shigu (active 1131–62; cat. 7).

Emperor Hongwu suspected military generals and officials of plotting against him and instructed his third son, Zhu Gang (1358–98), the Prince of Jin, based in Taiyuan, Shaanxi province, to eliminate the opposition—specifically by dismembering the accused officials (male relatives of the offending officials were simply decapitated, while women were sent to the capital in servitude). In 1392 and 1393 an estimated 15,000 people were executed.[29] Household belongings, including libraries and art collections, were seized and registered. Some of the loot was shipped to Nanjing, but as an incentive to Zhu Gang, his father allowed him to keep a large portion of the spoils. Zhu Gang's seal is found on distinguished surviving works, often in correspondence with the *siyin* half seal.[30]

Excavations of princely tombs have revealed riches indicative of a luxurious life in the imperial outposts of the Ming. Zhu Zhanji (1411–41), the ninth son of Emperor Hongxi (reigned 1425), was enfeoffed Prince Zhuang of Liang in Hubei province. He died of an unspecified illness at age thirty. The splendid contents of his tomb are largely attributable to his wife, Lady Wei (died 1451), who was interred with him ten years later. They had no children to whom they could pass on their treasures, which may account for the extraordinary wealth in the tomb: more than 1,400 items of gold and silver tableware, archaistic *jue* wine cups, and personal adornments such as gold and jade hairpins, pendants, bracelets, and other pieces of jewelry set with outsized sapphires and rubies. Their tomb also contained exquisite objects related to Tibetan Buddhism such as a gold plaque depicting the deity Mahakala.[31]

In 1380 Hongwu's fourth son, Zhu Di, was enfeoffed as the prince of Yan (now Beijing) to defend the northern border. In 1402 he usurped the throne from his nephew in Nanjing and took the title of Emperor Yongle (reigned 1403–24). In gratitude to the Daoist deity Zhenwu (the Perfect Warrior), whom he credited with his success, Yongle built an extensive series of temples at Mount Wudang and made Zhenwu the protector of the dynasty.[32]

Yongle moved the capital from Nanjing to his northern power base. Under pressure to display an aura of legitimacy, Yongle and his advisers designed a new palace complex, now known as the Forbidden City. Constructed from 1406 to 1420, the compound physically manifests the Confucian principles of centrality—a north-south axis is the anchoring spine of the compound—and balanced symmetry: the Hall of Literary Glory (*Wenhua dian*) represented civil (*wen*) society on the more prestigious east side, and the Hall of Military Eminence (*Wuying dian*) evoked the military (*wu*) on the west. These conventions were reinforced with symbolic colors, shapes, and numerology. In the yin-yang system, odd numbers (1, 3, 5,) are yang, or male, and even numbers (2, 4, 6) are yin, or female. The gendered numerology was applied to the proportions of the throne halls of the outer court, which were built on a ratio of 3:5; the buildings of the private inner court were constructed on a ratio of 2:4. This attention to detail created an idealized world that served as the imperial residence and ritual center for almost five centuries in the Ming and Qing dynasties.

A coalition of little-known steppe peoples identifying themselves as Manchu managed to conquer the Ming dynasty in 1644. A regent to the young Emperor Shunzhi, Prince Dorgon (1612–50) advised that the Forbidden City not be destroyed, as was the custom when crushing an enemy, but preserved for its symbolic value. This forbearance allowed the Ming imperial collection—at least those items that had not been already carried out of the palace—to be passed on to the Manchu court.

The second Qing emperor, Kangxi (reigned 1662–1722), welcomed the technical skills that Jesuit missionaries brought to Beijing, even as he rejected their proselytizing. Among them were Italian painters trained in European perspectival illusionism such as Giuseppe Castiglione (1688–1766), who won the admiration of three emperors. During his long tenure in the palace—where he was called Lang Shining—he created hundreds of illusionistic paintings and trained court artists in European techniques. Emperor Qianlong (reigned 1736–95) commissioned Castiglione to paint auspicious subjects (see cat. 129) and individual portraits. Qianlong loved things that trick the eye: celadon porcelain that mimics jade, lacquer that looks like wood, marble panels that are misty ink landscapes, stone that looks like meat, and two-dimensional paintings that are convincingly volumetric and spacious. However, in portraits he rejected the chiaroscuro that creates a sense of three-dimensionality, perceiving shading on faces and clothing as dirt.[33] Qianlong also commissioned large wall murals for many of the new halls he was building. To celebrate the subjugation of the Zunghar Mongols in 1761, he commissioned a mammoth wall mural (an affixed hanging, *tieluo*) measuring seventeen by eleven feet. Titled *Qianlong Watching Peacocks in Their Pride*, the skillfully illusionistic painting was created by an anonymous group of court artists.[34] In a corner of Qianlong's intimate retirement lodge, Studio for Retirement from Diligent Service (*Juanqin zhai*), a ceiling is painted with a trellis from which hang lavender wisteria blossoms. When viewed from the spot where the emperor would have sat for private opera performances, the painted wisteria is a simulacrum of reality, the angle and tonality of each heavy blossom perfectly calculated to deceive.[35]

Qianlong personally participated in creating culture through practicing calligraphy, composing poems, inscribing artworks, and occasionally painting. He conscientiously appealed to his various constituencies: Manchus, Mongols, Tibetans, and Chinese. In the stele at the Lama Temple in Beijing, inscriptions on each of the four sides are in different languages and with slightly different messages depending on the audience.[36]

During Qianlong's reign, religious practice was a central feature of life in the Forbidden City. The grandest halls of the palace were devoted to the imperial cult in which the emperor, as son of heaven, represented all mankind. In the smaller Hall of Ancestral Worship (*Fengxian dian*) he performed rites as the head of the clan. Daoist ceremonies were performed in the Hall of Imperial Peace (*Qin'an dian*), which is at the northern end of the symbolically important central axis. Unique to the Manchus was the daily shamanistic worship of totem dolls accompanied by cooking a sacrificial black hog. Each morning palace women and eunuchs conducted these rites in the Palace of Earthly Tranquility (*Kunning gong*), a grand hall modified from the empress's official residence.

Most worship, however, was conducted in domestic areas away from the central axis. Like their Mongol predecessors, the Manchu rulers focused on Tantric

Buddhism. By the eighteenth century there were about fifty spaces dedicated to Buddhist worship in the Forbidden City: thirty-five freestanding halls and more than a dozen chambers and altar niches. At the behest of Kangxi, the Hall of Rectitude (*Zhongzheng dian*) was built in 1697 for visiting Tibetan and Mongolian lamas. Cloisters with multiple altars surround a central hall. Workshops there made thousands of gilt-bronze Buddhist deities of exquisite craftsmanship for gift exchanges and for contemplative exercises. Hundreds of these line the walls and fill the altars of chapels mentioned below.

Qianlong was a tireless builder of halls—at the Garden of Perfect Brightness (*Yuanming yuan*); at Summer Palace; at the summer retreat of Chengde, north of Beijing; and in the Forbidden City. In 1769 he extended the Garden of Benevolent Tranquility (*Cininghua yuan*) for the religious practice of empress dowagers. The garden lies just south of their spacious residences, the Palace of Longevity and Health (*Shoukang gong*) and the Palace of Benevolent Tranquility (*Cining gong*). The garden features a large lotus pond and several structures for Buddhist worship. The Tower of Precious Forms (*Baoxiang lou*) held 787 copper-alloy figures and was probably built to commemorate the eightieth birthday of Qianlong's mother in 1771.[37] In the same year he refurbished the Hall of Exuberance (*Yinghua dian*), which dated back to 1567.[38] Two ancient Bodhi trees that still flank the central path are said to have been planted by the mother of Emperor Wanli (reigned 1573–1620). The Hall of Exuberance was for the use of the empress and consorts who lived in nearby courtyards. The two-story Pavilion of Buddhist Glory (*Fanhua lou*) at the northeast corner of the Forbidden City in the Palace of Tranquil Longevity (*Ningshou gong*) contains six spectacular cloisonné stupas.[39]

One of the more dramatic Buddhist halls in the Forbidden City is the Pavilion of Raining Flowers (*Yuhua ge*). Construction on the hall began a year after the death of Qianlong's childhood sweetheart and empress, Xiaoxian (1712–48). She was beautiful, demure, industrious, and frugal.[40] While accompanying Qianlong on a trip, she fell ill and died. The grieving emperor granted her a posthumous title, had her coffin placed in the Palace of Eternal Spring (*Changchun gong*), had her portrait reproduced and installed in dozens of halls of the Inner Court, and took the unusual step of requiring court officials to wear mourning clothes for twelve days. In a space immediately adjacent to her residence, the Pavilion of Raining Flowers rose to be one of the tallest buildings in the Forbidden City. Visible from a distance are the four gilt-bronze dragons on the roof that proclaim its Tibetan Tantric identity. From the outside, the building appears to be three stories, but inside it has four levels coinciding with the four levels of Buddhist enlightenment. Qianlong named it Pavilion of Raining Flowers after a passage in his favorite sutra, the *Vimalakīrti-nirdeśa*, in which a beautiful goddess sprinkles blossoms that stick to those of inferior wisdom. In the painting of this subject by Wang Zhenpeng (fig. 3) the goddess is shown holding a basket of flowers. Next to her is the agitated Śāriputra, who is trying to shake the damning blossoms from his robe.

The quality of materials and the detailing of altars, sculptures, and three-dimensional mandalas (fig. 7) signal the importance of the Pavilion of Raining Flowers to Qianlong. The emperor and his Tibetan-Mongolian spiritual mentor, Rolpay Dorje (1717–86), met there regularly.[41] Believing himself to be the most powerful man under heaven, it is not impossible that Qianlong was exploring ways to commune with Xiaoxian or facilitate the incarnation of her soul. Upon his death in 1799, Qianlong was interred with Xiaoxian in a lavish tomb, Yuling, east of Beijing.

FIGURE 5
Pavilion of Raining Flowers (*Yuhua ge*),
1753–57, Forbidden City, Beijing. Qing dynasty
(1644–1911), reign of Emperor Qianlong
(1736–95). Detail of roof line (left) and three-
dimensional Buddhist mandala (right).

Now open to the public, Yuling's interior is lined with white marble exquisitely carved with Buddhist images and 30,000 non-Chinese characters, difficult to decipher and never intended to be seen.

The current exhibition is drawn from collections that were assembled by generations of imperial families, but it was given its most spectacular form by Emperor Qianlong. Because physical and intellectual possession of ancient culture was linked to concepts of legitimacy, rulers had historical justification for assembling collections of art and antiquities. Calligraphy was valued over other arts due to its inextricable connections to history, to mystical communication, to texts, and, of course, to aesthetics. But prestigious antiquities and the high arts of calligraphy and painting were only a small part of court acquisitions and philanthropy. Tremendous resources were given to large building projects and spiritual causes in this life and for the next. Although *Emperors' Treasures: Chinese Art from the National Palace Museum, Taipei* exhibits a mere fraction of what imperial patronage inspired, we are fortunate indeed to be able to share this cultural heritage.

NOTES

1. Sima Qian (first century BCE) wrote in his authoritative history that the First Emperor of Qin lacked heaven's mandate. See Sima Qian 1979. On the mandate of heaven and imperial collecting, see Ledderose 1978–79.

2. Ebrey 1999.

3. Lorge 2012.

4. Sturman 1997, 7–8, 16.

5. McNair 1998, 63–75. McNair 1990. Su and Huang also no doubt admired Yan's boldness in speaking truth to power.

6. Bickford 2006.

7. Ebrey 2014, 128.

8. Patricia Buckley Ebrey compares the two collections in Ebrey 2008, 342–46.

9. Ebrey 2008, chaps. 6, 7, and 8 on collecting and cataloguing antiquities, calligraphy, and painting; summary tables are on pp. 156–57, 212, and 262.

10. Chaffee 1999, 113–20, 132–34. Ebrey 2014, "Losing Everything, 1126–1127," 449–74.

11. Mowry 1995, 37.

12. In the eighth century the "Six Ministers" interpreted the line "Dongting waves, ah, tree leaves fall" as "a metaphor for petty men (*xiao ren*) taking authority and therefore worthy men being cast aside." See Murck 2000, 117–21.

13. In 1130 the office for imperial clan affairs designated Jizhou an imperial clan center. Chaffee 1999, 120–21.

14. Chaffee 1999, 132–35. For the importance and uses of portraits, see Stuart and Rawski 2001, esp. 36–41.

15. The Tianjin Art Museum's *Auspicious Omens for Dynastic Revival* by anonymous twelfth-century court artists includes a scene of Gaozong dreaming of Emperor Qinzong handing him the imperial robe. Murray 2007, pp. 83–84, pl. 16.

16. Murray 1993. For Gaozong's other uses of calligraphy to establish his authority, see Murray 1986.

17. Hui-shu Lee 2010, 163–65, 169.

18. McCausland 2003. Murray 1990, 27–53.

19. Murray 2007.

20. Khaishan (Wuzong) seized the throne in 1307 and reigned until 1311; his younger brother Ayurbarwada became Emperor Renzong (reigned 1312–20). Fu 1990, 61.

21. Fu 1990, 63–66.

22. Ibid., 71n5.

23. McCausland 2011, 73–74.

24. Weidner 1986.

25. Rossabi 1988, 141–47.

26. Craig Clunas describes the regional courts in Clunas 2013. Clunas's translation of *wang* as "king" rather than the more common "prince" is justified on pp. 8–9.

27. Li Dongyang (1587) 1963.

28. Smithsonian 2015.

29. Pang 2016. The dead included family members, eunuchs, and retainers from the households of 268 dukes, marquises, affluent officials, and landowners. See also Pang 2014.

30. On Zhu Gang's collection, see Barnhart 1991.

31. Clunas 2013, "The Jewels of the King of Liang," 139–164. Many of the treasures from the tomb of Prince Zhuang of Liang and Lady Wei are illustrated in Clunas and Harrison-Hall 2014 and Zhang 2015.

32. Zhang 2015, 72.

33. Kleutghen 2015, 11.

34. Ibid., 142–77.

35. Ibid., 228–32.

36. Berger 2003, 34–36.

37. Ibid., 104–08.

38. Wan Yi 1997, 82–83.

39. Berger 2003, 108–10.

40. Wan Yi 1997, 741.

41. Berger 2003, 2–4.

CATALOGUE OF THE EXHIBITION

HE LI

Song Dynasty (960–1279): A Great Patron Leads China's Renaissance

I|n 960 the consolidation of the Song dynasty by Zhao Kuangyin, a Han Chinese military commander of the Late Zhou state, resulted in a new centralized government that succeeded several short-lived kingdoms. The great Tang dynasty (618–907) had been torn by civil war, and Zhao Kuangyin (also known as Taizu; reigned 960–76) offered the best chance for the restoration of peace and order. In addition to improving the tax system and promoting religious tolerance, his principal policies focused on strengthening the intellectual foundation of society while weakening military power. This path sowed the seeds of future strife, however, as the Song faced constant invasions by nomads from the north.

The Song period was marked by multifaceted intellectual activity. The creations produced during this era, particularly painting and ceramics, made it one of greatest creative periods in history. Song art—notable for its order, harmony, and exquisitely crafted form—reached its peak during the time of Emperor Huizong (reigned 1101–25; see fig. 1).

The eighth emperor of the Northern Song dynasty was born Zhao Ji and was chosen at the age of eighteen as the successor to his brother, Emperor Zhezong (reigned 1086–1100), who died with no heir. After a short regency under the Empress Dowager Xiang (1046–1101), Zhao Ji assumed sole rule with the dynastic title of Huizong, "Glorious Emperor." Solidifying his mandate to rule, Huizong claimed to be the incarnation of a god and devoted himself to cultic rituals and cultural development. The most notable of these activities was his lavish and extensive patronage of court painting, settings and objects for rituals, interior decoration, and architectural projects. The art created during the last years of his reign is historically regarded as the "Xuanhe-reign style" (Xuanhe reign 1119–25). The style, subject, and presentation of these classic pieces inspired Chinese court arts for centuries.

In 1104 Huizong consolidated the "Three Principal Studies" into three departments, known as the imperial academies of writing, painting, and accounting.[1] This unprecedented development began with vigor. Under Huizong the Imperial Painting Academy significantly elevated the status of scholar-artists, who championed an aesthetic that was "elegant, not vulgar," one "expressing the originality and spirit of the object, not merely copying the old masters."[2]

Our knowledge of Huizong is greatly enlarged by the works of art he himself created. His distinct calligraphy, known as the "slender-gold" style, was highly praised (see cat. 1), and his skill in painting is evident in eleven known works depicting scenes from ancient myths and of contemporary figures and events woven into classical subjects.[3] Huizong's passion for literature and music can be seen in several of these paintings. His desire to reinstitute classical rites led him to sponsor the creation of a series of ritual vessels and publications. The meticulously compiled

Buddha Shakyamuni, Southern Song dynasty (1127–1279), cat. 18.

Imperial Music Bureau (1105) served as a guide for the organizational system and codes for the "elegant music" (*yayue*) of the court. To celebrate its completion, Huizong had the powerful minister Cai Jing (1047–1126) preside at the ceremony placing the newly cast bronze tripod vessels in the Palace of Nine Completions (*Jiucheng gong*) in the capital Bianjing (now Kaifeng, Henan province). In 1116 these vessels, along with another set of nine, were reinstalled in the Tower of the Celestial Constitution, a special hall in the imperial library in the capital.[4] The revival of Bronze Age ritual forms is a consistent characteristic of Song art that makes it easy to identify (see cats. 19 and 20).

Huizong promoted an orthodox form of Daoism, declaring the Divine Empyrean (*Shenxiao*) faith the principal sect of his empire.[5] Huizong's consistent patronage of Daoist rituals and dedication to building temples and altars departed from true Daoist doctrine. The Divine Empyrean doctrine advocated personal deification through development of the Daoist pantheon and practices such as rituals and alchemy. In 1117 Huizong, in an audience with more than 2,000 Daoist priests, was honored with the title of "August Emperor and Sovereign Patriarch of Dao" (*Jiaozhu Daojun huangdi*).[6] Huizong was thus acknowledged as both the ruler of the empire and a divine figure with a place in the Daoist spiritual hierarchy. Huizong entrusted the priests with great authority and granted them generous subsidies.[7] His efforts to establish his divinity led to a new aesthetic that embraced iconography, the use of metaphors, the color azure (see cats. 21 and 26), and jade, which was thought to embody the connection between heaven and earth. In 1117 the court acquired a large piece of jade from Yudian (now Hetian, Xinjiang province) from which Huizong ordered ceremonial pieces made. One of them, a seal with a dragon knob, was praised by Huizong in a four-line poem as symbolizing the mandate of heaven.[8]

Huizong set up an administrative network to create and strengthen the court's monopoly on art. The Directorate of Palace Works (*Jiangzuo jian*) and the Court for Literary Trends (*Wensi yuan*), which closely cooperated with the Ministry of Works (*Gongbu*), produced all products except paintings for the court. The Directorate of Imperial Manufactures (*Shaofu jian*) had no shortage of commissions for delicate items and sacred vessels made of gold, silver, jade, gemstones, silk, rhinoceros horn, and kingfisher feathers. This directorate also oversaw architecture, woodworking, and the production of ceramics.[9]

Ceramics were among the greatest accomplishments of Huizong's reign, as the emperor's patronage stimulated new forms and innovative techniques. The court set up exclusive imperial workshops near the capital to produce wares for temple rituals and daily life in the palaces (see cat. 21), and local shops were enlisted to meet the demand. Ceramics from the Song court—traditionally known by the names of the kilns in which they were produced: ru, jun, ding, and jian—stimulated great excitement among the elites in China, Korea, and Japan, and later imperial workshops were inspired by their original designs and glazes. One of the glazes developed at the Jian kiln in Fujian province, known as "hare's fur" for the fine streaks in the dark glaze, was especially favored by Huizong for its playful iridescence visible only under the sun (see cat. 24).[10]

Artisans were ever alert to new and inventive ways to appeal to the luxurious taste of the emperor and the court. The main center for textiles and embroidery in Jiangnan, south of the Yangtze River, flourished during the Song period. The textiles produced in the Ding prefecture (now Hebei province) were superior to all other silk handicrafts and were often commissioned by the court. The visual effect of cut-silk

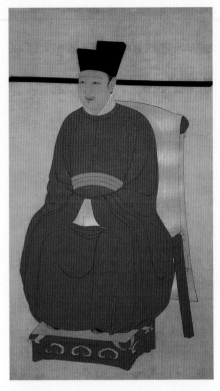

FIGURE 1
Seated Portrait of Song Huizong. Song dynasty (960–1279), reign of Emperor Huizong (1101–25). Hanging scroll, ink and color on silk.

(*kesi*) tapestries (see cats. 17 and 18) inspired potters at the Ding kilns to invent a method of mold-stamping ceramic wares to create relief designs. This technique soon became influential as the Ding incising method (see cat. 22) and helped make the prefecture a significant new source of decorative arts.

In 1108 Huizong launched a daring cultural project involving palaces, temples, ritual objects, interior objects, and landscaping known as the Program of Flora and Stone (*Huashigang*).[11] By 1122 Huizong's palace complex had expanded to a state of enormous, unrivaled splendor; the so-called Completion of Mountain Peaks (*Genyue cheng*) made a splendid backdrop.[12] This decades-long project demanded the intensive labor of thousands of workers and eventually led to the depletion of the state treasury.

Huizong's ambitions overwhelmed the country and put it in danger of attack by the nomadic Jurchen people from the northeast, who seized the northern part of the empire in the 1120s. Huizong's palace and properties—everything from his chariot to ritual vessels, including his collections of art, antiquities, jades, jewelry, instruments, and books—were largely obliterated by the Jurchen.[13] In 1127 Huizong and his son, the newly enthroned Qinzong (reigned 1126–27), along with 3,000 family members, servants, artisans, and entertainers, were dragged away as captives to the homeland of the Jurchen in the remote northeast, near Siberia. In 1135 Huizong, blind and ill, died at age fifty-three. Six years later, following a treaty between the Jurchen and the Song, Huizong's coffin, accompanied by his consort Wei (1080–1159), was allowed to return to Song territory. Huizong's son Gaozong (see cat. 4), the first emperor of the Southern Song dynasty (reigned 1127–62), had Huizong's coffin interred in Kuaiji (now Shaoxing, Jiangsu province).[14]

NOTES

1. Tuo Tuo (1345) 1969, vol. 6, chap. 19, 4531.

2. Ibid., chap. 157, p. 4857.

3. Ebrey 2014, 228.

4. Tuo Tuo (1345) 1969, vol. 6, chap. 104, p. 4745.

5. Ibid., vol. 7, chap. 462, p. 5659.

6. Ibid., vol. 6, chap. 21, p. 4533.

7. Ibid. vol. 7, chap. 462, p. 5659.

8. Ibid., vol. 6, chap. 154, p. 4845.

9. Ibid., chap. 163, p. 4875; chap. 165, pp. 4880–81.

10. Zhao Ji (1107–10) 1646.

11. Tuo Tuo (1345) 1969, vol. 7, chap. 472, p. 5678.

12. Ibid., chap. 468, p. 5671.

13. Ibid., chap. 22, pp. 4534–35.

14. Ibid., chap. 30, p. 4550.

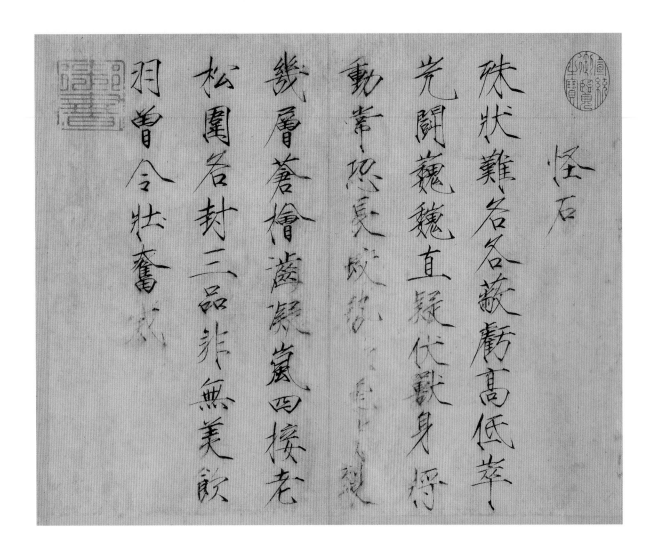

CAT. 1

北宋 徽宗趙佶書怪石詩墨寶冊
紙本

Grotesque Stones in the slender-
gold style

By Zhao Ji (Emperor Huizong, 1082–1135)
Northern Song dynasty (960–1127), reign of
Emperor Huizong (1101–25)
Album leaf, ink on paper
H: 34.4 cm, W: 42.2 cm
Gushu 000242-2

Shown at the Asian Art Museum only

The culturally inclined Emperor Huizong acquired a reputation as creative calligrapher and painter, and he spent years studying calligraphy for his own pleasure. This work not only testifies to the emperor's talent in calligraphy but also shows his celebrated "slender-gold" style, a type of standard script featuring sturdy, thin strokes that construct characters in a manner both strong and elegant.

Legend has it that Mi Fu (1051–1107), a painter, calligrapher, and contemporary of Huizong's, worshiped rocks, which to him symbolized the indomitable spirit of humankind. Reflecting this passion, Huizong's calligraphic poem praises the fabulous form of a unique rock. In an inscription on his rock painting in the Palace Museum, Beijing, Huizong said that he saw in rocks a world occupied by powerful dragons, the symbol of the Son of Heaven. Perhaps Huizong's belief in Daoism led to such alluring visions. His devotion to rocks had enormous influence: collecting, painting, and singing about rocks became a cultural phenomenon in the elite circles of the Northern Song dynasty.

Huizong actively studied the innovations of several masters. Cai Tao (active 1011–25), an attendant at the Ministry of Rites, recorded that Huizong often practiced painting with a guest named Wu Yuanyu, who was strongly influenced in calligraphy by Xue Ji (649–713) and in painting by the court painter Cui Bai (active approx. 1050–1100). Cai Tao also pointed out that Huizong drew inspiration from the techniques of Huang Tingjian (1045–1105), another artist and poet active at the time. Some works of art criticism also state that Huizong's calligraphy was a continuation of the style of Chu Suiliang (596–658).

SEAL MARK

"Imperial calligraphy" seal mark, which differs from seals used by Huizong and may be a later addition.

YLT WITH QN, HL

CAT. 2

北宋 歐陽脩書 致元珍學士
尺牘冊 紙本

Letter to Yuanzhen in semi-
running script

By Ouyang Xiu (1007–72)
Northern Song dynasty (960–1127)
Album leaves, ink on paper
H: 26.9 cm, W: 31.2 cm
Gushu 000249-20

Shown at the Asian Art Museum only

Ouyang Xiu was a civil servant who gained notoriety by protesting the unfair trial of an official named Fan Zhongyan (989–1052), who was wrongly demoted to a remote post in the south of China. Ouyang's uncompromising stance on the matter earned him a reputation as a heretic, and he was dismissed from the court to Xiazhou (now Hubei). There he became acquainted with Yuanzhen (Ding Baochen, 1010–67), a judge in the prefectural government. The two shared mutual views in politics as well as an interest in travel and poetry. After twelve years Ouyang was called back to court. The emperor kept him close and appointed him to complete important compilations.

In 1067, when Ouyang was sixty-one, his position was again endangered by the venomous smears of his opponents. Seeking mental and physical peace, Ouyang petitioned for a transfer to a regional government.[1] In this short letter, Ouyang explains to Yuanzhen his voluntary transfer: "not because of my illness," he writes, but because "there is no alternative." This letter sheds light on a distinguished court official who sacrificed his career in the name of justice. Ouyang's tragic career has made him popular within some intellectual circles throughout Chinese history. Moreover, his erudition, his advocacy of a plain rhetorical writing style, and his involvement in antiquarianism have earned him a place as one of the greatest intellectuals of the Song dynasty.

In addition to being a fascinating historical document, this is a work of calligraphy of high artistic quality. Executed with thick ink and steady brushwork and conveying a serene mood, it was described by the poet Su Shi (1037–1101) as being of "magnificent form and energetic frame" and a dignified, noble spirit. The literati of the Northern Song dynasty esteemed the strength in Ouyang's calligraphic art; he himself considered the Tang scholar-official and calligrapher Yan Zhenqing (709–785) the ideal model for intellectual pursuits.

YCH WITH QN, HL

1. Tuo Tuo (1345) 1969, vol. 6, chap. 318, pp. 5339–40.

宋人繪 溪山暮雪圖軸 絹本設色

Snow over mountains and streams at dusk, approx. 1100–50

Anonymous
Song dynasty (960–1279)
Hanging scroll, ink on silk
H: 102.1 cm, W: 55.9 cm
Guhua 000143

Shown at the Asian Art Museum only

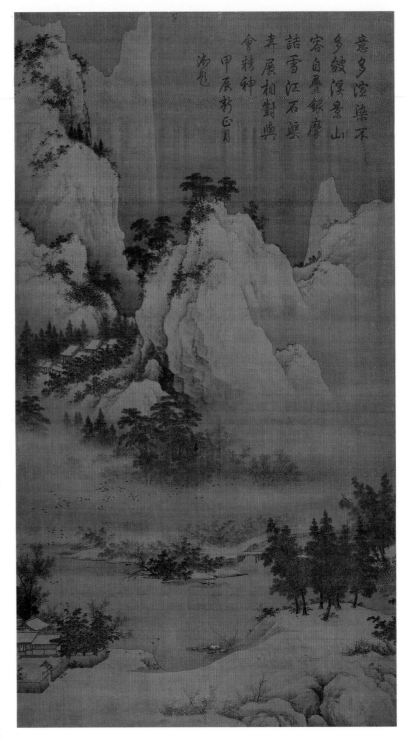

This winter mountain scene is one of the most important paintings made during the transition from the Northern Song to Southern Song dynasty in the early twelfth century. The artistic presentation here was a crucial step along the road to an entirely new category of landscape, one distinct from the styles of the Northern Song academy.

During the Northern Song reign of Emperor Huizong, the mountain scene came to embody the connection between divine nature and humanity. Huizong and his court artists also began to explore how best to depict the changing of the seasons in paintings. Huizong's winter scenes were prized for their atmospheric effects, conveying the cold, restrained energy under the gray cast of the snow.[1] The winter landscape has remained a favored subject of Chinese artists.

This work, with the placement of the mountain range in the center, resembles the monumental layout of Northern Song landscapes. Although more loosely handled, the delicate foliage has much of the Northern Song master Li Tang (approx. 1049–1130) about it. This painting utilizes vaporous effects to capture the chilling atmosphere of early winter and presents details of village life. In the twilight, cold air surrounds the mountains, and birds circle below. Pale, open spaces can be seen between the snowy gables of houses dotting the landscape. Ducks swim in partially iced rivers. Braving the wind, travelers walk with lowered heads. The composition conveys less grandeur than Northern Song mountain scenes, but it communicates a vivid impression of desolate coldness.

INSCRIPTION

"Many layers of meaning abound in sparse brushwork; the overlapping mountains are covered with silvery snow," written by Emperor Qianlong in 1784.

WMH WITH HL

1. *Zhongguo shuhua quanji* 1999, vol. 2, p. 130.

CAT. 4

南宋 高宗趙構半身像 絹本設色

Half-portrait of Emperor Gaozong, Zhao Gou

Anonymous
Southern Song dynasty (1127–1279)
Album leaf, ink and color on silk
H: 55.8 cm, W: 46.9 cm
Zhonghua 000322-11

Shown at the Asian Art Museum only

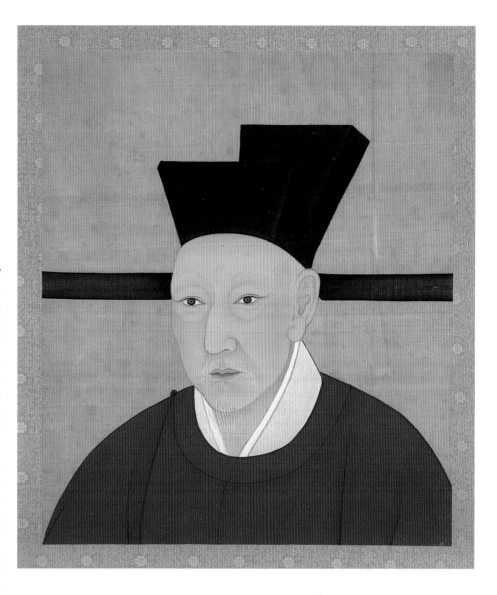

Zhao Gou (1107–87) was the ninth son of Emperor Huizong, whom he succeeded as Emperor Gaozong in 1127 when Huizong had been taken as a hostage of the nomadic Jurchen army to the northeastern frontier close to Siberia. Gaozong began his thirty-six-year rule, known as the Jianyan era, in the newly established Southern Song capital of Lin'an (now Hangzhou). During his rule he reestablished Huizong's painting academy, recruited learned scholars to his court, and continued to strengthen the imperial collection of painting and calligraphy. Being a gifted calligrapher himself, Gaozong mastered regular, running, and cursive scripts and influenced many calligraphers of his time. He was also the author of *The History of Brush and Ink* (*Hanmozhi*), an important book on the calligraphy of the Song and pre-Song eras.[1]

This portrait of Gaozong—one of a series in the album *Half-Portraits of the Song Emperors*—depicts him in the typical attire of the Song emperors: an official winged hat of black gauze and a red robe. His face is slender, his beard and eyebrows turning white, yet his eyes are bright and shine with intelligence. Although none of the portraits in this album are signed, the artist successfully captured each emperor's individual character. The original drawing on which this portrait was based was most likely done by a Song court painter.

FJL WITH HMS

1. Zhao Gou (1150–70) 1966.

CAT. 5

南宋 高宗吳皇后半身像 絹本設色

Half-portrait of Empress Wu

Anonymous
Southern Song dynasty (1127–1279)
Album leaf, ink and color on silk
H: 56.2 cm, W: 45.7 cm
Zhonghua 000323-5

Shown at the Asian Art Museum only

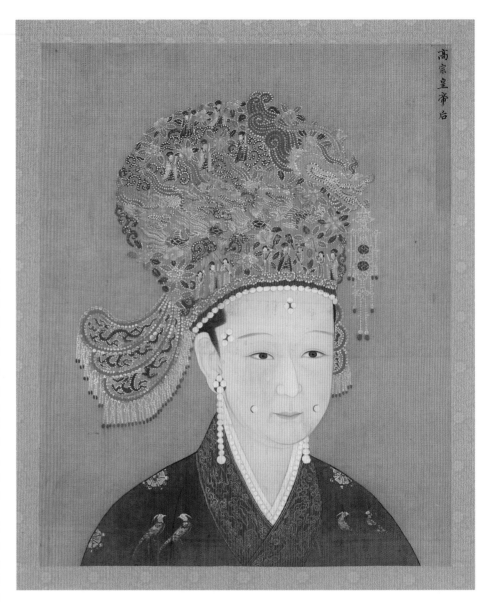

This painting, also from the album *Half-Portraits of the Song Emperors* (see cat. 4), is a portrait of Emperor Gaozong's second wife, Wu (1115–97). A native of Kaifeng, she joined the court concubines of Gaozong at the age of fourteen and was later honored with the title of "Ascendant Lady." When Gaozong became emperor of the Southern Song dynasty, he named Xing Bingyi (1106–39) empress, even though she; the former emperor, Huizong; and 3,000 others were exiled to the Jurchen homeland in Manchuria. Xing died there, and after her coffin was carried back to the Song heartland in 1142, Gaozong made Wu his empress.[1]

Wu was a loving companion to and major supporter of Gaozong during his turbulent reign. Endowed with immense personal courage, Empress Wu would don armor and stand near Gaozong on the parade grounds. She was highly intelligent and a disciplined calligrapher. Once the emperor grew so exhausted copying the texts of the classics that he asked Empress Wu to finish the task—and nobody was able to tell the difference between the two writers. Her keen sense of responsibility as empress dowager enabled her to help three of Gaozong's successors deal with the changing social conditions in the Southern Song dynasty until her death at eighty-three.[2]

In this half-portrait Wu appears as a middle-aged empress. Her robe is decorated with facing pheasants—a motif that symbolized female power and was reserved for the empress—and has a red silk collar covered with golden dragons. Her large imperial crown is covered with an elaborate and intricate pattern of nine dragons amid numerous flowers. Her face, with its gentle and calm expression, is adorned with pasted jewels that match her earrings. Inscribed with the words "Empress of Emperor Gaozong," this image appeared on the right side of the fifth page of *Half-Portraits of the Song Emperors*, opposite a portrait of the consort of Emperor Xiaozong (reigned 1106–09).

FJL WITH HMS

1. Tuo Tuo (1345) 1969, vol. 6, chap. 243, p. 5162.

2. Li Xinchuan 1983–86, chap. 1, p. 5.

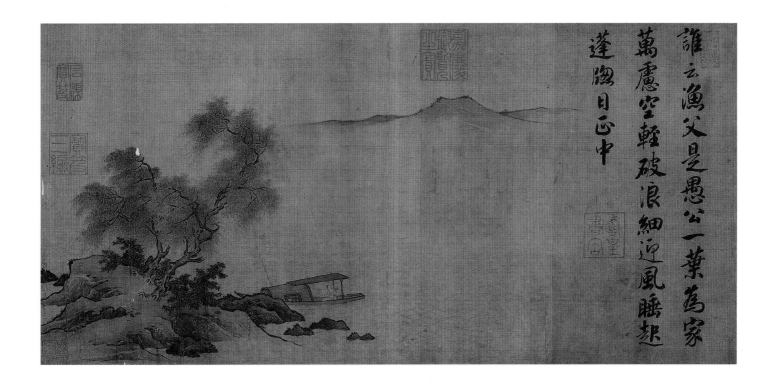

CAT. 6

南宋 (舊籤題高宗)孝宗趙眘題
宋人畫 蓬窗睡起 絹本設色

Awakening by a Window Awning,
1190

Anonymous
Calligraphy attributed to Zhao Shen (Emperor
Xiaozong, 1127–94)
Painting attributed to anonymous court painter
Southern Song dynasty (1127–1279)
Album leaf, ink and color on silk
H: 24.8 cm, W: 52.3 cm
Guhua 001291-1

Shown at the Museum of Fine Arts, Houston, only

The "fisherman in seclusion" was a subject that had special appeal to some Chinese emperors, who longed for seclusion themselves. Here, painting, poetry, and calligraphy come together to express this favorite theme. An isolated man dressed in a white robe, like that of a scholar-hermit, sits by a river, yawning at his fishing rod, waiting for the fish to bite. The mood of the scene is enhanced by the contrast between the heavy rocks on the bank and the gentle willows, bamboo, and ripples on the river. The spacious composition moves from the riverbank in the foreground at the left to the far distance at the right, an arrangement that reflects the landscapes of the Jiangnan region, where the Southern Song court had established its capital, and is a marked departure from the densely rendered Northern Song landscapes. The brushwork calls to mind the training of the Southern Song academy: the elegant strokes seen in the bamboo were inspired by the Song master Xu Daoning (approx. 907–1052), while the rocks and trees illustrate a method established by the court master Li Tang.

Four lines from a poem titled "Father Fisherman" by the Tang poet Zhang Zhihe (active 741–75) were written in running

script at the top of this work. This writing was once thought to be by Emperor Gaozong, but it has recently been reattributed to Gaozong's son, Emperor Xiaozong, whose handling of form was said to have been inherited from Gaozong, who studied the calligraphic work *Father Fisherman* by the master Huang Tingjian and the style of Wang Xizhi (approx. 303–61).[1]

SEAL MARKS AND INSCRIPTION

"Literary treasures of the long-lived emperor" (*Shouhuang shubao*), the seal used by Xiaozong after his abdication, and "Reign of Gaozong" (*Shaoxing*). In addition, four lines in running script quote a verse by Zhang Zhihe titled "Father Fisherman."

YLT WITH HL

1. Wang Yaoting 1995; Lu You 1977.

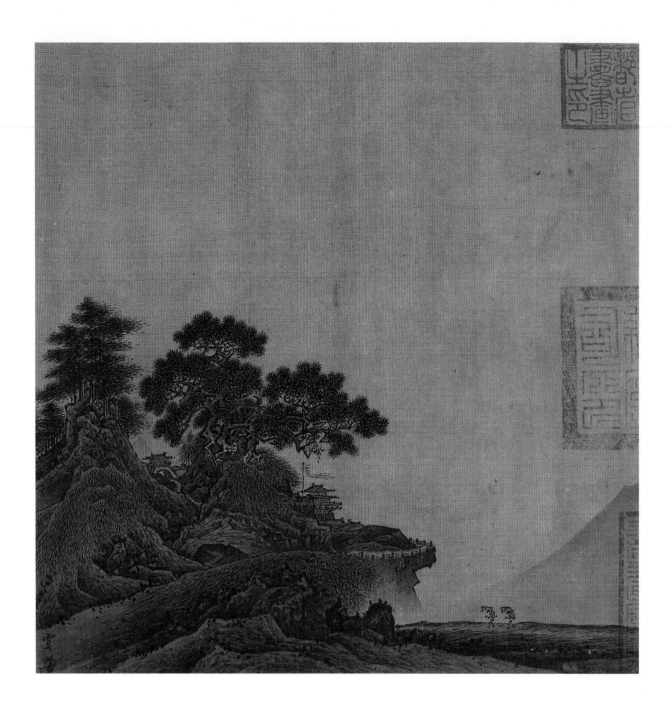

CAT. 7

南宋 賈師古繪 巖關古寺 絹本設色

Ancient temple in a mountain pass

By Jia Shigu (active 1131–62)
Southern Song dynasty (1127–1279)
Album leaf, ink and color on silk
H: 26.4 cm, W: 26 cm
Guhua 001243-2

Shown at the Museum of Fine Arts, Houston, only

This painting depicts an old temple nestled in the mountains and surrounded by pines and dense vegetation. Following the typical Southern Song landscape style, the artist filled only the lower left corner of the pictorial space and left the rest blank (see cat. 8). Two small figures walking on a winding path on the lower right direct our attention to the half-hidden temple. Using layered textures of deep green and ink-washed colors, the artist created a sharp contrast between the solidity of the mountains and the mist-filled background.

Jia Shigu was from Kaifeng, Henan province, and served as an usher (*zhihou*) in the Imperial Painting Academy during the reign of Emperor Gaozong. He was best known for his Buddhist and Daoist figure subjects. Given this sparse biographical information, the survival of this signed work is especially significant. It is a rare example of Jia's work as a landscape painter and offers insight into the stylistic development of Chinese landscape painting of the early Southern Song dynasty after Li Tang. Although this work is not dated, its close stylistic association with Li Tang's works—such as *Whispering Pines in the Mountains* (*Wanhuo songfeng*) and *Intimate Scenery of River and Mountains* (*Jiangshan xiaojing*)—clearly reveals their shared lineage.

INSCRIPTION
Signed by Jia Shigu at the lower left.
WRL WITH HMS

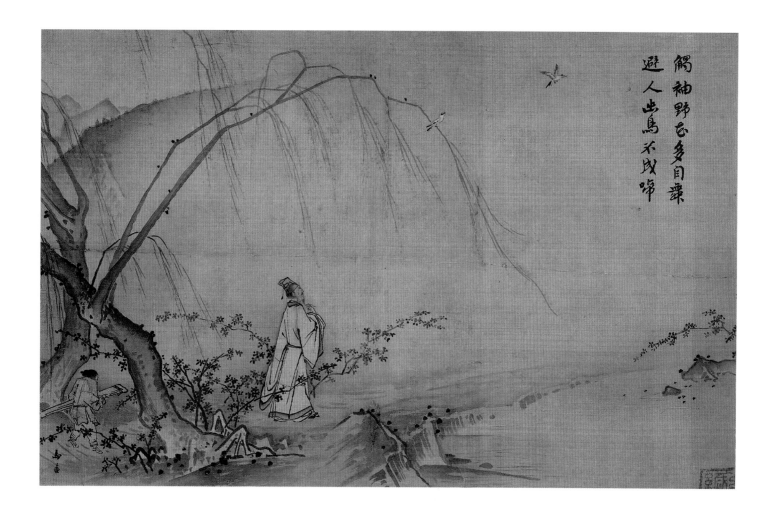

觸袖野花多自舞
避人幽鳥不成啼

CAT. 8

南宋 寧宗趙擴題 馬遠繪
山徑春行冊 絹本水墨設色

Walking on a path in spring

By Ma Yuan (active approx. 1160–after 1225)
Calligraphy attributed to Zhao Kuo (Emperor
Ningzong, 1168–1224)
Southern Song dynasty (1127–1279), reign of
Emperor Ningzong (1195–1224)
Album leaf, ink and color on silk
H: 27.4 cm, W: 43.1 cm
Guhua 001289–13

Shown at the Asian Art Museum only

Ma Yuan served as a court painter at the painting academy during the reigns of Emperors Guangzong (1190–94) and Ningzong (1195–1224). His career coincided with a distinguished period of artistic innovation, when the monumental Northern Song style of painting was considerably simplified and softened. Ma Yuan enjoyed great renown for a unique compositional feature seen here and known as the "Ma corner," in which the subjects of a painting are grouped together in one corner, leaving much of the remaining space empty. The relaxing mood created by this arrangement has been widely celebrated up to modern times.

This work is a prime example of a unique Chinese aesthetic that combines painting and calligraphy, a style that became prominent among painters of the Southern Song court. The poem inscribed in the upper right corner of this painting expresses the desire of a member of the elite to find inspiration by exploring nature. Echoing the poem, the painting shows a scholar dressed in a long robe walking among the swaying willows along a river and followed by a page boy holding a zither. Stroking his goatee, the scholar gazes at a bird on a willow branch that calls to another flying in the air. The subject of friends meeting for an elegant gathering deep in the mountains was a popular one in Song dynasty painting. The execution of brush and ink here is subtle: diluted ink and color are used to depict the tree trunk and branches, creating complex tonal variations. The robes of the figures are rendered with undulating and tapering brushwork.

INSCRIPTIONS

Signed by Ma Yuan. A two-line poem in calligraphy, attributed to Emperor Ningzong, is written in running script and reads: "Waving sleeves enable wild flowers to dance alone, the shunning human among quiet birds that caw no songs."
WMH WITH QN, HL

CAT. 9

南宋 寧宗趙擴題 馬麟繪
芳春雨霽冊 絹本水墨

Spring Fragrance, Clearing after Rain

By Ma Lin (active 1180–after 1256)
Calligraphy attributed to Zhao Kuo (Emperor Ningzong, 1168–1224)
Southern Song dynasty (1127–1279), reign of Emperor Ningzong (1195–1224)
Album leaf, ink and color on silk
H: 27.5 cm, W: 41.6 cm
Guhua 001289-14

Shown at the Asian Art Museum only

On a day in early spring, after the rain, fog envelops the forest; sparse trees and bamboo lean toward the river, tiny red flowers dot the landscape, and ducks play in the water. This was a popular subject, and here Ma Lin may have been inspired by the lines of poet Su Shi, "Few peach blossoms can be seen beyond the bamboo grove; ducks feel the warm water of spring before all others," which in turn were inspired by *Night Scenery by Spring Rivers* painted by Hui Chong (approx. 965–1017). Ma Lin's choice of such a sweet subject reveals his comprehension of and appreciation for these poetic narratives.

This painting depicts scenery in Lin'an (now Hangzhou), chosen as the capital of the Southern Song dynasty in 1129. In this peaceful environment, the wealthy of Lin'an were able to enjoy their refined taste in art, clothing, food, tea, and amusements. Unlike the monumental style of the Northern Song, Southern Song painting reflects a court style that was lyrical and elegant. Beyond the presentation, two trends are apparent in this work: the connection between the emperor and the artist was becoming closer, and the ties between painters and poets was growing tighter.

Ma Lin's career spanned the reigns of Emperors Ningzong and Lizong (1195–1264). He was clearly admired by Ningzong, who wrote the title *Spring Fragrance, Clearing after Rain* in calligraphy at the top of the painting, accompanying it with a seal mark representing Empress Yang Meizi, his wife (1162–1232). "Spring fragrance" might have referred to the Hall of Spring Fragrance in the imperial palace at Lin'an. According to a work by the Song writer Zhou Mi (1232–98) entitled *Old Stories from Wulin*, the Hall of Spring Fragrance was a spectacular spot where members of the imperial family were enticed to enjoy apricot flowers in the spring.

WMH WITH QN, HL

南宋 陸游書 行楷上問台閣尊眷
尺牘 紙本

Thank you letter in semistandard script

By Lu You (1125–1210)
Southern Song dynasty (1127–1279)
Album leaf, ink on paper
H: 29.3 cm, W: 31.6 cm
Gushu 000251-1

Shown at the Museum of Fine Arts, Houston, only

This is a rare example of a personal thank you letter from the Song poet Lu You. The letter, addressed to a senior friend, expresses Lu's gratitude for the gift of some Chinese herbal medicine. Along with this letter Lu sent a package of fifty pieces of fish and thirty compressed tea bricks called "plaque" (*kua*). The calligraphy, executed in semistandard script, is rendered in slender brushstrokes and balanced lines. In the exquisite composition of each character and the forceful yet firmly controlled strokes, Lu's writing shows the strong influence of the leading Song calligraphy masters, including Su Shi and Huang Tingjian.

Lu You was regarded as one of the "four greatest poets" of the Southern Song dynasty. He is also known for his commentary on Song history, *Notes from the Elder Leaner Temple* (*Laoxue an biji*), and his views on Song calligraphy, *Colophons and Inscriptions by Fanweng* (*Fangwong tiba*), the latter being an important contribution to our understanding of the history of Chinese calligraphy. This letter was documented in the Qing imperial catalogue, and, judging from the seals (see below), it entered the court during the reign of Emperor Qianlong (1736–95).

SEAL MARKS

"Treasures for the examination of His Majesty Qianlong" (*Qianlong yulanzhibao*), "Treasures for the examination of His Majesty Jiaqing" (*Jiaqing yulanzhibao*), and "Treasures for the examination of His Majesty Xuantong" (*Xuantong yulanzhibao*), all Qing imperial seals.

JZC WITH HMS

CAT. 11

南宋 范成大書 行草尺牘 紙本

Farewell letter in semicursive script

By Fan Chengda (1126–93)
Southern Song dynasty (1127–1279)
Album leaf, ink on paper
H: 32.9 cm, W: 42.8 cm
Gushu 000251-2

Shown at the Museum of Fine Arts, Houston, only

This farewell letter exhibits the fluid writing of Fan Chengda, one of the most revered scholars at the Song court and a close friend of Lu You (see cat. 10). A native of Wuxian (now Suzhou), Fan served at court and in the provincial governments in Guangxi and Sichuan. In 1170 he risked his life to travel to the occupied capital of Kaifeng to negotiate with the Jin court.[1] In addition, Fan became famous as a writer of poetry narrating the hardships of rural life, making him one of the few high-ranking officials who wrote on subjects concerning common workers and farmers. A maternal great-grandson of Cai Xiang (1012–67), an acclaimed official-calligrapher and tea master, Fan also studied the great calligraphers of the Northern Song, such as Huang Tingjian and Mi Fu (1051–1107), and the early masters known as the Two Wangs—Wang Xizhi and his son Wang Xianzhi (344–86). Yet Fan did not limit himself to the distinctive family calligraphic style or the precedent of earlier masters. Instead, he completely integrated scripts and methods to form his own unique mode of expression—one of the great achievements in the art of calligraphy.

This type of missive was known as an "urgent departure" (*jixia*) or "in the moment" (*zhihou*) letter. This particular letter was addressed to an unnamed recipient just before Fan's departure on a business trip. Fan writes that he has "quickly dashed off a few words in case I did not have an opportunity to say goodbye in person" and expresses his gratitude to the recipient, from whom he had learned much through what he "heard, experienced, and saw." The letter was likely written sometime between 1176 and 1186, the year that Fan returned to Wuxian after he retired from his official responsibilities. Fan used sharp, thin, spirited strokes in his small running script and employed his brush with great care and skill. Compared with his other works in a similar format, this letter shows fewer linking strokes.

The seals on this letter place it in the collection of the famous late Ming collector Xiang Yuanbian (nickname Zijing, 1525–90). It later entered the Qing court during the reign of Emperor Qianlong and appeared in the imperial catalogue *Treasured Splendors from Stone Canals (Shiqu baoji)* of 1745.[2]

SEAL MARKS
Seven seals, including "Collection of Zijing" (*Zijing suocang*), "Mountain man in ink forest" (*Molin shanren*), and "Highly treasured by the Xiang Zijing family" (*Xiang Zijing jiazhencang*).
JZC WITH HMS

1. Tuo Tuo (1345) 1969, vol. 7, chap. 386, p. 1009.
2. NPM 1971, vol. 4, pp. 2048–49.

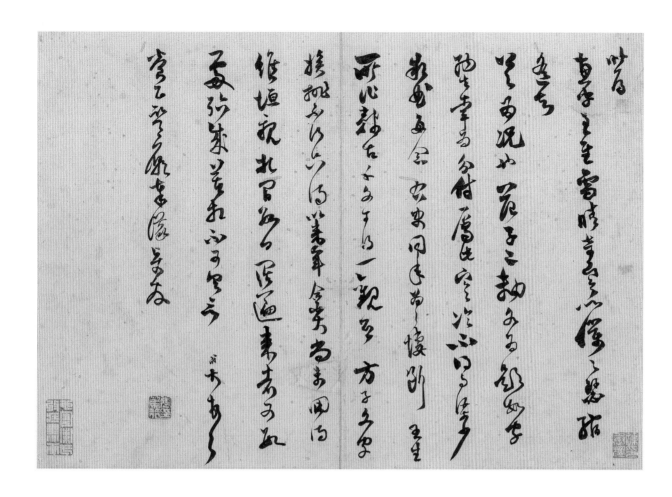

CAT. 12

南宋 范成大書 草書 致養正監廟
奉議尺牘 紙本

Letter to Gong Dunyi in cursive script

By Fan Chengda (1126–93)
Southern Song dynasty (1127–1279)
Album leaf, ink on paper
H: 30.9 cm, W: 43.9 cm
Gushu 00249-5

Shown at the Asian Art Museum only

This casual letter from Fan Chengda to his close acquaintance Gong Dunyi (1140–1201) opens with greetings acknowledging the winter season. The letter explains that Fan is returning two calligraphic works to Gong on which Fan wrote colophons. He then asks to borrow a work from Gong's collection, Wang Xizhi's masterwork *Thousand-Character Text*, in order to study its clerical script. The exchange makes Fan sentimental, reminding him of the late Zhang Xiaoxiang (1129–70); both Fan and Zhang had nicknames containing the character for "lake" (*hu*) and were famously known as the "Two Hus" among the masters of calligraphy in their day. At the close of the letter, Fan complains about social obligations, specifically the demands of important figures who come to him with various requests.

The letter was written on paper decorated with a pale printed pattern of lions playing with a ball, an early example of this type of decorative stationery. The calligraphy, in small cursive script, demonstrates Fan's achievement in this highly disciplined art. The dynamic and beautifully rendered brushwork moves fluently from one character to the next and from line to line, resulting in a harmonious blend of expression in both poetry and calligraphy. The few words of this letter convey a fresh, sincere tone and offer insight into Fan's many associates among the literati, their modes of correspondence, and their close bonds—as seen, for example, in the practice of borrowing and inscribing artworks from each other's collections.

YCH WITH HMS

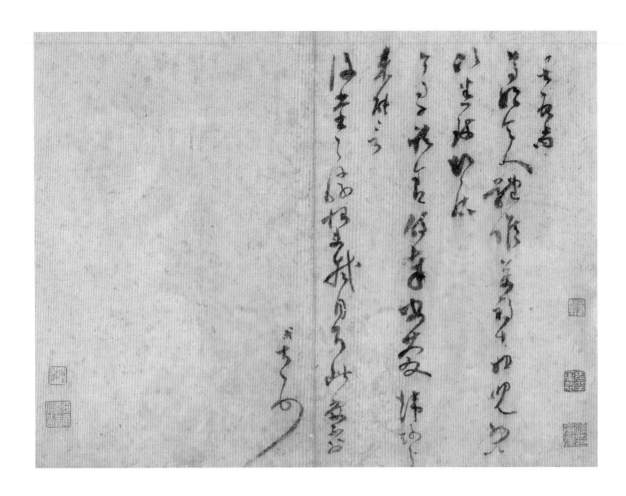

CAT. 13

南宋 范成大書 草書 尺牘 紙本

Letter to an aunt in cursive script

By Fan Chengda (1126–93)
Southern Song dynasty (1127–1279)
Album leaf, ink on paper
H: 32.1 cm, W: 42.8 cm
Gushu 000249-6

Shown at the Asian Art Museum only

The calligraphy of Fan Chengda was animated by a variety of freestyle forms and presentations, resulting in writing that was bold yet relaxed, loose yet firm, and maintaining gracefulness and naturalness throughout. This letter to his aunt is one of Fan's most fluid compositions. It addresses nothing important or serious—just chitchat. He was evidently delighted with the spontaneity and freshness of this letter. Both the content and the brush style are relaxed and free flowing, yet each stroke reveals Fan's skilled control. In just a few lines, Fan demonstrated that he had truly mastered various calligraphic techniques and reached a point of unrivaled personal expression. Fan was always at his best when writing poems and letters, moments when his mind, emotion, and hand acted as one.

YCH WITH HMS

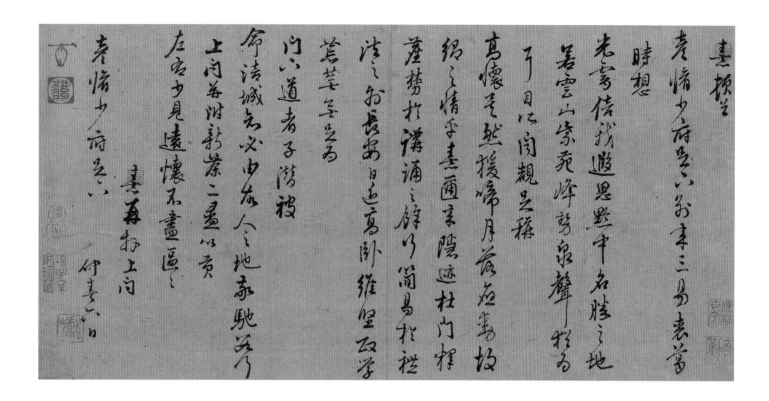

CAT. 14

南宋 朱熹書 行書致彥脩少府
尺牘 紙本

Letter to Yan Xiu in running script

By Zhu Xi (1130–1200)
Southern Song dynasty (1127–1279)
Album leaf, ink on paper
H: 27.3 cm, W: 55.1 cm
Gushu 000249-7

Shown at the Asian Art Museum only

Zhu Xi was one of the most influential figures in Chinese history. By studying the texts and theories of selected Confucians, he wove together philosophy, political science, and poetry to develop a cohesive principle that he felt would assure order in society. His ideas became the foundation of the imperial civil service examination, and neo-Confucianism of the Zhu school remained the intellectual core of the Chinese government until the early twentieth century.

In calligraphy Zhu followed earlier Song artists such as Su Shi and Huang Tingjian, who sought to personalize their art. This letter—written in running script, the most common form in Chinese writing—fully demonstrates Zhu's solid discipline. He maintains technical control without losing overall coherence, establishing a deliberate contrast between the loose spaces separating rows and the tight connections from character to character and occasionally dragging strokes to connect characters. The result is calligraphy that looks effortless and is full of rhythmic movement.

Zhu wrote this letter to a friend named Yan Xiu who was living somewhere in Guizhou and whom he had not seen in three years. Another colleague of Zhu's was traveling to the southwest, so Zhu took the opportunity to ask him to deliver the letter along with two packages of new tea to Yan Xiu. Warm, sincere, and simple, Zhu's sentiments in this letter follow Confucian principles regarding relationships: "The acquaintance of gentlemen should be as plain as water." Zhu's novel style is evident here: a lyrical mood, a precise choice of words, nothing flowery, only gracefulness.

Zhu Xi was born in Fujian province to a family originally from Zhaoyuan in Anhui province. The highest position he achieved during his long career was that of edict attendant at the Hall of Treasured Literature. He lectured at the Pavilion for Examination (*Kaoting*) studio in Jianyang, Fujian province.[1] Many of his publications were reprinted throughout the imperial era.

YCH WITH HMS

1. Tuo Tuo (1345) 1969, vol. 7, chap. 429, p. 5583.

南宋 樓鑰書 行書 呈提舉郎中
契丈劄子 紙本

Petition to the local judge in running script, approx. 1204

By Lou Yao (1137–1213)

Southern Song dynasty (1127–1279)

Album leaf, ink on paper

H: 34.1 cm, W: 40.7 cm, Gushu 000249-8;

H: 34 cm, W: 31.1 cm, Gushu 000249-9

Shown at the Museum of Fine Arts, Houston, only

This work of calligraphy is a rare legal document by the venerable Lou Yao. Born into a prestigious family from Siming, the well-educated Lou was known (along with Zhu Xi; see cat. 14) for setting a high moral standard for officials. Lou achieved the rank of imperial attendant of the censorate during Emperor Ningzong's reign. A conflict with the powerful chancellor Han Tuozhou (1152–1207) caused Lou to resign the position and return to his hometown of Zhejiang. After a thirty-year retirement, Lou, then more than seventy years old, was called back to the court to work with scholars and was eventually put in charge of the Ministry of Personnel.[1]

This document was drafted around 1204, during Lou's retirement. It is a petition to a local judge appealing a decision in a land dispute concerning a poorhouse (*yizhuang*) established by local gentry, including Shen Huan (1139–91) and Lou's uncle, Wang Dayou (died 1200). After Wang's death, Lou Yao managed the property. This work was not meant to display artistic calligraphy. Luo's free rendering, evenly structured characters, and the use of thick ink reflect his character—honest, loyal, and straightforward. In his downward stroke, one can detect the approach of the classical calligrapher Yan Zhenqing. Lou was best known for his large calligraphic works. This reputation earned him the honor of being asked by Emperor Gaozong to write the hall plaque for the newly built Imperial University.

YCH WITH HMS

1. Tuo Tuo (1345) 1969, vol. 7, chap. 395, p. 5509.

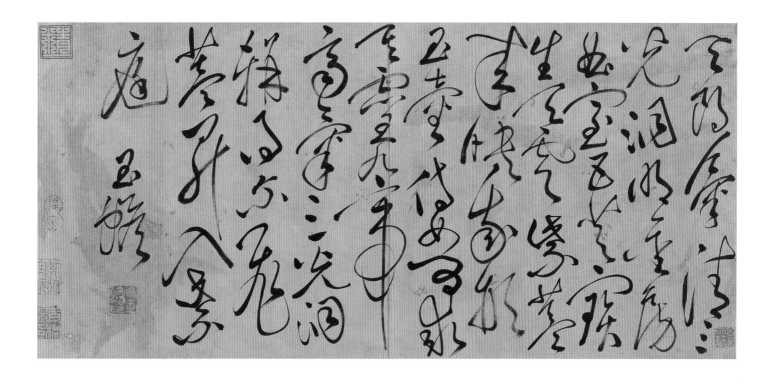

CAT. 16

南宋 白玉蟾署名書 四言詩冊 紙本

Four-line poem *Blue Sky, Clean Air* in cursive script

Signed by Bai Yuchan (active 1208–24)
Southern Song dynasty (1127–1279) or later
Album leaves, ink on paper
H: 24.5 cm, W: 52.5 cm
Gushu 000249-13

Shown at the Asian Art Museum only

While establishing a work's authenticity is one of the essential principles of modern scholarship, it seems not to have been a critical matter to connoisseurs in dynastic times. Many artworks once accepted as originals and collected by emperors are now being reconsidered as their originality, the identity of the artist, and date are scrutinized. A few works included in this exhibition provoke an exploration of the developing scholarship and connoisseurship of Chinese art.

This work quotes from a congratulatory verse, *True Scripture of the Great Cavern of Highest Purity*, regarded as one of the three principal doctrines in Daoism. The lines describe heaven as being rich with illumination and purple clouds, a place from which the nine emperor-gods spread their energies to form the universe. These words helped guide people in cultivating a meditative practice called inner alchemy in order to achieve spiritual perfection.

The cursive script of this calligraphy departs from the convention requiring characters to be arranged vertically. Rather, these characters are placed in an irregular and unpredictable manner, resulting in a boldly vibrant composition full of dynamic rhythm. This work is characteristic of the calligraphy of Bai Yuchan, a legendary Daoist priest considered the founder of the practice of inner alchemy in the Southern Song dynasty. It is said that Bai's calligraphy got better as he became more drunk. Only three pieces by Bai survive, each in a different style. Supporting the case for his authorship of this work is a historical document that describes his writing as "large, cursive, like flying dragons and dancing snakes." Modern scholarship, however, has cast doubt on this conclusion: a careful examination of the strokes in certain characters suggests that this work might have been completed at a later time.

YCH WITH QN, HL

南宋 緙絲 群仙拱壽圖軸

Eight Immortals greeting the God of Longevity

Southern Song dynasty (1127–1279)
Hanging scroll, silk tapestry (*kesi*)
H: 41.3 cm, W: 23.8 cm
Gusi 000088

Shown at the Museum of Fine Arts, Houston, only

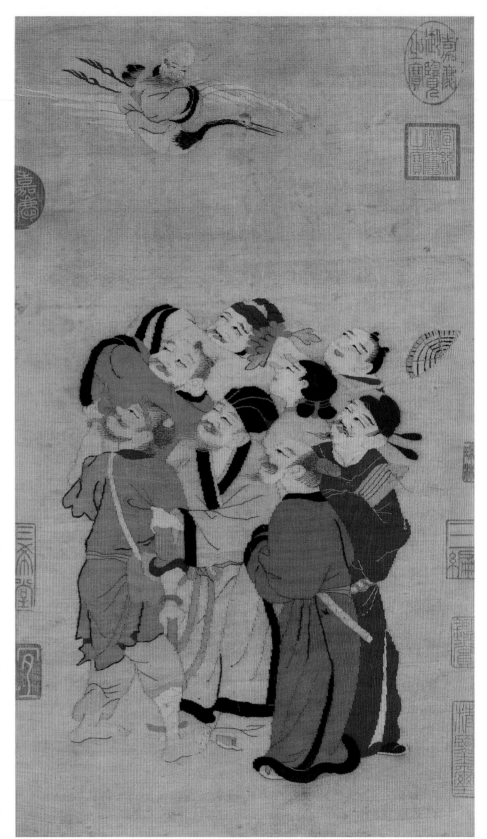

Depicted on this cut-silk (also called "carved-silk," or *kesi*) tapestry are the Eight Immortals greeting the God of Longevity, on his crane. Originating in the Tang and Song dynasties, the story of the Eight Immortals consisted of different personages and served different functions at different times. It was not until the publication of Wu Yuantai's *Eastern Travels: The Origins of the Eight Immortals* in the sixteenth century that they became codified as Li Tieguai, Han Zhongli, Lan Caihe, Zhang Guolao, He Xiangu, Lu Dongbin, Han Xiangzi, and Cao Guojiu. The God of Longevity is a stellar god who heads the twenty-eight lunar mansions. He is short and plump, carries a staff, and has a large head with a prominent forehead. The image of the Eight Immortals bestowing longevity was a beloved motif in birthday gifts, and the presence here of the God of Longevity and his white crane make this an auspicious example of the type.

This piece exemplifies the high standard reached in Song-era cut silk. It was woven on a plain loom using a method that retained the full warp and cut the weft. A design was first drawn on the warp, and, according to the color scheme, threads of various colors were looped onto individual shuttles. The shuttle weaved back and forth following the design, but on the point of return, the thread was not linked to a thread of a different color on the weft. It is difficult to weave human figures with this technique, especially when they are small. The woven patterns at the top and bottom of this work are identical but reversed. This type of weaving was inspired by painting and calligraphy—especially their composition, content, and artistic conception—as well as by traditional design.

WET WITH TB

CAT. 18

南宋 緙絲佛像 軸

Buddha Shakyamuni

Southern Song dynasty (1127–1279)
Hanging scroll, silk tapestry (kesi)
H: 59.8 cm, W: 52.5 cm, Gusi 000132

Shown at the Asian Art Museum only

Here Buddha Shakyamuni is seated inside a circular halo and upon a four-tiered lotus throne. He is shown with the usual protuberance on his head, his face slightly rounded, with soft and peaceful features and a solemn expression. He wears an ochre-red cloak (kesa) with graceful folds, exposing his right shoulder. His hands, with palms facing up and thumbs touching in the gesture of meditation, rest in front of his abdomen. Legend has it that it was in this posture that the Buddha sat beneath the Bodhi tree and became enlightened. While it is difficult to display skin texture and facial features using the cut-silk technique, this work is precise in its depiction. The natural and delicate color separation along the weft accentuates the stately air of the Buddha and is representative of Song dynasty kesi depictions of Buddhist subjects.

The use of kesi became widespread as the technique improved during the Song period. Weavers increased the production of kesi for mounting (in sutras and on paintings) and integrated the art of painting into the kesi technique for purely aesthetic reasons. Common themes included landscapes, birds and flowers, and human figures. Mythological subjects and those containing auspicious meanings were often used as gifts for birthdays and other occasions. Buddhist and Daoist themes were added to the kesi repertoire during the Southern Song period. The images of Buddhas and bodhisattvas of the Song dynasty became more secular and approachable, creating an elegant and graceful style while retaining their dignity and rich emotional appeal.

WET WITH TB

CAT. 19

北宋徽宗朝 青銅 夷則鑄鐘

Ritual instrument bell (*Yize zhong*), approx. 1105

Northern Song dynasty (960–1127), reign of
Emperor Huizong (1101–25)
Bronze
H: 28.1 cm, W: 18.4 cm
Zhongtong 000742 JW-1944

In order to restore the spirit of the great
ancient Xia, Shang, and Zhou dynasties
(before 256 BCE), Emperor Huizong estab-
lished a new system of rituals and music.
The rituals reinforced the Confucian way
and maintained social order, while music
was written to enlighten people. Soon
after the emperor took the throne, he
commissioned a set of bronze bells known
as "Great prosperity" (*Dasheng*) bells in
imitation of the bells of the Spring and
Autumn period (771–approx. 480 BCE).
In 1105 court composers completed a
new score of twelve movements for the
Dasheng bells to revive the music of the
ancient dynasties, after which a special
agency to administer the court orchestra
was established.

This *yize* bell was one of the *Dasheng*
chimes. It has a flat lip, a handle consist-
ing of two dragons facing each other, and
a body decorated with interlaced dragon
motifs. The middle panels on the body fea-
ture inscriptions. On one side, the *yize*, or
tone, of the bell is recorded (a recent test
indicates it is a high G). The other side
was originally inscribed with the char-
acter "*Dasheng*" but was subsequently
altered. This vessel was likely a war tro-
phy acquired by the nomadic Jurchen
army upon its capture of the Song capi-
tal in 1127, and the inscription was inten-
tionally modified to a character meaning
"great concord" (*dahe*) in order to justify
the invasion.

LC WITH TLJ

CAT. 20

北宋徽宗朝 青銅 政和鼎

Ritual tripod vessel *(Zhenghe ding)*, approx. 1116

Northern Song dynasty (960–1127), reign of
Emperor Huizong (1101–25)
Bronze
H: 23.2 cm, Diam: 19.4 cm
Zhongtong 000437 JW-2811

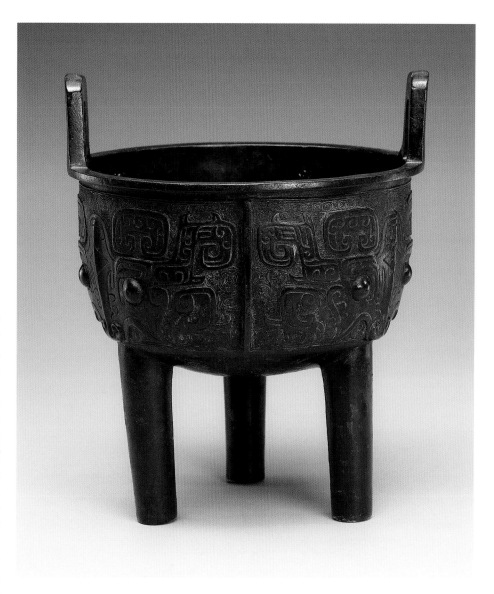

During the reign of Emperor Huizong, the court endeavored to recapture the glories of the Bronze Age Xia, Shang, and Zhou dynasties by reinterpreting the Confucian canons, writing in classical styles, commissioning instruments and music in old styles (see cat. 19), and restoring forgotten rituals. As part of this effort, Huizong reinstated the nine-*ding* tripod system of the Zhou dynasty. To this end, his court commissioned a large quantity of ritual vessels based on archaic models—a commission that helped revivify an ancient style of craftsmanship and influenced connoisseurship of that time. Huizong's interest in ancient bronzes was also reflected in the *Antiquities Catalogue of Xuanhe (Xuanhe bogutu)*, compiled by his decree between 1119 and 1125.

This bronze tripod is a good example of the emperor's archaic ambitions. Emulating the style of vessels from the Shang dynasty (approx. 1600–1050 BCE), it has two vertical handles, a round belly, and three cylindrical legs. The body is decorated with three groups of high-relief animal masks on a spiral background separated by flanges. Although this tripod imitated ancient bronze styles as much as possible, it nonetheless reflected Song dynasty characteristics in its casting technology and calligraphic inscription.

Emperor Huizong's embrace of Zhou culture extended to the royal habit of awarding gifts to worthy officials. This tripod was given to one such official, Tong Guan, for use in his ancestral shrine.

INSCRIPTION

Thirty-three characters cast on the bottom of the vessel read, "On the *jiawu* day of the eleventh month, the sixth year of *Zhenghe* [1116], the emperor ordered the commission of ritual *xing* tripod, awarded it to Guan the director of the privy council [*Shu mi yuan*], to be used for worshiping his ancestors, may his sons and grandsons forever treasure it."

LC WITH TLJ

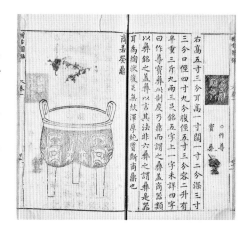

Illustration of a Shang dynasty (approx. 1600–1050) bronze tripod vessel from the *Antiquities Catalogue of Xuanhe (Xuanhe bogutu)*, compiled 1119–25, republished 1752. Edited by Wang Fu (1079–1126). Northern Song dynasty (960–1127), reign of Emperor Huizong (1101–25). Woodblock print.

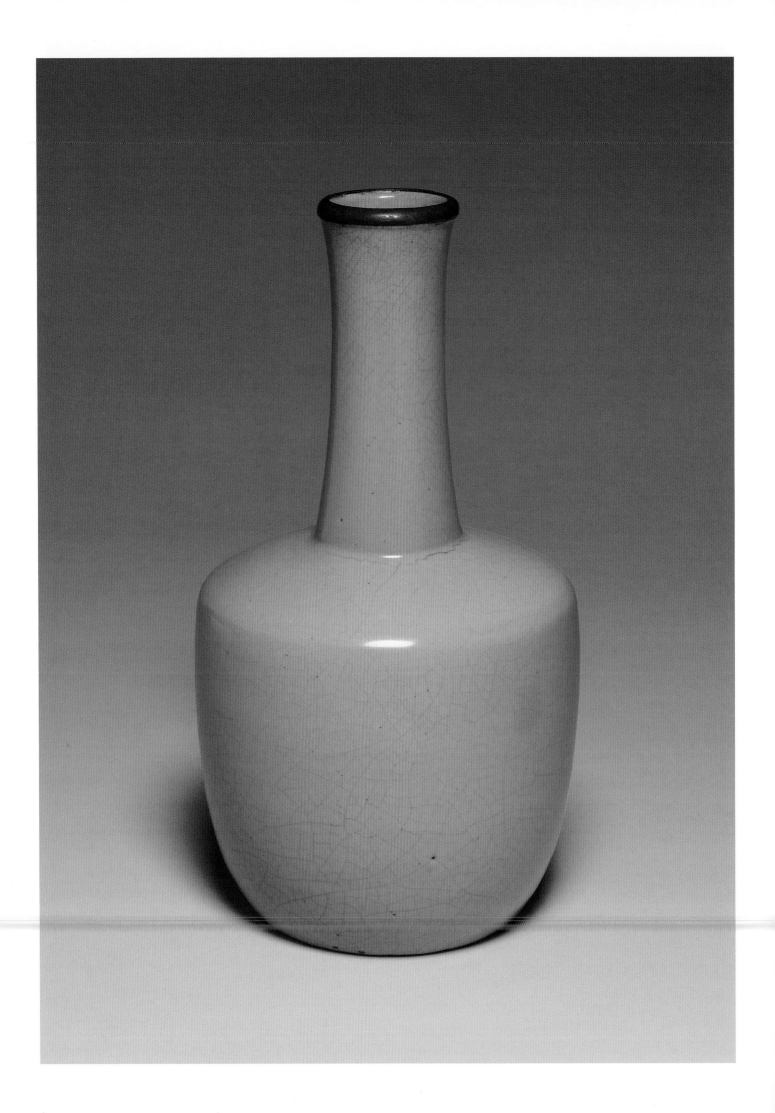

CAT. 21

北宋 河南汝窯 青瓷紙槌瓶

Vase carved with Emperor Qianlong's poem on the base

Official Ru kiln, Henan province
Northern Song dynasty (960–1127)
High-fired ceramic with celadon glaze
H: 22.4 cm, Diam: mouth 4.4, base 8.6
Guci 017856 Kun-223-5

One of only two surviving vases of its kind (among about sixty pieces that have been identified as Northern Song official ru ware), this vase is an extremely rare masterwork of the highest grade. Located in the Ru prefecture (now Henan), the official Northern Song Ru kiln was principally patronized by Emperor Huizong and was active for fewer than twenty years in the late eleventh and early twelfth centuries.

The mallet-shaped vase features a soft bluish glaze that coats the entire body and base. The five "sesame" spur marks on the bottom exhibit the careful craftsmanship achieved by the Northern Song Imperial Workshop, which soon became an inspiration for makers of other ceramics, in particular Korean celadon. A brass band mounted along the mouth rim of the long, straight neck of the vase has loosened, revealing tool marks that attest to old damage that had been specially repaired so that it could be fastened with the metal band. Before the damage the vase's neck would have expanded to form a wide, round, dish-shaped opening at the top, consistent with ru vases found at the site of the official Ru kiln site.[1] This form originated in Iranian glass, two examples of which have been unearthed from important Liao dynasty sites: the tomb of the princess of the Chen state (buried 1018) in Inner Mongolia, and the Dule Temple (built 984) in Hebei.[2] Chinese potters from major kilns, including Ru and Ding, adopted the form for ceramics.

Exactly when this vase entered the imperial collection is uncertain. An eight-line poem by Emperor Qianlong carved on its flat base proves its prominence in the eighteenth century. The emperor's praise for the vase's "fresh blue" glaze, its tiny "nail-like" spur marks, its "radiating fragrance even with no flowers present," and its ceremonial function in the Hall of Ancestral Worship (*Fengxian dian*) all show the extent of his connoisseurship of ru ware.

INSCRIPTION

A poem by Emperor Qianlong from midsummer 1778 is carved on the base.
PCY WITH HL

1. HICRA 2008, 72. *Wenwu* 1989.11, p. 3, pl. 1.

2. *Wenwu* 1987.11, p. 18; *Kaogu* 1990.12, p. 1120.

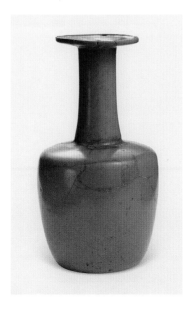

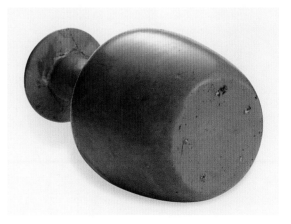

Ru vase. Excavated at the Qingliangsi Ru kiln site, Baofeng county, Henan province, in 2001. Northern Song dynasty (960–1127). High-fired ceramic with bluish glaze.

CAT. 22

北宋 河北定窯 白瓷劃花蓮紋梅瓶

Vase incised with a lotus design

Ding kiln, Hebei province
Northern Song dynasty (960–1127)
High-fired ceramic with white glaze
H: 35.4 cm, Diam: mouth 4.7 cm, base 9.3 cm
Guci 013471 Ju-91

Shown at the Museum of Fine Arts, Houston, only

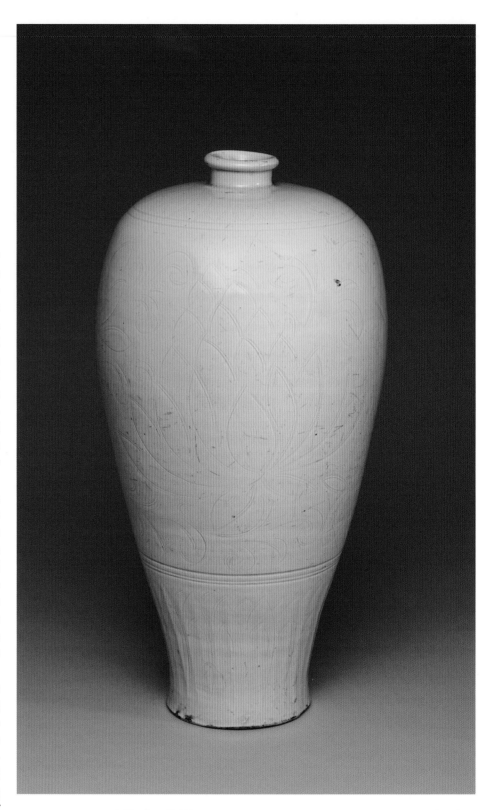

This plum vase (*meiping*) with an ivory glaze is among the finest and largest items produced at the Ding kiln in Hebei province (now Quyang) during the Northern Song period. The Ding potters of this era specialized in creating carefully incised designs whose graceful effects relied on the combination of the whitish glaze and controlled carving by hand. The warmth of this glaze is complemented by droplets in thickly glazed areas. This so-called teardrop glaze became the Ding kiln's signature feature, one sought after by connoisseurs.

This handmade vase has a small mouth with a smooth everted rim. The wide shoulders of the elongated body taper to a narrow base designed to be set into a stand. The unglazed inner base was carved to form a shallow foot ring around the edge. The exterior is incised with three friezes of the lotus design: a band of lotus petals, lotus scrolls, and a circle of lotus tendrils. Small-mouthed vases such as this were originally designed to serve wine.

Large pieces in this style were made at the Ding kilns as early as the Tang dynasty. The kilns were chosen by the court to make imperial ware for daily use in the palace. It is known from Song literature that vases of this type were called "plum vases" or "wine vases," indicating their various functions. As the trends of wine drinking and flower arranging spread throughout the Song empire, the demand for ceramic vases soared. Large-scale vessels such as this, however, required advanced skills in potting, decoration, and glazing and could not be mass produced.

Owing to their scarcity, Ding *meiping* remained highly valued by later monarchs.
PCY WITH HL

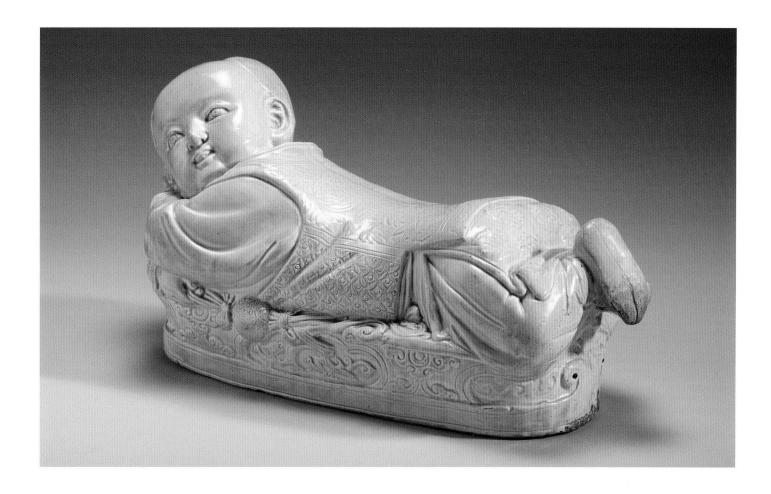

CAT. 23

北宋 河北定窯 白瓷嬰兒枕

Pillow in the shape of a recumbent boy

Ding kiln, Hebei province
Northern Song dynasty (960–1127)
High-fired ceramic with glaze
H: 18.8 cm, L: base: 31 cm, W: base: 13.2 cm
Guci 004923 Wei-526

This is an exceptional example of the sculpting style of Song ceramicists and one of three known existing ding "boy pillows" of its kind. The boy is lying on his belly on an oval pedestal representing a wooden couch-bed carved with dragonets and clouds, his back softly curved as if offered as a pillow. At the edge of the bed, near the boy's right hand, a brocade ball represents the wish that the family possessing this object be blessed with prosperity. The piece was made first by molding, cutting, and carving the clay and then altering it with incised details as necessary. The flower roundels on the boy's inner robe, combined with the stylized patterns on his vest, are typical of the Song weaving style.

Ceramic pillows emerged in the north during the Tang dynasty. Whether they were actually slept upon or merely used for funerals remains a topic of scholarly dispute. Based on descriptions in Song poetry, most scholars now believe that such pillows were actually used for sleeping. As ceramics became more pervasive, children became an inspiration to Song potters. The Ding kilns, which once supplied fine, white-glazed products to the Northern Song court, were some of the first to manufacture such boy pillows, which were highly sought after by a large family-oriented market.

This particular work was highly treasured by Emperor Qianlong. His poem, carved on the base, acknowledges it as a piece of "fine Song ding ceramics" on which one could dream of being an "incarnation of a butterfly, as Master Zhuangzi [a Chinese philosopher, active approx. 375–250 BCE] did." The emperor's meticulous observations note the "brocade" and "embroidered" fabrics on the boy's couchbed. He also pointed out that the residual clay pieces inside the hollow interior make the work an "alarm pillow" because the clay pieces would make clinking sounds when the pillow was shaken.[1]

INSCRIPTION
A poem by Emperor Qianlong, dated the third month of 1773, is carved on the base.
LYH WITH HL

1. NPM 1976, vol. 7, chap. 13, p. 34.

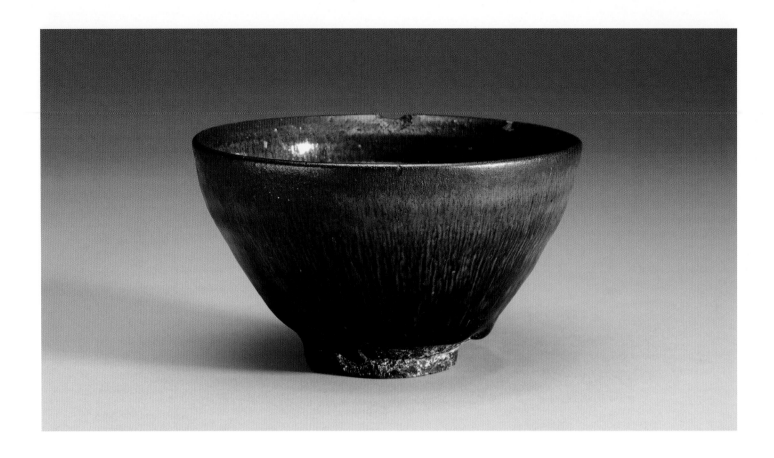

CAT. 24

北宋 福建建窯 黑釉兔毫盞

Tea bowl with "hare's fur" glaze

Jian kiln, Fujian province
Northern Song dynasty (960–1127)
High-fired ceramic with suffused glaze
H: 6.5 cm, Diam: mouth 11.5 cm, foot 4.2 cm
Guci 008624 Lü-163-25

This small bowl features a thick, dark glaze with fine, threadlike streaks immersed in the coating, a characteristic that gives this glaze its name: "hare's fur." This subtle decorative effect was much admired by Emperor Huizong, who dedicated one section in his *Discussion about Tea* (1107–10) to the subject of small, black glazed tea-cups, stating those with hare's fur glaze were of the highest grade.[1] Others praised their excellence as well. The renowned scholar-official and tea master Cai Xiang said that "if the color of tea is white"—referring to the frothy white foam that forms when the tea is whisked—"its cup should be black, with decoration like that of the Jian kiln's hare's fur."[2] Many Song poets, including Su Shi, vividly described the beauty of tea wares and the process of whisking tea.

The hare's fur glaze was first achieved at the Jian kilns during the Song dynasty. Crystallization of metallic minerals produced during the cooling process formed the myriad streaks in the glaze. Archeological finds have revealed that phrases such as "gold and silver crackles" were used to describe suffused glazes, providing further proof that poetic and lyrical terms for ceramic glaze were fashionable at the time. Although other kilns attempted to emulate the glaze, the works produced at the Jian kilns were the most refined and highly regarded hare's fur pieces. In the thirteenth century, Chan monks introduced this glaze to Japan, where it came to be known and appreciated as *tenmoku* ware.

Bowls of this type inscribed with the Chinese character for "tea" were unearthed at the Luhua site of the Jian kilns, further establishing their use as tea cups. Archaeological records show that these cups have been found at multiple Jian kiln sites, some bearing engraved inscriptions reading "tribute bowl for the court" (*jinzhan*) and "for imperial use" (*gongyu*) on the bottom.[3]

INSCRIPTION

The character *lü* is carved in regular script on the unfired clay of the base after being dried in the shade, a technique rarely seen today. The meaning of this character is unclear, but it was probably related to inventory purposes.

YSC WITH JC

1. Zhao Ji (1107–10) 1646.
2. Cai Xiang (1064) 1968.
3. *Kaogu* 1984.7, pp. 638–41; 1990.12, p. 1097, pl. 5.

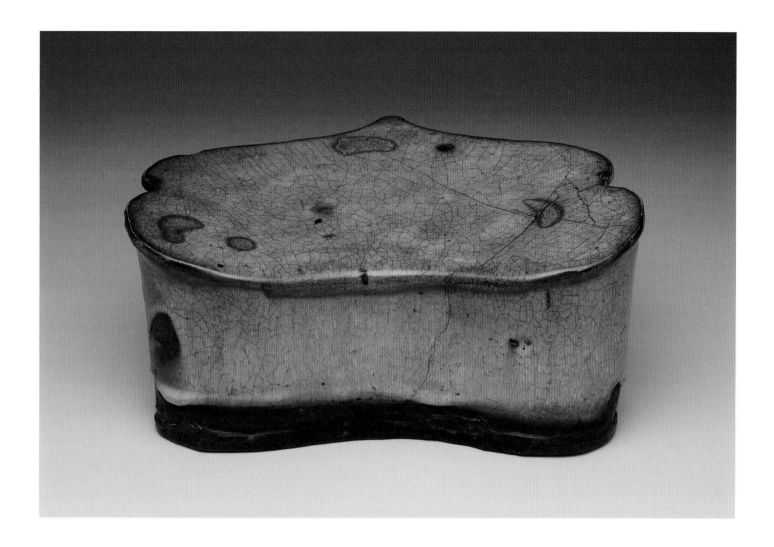

CAT. 25

金朝 河南鈞窯 乾隆皇帝題
〈詠汝窯瓷枕〉御製詩如意形枕

Pillow in the shape of a wish-granting wand (*ruyi*)

Jun kiln, Henan province
Jin dynasty (1115–1234)
High-fired ceramic with suffused glaze
H: 13.4 cm, L: top 30.8 cm, base 28 cm,
W: top 19.7 cm, base 19 cm
Guci 017425 Yu-843

A lobed, mushroom-shaped pillow with a slightly concave top and a flat base, this form is traditionally called the *ruyi*—the wish-granting wand—after a wild fungus. The wild mushroom appears in a wide range of Chinese medicinal preparations and is an essential ingredient in mythological and religious alchemy. Its reputation for healing and magical powers guaranteed it a place of prominence in religious, court, and popular arts, and the *ruyi* is closely associated with eternity and the God of Longevity. During the late Song period, the form was adopted for ceramic pillows that were mainly produced by kilns in the central plains during the thirteenth and fourteenth centuries.[1]

This pillow's large size and graceful shape, with its smoothly curved edges and bright primrose mottles suffused with a cerulean glaze, attest to its importance in the imperial collection. A poem by Emperor Qianlong carved on the bottom discusses the strength, probity, and diligence of Confucians through analogy with glaze's color and form. Qianlong confesses to cultivating himself by diligently getting up before dawn, ironically hinting that he did not use his pillow as long as he would have liked. However, the emperor misidentifies this jun pillow as a Ru kiln product—a long-standing mistake that continued until the twentieth century. The error is understandable given the old saying about "the difficulty in distinguishing between the jun and the ru," which came about because the two kilns were geographically close, produced similar types of products for hundreds of years, and used similar glazes and methods of shaping.

SEALS AND INSCRIPTION

A poem by Emperor Qianlong, dated fall 1776, and his seals "be virtuous" (*bide*) and "eloquent and fluid" (*langrun*) are carved on the base.

PCY WITH HL

1. Zhang Bai 2008, vol. 3, pp. 185, 190, 213; vol. 6, p. 147.

CAT. 26

南宋 浙江官窯 青瓷貫耳壺

Vase in the shape of an ancient
bronze vessel

Guan kiln, Zhejiang province
Southern Song dynasty (1127–1279)
High-fired ceramic with celadon glaze
H: 26.6 cm, L: mouth 9.4 cm, W: mouth 11 cm
Guci 014022 Yu-566

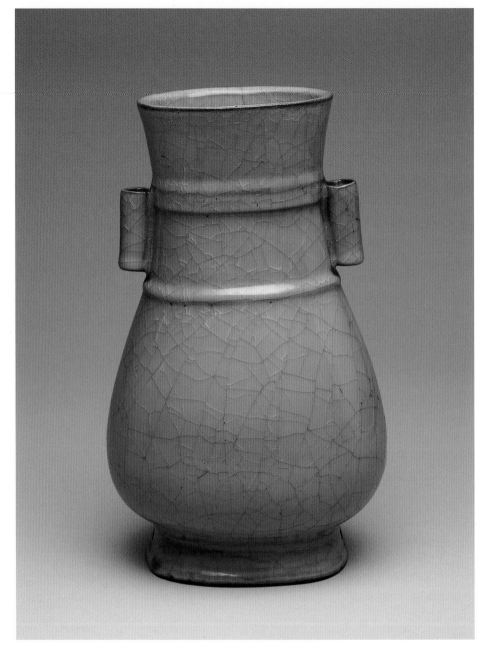

Identical in form to an ancient cere-
monial bronze *hu* vessel, this type of
celadon-glazed vase has been identified
as a product of the official Southern Song
kilns on Turtle Hill (*Wuguishan*), in the
present-day suburbs of Hangzhou city,
and traditionally referred to in documents
as the Jiaotanxia kilns.[1] Illustrated in
Antiquities Catalogue of Xuanhe (*Xuanhe
bogutu*),[2] the Bronze Age *hu* form pro-
vided the official Southern Song kilns
with a primary model for reproduction.
Evidence of this archaic style could be
found in the Northern Song, and pieces
in this style continued to be commis-
sioned in the Southern Song. When the
Southern Song court lost its foundry, the
new ceramic shops made celadon wares as
substitutes for bronze vessels.

Following Northern Song Ru kiln tradi-
tion, the official Southern Song kilns devel-
oped a multiple-glaze method. Famous for
its "incense ash" gray clay and semitrans-
lucent celadon glaze with "icy crackling,"
guan ware usually bears a subtle grayish
color around rim and foot, where the body
shows through the thinner glaze, and is
referred to as the "purple mouth and iron
foot." This work, with its balanced form,
even layer of glaze, and crackles in beau-
tiful icy patterns, is an example of the
best-known official Southern Song ritual
ware. The glaze texture gives the work an
exceptional degree of warmth and an oily,
jade-like appearance.

Emperor Qianlong favored the official
Southern Song guan ware, and twenty-
seven of these celadon works in the collec-
tion of the National Palace Museum carry
his inscriptions.[3] This vase, according to

writing on the base, caught Qianlong's eye
for its smooth glaze and design, which
allowed it to be easily carried by passing
a cord through the two cylindrical tubes
along the neck and rectangular holes on
the sides of the base.

INSCRIPTION
A poem by Emperor Qianlong, dated
spring 1773, is carved on the base.
PCY WITH HL

1. IOA 1996, p. 36, pl. 26, fig. 2.

2. Wang Fu (1119–25) 1752, vol. 12, pp. 9–20.

3. NPM 1989.

CAT. 27

南宋 浙江龍泉窯 青釉琮式瓶

Vase in the shape of an ancient *cong* vessel

Longquan kiln, Zhejiang province
Southern Song dynasty (1127–1279)
High-fired ceramic with celadon glaze
H: 26.4 cm, Diam: mouth 7.8 cm
Guci 014108 Nai-390-14

This green-glazed vase bears witness to a long history of developments in the form called the *cong*. Originally seen in neolithic jades, the *cong* was a hollow square object with a round opening in the center. According to the late Bronze Age classic *Rituals of the Zhou* (*Zhou Li*), the jade *cong* was a ritual object used to worship heaven, earth, and the four cardinal directions. This meaning and function were gradually forgotten, and the word for *cong* was no longer identified with jades of this shape. By the eighteenth century, many people—including Emperor Qianlong—thought the existing jade tubular *congs* were chariot components. This misunderstanding was eventually clarified by Qian Dian (1741–1806), a Qing scholar who, in his *Annotation on the Dictionary of Archaic Terminology* (*Shuowen jiezi gouquan*), rediscovered and decoded the origin of the *cong*.

After the neolithic period the *cong* form underwent tremendous change. In the archaic revival of the Song dynasty, the tubular *cong* was transformed into a vase made of various materials—bronze, stone, and, in this case, ceramic—and decorated with raised lines rather than the mythological masks that appeared on the ancient jades. The form was put into heavy production at Longquan, and similar pieces datable to 1236 have been unearthed at Sichuan.[1] Ceramic *cong* vessels were used to hold yarrow weeds in ritual ceremonies and, from the Southern Song dynasty onward, flower arrangements. The base of this vase is unglazed.

YSC WITH LJ

1. *Wenwu* 1994.1, p. 7.

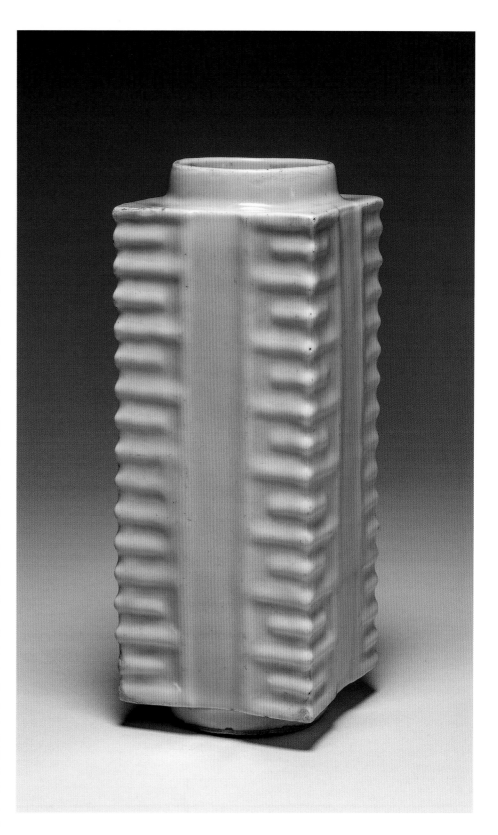

CAT. 28

南宋 江西吉州窯 黑釉葉紋瓷碗

Bowl with tree leaf design

Jizhou kiln, Jiangxi province
Southern Song dynasty (1127–1279)
High-fired ceramic with black glaze
H: 5.1 cm, Diam: mouth 14.5 cm, base 3.2 cm
Guci 016991 Lü-165-26

Its distinctive design, composed of a desiccated leaf against thick black glaze, suggests this tea bowl was a product of the Jizhou kiln. The Jizhou potters invented an unusual method of appliquéing paper cutouts or tree leaves—often mulberry leaves—to the interior of tea bowls, which then burned off during firing and left designs in strong contrast to the dark-glazed ground. Exemplified by a similar bowl found in a 1206 tomb in Jiangxi,[1] this decorative technique had developed into a well-controlled mastery by the early thirteenth century. The use of mulberry leaves at the Jizhou kilns was probably inspired by the notion of poet Chen Xingyi (1090–1138) that the leaf was infused with the Zen spirit. In the southeast, the Zen practice of having three bowls of tea after a meal was common. A tea bowl containing the Zen spirit was essential for amateur and master tea drinkers alike.

YSC WITH HL

1. Zhang Bai 2008, vol. 14, p. 54.

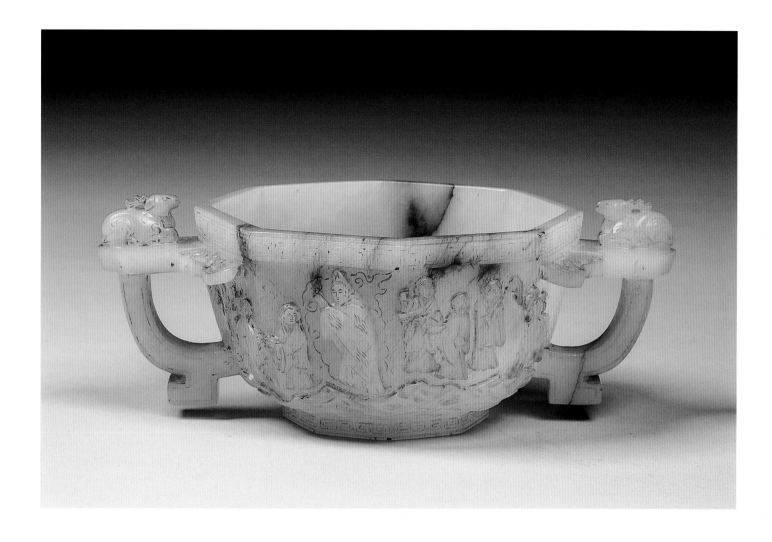

CAT. 29

遼-北宋 玉 人物紋雙鹿耳杯

Cup with human figures

Liao or Northern Song dynasty (907–1127)
Nephrite
H: 5.1 cm, L: 14 cm, W: 9.5 cm
Guyu 003803 Tian-55-17

Made of greenish white nephrite (one of two minerals commonly known as jade), this octagonal cup is worked in high relief, showing five servants surrounding a female Daoist deity. With a background of finely incised lines presenting clouds and mist around the immortal paradise where devotees dabble in medicine and pure alchemy, the image creates an intriguing effect. Two handles serve as plinths to support deer, an animal associated with the sacred mountains worshiped by the ruling class.

During the Song dynasty jade vases, plates, cups, and bowls were regarded as symbols of luxury. At that time the scholar-officials known as the literati favored a modest lifestyle, and court officials would remind the emperors not to use jade, citing the admonitions of their ancestors. (Once, when planning a banquet, Emperor Huizong asked his subjects if using jade vessels would cause him to be criticized for being "too extravagant."[1]) On the northern frontier, the private production of jade vessels was prohibited throughout the Liao, Jin, and Yuan dynasties (907–1368). Despite this, the upper class daringly commissioned jade pieces, as evidenced by the plates and bowls often found in the tombs of people of rank; horse fittings were sometimes also adorned with jade. Some of these elegant jade utensils from the Song and Yuan dynasties were prized artifacts in imperial collections, particularly the Qing royal collections, and reflect the diverse styles and skills of the jade craftsmanship of the period.
LTC WITH TLJ

1. Tuo Tuo (1334–45) 1969, vol. 7, chap. 472, p. 5678.

CAT. 30

南宋 青玉 螭紋璧

Bi disc with playing dragons

Southern Song dynasty (1127–1279)
Nephrite
Diam: 10.3 cm, hole: 3.2 cm, Depth: 0.7 cm
Guyu 000476 Cang-165-1

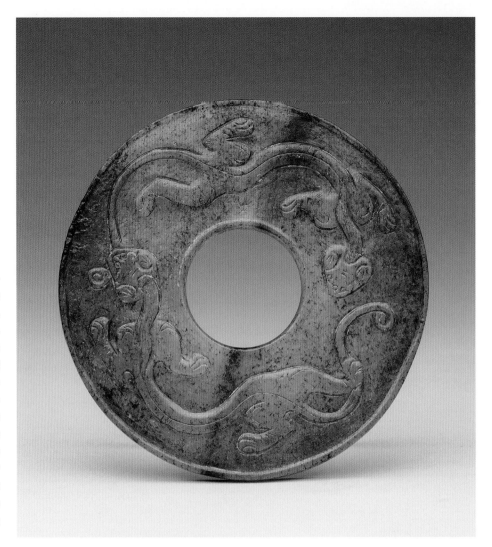

Late Bronze Age documents (300–200 BCE) associate the round jade disc known as the *bi* with the heavens, with its central opening representing a beam of light. Ancient *bi* were used in rituals and worn or collected by men. Following Northern Song style and the contemporary taste for ancient artworks, the Southern Song court produced many jade items in archaic styles for ritual purposes and personal accessories. Song mandarins did not want to feel obliged to wear only ancient jades; they wanted to wear ones reflecting current styles as well. Thus, this jade disc evolved from its original form and function into a piece of high fashion.

The decorations on this *bi* adopted the styles of the late Warring States (approx. 480–221 BCE) and Western Han (206 BCE–9 CE) periods—specifically, intertwined dragons, wish-granting wands (*ruyi*) or clouds, and grain-and-nail motifs. The two low-relief dragons have triangular faces. One bites the other's tail and stands on its own curved tail, creating an effect of movement. The crawling poses of the dragons further reinforce the spiraling sequence around the disk.

The greenish jade of this disk was artificially and unevenly dyed to pale brown during the late Ming or early Qing dynasty to mimic the effects of age. The techniques evident here are, however, not identical to those used on its archaic model. For example, the polishing method here is very different from that used in ancient jades. The dragons' eyes here have been drilled directly into the jade, with the friction of the bit producing a smooth, polished edge, whereas an ancient piece would show rough tool marks from a slow abrasive process. These dragons

Ink rubbing

are shown creeping along the flat surface of the jade, as if from a bird-eye's view. While this orientation is commonly seen in Southern Song jades, it is a much less elaborate treatment than seen in the jades of the Warring States and Western Han periods. Several jade discs worked with dragon motifs in this style have been found in Southern Song tombs in Zhejiang and Sichuan.[1]

CLT WITH TLJ

1. Gu Fang 2005, vol. 8, p. 215; vol. 13, p. 185.

CAT. 31

南宋-元朝 青玉 雲紋圓盒

Round box with whirling clouds

Southern Song or Yuan dynasty (1127–1368)
Nephrite
H: 2.2 cm, Diam: 6 cm
Guyu 006107 Kun-202-40

Evidence in archaeological finds indicates that many jade pieces from the tenth to fourteenth century were small and covered with simple designs and served as decorative or scholarly objects. A small jade box such as this could have been used to hold incense, makeup powder, or paste for seals.

The lid and body of this greenish white nephrite box are the same height. The lid has a flat top, and the wall of the body is vertical. The exterior is fully carved with cloud designs, three in the inner circle, and six in the outer circle. Both the shape and the decorations of this jade box are similar to silver and lacquer boxes of the period. The simple, delicate style is characteristic of the artistry of the Southern Song period. The circular cloud motif in particular is consistent with the designs popularly used for gold, silver, and lacquer works from the thirteenth and fourteenth

centuries. Fine examples of lacquerwares and a silver box with such stylized clouds have been unearthed at Jiangxu, Anhui, Sichuan, and Hunan.[1]

LTC WITH TLJ

1 *Qiqi* 1989, pls. 100 and 107; HPM 2009, pl. 539.

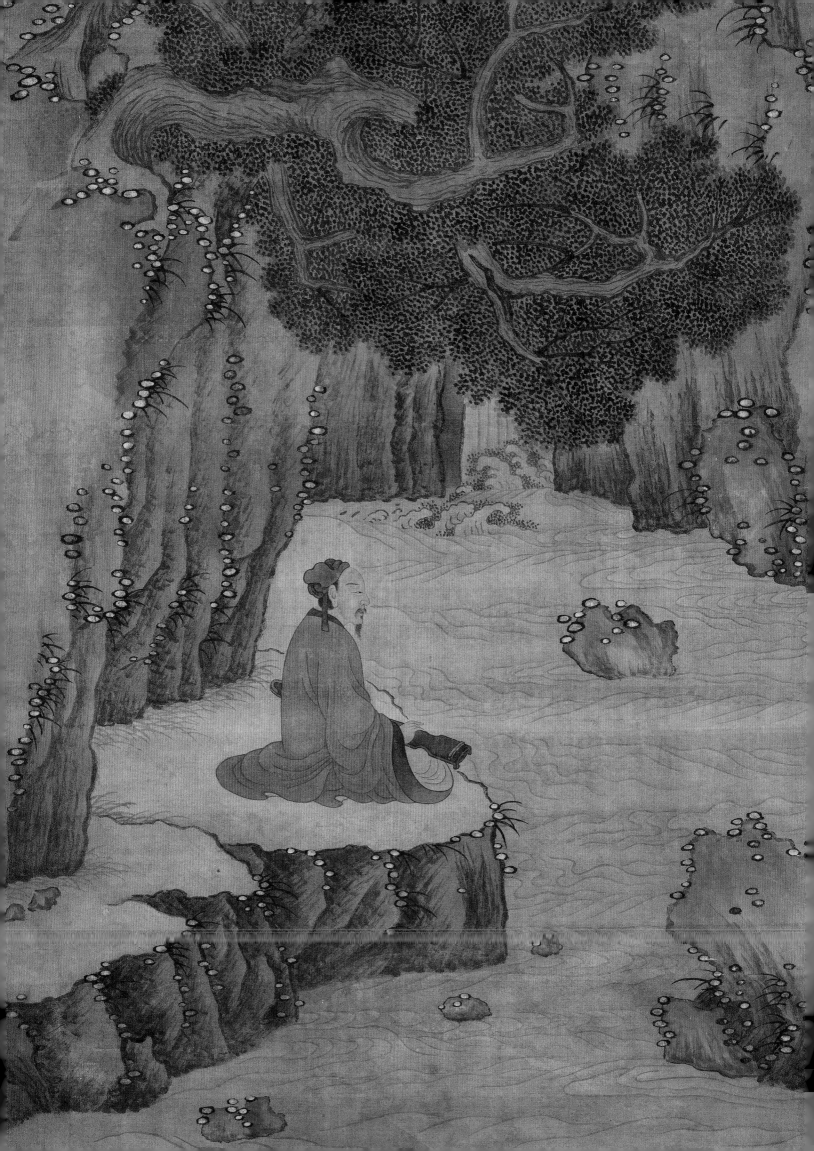

Yuan Dynasty (1271–1368): Mongol Rule Captures a Rustic Aesthetic

Artworks from the Yuan dynasty show the rich diversity of Mongol-ruled China. Departing from the delicacy of Song-era art, Yuan art captures a rustic strength and conveys a universality appropriate to a society of coexisting cultures and religions while also reflecting the very real unrest caused by ethnic conflict. Motivated by the Mongols' ambition to create a vast empire, commercial trade with other regions expanded enormously during this period and brought dynamic new influences to Chinese culture.

The Great Khan of the Mongol empire and founder of the Yuan dynasty, Kublai Khan (reigned 1271–94; see cat. 32) was born in 1215 to Tolui (1190–1232), the youngest son of Genghis Khan, and Sorghaghtani Beki, a Christian noblewoman from the Kereit tribe. In 1260 Kublai succeeded his brother Emperor Xianzong (died 1260), who perished during a military campaign. As the first Mongol leader to truly complete the transition from conqueror to ruler, the young Kublai followed the example of his mother, who had gained the support of her Chinese subjects by granting autonomy to newly conquered Chinese territories. Kublai's early governance of northern China (1230–40) was successful, but it also proved that it was necessary to revise the Mongols' "old ways"—which were centered on a nomadic lifestyle—and obtain the assistance of the Chinese to manage agriculture and taxation. His Chinese counselors Liu Bingzhong (1216–74), Wang Xiao (1190–1273), and Yuan Haowen (1190–1257) strongly influenced him in many important political and religious decisions. In 1264, on the advice of Liu Bingzhong, Kublai chose Yanjing, the former capital of the Jurchens' Jin dynasty (1115-1234), and now Beijing, as his capital, Dadu. In 1276 the Mongols defeated the Jurchen and Southern Song and continued military expeditions throughout Central and Southeast Asia.

With his appreciation for Han Chinese culture and his ambition to unify a diverse empire, Kublai made sure his administration included a mix of ethnicities. Many Chinese scholars who had fled the Mongol invasion of northern China were persuaded to return and took positions at the Yuan court. With their assistance, Kublai developed policies, especially concerning taxation and the economy, that resembled those of earlier Chinese dynasties. Yet Kublai did not become completely Sinicized. His first objective was to restore Mongol authority over the vast Chinese domains. To this end, he imposed a system that established Mongols at the top of the ethnic hierarchy, followed by their Central Asian and Tibetan allies, with Han Chinese at the bottom. Such discrimination created severe conflict between the Mongols and the Chinese.

Kublai strived for stability and harmony in his vast empire and took a pluralistic view of religion, with the goal of resolving disputes among various believers.

Playing the Zither (Qin) *by Autumn Waters* (detail), Yuan dynasty or Ming dynasty (1271–1644), cat. 35.

In 1260 he granted the Tibetan Buddhist Lama Phags-pa (1235–80) the title of "Imperial Preceptor" and a jade seal, charging him with promoting the religion throughout the empire.[1] Following in the footsteps of his grandfather Genghis Khan, Kublai invited the Thirty-sixth Celestial Master Zhang of the Orthodox Daoist Unity (*Zhengyi*) sect from Dragon and Tiger Mountain in Jiangxi to his capital three times; the Daoist master was granted a silver seal and named the imperial Daoist authority.[2] In 1275 the Department of Religious Iconography Promotion (*Fanxiang tijusi*) was established to produce iconic religious works in paint, clay, and wood.[3] Kublai won over Westerners in 1289 by putting the Department of Reverence for Blessings (*Chongfu si*) in charge of Christian churches and communities.[4] In 1271 he invited Muslim astrologers from Central Asia to establish an observatory and make Arabic calendars in Chinese.[5]

Unlike the Chinese emperors who were well versed in literature and calligraphy, Kublai did not make art; instead, he expressed his taste through administration. Specific offices were set up to undertake the manufacture of ritual objects, attire, accessories, and items for the imperial household and interiors. The Ritual Institute (*Taichang liyi yuan*; established 1260) and the Office of the Supreme Temple (*Taimiao shu*; established 1266) were responsible for preparing all imperial ritual ceremonies.[6] The Bureau of Utensils (*Qiwu ju*; established 1263) supplied the materials—chariots, tents, gold and silver utensils, and other fine objects—used in palaces and temples. The Bureau of Rhinoceros Horn and Ivory (established 1263) oversaw 150 artisan families who produced sculptures, ornaments, and even dragon beds for members of the nobility.[7]

These departments grew rapidly as Kublai's new capital prospered. Precious luxuries, especially items favored by the Mongols, necessitated specific care. About 230 artisans, pet keepers, boat rowers, musicians, and entertainers worked at the Bureau of the Imperial Honor Guard (*Yiluan ju*; established 1274) and provided a wide range of services and materials.[8] By 1290 more than 2,000 gold, silver, and highly valued personal accessories were registered at the Storehouse of Implements (*Qibei ku*).[9] Kublai reorganized the headquarters of the Artisan Workshop Institute (*Jiangzuo yuan*; established 1293), which produced works in gold, silver, and jade; textiles; crowns; ornaments; and other decorative objects.[10] The Directorate General of Artisans (*Renjiang zongguan fu*) recruited artisans from the Dadu region.[11] Seven hundred families of artisan laborers who worked with metals, lacquer, painting, and enamel were registered with the Department of General Household Service (*Diying si*) in the early Yuan period. By 1261, 450 families dealing with clay, wood, chariots, metals, bamboo, hemp, and architecture served under the Palace Maintenance Office (*Xiunei si*).[12]

To supply the enormous building projects in Dadu, the Yuan court set up four adjacent ceramic shops in 1274 where 300 families produced architectural tiles.[13] The high-quality porcelain used in rites and daily life at the Yuan court was managed by the Fuliang Bureau of Porcelain (*Fuliang ciju*) in Jingdezhen (now Jiangxi province) in 1279 (later administratively under the Artisan Workshop Institute).[14] Fuliang produced the underglaze cobalt-blue glaze, copper-red glaze, white glaze, and peacock-blue wares that are representative of the Yuan aesthetic over the next decades, until the region was sacked in a peasant rebellion in 1352.

Kublai shaped the court art of the Yuan through sustained patronage of official artists and artisans and by employing foreigners noted for their skill in unusual arts and crafts. This audacious path transformed the elegant aesthetic of the Song

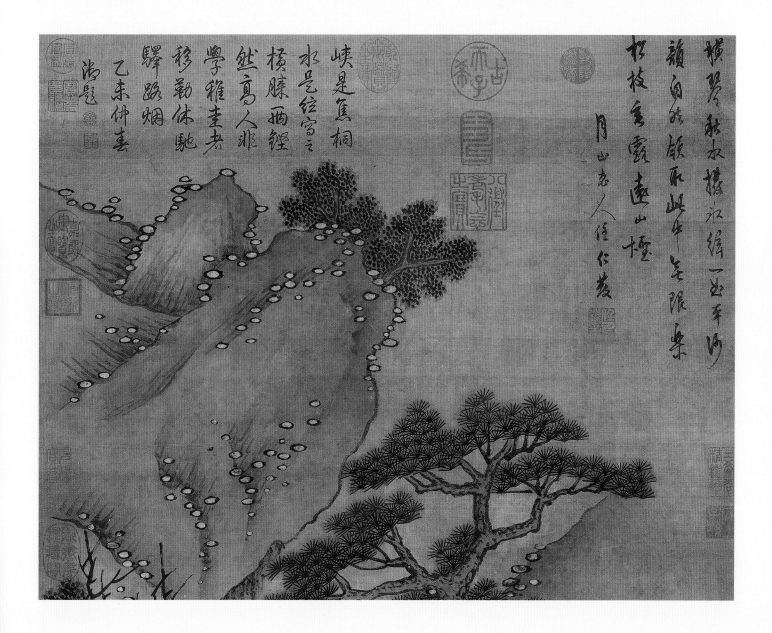

Playing the Zither (Qin) *by Autumn Waters* (detail), Yuan dynasty or Ming dynasty (1271–1644), cat. 35.

culture into a more earthy one marked by vigor and strength. During his reign, Kublai increased taxes, and his discriminatory policies exacerbated racial tensions. Yet, his policy of incorporating Chinese culture into Mongol rule, reforms that placed less emphasis on nomadic ways, and the consolidation of the bureaucracy all served to form a strong foundation for his empire. Later Mongol emperors were influenced by his example, especially Renzong (reigned 1312–20), Yingzong (reigned 1321–23), and Wenzong (reigned 1328–29; 1330–32), who saw Yuan art reach its climax during his reign.

NOTES

1. Song Lian (1369) 1969, chap. 202, p. 6580.

2. Ibid., p. 6581.

3. Ibid., chap. 89, p. 6361.

4. Ibid.

5. Ibid., chap. 90, p. 6363.

6. Ibid., chap. 88, p. 6355.

7. Ibid., chap. 90, p. 6361.

8. Ibid., p. 6363.

9. Ibid., chap. 88, p. 6361.

10. Ibid., p. 6355.

11. Ibid., chap. 85, p. 6347; chap. 88, p. 6355.

12. Ibid., chap. 90, p. 6361.

13. Ibid.

14. Ibid., chap. 88, p. 6356.

元朝 元世祖忽必烈半身像冊
絹本水墨設色

Kublai Khan as the First Yuan Emperor, Shizu

Yuan dynasty (1271–1368)
Album leaf, ink and color on silk
H: 59.4 cm, W: 47 cm
Zhonghua 000324-00003

Shown at the Asian Art Museum only

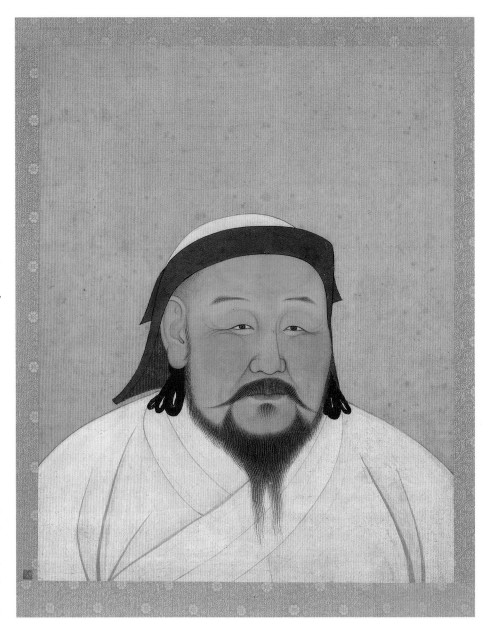

This work is—along with the portrait of Empress Chabi (cat. 33)—among eight paintings in the album *Bust Portraits of Mongol Yuan Emperor*s. Here, Kublai's head position and calm facial expression are typical of formal imperial portraits, reflecting the routine, competent process that produced the many bust portraits attributed to court workshops. The outlining of the contours of the head and attire and the general tendency toward soft color washes applied to the forehead, eyebrows, cheeks, and chin to give the illusion of lifelike, three-dimensional forms required refined technique that differed from traditional Chinese methods, which primarily involved ink lineation.

The Mongol identity of Kublai Khan is established in this portrait by his plain robe, leather hat, and three braided loops of hair hanging from behind the ear to the shoulder. All Mongols, regardless of rank, shaved the hair off the top and back of the head, leaving a little on the forehead and three braided loops below each ear.

Small bust portraits such as these were likely produced at the emperor's decree by a court painter. Indeed, the direct manner of this drawing and its lack of a signature have led to its attribution as the product of court workshops, which may have employed a standard, system-wide model established by the Department of Religious Iconography Promotion. Portraits of Yuan monarchs were often enshrined in the royal Temple of Great Sacred Longevity and Tranquility in Dadu; in 1328 or 1329 the temple was renamed the Hall of Imperial Divinity.

These portraits were later kept in the Hall of Southern Fragrance (*Nanxun dian*) in the Forbidden City, which had originally been used by Ming emperors for entertainment but was later designated by Emperor Qianlong (reigned 1736–95) as a place to display portraits of members of the imperial family throughout the dynasties.

SFC WITH QN, HL

CAT. 33

元朝 世祖后徹伯爾 (察必) 半身像
冊絹本水墨設色

Kublai Khan's consort, Empress Chabi, approx. 1271–75

Yuan dynasty (1271–1368)
Album leaf, ink and color on silk
H: 61.5 cm, W: 48 cm
Zhonghua 000325-1

Shown at the Museum of Fine Arts, Houston, only

Chabi (1227–81), consort of Kublai Khan, was designated empress by Kublai upon his founding of the Yuan dynasty in 1271. She was the only female Mongol aristocrat given an honored position on the ancestral altar in the Supreme Temple (*Taimiao*) in Dadu. Chabi was devoted to her husband, and her kindness and faith in humanity made her a good influence in the Yuan court. Delightful and frugal, she led the staff of the inner palace in producing everyday materials, recycling bow strings into durable fabrics and discarded leather into rugs. She modified the Mongol-style cap into a brimmed hat and the long robe into a strange-looking, sleeveless, collarless tunic that allowed Kublai to ride comfortably through the fields on horseback. When the entire government was celebrating her young son's debut at court, she warned Kublai, "No empire lasts forever." And when Kublai offered her his war trophies from Song households, she refused them all, saying, "The Song collected them over years to hand down to their future progeny, how can I have the heart to take a single thing?"[1]

Here, Chabi gazes at a slight angle and wears a red robe with a wide, brocaded border and two narrow pieces of trim—a traditional tailoring technique used to make magnificent robes from fabric such as the Central Asian textiles woven with gold thread. Her tall crown, called a *gugu* in Mongolian, is a round cap with a tall cylindrical tube at the center worked from two pieces of birch bark. Wrapped in red silk with floral embroidery, the crown is held together by a net made of gold filigree

and pearls; a feather is mounted at the top. Pigments in shades of red have been rubbed on the empress's cheeks, creating a smooth transition from robe to face, from bright red to pink, from intense flat colors to subtle touches of tone. The artist's technique appears to be that of a refined court painter especially skilled in the delicate treatment of the face, a method rarely seen in portraits by Song painters.

SFC WITH QN, HL

1. Song Lian (1369) 1969, chap. 114, pp. 6414–15.

元朝 高克恭繪 春山晴雨軸
絹本設色

Spring Mountains after Rain, 1299

By Gao Kegong (1248–1310)
Yuan dynasty (1271–1368)
Hanging scroll, ink and light color on silk
H: 125.1 cm, W: 99.7 cm
Guhua 000230

Shown at the Museum of Fine Arts, Houston, only

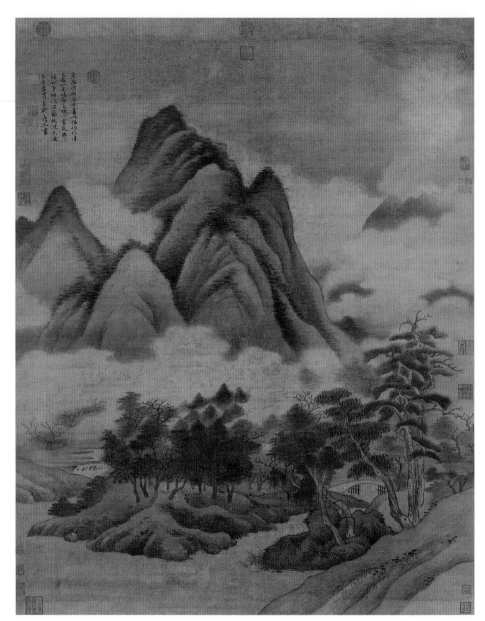

This misty mountain scene is an unconventional landscape by the accomplished artist Gao Kegong. Gao was of Islamic ancestry from West Asia, and his father was a Confucian scholar. He achieved the position of minister in the Yuan Ministry of Justice. As a non-Chinese artist of high rank, Gao acted as a kind of bridge between Song and Yuan painting. His dedication to painting was likely reinforced by his acquaintance with the great Chinese artist Zhao Mengfu (1254–1322, see cat. 42) when Gao served in the regional government. He was said to have spent his entire life focusing on the study of the "Mi style," developed by Song artists Mi Fu (1051–1107) and Mi Youren (1086–1165), as well as the styles of other masters such as Li Cheng (916–67) and Dong Yuan (died 962).

This work captures the moment right after rain showers have fallen in the mountains. In the foreground, Gao depicts rivers running beneath a bridge and banks with a dense cluster of trees; behind the trees are conical peaks standing tall and upright; fog and clouds float between the foreground and mid-ground. The cord-shaped strokes that outline the hills and the uniformly arranged dots on the rocks were characteristic of the Mi style. Gao's deep attraction to the dense composition of earlier northern Chinese landscape traditions is evident in the arrangement of the elevated peaks here—so much so that he reproduced them in another version ten years later (also in the collection of the National Palace Museum).[1]

INSCRIPTION

An inscription at the top left by Li Kan (1245–1320), Yuan minister of personnel and a renowned bamboo painter, confirms that Gao created this work for him in the summer of 1299.

WRL WITH HL

1. NPM 1990–2010, vol. 4, p. 9

CAT. 35

元-明朝 任仁發署名 橫琴高士
圖軸 絹本設色

Playing the Zither (Qin) *by
Autumn Waters*

Signed by Ren Renfa (1254–1327)

Yuan dynasty or Ming dynasty (1271–1644)

Hanging scroll, ink and color on silk

H: 146.3 cm, W: 55.8 cm

Guhua 000256

Shown at the Asian Art Museum only

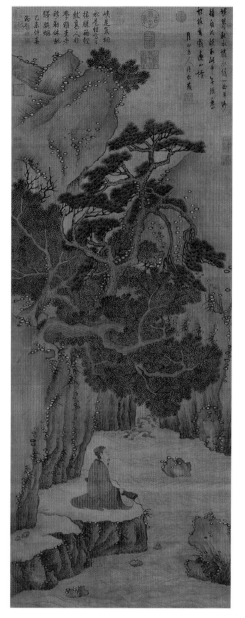

The *qin*, an ancient Chinese stringed instrument like a zither, was played at ritual ceremonies and for the entertainment of noblemen. The *qin*, poetry, painting, and the game go were regarded as the four pleasures of the literati in dynastic China. Song-era landscape paintings began to include figures with a *qin* singing of legendary sages from historical sagas. An early depiction on silk of a musician playing a *qin* was inscribed and signed by Emperor Huizong (reigned 1101–25).[1] Later artists embraced this theme as a way to protest the ravishing of Chinese culture by the Mongols during the Yuan dynasty, and many members of the elite produced compositions featuring a hermit playing a *qin* in the remote mountains (see cat. 38). This painting, then, is an expression of the literati's search for new values in the art of the past.

Born in Songjiang (now Jiangsu), Ren Renfa passed the local civic service examination in 1267 and entered the Pacification Office at the Yuan court. He spent much of his creative energy painting and practicing calligraphy. His works featuring horses earned him a reputation as one of the best horse-and-figure painters in Chinese art history, and he was studied and copied by later artists. However, the calligraphic style and the brushwork evident in the foliage and rocks here offer clues that this work might have been completed later, during the Ming dynasty.

Emperor Qianlong treasured this painting, and in 1775 he inscribed his own four-line poem and applied all eight of his seals to it—an honor reserved for his most favored works. Qianlong was attracted to the painting's "green gorges, and fluid water," which, he wrote, sounded to him "like strings." He also boasted that "a great man" did not try to imitate a Confucian gentleman by playing the *qin*, saying that it was simply one of his pastimes when "taking a break from horseback riding."

INSCRIPTIONS

Signed "Ren Renfa" at the top right. A four-line poem by Emperor Qianlong, "Playing the Zither (*Qin*) by Autumn Waters and Plucking the Cold Strings" is inscribed at the top left.

SEAL MARKS

Eight seals of Emperor Qianlong, including "Sacred elder son of heaven" (*Guxi tianzhi*); "Long life" (*Shou*); and "Treasures from the wise elder of eight portents" (*Bazheng maonian zhibao*). Seal of Emperor Jiaqing (reigned 1796–1820): "Treasure for the examination of his Majesty Jiaqing" (*Jiaqing yulan zhibao*). Seal of Emperor Xuantong (reigned 1908–11): "Treasure for the examination of his Majesty Xuantong" (*Xuantong yulan zhibao*).

WRL WITH HL

1. *Zhongguo shuhua quanji* 1999, vol. 2, p. 150. While the painting *Listening to the Zither* with Huizong's inscription has been traditionally identified as the emperor's work, some scholars have asserted the painting itself was most likely executed by a court painter.

元朝 柯九思繪 晚香高節軸
紙本水墨

Bamboo

By Ke Jiusi (1290–1343)

Yuan dynasty (1271–1368)

Hanging scroll, ink on paper

H: 126.3 cm, W: 75.2 cm, Guhua 000243

Shown at the Museum of Fine Arts, Houston, only

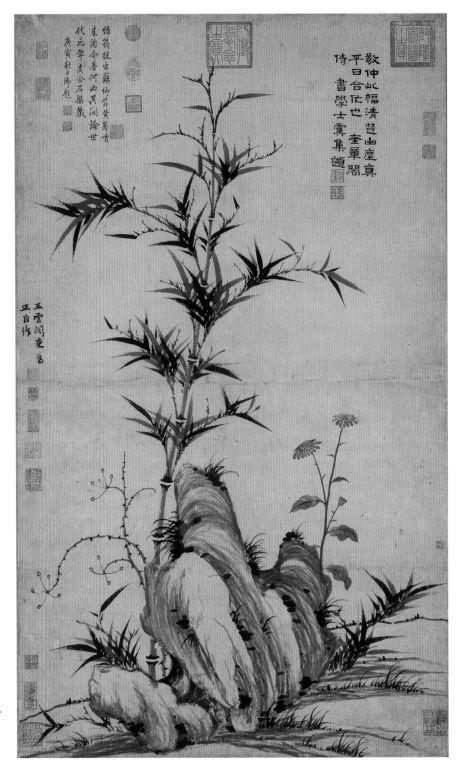

This scroll of bamboo set off by rocks and chrysanthemums illustrates the belief that everyday elements arranged in a disciplined manner can be significant and valuable as a celebration of the ordinary. Ke Jiusi, another admirer of Zhao Mengfu (see cat. 42), regarded bamboo painting as his most important activity. He understood that in sketching bamboo one "ought to execute the calligraphic method used in running script," which, he said, only the two old masters, Wen Tong (1019–79) and Su Shi (1037–1101), were "capable of rendering." Wen's maxim—"Before painting bamboo, I must first achieve the complete bamboo in my heart"—is considered the essential principle for painters of bamboo.

In depicting this bamboo-rock-flower combination, Ke utilized a variety of techniques and tonalities: calligraphy-like brushwork for bamboo stems, cord-like or pockmarked strokes dotting the rocks, delicate brush applications for the flower, dense ink dyes on the front and sides of the leaves, and washes for the back surfaces. The finished bamboo, which looks simple but was technically very complicated, won high praise for Ke Jiusi, who was considered one of the best Yuan bamboo painters.

Ke Jiusi's inscription dedicates the painting to his friend Zhengchen (Qing Tong, died 1368) from Gaochang (now Xinjiang), whose family's accomplishments had been acknowledged by Emperor Renzong. The friendship between Zhengchen and Ke testifies to the popularity of gatherings where intellectuals could enjoy mutual interests in classical antiquity and connoisseurship.

Ke Jiusi was from Taizhou, Zhejiang province, and was recommended to a Mongol noble, remaining loyal to him until Emperor Wenzong ascended the throne. Ke was appointed to the post of doctor, a position of the fifth rank, and was put in charge of reviewing painting and calligraphy at the Hall of Literature (*Kuizhang ge*). Three years later, he was dismissed. Following Wenzong's death, Ke lost hope of resuming his career and went to the Wu region in the southeast, practicing Daoism in his final years.

INSCRIPTION

"For Zhengchen, painted by the Gentleman from Five Cloud Studio."

WMH WITH QN, HL

元朝 王蒙繪 東山草堂圖軸
紙本水墨設色

Thatched House on the East Mountain, 1343

By Wang Meng (1308–85)
Yuan dynasty (1271–1368)
Hanging scroll, ink and light color on paper
H: 111.8 cm, W: 61 cm, Guhua 000287

Shown at the Asian Art Museum only

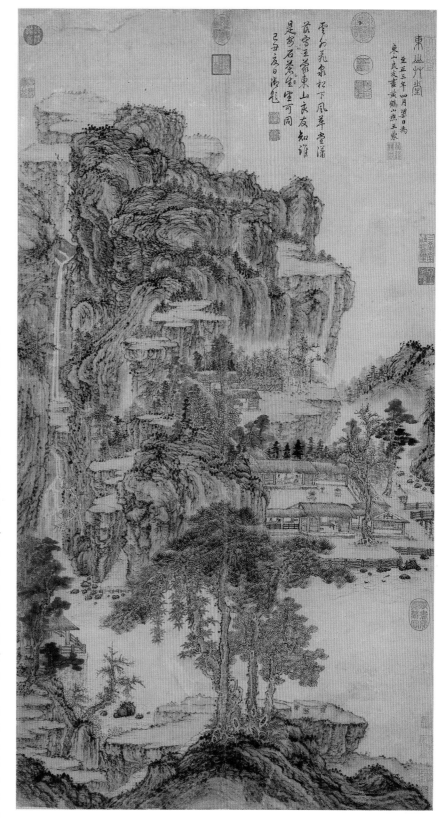

This panoramic mountain view combines real and fictional characters to create a narrative concerning an elite social gathering in remote mountains, a subject that dominated one aspect of Yuan painting. Presenting a complex web of anecdotes and interweaving plots, the artist employed the natural structure of the landscape to frame this settlement of elite recluses. Three scholars sit on the floor of a thatched cottage situated between a river and a towering mountain, while two servant boys run along the corridor as if serving tea and wine. This work ironically reflects the artist's own experience of living in seclusion on Mount Yellow Crane during a period of turmoil at the end of the Yuan dynasty and the beginning of the Ming dynasty. Somberly and expressively executed, it reflects a time of unrest and conveys a pessimistic attitude toward society.

A grandson of the artist Zhao Mengfu (see cat. 42), Wang Meng is recognized as a representative of the Zhao family style. He studied the work of famous classical masters Dong Yuan and Ju Ran (active late tenth century) yet developed his own signature techniques using a mass of short, quick, and curly brushstrokes to create compositions that lack the deep, heavy layers seen in classical landscapes. Wang Meng's approach inspired seventeenth-century painters to explore a so-called coiling dragon, or zigzag, composition to convey flowing movement.

A native of Huzhou, Zhejiang province, Wang Meng was driven to succeed and entered into civil service at the Yuan court. His career as an official was short, however, and he retreated to the Yellow Mountains to seek respite from the pressures of court. At the beginning of the Ming dynasty he was made an overseer of the Tai'an region. His subsequent involvement in a political case landed him in jail, where he spent the rest of his life.

INSCRIPTION

"Thatched house on the East Mountain, for a good friend from the East Mountain, Wang Meng—yellow crane woodman [*Huanghe shanqiao*], the fourth month of the third year *zhizheng* [1343]."
YJL WITH QN, HL

元朝 朱德潤繪 林下鳴琴軸
絹本水墨

Playing a Zither (Qin) *beneath the Trees*

By Zhu Derun (1294–1365)

Yuan dynasty (1271–1368)

Hanging scroll, ink on silk

H: 120.8 cm, W: 58 cm, Guhua 000247

Shown at the Museum of Fine Arts, Houston, only

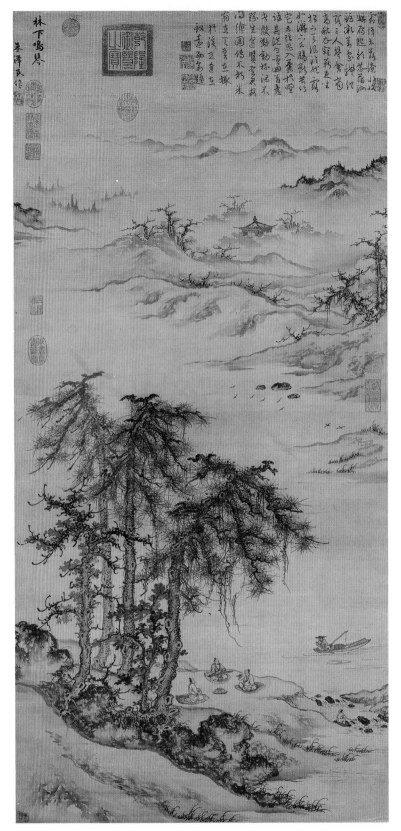

Certain Mongol patrons during the Yuan period increasingly began to appreciate the value of supporting classical painting among the literati. Many Yuan artists created works in response to the classical landscapes of Li Cheng and Guo Xi (active approx. 1050–1100) in ways that demonstrated the role of realism in the depiction of nature. One such artist, Zhu Derun, possessed the ability to transmit moral values through his creations, stressing the importance of Confucianism by incorporating human figures into his rendering of nature. That concept is addressed in this painting of an elite gathering enlivened by the beauty and serenity of the landscape.

Here, a scholar dressed in a long robe sits in the shade of pine trees by a river, playing the zither as he engages in conversation with two friends. A young servant carries water from the river to make tea. A fisherman paddles by on a raft. Across the river, far in the distance, ancient temples emerge from clouds and heavy mist. Zhu's composition is the most literal example of how he borrowed the treatment of space in the work of Li Cheng and Guo Xi for his own use. However, his delicate portrayal of figures, fluid brushwork in vines and rocks, and quick sweeps of the brush to render vegetation in the distance all display the sophisticated skills he used to inject his personality into the composition.

Zhu Derun was born into a prominent family, and his ancestor, Zhu Guan (961–1049) was known as one of "the five venerable scholars of Suiyang" in Henan province. His forebears sought refuge from war in the Wu region in the southeast. In 1319 Zhu received a summons from Emperor Renzong through Lord Shen, the emperor's son-in-law. The emperor honored Zhu with a position as a compiler of national history in the Hanlin Academy. Years later, when Zhu was summoned to court, he presented Emperor Yingzong with paintings inspired by snow.

INSCRIPTION

"Playing the zither beneath trees, painted by Zhu Zeming" (the artist's sobriquet).

WMH WITH QN, HL

CAT. 39

元朝 元人畫 麻姑獻壽 軸
絹本設色

Goddess Magu

Yuan dynasty (1271–1368)
Hanging scroll, ink and colors on silk
H: 150.9 cm, W: 86 cm, Guhua 002064

Shown at the Asian Art Museum only

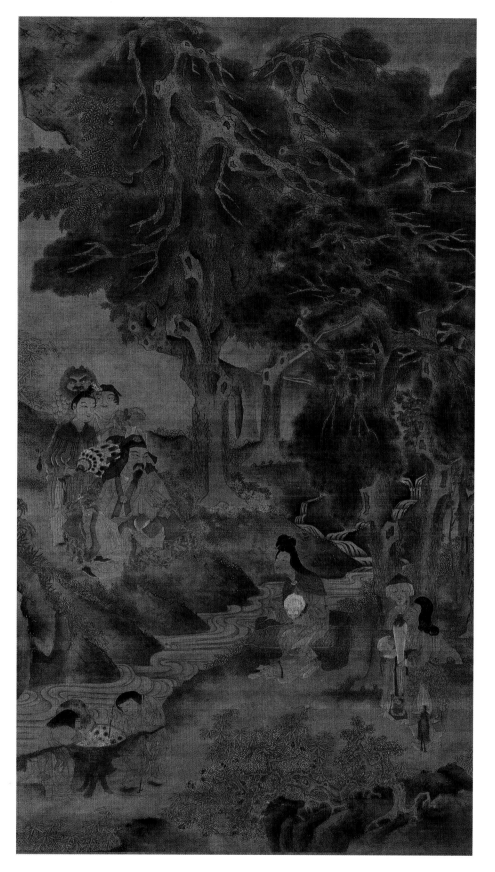

Magu (Hemp Maiden), the Taoist Goddess of Longevity, was one of the most popular images in Chinese art from the 1400s through the early 1900s. Her distinctive attributes and magical power were believed to bring prosperity, long life, and luck to a family. There are many versions of the life of Magu. She was known for making wine that conferred immortality on those who drank it. This wine was her gift to the Queen Mother of the West at her birthday banquet, which all the immortals were invited to attend. "Magu offering longevity" thus became a popular theme for celebrating a woman's birthday.

Magu's association with longevity was first introduced by Ge Hong (283–343) in his *Anthology of Immortals (Baopuzi)*, where she is described as a beautiful young girl with magical abilities. She is regarded as the female adept who knew Inner Alchemy, the meditative practice that was designed to aid the individual in achieving immortality and spiritual completeness. In art, Magu is always depicted in skirts and shawls made of leaves and grass, presenting fruits, plants, and gourds containing magic elixirs believed to confer health and longevity on the recipient.

This painting depicts the immortals Wang Yuan and Magu sitting opposite each other across a stream in a pine forest and accompanied by their attendants. The figures, trees, and flowers are painted in a mannerist fashion, with decorative wave patterns and line work in the drapery resembling fine wires. Although the painting has been attributed to an artist of the Yuan dynasty, its decorative effects more closely resemble the style of a slightly later period.

YLT WITH TB

CAT. 40.1

CAT. 40.2

CAT. 40.3

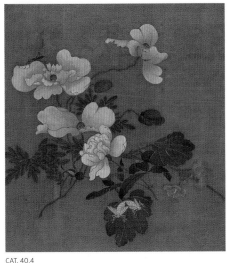

CAT. 40.4

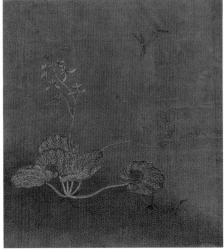

CAT. 40.5

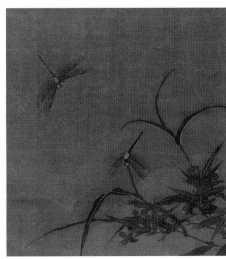

CAT. 40.6

CAT. 40

元－明朝（傳）王淵繪 花卉草蟲
集錦冊 絹本設色

Flowers and insects

Attributed to Wang Yuan (active 1280–after 1349)
Yuan dynasty or Ming dynasty (1271–1644)
Album leaves, set of twelve pages, ink and
colors on silk
H: 25.9 cm, W: 23.6 cm
Guhua 001101

From the tenth century onward, the realistic style developed by Huang Quan (approx. 903–65) dominated Chinese paintings of flowers and birds. By the fourteenth century Wang Yuan had found a coherent way of meticulously painting these subjects, a development that became a key influence on progressive artists in following centuries. This set of twelve paintings is so rich in detail and full of floral varieties that we can only conclude that the artist must have had a deep knowledge of and love for the botanical world. Here he has painted narcissus, flowering peach, poppy, hollyhock, saxifrage, commelina, morning glory, bamboo, raspberry, Chinese parasol tree, chrysanthemum, hibiscus, willow, dianthus (China pink), and more; insects include butterflies, moths, bees, crickets, dragonflies, snails, cicadas, praying mantis, and katydids.

Most of the paintings in the album are close-up views, as if looking through a magnifying glass. Two outstanding examples are the first and third leaves. The first is an intimate view of the corner of a garden where narcissus flowers grow in a grassy area beside a fantastic garden rock with a butterfly fluttering in the air above. The third leaf captures the poetic mood of fallen flower petals. Most works here are executed with double outlines that are filled in with color, one of the fundamental techniques for Chinese bird-and-flower paintings. It is supplemented with line drawing and the "boneless" (*mogu*) method of painting, which dispenses with outlines. All these techniques reflect the artist's careful attention to detail.

Wang Yuan studied the ancient masters yet was not inhibited by tradition in achieving his personal style. Historical

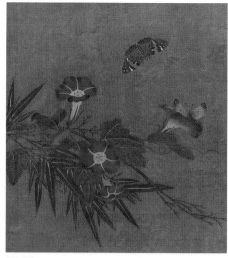

CAT. 40.7

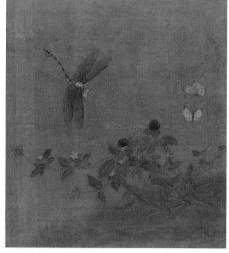

CAT. 40.8

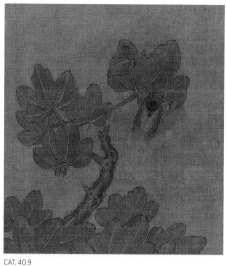

CAT. 40.9

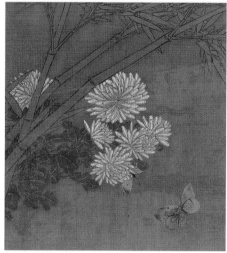

CAT. 40.10

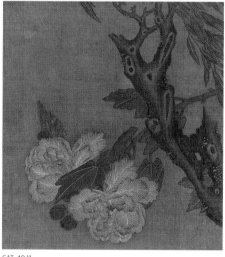

CAT. 40.11

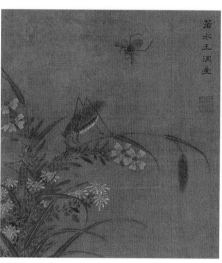

CAT. 40.12

sources state that he modeled his bird-and-flower paintings on the precise, meticulous works of Huang Quan, yet Wang Yuan's brushwork reflects the more relaxed spirit of the Yuan dynasty literati. Moreover, he chose for his subjects simple, archaic forms intended to revive the spirit of the past. While the present album has the unpretentious quality of Wang Yuan's work, its flatter painting is closer to Ming dynasty styles.

YLT WITH SKN

南宋末−元初 錢舜選書 七言律詩
紙本楷書

Eight line poem in standard script,
approx. 1260–1320

By Qian Shunxuan (active late 13th–early
14th century)
Southern Song dynasty or Yuan dynasty
(1127–1368)
Album leaves, ink on paper
H: 29.8 cm, W: 48.5 cm
Gushu 999340-15

Shown at the Asian Art Museum only

The only known surviving calligraphic
work by Qian Shunxuan, this eight-line
poem was written to celebrate the new-
born son of the family of the Haozhai
residence. Qian wished the baby boy a
magnificent future: "Soon he will achieve
mastery of poetry and calligraphy, flowing
with speed rivaling the horse; in time his
goals will be achieved, with glory as great
as the noble *qilin* [unicorn]." The eloquent
expression of high expectations for boys
was popular in the social intercourse
among mandarins of the time.

Qian Shunxuan, a native of Wu (now
Suzhou), was a mentor to and instructor
of the prominent scholars Chen Shichong
(1245–1308) and his son Yuzi, who were
known as the Two Chens of Linchuan
(now Jiangxi). The formal style (in regu-
lar script) and well-organized execution
of this work combine to convey care and
reverence and achieved Qian's goal of
fashioning a dignified expression through
a symmetrical presentation. The neatly
arranged formation of the characters hints
at the origin of this classical tradition,
which was developed by the Tang writer
Ouyang Xun (557–641).

The poem was written on distinctive
decorative paper that is bordered with
interlacing floral scrolls and features
squares to frame the characters. This grid-
ded format is extremely rare, making it an
important example for the study of Song
and Yuan letters, most of which would
have been written on paper with vertical
lines only.

INSCRIPTION

"Borrowing the great verse of Jinzhai for a
celebration of Haozhai's precious newborn
boy. Respectfully, Chuntang, Mansou Qian
Shunxuan."

YCH WITH HL

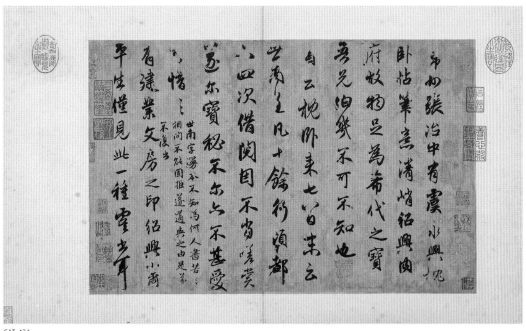

CAT. 42.1

CAT. 42.2

CAT. 42

元朝 趙孟頫、鮮于樞書
墨蹟合冊 紙本

Calligraphic works

By Zhao Mengfu (1254–1322) and
Xianyu Shu (1246–1302)
Yuan dynasty (1271–1368)
Album leaves, eight pages, ink on paper
Various dimensions
Gushu 000252-0

These eight album leaves showcase calligraphic works that are considered among the best the art has to offer. They offer a rich combination of transcendence and practical commentary. Assembled together in one set are four individual works by two Yuan-period artists (42.1–42.4) along with commentary by six scholars of the Ming dynasty (42.5–42.8).

Zhao Mengfu was born in Huzhou (now Jiaxing), Zhejiang province. An eleventh-generation descendant of Taizu, founding emperor of the Song dynasty (reigned 960–76), Zhao started to shine as a learned and versatile youth. He served

as a first-rank court official through five generations of Mongol emperors. His works of literature, art criticism, painting, and calligraphy qualify him as one of the most important figures in Chinese art history. Xianyu Shu, a native of Yuyang (now northern Beijing), was a renowned poet, calligrapher, and discerning collector. Yu Ji (1272–1348), a member of the Yuan elite, asserted that Zhao, Xianyu, and Deng Wenyuan (1258–1328) dominated calligraphy at that time.

The first work in the album from Zhao Mengfu conveys to Xianyu Shu exciting news on his gaining access to calligraphic

CAT. 42.3

CAT. 42.4

CAT. 42.5

work by Yu Shinan (558–638) in Dadu (42.1). In the second, Zhao records the biography of a member of the Tang elite, Pei Xingjian (619–82) (42.2). These two works reveal a calligraphic style that is graceful yet dynamic, using different parts of the brush to configure various sharp, steep, and subtle strokes. The third letter, from Zhao to a friend in the south, was a survey of artworks Zhao had gained access to in 1288 when he began serving at court (42.3). This work, bearing characteristics reminiscent of the presentations by classical masters of the fourth century, reflects Zhao's early style, which he developed when he was in his mid-thirties.

The fourth work, written in running script by Xianyu Shu, summarizes his knowledge of old masters of the Tang (618–907) and Song (960–1279) periods and how the cursive script, in particular, was reinforced aesthetically through different religious practices (42.4). As was his tendency, Xianyu allowed the ink application to remain evenly, solidly visible around each character, leaving subtle spaces between strokes to give a sense of flow and consistent movement. The brilliant handwriting Xianyu mastered over thirty years remains utterly original, and these refined technical skills make him one of most creative calligraphers in the history of the art.

JZC WITH QN, HL

CAT. 42.6

CAT. 42.7

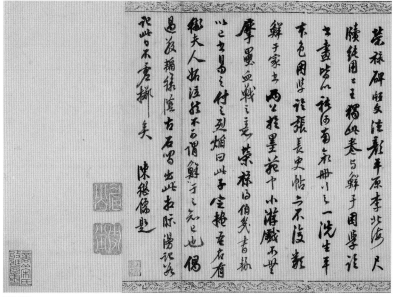

CAT. 42.8

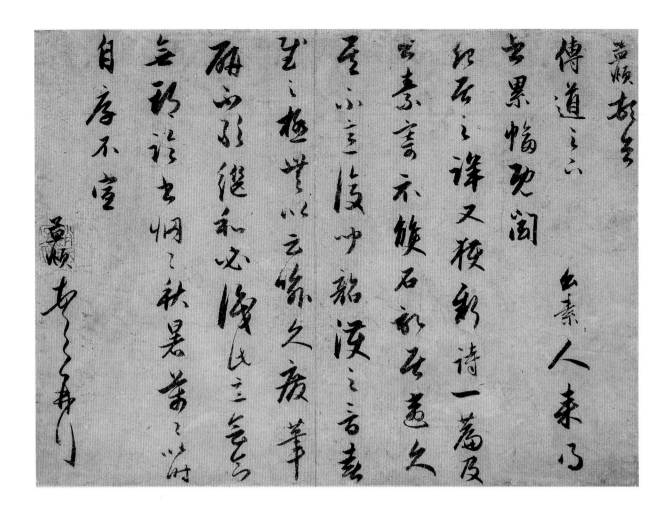

CAT. 43

元朝 趙孟頫署名書 致傳道
尺牘 紙本

Letter to Chuan Dao in running script

Signed Zhao Mengfu (1254–1322)

Yuan dynasty (1271–1368)

Album leaves, ink on paper

H: 25 cm, W: 34.3 cm

Gushu 000251-3

Shown at the Museum of Fine Arts, Houston, only

Zhao Mengfu's art has enjoyed long-lasting fame. He enriched the highly disciplined structure of calligraphy with his unique gracefulness, contrasting stern execution with fluid movement. His style developed through the years, and his works were highly prized acquisitions, especially for those emperors who practiced calligraphy seriously.

This work was recorded in the imperial collection and has been published as Zhao Mengfu's calligraphy. Since correspondence between members of the elite in dynastic periods was routine, and since this letter, which is neither extraordinary nor dramatic, contains some characters similar to those of Zhao's writings, the claim that this letter was written by Zhao has seemed convincing. However, a recent discovery revealed a crucial detail: the letter's recipient, Chuan Dao, was the sobriquet of two Yuan people, neither of whom was Zhao's contemporary but of a later generation.[1]

This calls attention to a common occurrence in private collections, where a copy that has been signed with the artist's name is regarded as authentic. In fact,

it is quite common in all cultures of the world to copy the works of masters, either to continue a great legacy, master one's skill by tracing an original, or profit from selling replicas. The Chinese probably had the longest tradition of this practice, and Zhao Mengfu's works have been some of the most studied and copied throughout history. A Ming author, Deng Fu (active mid-sixteenth century), pointed out that most of the so-called works by Master Zhao in the Jiangnan region were copies, probably made by the more than 400 persons known to specialize in copying his work. Still, the copying did not seem to be a serious matter for the collector-emperors. Many pieces from the original imperial collection have been reidentified and redated after modern research, marking a new era in the revival of classicism.

INSCRIPTION

"Mengfu."

JZC WITH QN, HL

1. The two persons who shared the sobriquet Chuan Dao were Zeng Guan (active 1340–60) and Luo Xuanming (active approx. 1450–1500).

CAT. 44

元代 歐陽玄 行楷書 唐僧釋皎然
五言詩 紙本

Ancient-style verse in semistandard scripts

By Ouyang Xuan (1273–1375)
Yuan dynasty (1271–1368)
Album leaf, ink on paper
H: 25.1 cm, W: 35.3 cm
Gushu 000251-4

Shown at the Museum of Fine Arts, Houston, only

This calligraphic work presents a composition by the Tang dynasty monk Jiao Ran (approx. 720–98) concerning his visit with an alchemist on the western peak of Mount Tianmu.[1] This ancient-style verse is composed of twelve lines, each containing five words. To achieve a dignified classical form that matched the rhythmic formality of words, Ouyang used both regular and some semirunning scripts. His writing shows solid skill in the calligraphic style of Su Shi, yet demonstrates his own aesthetic, seen in his brushwork and the shaping of the characters. The work was originally written on a larger piece of paper that has unfortunately been trimmed on all sides. Nonetheless, the writing maintains a perfect balance in the spacing of characters and lines.

Ouyang Xuan was originally from Luling, Jiangxi province, and spent most of his life in Liuyang, Hunan province, where he witnessed one of the most momentous political and social upheavals in Chinese history. Brilliant, erudite, intellectual, and wise, he was a free spirit who ignored the civil service examination—though he eventually earned the metropolitan graduate (*jinshi*) degree in 1315 and was granted the title of "Academician" by the court in 1339. His writing focused on poetry, philosophy, and calligraphy. His choice here of a Tang monk's composition reflects a phenomenon among the literati of his time, who sought inspiration from the products of the Tang and Song cultures.

INSCRIPTION AND SEAL MARKS

"Written by Ouyang Xuan" (*Ouyang Xuan shu*), with "Xuan" missing a stroke. Three Qing imperial seals: "Appreciation of Qianlong" (*Qianlong jianshang*), "For thorough appreciation of the Three-Rarity Court" (*Sanxitang jingjianxi*), and "Blessed posterity" (*Yizisun*). Three collectors seals, including a seal of Qiu Yuan (1247–1326): "The collection of the family from Nanyang" (*Nanyang jiacang*).

JZC WITH HMS

1. Gao Bing (1402–23) 1983–86, chap. 23, p. 327.

CAT. 45

元朝 江西景德鎮 鑲銀扣藍釉描金
把杯、盤

Cup and saucer with gilt decorations

Jingdezhen, Jiangxi province
Yuan dynasty (1271–1368)
Porcelain with cobalt-blue glaze and gilt decoration
Cup H: 3.4 cm, Diam: mouth 8.5 cm, L: 10 cm
Guci 017371 Tian-1146-1
Saucer H: 0.8 cm, Diam: mouth 15.5 cm
Guci 017370 Tian-1146

This wine cup and saucer set was among the most important porcelain items of the Yuan period, as blue monochrome sets were exceptionally rare. The intense cobalt blue testifies to the unique aesthetic of the Mongolian rulers.

During the Tang dynasty (618–907), cobalt blue had been used to decorate ceramic goods for export. As trade lagged during the Song period, the use of cobalt blue decreased noticeably. In the fourteenth century, however, the success of the Mongols' territorial expansion opened access to the Islamic world, and Islamic art—in which cobalt was a key element—had a profound influence on Chinese porcelain and metal cloisonné ware made for Mongol nobles and their Islamic allies. The porcelain center in Jingdezhen mastered the use of cobalt for monochrome glaze and underglaze decoration and developed a new decorative scheme that involved applying gold over the blue. The practice of gilding white glaze first emerged in Tang ceramics and was extended to monochrome glazes during the Song dynasty. Reflecting a new trend under Mongol rule, Yuan porcelain favored the blue-and-gold scheme, appearing mostly on dishes, bowls, and ritual vessel forms—as can be seen in archaeological finds from Yuan burials.[1]

Cups in this shape, modeled on the ancient bronze *yi* vessel, were also made in silver and in ceramics with monochrome glazes. Both the cup and the saucer in this set were embellished with gold motifs, though most of it has fallen away. The gold residue reveals traces of a dragon playing with a pearl at the inner bottom of the saucer, a diamond design encircling the inner rim of the cup, twelve floral roundels at the bottom, and plum branches around the exterior. The plum blossom, a symbol of faith and self-esteem, was a significant subject in Yuan art.

PCY WITH HL

1. *Wenwu* 1965.2, p. 18, pl. 2; 1989.11, p. 25, pl. 6.

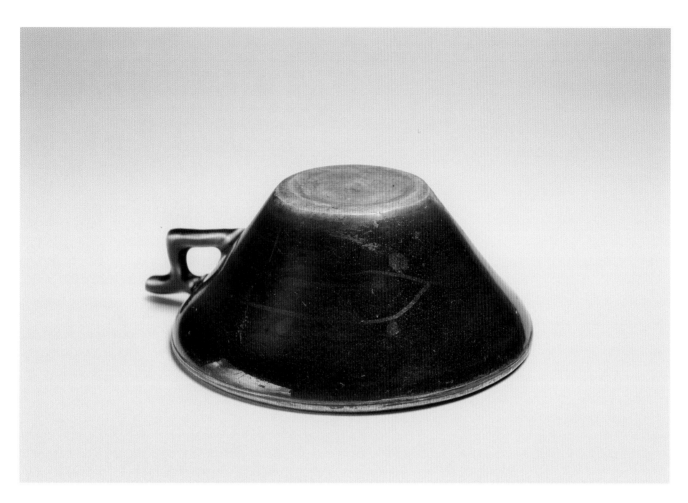

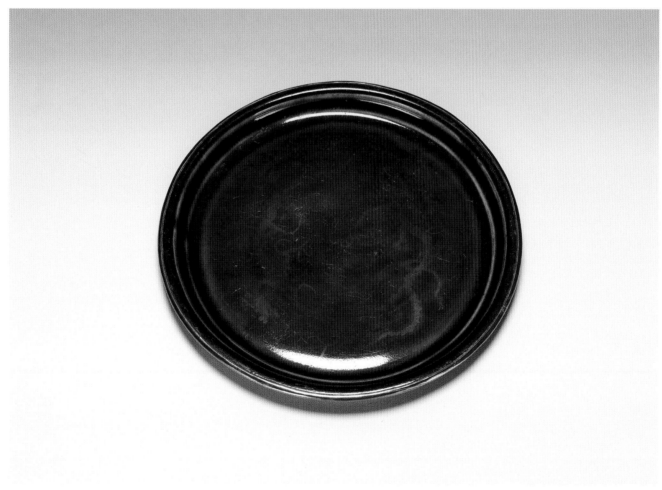

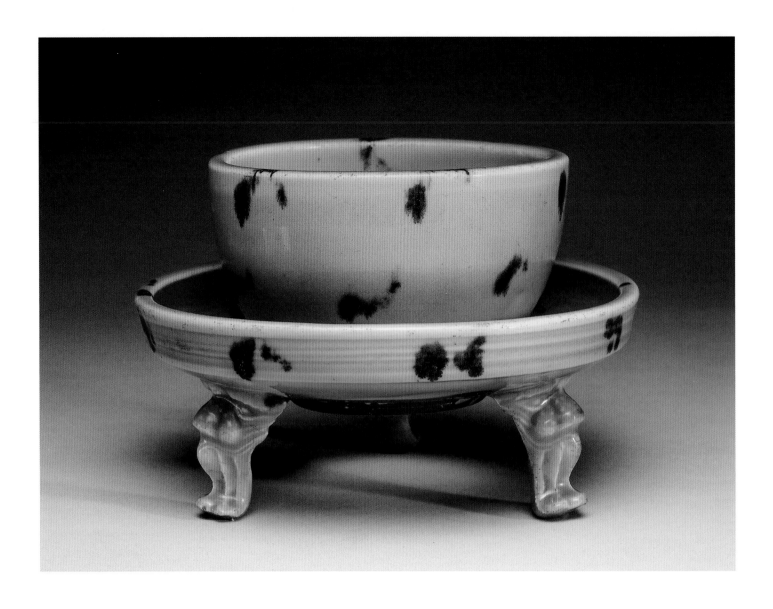

CAT. 46

元—明 浙江龍泉窯
青瓷赭斑三足盞

High-footed bowl

Longquan, Zhejiang province
Yuan dynasty (1271–1368)
High-fired ceramic with green glaze and dark
brown mottle
H: 16.6 cm, Diam: mouth 17 cm, tray 24 cm
Guci 017829 Que-501-20

During the Northern and Southern dynasties, it was common practice to add wood bases to flowerpots, censers, wine jars, and other daily utensils to heighten, stabilize, and beautify them. From the Song dynasty on, usage of ceramic trays became even more prevalent, and utensils and trays were custom-made as two-piece sets. Archaeological finds have also unearthed, however, "sets" that were fused together into a single piece. During the Six dynasties period, the Zhejiang Yue kiln often added reddish-brown spots to their celadon ware, a style of ornamentation that continued in the Zhejiang Longquan kiln throughout the Song and Yuan dynasties. A representative example of Longquan ware, this piece has a broad-mouthed bowl that rests upon a tray with three animal-shaped legs carved in relief. The tray has a small wall with a curved lip, and the thin celadon glaze has a slight yellow tint that also reveals the white roughcast underneath. It is decorated with reddish-brown spots. The form of this piece served a variety of purposes and its design may have been used for separating or protecting items in the top container. The bowl, for example, could be used to hold food, while the tray could hold water. The close proximity of water to the bowl would serve as a trap for any insects that would contaminate the food.

YSC WITH JC

CAT. 47

金-元朝 玉 仕女焚香
"秋山"圖紋飾件

Ornament in the form of the "autumn mountains"

Jin dynasty or Yuan dynasty (1115–1368)
Nephrite
H: 9.7 cm, L: 8.5 cm, W: 2.7 cm
Guyu 002826 Xiang-99-8

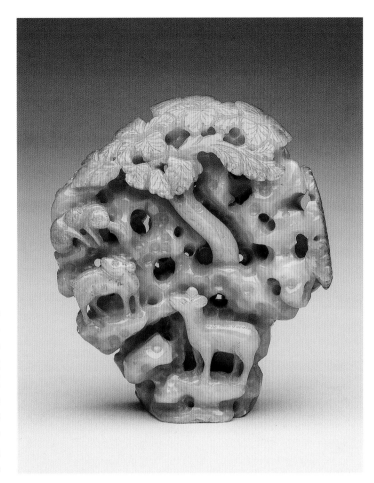

This ornament of greenish white nephrite shows yellowish impurities, suggesting the stone was collected from a river and marking it as an example of so-called water jade. The artisan skillfully carved multilayered openwork designs in relief on both sides of the object. One side features two deer standing in the woods and a pair of playful monkeys peeking down from a tree branch. Both of the deer seem to be on the alert, looking in the same direction, suggesting a potential crisis—perhaps an advancing hunter. This theme is closely related to the nomadic tribes' customary autumn hunt in the mountains.

On the opposite side is another autumn scene, one depicting human figures. Under a pine tree, a seated lady, accompanied by a crane and a turtle, reads a handscroll next to an incense burner and *lingzhi*, the "mushrooms of immortality." An immortal deity holding a tray of fruits descends on the swirls of a cloud, as if offering magic fruit as a reward for the woman. The depiction of mushrooms combined with pine trees, cranes, and turtles—all of which enable a believer to see the numinous world—is common in Daoism. With two themes on one ornament, this exquisite piece reflects the cultural interactions and integrations during the twelfth and thirteenth centuries in China.

LTC WITH TLJ

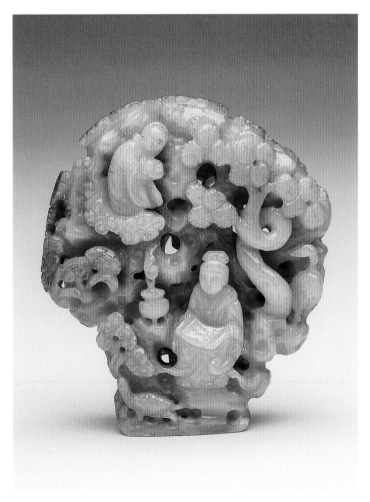

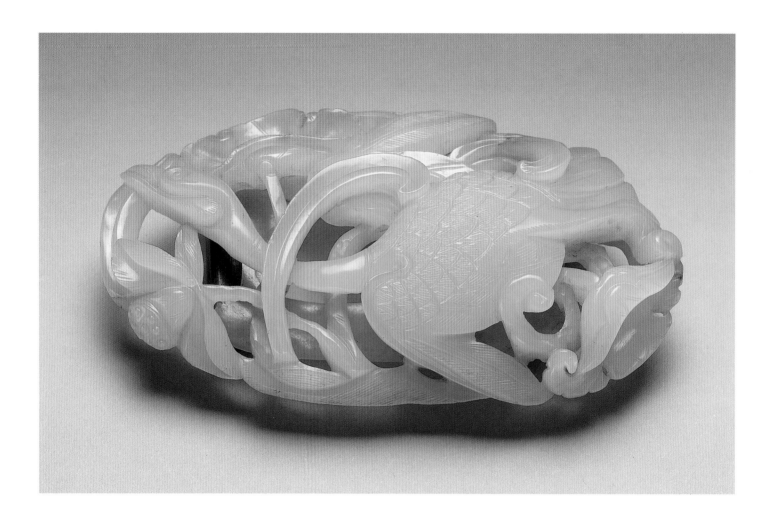

CAT. 48

元朝 青白玉 大雁紋腰帶佩飾

Belt ornament with wild geese motif

Yuan dynasty (1271–1368)
Nephrite
L: 11.2 cm, W: 6.2 cm
Guyu 003076 Jin-1544-205

This exquisite belt ornament was made of pure white nephrite. Carved in multi-layered openwork, the design shows a swan swimming in a lotus pond. This subject reflects the lifestyle of the Qidan (Khitan), Mongol, and Jurchen nomads, who were based in China's north and northeast. According to *A History of the Liao Dynasty* (*Liaoshi*), each spring the emperor led his officials on a hunt (with eagles) of swans and geese along the riverbank. In 918 Taizu (872–926), the founding emperor of the Liao dynasty, sacrificed a swan in a ceremony worshiping the sacred mountains.[1] Scenes of "the eagle catching a swan" were common in jades, ceramics, and textiles during the Liao and Jin dynasties (907–1234). Fabric with the eagle-catching-a-swan design was reserved for the "spring water uniform" (*chunshui fu*)[2] in the Jin system of court attire, and it continued to be popular in the Yuan dynasty.

No eagle appears in this piece, perhaps reflecting a decline in the use of such nomadic themes by certain artisans. The openwork around the swan's head is an eyelet opening that has become indented over time, suggesting a hook was once attached to it. The center of the rear is worked with a rectangular frame carved with a cloud motif in a form of the *ruyi* mushroom head; a bronze buckle is affixed on both sides for use with a belt hook. The style of this ornament is similar to that of several jade buckles from the Yuan period found in a tomb in Wuxi, Jiangsu province.[3]

LTC WITH TLJ

1. Tuo Tuo (1344) 1969, vol. 7, chap. 1, p. 5739.
2. Ibid., chap. 43, p. 5944.
3. Gu Fang 2005, vol. 7, p. 187.

CAT. 49

元－明朝初期 青玉 龍紋帶版
(附清代木座)

Jade belt plaque with dragon design, approx. 1300–1400

Yuan dynasty or Ming dynasty (1271–1644)
Nephrite, with wood stand made in the
Qing dynasty (1644–1911)
H: 13.6 cm, W: 8.9 cm
Guza 000002 Jin-246-63

Made of a pure white nephrite, this belt plaque features a flying dragon with five claws in the mist of clouds surrounded by a radiating flower motif with an interlaced grass background. The four corners are decorated with blossoming flowers in profile. The style of the dragon and the configuration of the design are similar to a jade belt excavated from the Ming-period Wang Xingzu tomb in Nanjing,[1] suggesting it was likely made during the late Yuan or early Ming dynasty.

This elaborately decorated belt plaque was a prize in the collection of Emperor Qianlong. Although jade making boomed under Qianlong's patronage, there was a shortage of high-quality raw materials at the time. As a result, the Qing Imperial Workshop often added embellishments to ancient jade objects to give them a fresh look. The addition of an elaborately designed wooden stand completed in the Qing period made this belt plaque one of the emperor's favorite antiques.

LTC WITH TLJ

1. *Kaogu* 1972.4, pp. 31–33; He and Knight 2008, pl. 1.

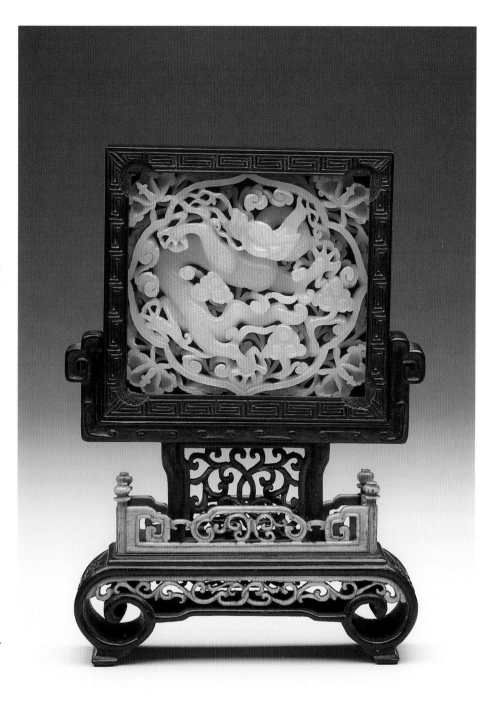

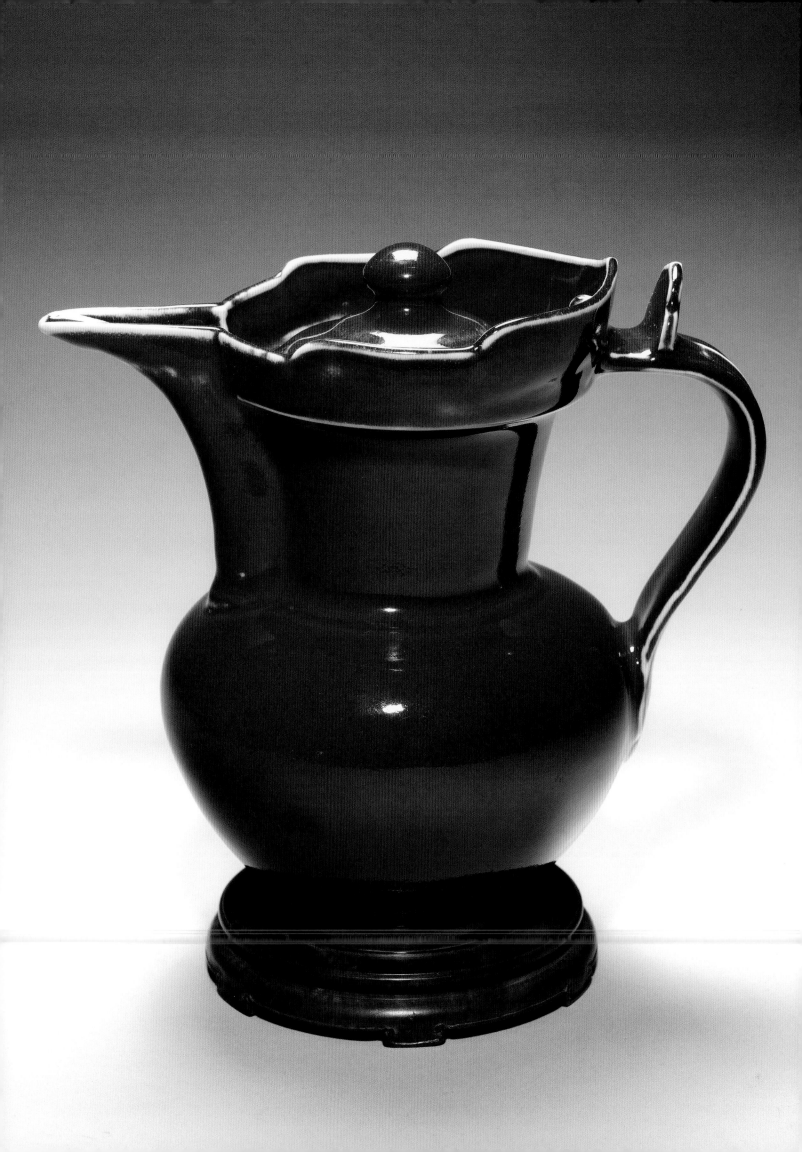

HE LI

Ming Dynasty (1368–1644): Rulers Restore a Bright (*Ming*) Culture

In 1368 the Han Chinese reclaimed their country from the Mongols and established the Ming dynasty. Ming founder Zhu Yuanzhang took the imperial title of Hongwu and reigned until 1398. Hoping to regain the esteem of the Han majority in the heartland, the early Ming rulers sought to restore a "bright" (*Ming*) culture that integrated classicism, Confucianism, Daoism, and Tibetan Buddhism.

Zhu Di, Prince of Yan, was the fourth son of Emperor Hongwu. In 1402 he usurped the throne from his nephew, Emperor Jianwen (reigned 1399–1402), in the Ming capital of Nanjing by brutally striking down the members of court who opposed him. He began his reign under the title Yongle, meaning "Perpetual Happiness," and reigned from 1403 to 1424 (see fig. 1). Yongle built a new capital in what is now Beijing (then called Yan), creating an enormous complex surrounding his grand palace. Known as the Forbidden City (built 1406–20), this is the largest royal development in the world and was home to offices for administration and cultural affairs. Although Yongle wished to establish a great empire and sent military campaigns to the frontiers of China,[1] the Ming never controlled territories on the scale of the vast Yuan empire.

In his quest to realize his vision of the Ming as a great nation with a strong presence in trade, Yongle reinstated the Maritime Trade Supervisorate (*shibosi*), which had been shut down in 1370 due to uncontrolled piracy,[2] to regulate trade along the seacoasts. He sent eunuchs and official envoys to other parts of Asia to maintain diplomatic relationships with other countries.[3] From 1405 to 1422, Yongle dispatched the Muslim eunuch Zheng He (1371–1433/35) to lead his fleet on six oceanic expeditions that reached more than thirty countries and kingdoms from Southeast Asia to the Persian Gulf, even to the coastal fringes of East Africa.[4]

Following Hongwu's lead in restoring Han Chinese culture, the Ming court adopted Neo-Confucianism, which had been developed by the Song official and philosopher Zhu Xi (1130–1200; see cat. 14). The publication of major works such as the *Great Canon of the Yongle Era* (*Yongle dadian*; 1407), *Four Books and Five Classics of Confucianism* (*Sishu Wujing*; completed 492–79 BCE), and *The Great Compilation on Nature and Principles* (*Lixing daquan*; 1414), a compendium of neo-Confucianism, typify the revitalization of Chinese culture under Yongle. He designated Confucian learning as the foundation of the Chinese civil-service system. This system, based on education and a rigorous examination system, recruited bureaucrats for their intellectual merit rather than heredity. In 1404 Yongle, inspired by Neo-Confucian thinkers such as Zhu Xi, staffed the Hanlin Academy with about sixty scholar-officials to prepare for the examinations and to compile state documents on history, literature, and art.

Ewer in the shape of a monk's cap with poem by Emperor Qianlong carved on the bottom, Ming dynasty (1368–1644), reign of Emperor Xuande (1426–35), cat. 70.

Yongle welcomed Daoism, Tibetan Buddhism, and other faiths. Upon his ascension to the throne he honored the Daoist priest Yao Guangxiao (1335–1418) as "number-one hero": Yao had helped legitimize Yongle as emperor by prophesizing that a military coup d'état was the will of Zhenwu, a Daoist deity known as the Perfect Warrior.[5] Yongle's personal devotion assured the vigorous spread and popularity of the Zhenwu cult across the country.[6] In 1403, 1406, 1408, and 1409 Yongle invited Tibetan Buddhist lamas from Yunnan and Tibet to Nanjing to promote their faith. He granted them hierarchical titles with authoritative seals and bestowed upon them gilt Buddhist statues and porcelain ritual wares.[7]

Yongle was well educated in Chinese culture by his father, Hongwu, who favored the Song painter Li Gonglin (1049–1106) and arranged a study hall, library, and learned tutors for his children—going so far as to assign pieces of calligraphy from the Song-period *Model Calligraphies from the Imperial Archive* (*Chunhua getie*) for them to trace. Ming imperial records and individual narratives all attest to Yongle's keenness for literature and calligraphy. According to one Ming writer, Yongle displayed his knowledge of the principles of writing as early as the age of eight. For practice Yongle wrote 100 characters daily, except in the winter, during ritual occasions, and on holidays. Yongle recognized mandarins who excelled as poets and artists, especially the Shen brothers: Shen Du (1357–1434 ; see cat. 52) and Shen Can (1379–1453; see cat. 54), whose well-structured and balanced calligraphy, later known as the "bureaucratic" or "cabinet" (*taige ti*) style, was influential in the Ming court.

Unlike his father, who used eunuchs only to manage his family's daily life within the inner palace and restricted them from participating in public affairs, Yongle relied heavily on them. He gave them unprecedented authority in diplomatic, financial, and military missions, only to learn that over time they had tainted all of these areas with corruption.

Zhu Zhanji, the eldest grandson of Yongle, ascended the throne upon the death of his father, Emperor Hongxi (reigned 1425; see fig. 2). He chose the name Xuande, which means "Promoting Virtue," and reigned until 1435. Aware that Yongle's military campaigns and maritime expeditions had nearly bankrupted the court, Xuande shifted his focus to domestic matters. He curtailed naval exploration by cutting off the supply of lumber for ships (1426 and 1430), stating that the "country's priorities should center on agriculture."[8] He instituted a more intellectually oriented court, selecting dedicated officials who governed firmly yet justly. His laws and policies were clear and fair, and his ten-year reign was marked by honesty, justice, and benevolence. Grain was plentiful, and the people were happy.

Xuande was both athletically and artistically talented. His mastery of brushwork in painting, fluidity in calligraphy, and natural style and skill in impromptu poetry were all acknowledged by Ming-period writers; Qian Qianyi (1582–1664) called him an "excellent rival" to Song dynasty emperor Huizong (reigned 1101–25).[9] His thirty-one surviving works often capture subjects—human figures, monkeys, sheep, cats, dogs, bamboo, pine, or weeds—in dramatic moments. Fulfilling Yongle's desire to reestablish the Hanlin Academy to its Song-era glory, Xuande recruited gifted elites, including some who had been demoted or imprisoned by Yongle. The art of his reign showed great progress, with a magnificent outpouring of imagery, colors, and decor that served to affirm the dominance of the great Ming.

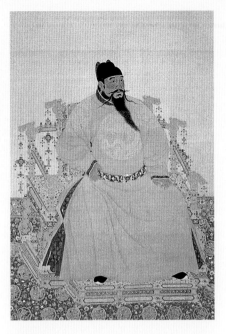

FIGURE 1
Portrait of Emperor Yongle. Ming dynasty (1368–1644), reign of Emperor Yongle (1403–24). Hanging scroll, ink and color on silk.

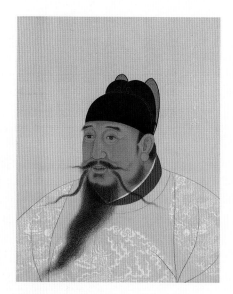

Porcelain proved to be an ideal medium for Ming cultural ambitions, and the court devoted considerable financial resources and institutional energy to restoring the manufacture in Jingdezhen. Ming porcelain was created for a variety of distinct uses: for political purposes, for export, for use by the emperor and his family, and for the common people. During the early Ming period, the court sent orders to several private shops, including Longquan in Zhejiang province. By 1402, however, Jingdezhen routinely supplied tributary porcelain to the court, and the Imperial Workshop, located in Zhushan, operated twenty kilns. In the early-to-mid-Ming period, no single official was assigned to the kilns; instead, provincial governors managed the potteries in addition to their other duties. The court supervised production of ceramics closely, and the Jingdezhen workshop would submit designs for approval before producing any pieces.[10] During the reign of Emperor Hongwu, the imperial ceramic productions, whether executed at official workshops or commissioned from private shops, began to use a reign mark of four or six characters, usually applied to the base but occasionally on the inside or outside of a work. This emblem remained a standard feature of official ceramic productions until the Qing dynasty.

The color red was believed to symbolize the good fortune of the Ming, and it therefore dominated court art. Red lacquer flourished during the Ming period and remained popular for centuries. Before the Ming, the production of lacquer work was concentrated in the south. It was Yongle who established the official lacquer workshop, the Orchard Factory (*Guoyuan chang*), in Beijing. Early Ming lacquerware featured deep, thick, and smooth carving (see cat. 60). Yongle shared his admiration for red lacquerwares with foreign dignitaries; between 1403 and 1407 he sent Japanese envoys home with 303 red lacquer items for select nobles there.[11] Both Yongle and Xuande kept close tabs on the Orchard Factory and selected some individuals to work there.

Jade also reached a new peak of artistic importance during this period. Jade crafting had existed in the Wu region (the area around Nanjing, Suzhou, and Yangzhou in the southeast) since ancient times, but not until the Ming period were its activities organized into a commercial system to satisfy the demand for increased output and novel designs. Ming nobility, great patrons of jade, did much to stimulate development of the jade craft, and jade cutters mastered difficult techniques in order to capture this market. The court regulated the number and design of jade belt plaques to indicate the owner's social status, and the popularity of this accessory became widespread, especially among high-ranking and wealthy members of society (see cat. 79).

NOTES

1. Zhang Tingyu (1739) 1969, chaps. 6–7, pp. 7105–08.

2. Ibid., chap. 75, p. 7257.

3. Ibid., chaps. 324–326, pp. 7914–22.

4. Ibid., chap. 6, p. 7105; chap. 7, p. 7107; chap. 304, p. 7841.

5. Ibid., chap. 145, p. 7432.

6. Ibid., chap. 50, p. 7202.

7. Ibid., chap. 331, pp. 7935–37.

8. Ibid., chap. 9, p. 7109.

9. Lin Lina 1994.

10. Li Zhiyan, Bower, and He 2010, chap. 8.

11. Zhu Jiajin 1995.

CAT 50

明洪武朝 朱侃繪 童貞像軸
紙本設色

Bodhisattva Manjushri as a chaste youth, 1376

By Zhu Kan (active late 14th century)
Ming dynasty (1368–1644), reign of
Emperor Hongwu (1368–98)
Hanging scroll, ink and colors on paper
H: 52.5 cm, W: 26 cm, Guhua 001313

Shown at the Museum of Fine Arts, Houston, only

The cult of Buddhist iconography achieved widespread popularity after the founding of the Ming dynasty. Manjushri, bodhisattva of wisdom, was said to help sentient beings and took many forms, sometimes appearing as a monk or even a goddess. When he appeared as a young man he was called "Manjushri, the Ever Youthful" (*Manjushri Kumarabuta* in Sanskrit) and was shown—as he is in this painting— wearing long hair, carrying a sutra, and held aloft on a cloud. The portrayal of Manjushri, especially dressed in red, was an auspicious blessing for Ming dynasty triumphs. The smooth, flowing lines of this painting depict Manjushri as an approaching savior among carefully delineated layers of white clouds.

Zhu Kan, a native of Changshu, Jiangsu province, was noted for his figure paintings and landscapes. He derived his basic principles of painting from the Song artist Xia Gui (active 1195–1224).

SEAL MARKS AND INSCRIPTIONS

Eight seals of Emperor Qianlong and the seals of Emperors Jiaqing (reigned 1796– 1820) and Xuantong (reigned 1908–11). "On the first day of the first month, *bingchen* (1376), painted by Buddhist disciple Zhu Kan." Emperor Qianlong's 1775 colophon describes the emergence of the chaste youth from cloudy mists. It is reminiscent of the "holy sun illumination," whose devotion to "rescuing people on earth from the abyss of misery" was the red Ming's idealism.

SFC WITH TB

明永樂朝 王紱繪 山亭文會圖軸
紙本水墨淡色

Literary Gathering at a Mountain Pavilion, 1404

By Wang Fu (1362–1416)
Ming dynasty (1368–1644), reign of
Emperor Yongle (1403–24)
Hanging scroll, ink and light color on paper
H: 129.5 cm, W: 51.4 cm, Guhua 000385

Shown at the Asian Art Museum only

This painting presents the time-honored subject of literati gathering in remote mountains. The main peak looms above the misty clouds. Below, inside a rustic pavilion, three scholars sit around a table deep in discussion. Outside, two men lean over a railing to better view a waterfall. At the lower left, two men walk and talk behind the rocks and are followed by a servant carrying a *qin*, or zither. A relaxed figure leisurely sails toward them from below the distant cliff. The mountains, rocks, and trees are rendered with brushwork that is dry, blunt, and rich with variations. The thick ink and shadings of light color contribute to its profound atmosphere.

Wang Fu occupied a pivotal position in the transition between late Yuan and early Ming painting. A native of Wuxi, Jiangsu province, and an intellectual in the Ming court, he modeled his paintings after the Yuan masters Ni Zan (1301–74) and Wang Meng (1308–85; see cat. 37) and excelled in ink bamboo and landscape subjects. Political turmoil in the early Ming dynasty cast a shadow over his early career. The slightest hint of disobedience or disrespect to the emperor could result in severe consequences, including banishment and execution. Wang Fu evidently ran afoul of Hongwu and was exiled to Jiulong Mountain in Shanxi for twelve years, until the emperor's death. During the reign of Emperor Yongle, he returned to court on the strength of his literary talents. He served in the imperial library, the Pavilion of Literary Profundity (*Wenyuan ge*), and participated in the compilation of the encyclopedic *Great Canon of the Yongle Era* (1407). Later, he was engaged in preparations for moving the capital from Nanjing to Beijing. In 1414 and 1415 he accompanied Yongle on two inspection tours of the south.

INSCRIPTIONS

"Literary Gathering in a Mountain Pavilion / by Mountain-man at Nine-dragon Mountain, Wang Mengduan / on mid-autumn day in the year *jiashen* [1404] of the Yongle reign" written in seal script by Wang Fu, demonstrating his mastery of calligraphy as well as his habit of inscribing his works. Emperor Qianlong (reigned 1736–95) added two inscriptions in 1759 and 1780.

JJC WITH SKN

CAT. 52

明朝 麒麟沈度頌軸 絹本水墨設色

Shen Du's ode on a painting of *qilin* (giraffe), approx. 1414

Anonymous court artists

Ming dynasty (1368–1644)

Hanging scroll, ink and color on silk

H: 90.4 cm, W: 45 cm

Guhua 02364

Shown at the Asian Art Museum only

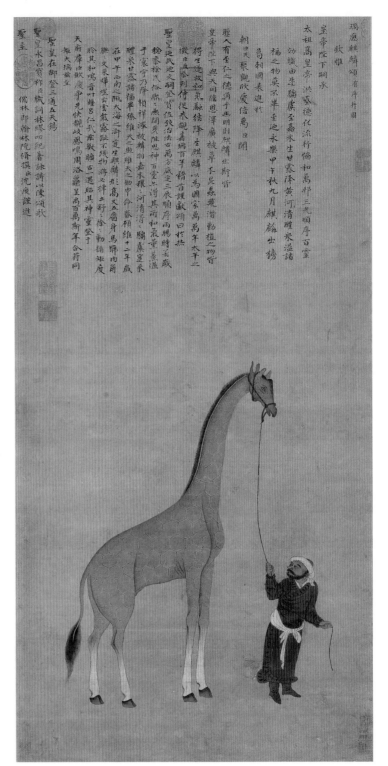

This painting attests to the success of Emperor Yongle's policy of establishing alliances with foreign kingdoms. Yongle increased the fame of the Ming abroad, and his court received notable tributes from foreign envoys. In 1414, when mariner Zheng He returned from one of his expeditions, an envoy from the king of Bengala (now Bangladesh) presented Yongle with a giraffe.[1] The entire Ming court was awestruck by the strange animal, for many had never seen one before.

In an attempt to flaunt his influence, Yongle ordered court artists to make paintings of the exotic tribute items he had received, including the giraffe, to give as gifts to members of the court. Several giraffe paintings were produced, reflecting a new interest in natural history among the Ming. The few surviving giraffe paintings are similar in composition: A foreign trainer with curly hair and an authoritative gaze pulls the giraffe by a long cord around its neck. The animal, unfamiliar as it was to Chinese painters, was executed with rather simple techniques. The mottles on the animal's skin became large geometric forms highlighted by ink lines.

Each giraffe painting also contained a copy of *The Eulogy of the Qilin* [Chinese unicorn], *an Auspicious Omen*, compiled by the scholar and calligrapher Shen Du, which praised the giraffe as "five *zhang* [roughly 16 feet] tall, with a deer-like body, horse-like hooves . . . behaving confidently and gracefully in a way that seemed well-disciplined and law-abiding." Shen Du was acknowledged by Yongle as his court's "Saint of Calligraphy" and,

with his brother Shen Can, created a distinctive approach known as the "cabinet" style, which spread widely during the Ming period (see cat. 54). His tribute to the giraffe was copied by an unknown court artist in a delicate style that lacked Shen Du's fluid smoothness and classical elegance.

LNL WITH QN, HL

1. *Ming Taizong shilu*, chap. 155.

CAT. 53

明朝永樂十七年 (1419)
《妙法蓮華經》七卷 泥金寫本

Marvelous Scripture of the Lotus Sutra, 1419

Ming dynasty (1368–1644), reign of
Emperor Yongle (1403–24)
Accordion-mounted albums, gold on
indigo paper
Frame H: 26 cm, L: 12.1 cm
Gufo 000301, 000307

Shown at the Asian Art Museum only

Emperor Yongle and his father, Emperor Hongwu, were both fervent devotees of Buddhism. In fact, Yongle's zeal surpassed that of his father, and he contributed much to the promotion of Chinese and Tibetan Buddhism. Among his achievements were publishing the Buddhist scriptures known as the Tripitaka in Nanjing (1412–17) and Beijing (1421–40) and completing the first printing in Nanjing of the Kanjur in Tibetan. He also had many Buddhist sutras printed by the Imperial Household Department. He wrote twelve prefaces for the Mahayana sutras and twelve epilogues for the *Eulogies to the Buddha and Bodhisattvas.*

This handwritten sutra from the Imperial Household Department was based on the translation by Kumārajīva (344–413; see cat. 69) in seven volumes and twenty-eight chapters. This version contains a chapter on Devadatta not found in the original Sanskrit text or other translations. The sutra is written in gold on indigo paper, gathered in accordion-mounted volumes, and stored inside a wooden container. Using the lotus blossom as a metaphor, the *Marvelous Scripture of the Lotus Sutra* explains that pure Buddha nature can be found in all sentient beings regardless of caste, that are all equal, and that all may achieve Buddhahood if they follow correct Buddhist practice. The Tiantai school of Buddhism considered this sutra its basic text and called it the "king among sutras."

KWL WITH TB

明永樂朝 沈粲書 楷書章草今草
三體並書 登小山應制詩軸 紙本

Poems on the order of Emperor Yongle, 1420

By Shen Can (1379–1453)

Ming dynasty (1368–1644), reign of
Emperor Yongle (1403–24)

Hanging scroll, ink on paper

H: 121.7 cm, W: 28.7 cm

Gushu 000013

Shown at the Museum of Fine Arts, Houston, only

This five-poem set is a significant work by
Shen Can, an innovative calligrapher and
illustrious scholar favored by Emperor
Yongle. In 1420, at the request of some-
one by the name of Chongdao, Shen copied
five poems that he had composed on the
order of Emperor Yongle to describe the
imperial complex around Small Mountain
(*Xiaoshan*) in Beijing. Shen compares
the spot to the Daoist paradise of Penglai
Island: the palace is illuminated by myr-
iad flowers swaying in the spring wind;
the dragon rivers ripple around the island;
the sacred towers echo the palace built of
jade; herbaceous peonies cast rosy shad-
ows; cranes hide deep in groves of foliage;
the whistling of the pine trees reaches to
the heavens; ordinary birds feel unworthy
of flying up to the complex's high phoenix
terrace. Shen writes that even the immor-
tal world cannot surpass such grandeur.
This commission was likely linked to
the celebration of the completion of the
Forbidden City, where Yongle settled his
court in 1421.

This piece combines three different
scripts, a practice rarely seen in Ming cal-
ligraphy. Shen Can's semicursive script
(*zhangcao*) is marked by an archaic sim-
plicity, and the new cursive script (*jincao*)

is full of dynamic restraint; both are set off
by the neat and elegant semiregular script
(*kaishu*) and together present a vision
of harmony.

Shen Can was from Huating (now
Shanghai) and served the Ming court in
several positions: scholar at the Hanlin
Academy, draftsman, editorial assistant,
and vice director of the Dali regional
office. Shen Can and his older brother
Shen Du were known as the Old and Young
Doctors, and their writing dominated cal-
ligraphic styles at the early Ming court.
Shen Can's mastery of the cursive style
made him a capable rival of his brother.[1]

INSCRIPTION

"For Chongdao I recorded the poems on the
Ten-Thousand-Year Mountains / again,
the Small Mountain poem / written all
into one / would not dare sing my own
praises / by Can."

JJC WITH HL

1. Zhang Tingyu (1739) 1969, chap. 286, p. 7793.

CAT. 55

明永樂朝 江西景德鎮 青花
龍穿纏枝花紋天球瓶

Vase with a flying dragon amid flowers

Jingdezhen, Jiangxi province
Ming dynasty (1368–1644), reign of
Emperor Yongle (1403–24)
Porcelain with underglaze cobalt-blue decoration
H: 42.2 cm, Diam: mouth 9.3 cm, base 16.2 cm
Guci 011422 Que-437

During the reigns of Yongle and Xuande, large porcelain pieces such as celestial globe vases and flat flasks were manufactured for the court's needs. The distinctive blue color of these works comes from pigments of cobalt oxide. After decorations were painted and a transparent glaze applied, the piece was fired at approximately 1200°C. The porcelain of this period is rich in color and may be speckled with green rust spots, forming a distinctive style that inspired early Qing dynasty antique porcelain reproductions.

As the most famous blue-and-white piece from the Yongle period at the National Palace Museum, this rather large and stately celestial globe vase has great appeal. The vase's roughcast surface is dense, while its glaze is lustrous and smooth. It has a slightly concave base, a round belly, and a sleek neck, its mouth slight yet extravagant. Wrapped around its body is an imposing three-clawed dragon, full of scales. It peers back with a pair of round eyes and takes great strides with open claws, its open mouth exposing tongue and teeth. Smoothly painted lotus decorations in thick, bright blue ornament the vase's background and neck, revealing superbly crafted porcelain.

LYH WITH JC

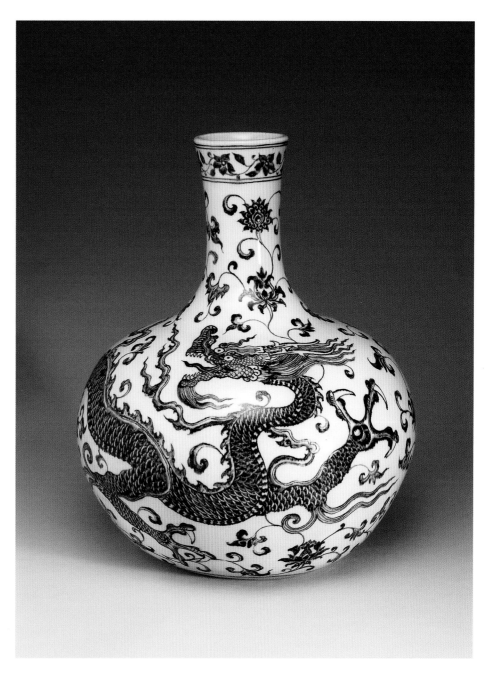

CAT. 56

明永樂朝 江西景德鎮 青花
西域舞樂人物紋扁壺

Vase with West Asian
entertainers

Jingdezhen, Jiangxi province
Ming dynasty (1368–1644), reign of
Emperor Yongle (1403–24)
Porcelain with underglaze cobalt-blue decoration
H: 29.7 cm, W: base 12 cm, L: base 8 cm
Guci 012549 Que-441

Flat pots with double ears were first fired
during the reign of Emperor Yongle and
continued to be produced through the
reign of Xuande. As far as we know, these
vessels were available only as mono-
chrome-white and blue-and-white prod-
ucts; decorations on the blue-and-white
works included flower and birds, floral
designs, fruits, and human figures. Only
two blue-and-white flat pots with Central
or West Asian figures exist in the world:
one at the Topkapi Museum, Istanbul,
and this rare and precious piece. It show-
cases Ming craftsmanship in porcelain and
reflects the cultural exchanges between
China and the rest of the world.

The body design depicts five fig-
ures—three on one side, two on the
other—engaged in music making and
dance. Their faces and clothing reveal
the figures to be not Chinese but West
Asian. The body of this pot is full, yet
delicate, with a glossy glaze covering
the entire vessel except the oval base.
The straight neck features empty-
banana-leaf patterns all around, while
lotus-petal patterns encircle the sloping
shoulders and lower parts of the body.

LYH WITH DH

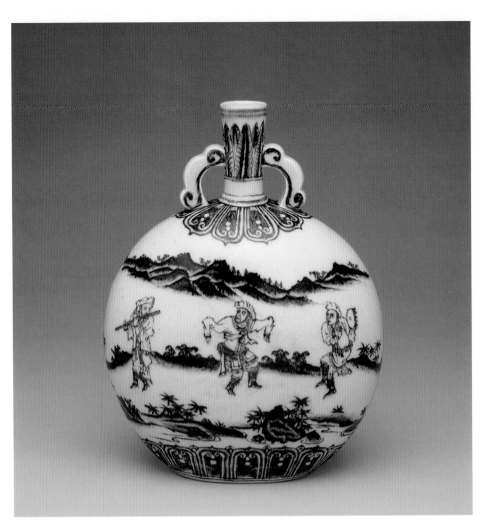

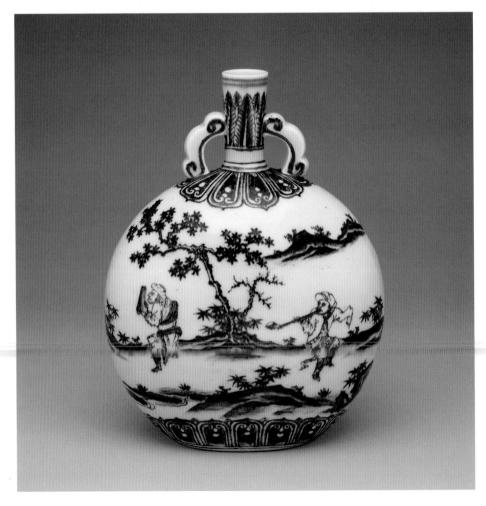

CAT. 57

明永樂朝 江西景德鎮 青花
四季花卉圓洗

Basin with flower designs

Jingdezhen, Jiangxi province
Ming dynasty (1368–1644), reign of
Emperor Yongle (1403–24)
Porcelain with underglaze cobalt-blue decoration
H: 12 cm, Diam: mouth 26.6 cm
Guci 016863 Que-430-13

As the Ming court established contact
with Central and West Asia, the prod-
ucts of official kilns reflected these
exchanges. Many shapes and decorative
patterns influenced by Islamic civiliza-
tions emerged at that time. This basin was
just such a vessel, originating in rimmed
basins of metal and colored glass from
West Asia. Only a small quantity of this
type of blue-and-white basin was made
at the Imperial Workshop in Jingdezhen;
among them, a similar piece at the Asian
Art Museum, San Francisco, is the only
known example in the West that features
the eight auspicious symbols of Buddhism
on the bottom interior.[1]

This basin has an exquisite body and
a lustrous glaze. The entire vessel is dec-
orated with flowers in underglaze blue.
Finely and firmly executed geometric flo-
ral patterns appear on the inside toward
the bottom. A network of flowers covers
the walls of the vessel, inside and out,
while billowing wavy patterns are painted
in four groups near the mouth. In sum, the
decorator of this basin achieved rare har-
mony in the selection, proportions, and
layout of the flowers and leaves.

LYH WITH DH

1. He Li 1996, pl. 398.

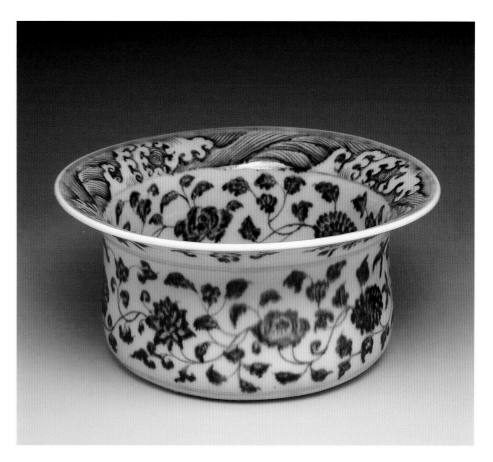

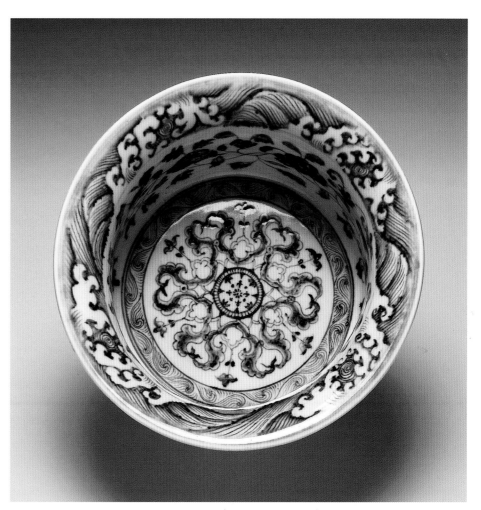

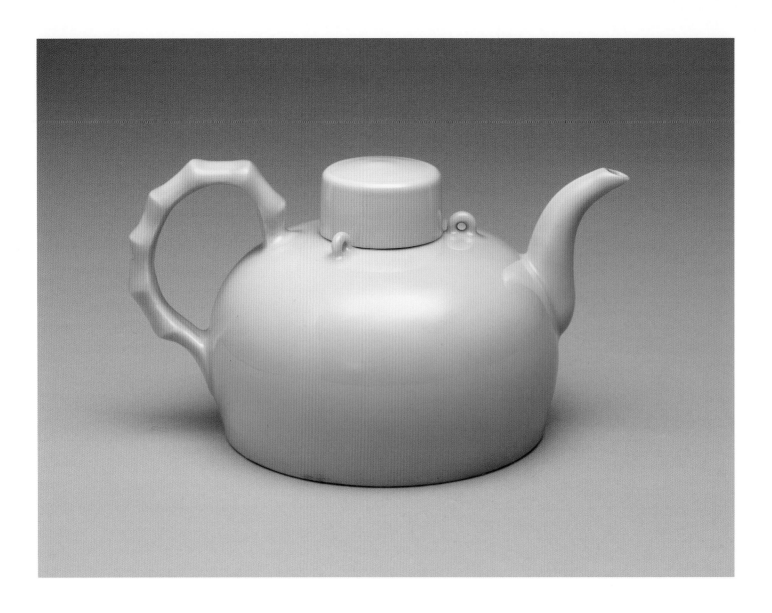

CAT. 58

明永樂朝 江西景德鎮
甜白釉三系把壺

Teapot with "sweet-white" glaze

Jingdezhen, Jiangxi province
Ming dynasty (1368–1644), reign of
Emperor Yongle (1403– 24)
Porcelain with sweet-white glaze
H: 11.4 cm, L: 20 cm, Diam: mouth 4 cm,
base 12.9 cm
Guci 017825 Wei-572-8-2

The delicate, even, warm white glaze of Yongle-era porcelain has been known since the Ming era as "sweet," hence the term "sweet-white" glaze. This was the principal type of porcelain used in the palace during the reign of Emperor Yongle. The emperor himself was recorded as saying that he preferred the translucent white Chinese ceramics he used every day to the Islamic jade bowls offered to him as tribute. This was certainly one of the reasons why sweet-white glazed porcelain was produced in such large quantities.[1] According to excavation reports concerning the Ming imperial kilns at Zhushan, in Jingdezhen, sweet-white glazed porcelain accounted for more than 98 percent of all excavated objects from the early part of the Yongle era.

This teapot has a small mouth, a short straight neck, and round shoulders that feature three ringlike knobs. The handle takes the form of bamboo segments, and a flat lid covers the opening of the neck. The entire vessel, excepting the base, has a white glaze. Extant porcelain teapots with this shape are rare; one similar vessel in the collection of the National Palace Museum is a blue-and-white teapot with a handle that is decorated with a pair of phoenixes.

LYH WITH DH

1. *Ming Taizong shilu* 1966. The record on the day *dingwei* of the tenth month in the fourth year of the Yongle reign.

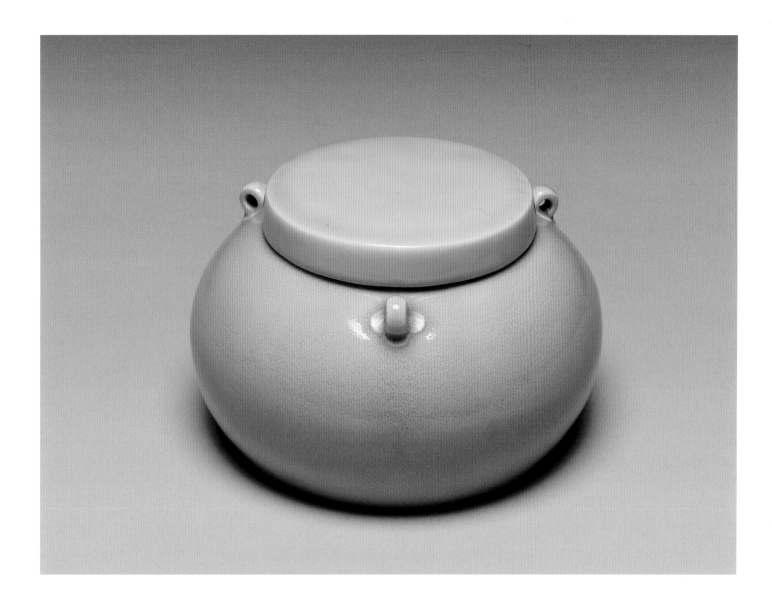

CAT. 59

明永樂朝 江西景德鎮
翠青釉三繫蓋罐

Jar with pale green glaze

Jingdezhen, Jiangxi province
Ming dynasty (1368–1644), reign of
Emperor Yongle (1403–24)
Porcelain with pale green glaze
H: 10 cm, Diam: mouth 8.5 cm
Guci 017644 Que-430-60

The pale green glaze ware produced during the reign of Emperor Yongle was characterized by tiny air bubbles appearing throughout the glaze. Such a glaze is called "wintry celadon," "cold celadon," or "Eastern celadon" in historical documents. In his encyclopedic *Compendium of Materia Medica* (1578), Li Shizhen (1518–93) called it "cold green" glaze since it remained green even in the winter months.

The Ming celadon was admired by all the Qing emperors. In his book *Records of Jingdezhen Ceramics* (*Jingdezhen tao lu*; 1815) Lan Pu, a Jingdezhen native, confirmed that one of the official Ming products that the Qing Jingdezhen workshop copied was the winter green ware.[1] According to an imperial inventory, wintry celadon products were remade and presented by the Qing official Tang Ying (1682–1756).

The unusual shape of this delicate and pretty vessel was an innovation of the imperial kilns. A flat lid covers the top, while rings emerge from four-petaled flowers on the shoulder. White glaze was applied to the inside of the jar, while the "wintry" pale green glaze covers the outside.

YSC WITH DH

1. Lan Pu (1815) 1991, chap. 2.

CAT. 60

明永樂朝 朱漆剔紅 花卉長頸瓶

Vase with flower designs

Ming dynasty (1368–1644), reign of
Emperor Yongle (1403–24)
Carved red lacquer (*tihong*)
H: 16.7 cm, Diam: mouth 6 cm, neck 4.6 cm,
belly 9.2 cm, base 8.5 cm
Guqi 000468 Que-395-2

Shown at the Asian Art Museum only

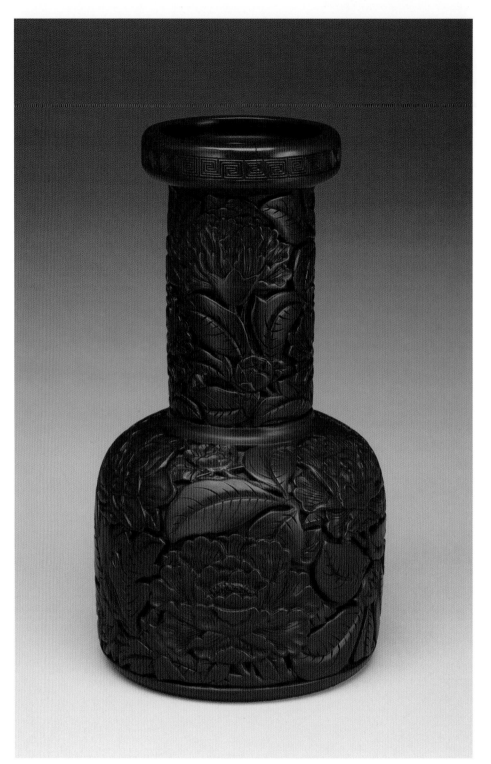

The only known surviving example of its
kind made by the imperial lacquer shop
during the Yongle period, this vase differs
from all other Yongle-era lacquer pieces
in its shape. Usually called a "paper-
mallet vase" because its long, straight neck
resembles a mallet, its form may actually
have been copied from Islamic glassware.
The vase is completely covered with flo-
ral patterns featuring wavy leaves strewn
around open flowers: peony, thistle, cape
jasmine, and chrysanthemum. These ele-
ments are handled with regularity and
balance, conveying a sense of order that
is similar in spirit to the floral patterns on
the blue-and-white porcelain of the late
Yuan and early Ming dynasties. The solid
layers of polished lacquer throw the deli-
cate petals and leaves into relief, and the
structures of the leaves are engraved with
vigor. The fluidity of the design and the
adeptness of the engraving are apparent
everywhere.

The lacquerware of the Yongle court
stands at the pinnacle of Chinese lacquer
craftsmanship, and this particular piece—
with its clear but unexposed incisions,
polished cutting, and slender and metic-
ulous forms—exemplifies that achieve-
ment. During the reign of Emperor Yongle,
craftsmen from around the country were
required to serve corvée labor in the capi-
tal and produce lacquerware for the court.
The official publication of Jiaxing (near
Suzhou) recorded that the two great lac-
querers Zhang Degang (active 1400–30)
and Bao Liang (active 1420–40) were once
summoned to serve as assistant directors
at the official Orchard Factory lacquer
workshop in the capital. The meticulous
handiwork of these craftsmen at the work-
shop is clear: after 600 years, this vase is
still sturdy, and its colors are still fresh.
Such superb craftsmanship reflects the
prosperity of the early Ming dynasty.

INSCRIPTION
"Produced during the reign of Emperor
Yongle in the Great Ming," six-character
inscription incised on the base.
HHC WITH DH

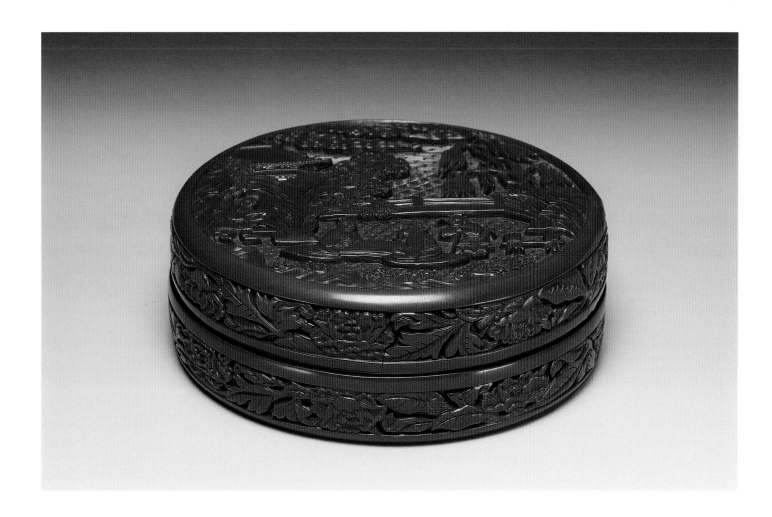

CAT. 61

明永樂朝 朱漆剔紅
山林對奕圖圓盒

Round box with a scene of
figures playing the border
chess game go

Ming dynasty (1368–1644), reign of
Emperor Yongle (1403–24) or earlier
Carved red lacquer (*tihong*)
H: 4.8 cm, Diam: 13.2 cm
Guwen 000077N1 Lü 1868-4

Shown at the Museum of Fine Arts, Houston, only

Red lacquer objects, especially round boxes, were favored by Emperor Yongle. Indeed, he is known to have given lacquerwares, including a "fragrant" or incense box, to the Japanese royal family. The tight seal and light weight of cylindrical lacquer boxes made them suitable containers for fragrant materials such as incense. A lacquer box similar to this one is shown being held by a servant in *Portraits of Arhats* (1271–1368) in the collection of the National Palace Museum.[1]

The cover of this box depicts two elders sitting cross-legged and playing go, with a bystander behind them carrying firewood. This scene comes from a tale by writer Ren Fang (460–508) about a man named Wang Zhi who climbed a mountain in search of firewood and encountered two boys playing go. While watching the game, centuries passed, with the firewood and the axe becoming utterly weathered and rotten. The otherworldly sense of time and space in this scene related to the concept of a Daoist paradise dating back to the Yuan dynasty (1271–1368) and was one of the favorite artistic themes of the Ming dynasty.

The lid presents a composition of garden and figural imagery popular in lacquer carving during the reigns of Yongle and Xuande: balustrades demarcate the foreground, strange rocks encircle the center, shadowy trees and a pavilion with a door open fill out the middle ground. Ripples play across the water, while in the distance clouds float in the sky. The brocade-like patterns in the ground, water, and the sky served as a model for subsequent lacquer designs in later centuries. The clearly layered figural composition, the rosy hue of the lacquer, the solidity of the finish, and the consummate detail of the craftsmanship all represent the high level of lacquer craftsmanship at the Ming court.

INSCRIPTION

"Produced during the reign of Emperor Yongle in the Great Ming" inscribed on the base.

HHC WITH DH

1. NPM 1990–2010, vol. 5, p. 179.

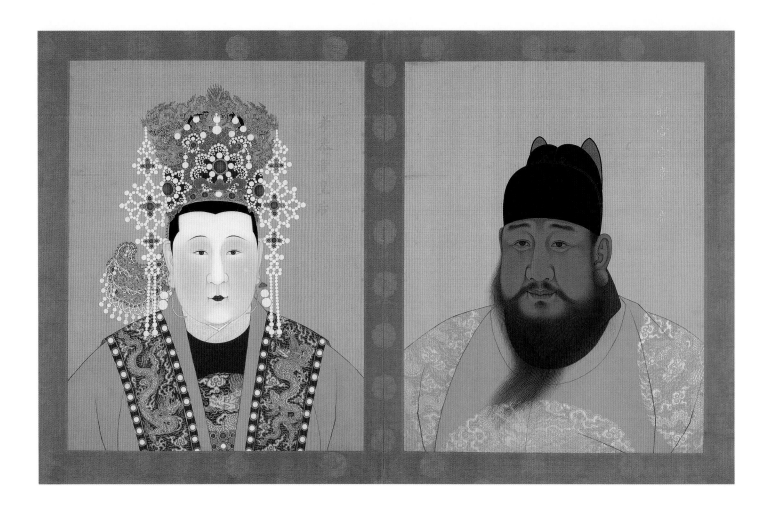

明宣德朝 宣宗朱瞻基 孝恭章皇后
孫氏半身像 絹本設色冊頁

Half-portraits of Emperor Xuande and Empress Sun, Xiaogong Zhang

Ming dynasty (1368–1644), reign of
Emperor Xuande (1426–35)
Album leaves, ink and colors on silk
H: 66 cm, W: 51.8 cm each
Zhonghua 000326-4

Shown at Museum of Fine Arts, Houston, only

This painting comes from an album called *Ming Imperial Portraits of Emperors and Empresses*. This fourth leaf shows the half-portraits of Emperor Xuande with his second empress, Sun, who received the posthumous title of Empress Xiaogong Zhang (1399–1462). In 1428 Xuande deposed his first wife, Empress Hu Zhangxiang (died 1443), for reasons of illness and her inability to produce a son; he granted her the title "Quiet Benevolent Immortal Master" and sent her into retirement at the Palace of Long Peace. He then installed his favorite concubine, known as the Noble Consort Sun, as his new empress. She came from a prominent family and as a teenager had been chosen by Emperor Yongle to serve Xuande. As Xuande's wife, Empress Sun passed off a servant's son as her own, thereby assuring the emperor of an heir; that heir would become Emperor Yingzong (1436–49; 1457–64).[1]

These portraits capture the likenesses of the imperial couple with fine brushwork. The artist emphasized the unique facial features of each figure. Xuande has a dark, rosy complexion with a thick full beard; each strand of hair is painted individually, allowing us to see his collar and robe through the beard. His crown—the matte finish conveying its velvet texture—includes a black gauze cap with two folds on the top known as the "crown with wings of kindness" (*yishan guan*) for its resemblance to the Chinese character for "kindness." His yellow robe is notable for its round dragon-and-cloud pattern rendered in glittering gold dust.

Sun wears a jeweled crown over a tall bun. Her yellow robe with dragon-and-cloud emblems indicates her status as empress. The artist carefully emulated the style of her makeup by applying white powder to the forehead, nose, and chin, light rouge to the cheeks, and deep red color to the lips. The jewels and gold ornaments on her crown are enhanced with gold paint and other treatments to enhance their reflective quality and smooth texture.

SFW WITH SKN

1. Zhang Tingyu (1739) 1969, chap. 113, p. 7368.

CAT. 63

明宣德朝 宣宗朱瞻基 書畫合璧冊
紙本水墨

Harmonious pair of painting and calligraphy, 1428

By Zhu Zhanji (Emperor Xuande, 1398–1435)
Ming dynasty (1368–1644), reign of
Emperor Xuande (1426–35)
Album leaves, ink on paper
Painting H: 29.4 cm, W: 33.8 cm;
calligraphy H: 26.5 cm, W: 14.7 cm
Guhua 001124

Shown at the Asian Art Museum only

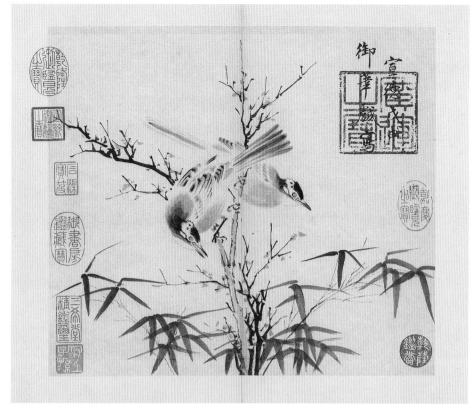

CAT. 63.1

This album set is the sole work to combine a painting and a corresponding verse by Emperor Xuande, to whom only a handful of paintings can be verifiably attributed. The spontaneous sketching and free, easy writing of this rhythmic verse exemplify his versatile talents in painting, calligraphy, and poetry. Choosing a nature-inspired subject for this formal painting experiment, Xuande integrated a pair of bulbuls with plum and bamboo branches to create a balanced whole. He proved his skill in the "boneless" (*mogu*) technique, in which the birds and bamboo were portrayed by ink applied directly to paper without outlines. His precise and fluid brushwork intimately united the birds and plants in an atmosphere of sensual allure. It is not certain who instructed Xuande in painting and calligraphy, though it is clear from works such as this that he studied the flower-and-bird paintings of Bian Wenjin (active 1403–35; see cat. 68), a court painter who served Xuande in the inner palace.

Xuande placed this painting in a literary context—and imbued it with extremely emotional sentiment—by composing a long verse on the other five pages of the album. Titled "One Branch of a Flower," Xuande's poem compares the flower to a woman isolated within the "embroidered curtains" of her chamber, weeping for her heartless lover. "Both eyes brimming with tears that wash off her red makeup," she knows only the "plaintive sorrow reflected

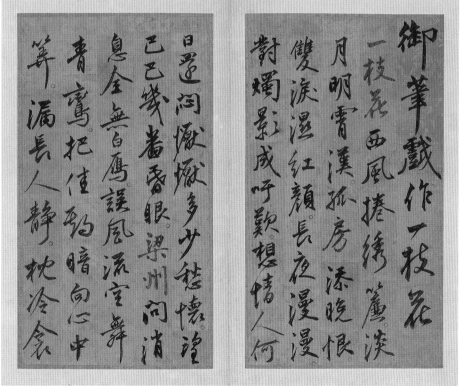

CAT. 63.2

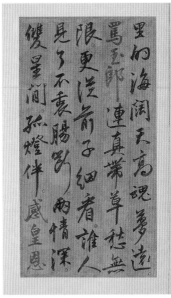

CAT. 63.4

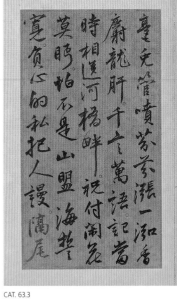

CAT. 63.3

CAT. 63.6

CAT. 63.5

by a candle through the long night." Without the company of her lover, the pillow "feels cold; the fur, chilly. . . . How is she to transmit her cherished desires across the long distance to him? . . . Vivid are her last memories of seeing him off at the bridge; meaningless now is his oath of eternal love as they uttered words of farewell. . . . As flowers fade, the young face ages; who would collect withered leaves or shrunken stems?" The emperor concluded that one should "value the scene when it is nice" or else experience the sting of "regret when it is too late."

Xuande's semicursive script runs in vertical rows. His use of dark and light ink creates marvelous accents between the phrases, and the varied spatial arrangement between characters exhibit Xuande's mature, well-controlled calligraphy.

INSCRIPTIONS

"Playfully written by the Emperor in the year *wushen* [1428] of the Xuande reign" inscribed at the top right of the painting. "The third year of the Xuande reign," referring to 1428, is written on the last page of the album.

SEAL MARK

"Treasures of Vast Fortune" (*Guangyun zhibao*) placed over Xuande's inscription on the painting.

SFC WITH HL

CAT. 64

明宣宗朝 宣宗朱瞻基繪
花下貍奴圖軸 紙本設色

Cats in a flower-and-rock garden, 1426

By Zhu Zhanji (Emperor Xuande, 1398–1435)
Ming dynasty (1368–1644), reign of
Emperor Xuande (1426–35)
Hanging scroll, ink and colors on paper
H: 41.5 cm, W: 39.3 cm
Guhua 000421

Shown at the Asian Art Museum only

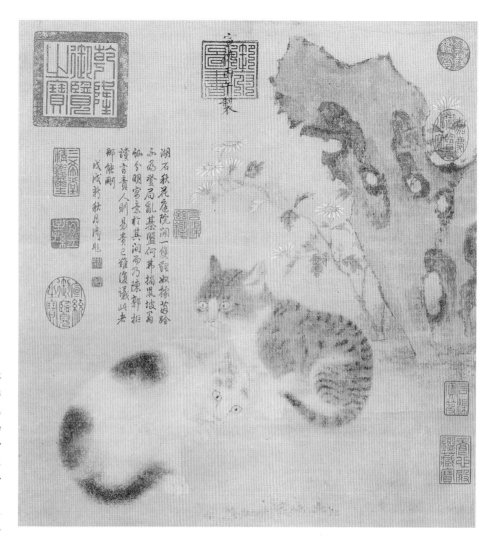

Emperor Xuande occupies an important position in the history of Chinese politics and arts. An able and conscientious ruler, he wisely appointed worthy and capable officials. History refers to his ten-year reign as a period of peace and prosperity. His accomplishments in the arts further distinguish him.

Xuande was fond of the arts and literature and excelled in painting, especially landscapes, figures, animals, insects, and bird-and-flower subjects. He often gave his artworks as rewards to trusted officials. His plan to revitalize the painting academy influenced the artistic trajectory of China for an entire generation. According to historical records, whenever any artist in the academy presented artworks for inspection, the emperor would examine them carefully and then add his comments. Under Xuande the painting academy reached a height of excellence comparable to the achievements of the Hanlin Academy under Song dynasty Emperor Huizong.

Xuande's style was influenced by the literati tradition and emphasized fine lines and subtle ink tonalities. This painting depicts two playful cats, one licking its paw and the other resting in the shade of a garden rock and wild chrysanthemums. Xuande applied the background colors first and then used fine lines and textured strokes to render the cats' fur and features. He copied the shape of the rock from one at Lake Taihu near Suzhou and then used a dry brush to add surface texture. The chrysanthemum was drawn with a fine brush before color was added. With its fresh, elegant atmosphere, this painting emulates the style of the Song court artist Li Di (approx. 1100–after 1197). The cats' gestures and expressions contribute to the charm that epitomizes Ming genre paintings.

INSCRIPTIONS

"Produced in the year *bingwu* [1426] of the Xuande reign" written by Xuande. In 1778 Emperor Qianlong added a poem in running script and the inscriptions "Poetic Pound" and "Marvelous depictions of dark cats."

SEAL MARKS

Xuande's seal, "Books of the imperial palace" (*Yufu tushu*), and five seals from Qianlong.

SFW WITH SKN

CAT. 65

明朝 李在繪 (舊傳宋郭熙)
山莊高逸圖軸 絹本設色

Mountain villa and lofty retreat

Attributed to Li Zai (died 1431)
Ming dynasty (1368–1644)
Hanging scroll, ink on silk
H: 188.8 cm, W: 109.1 cm
Guhua 000829

Shown at the Asian Art Museum only

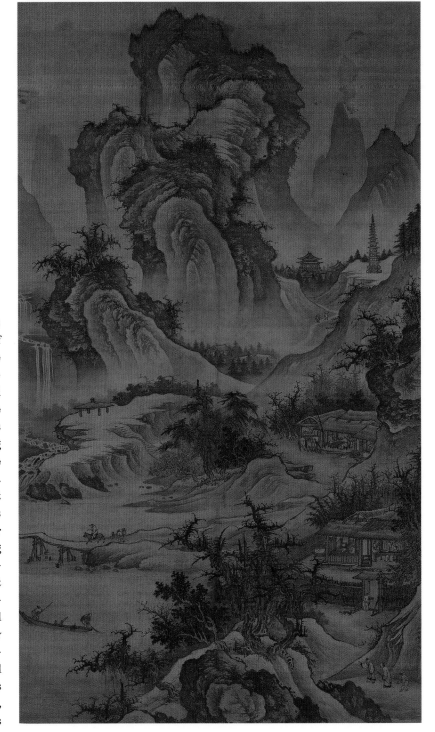

This outstanding painting possesses considerable importance in terms of antiquity, connoisseurship, and its place in the imperial collection. It is a classical-style painting of the Ming period that was registered in the records of the Qing Imperial Household Department as the work of a Song master. The painting was so identified due to the appearance of the signature of Guo Xi (active approx. 1050–1100) and a composition reminiscent of the naturalistic style of painting in his day. Guo Xi became a court artist under Emperor Huizong's father, Shenzong (reigned 1068–85), and his monumental painting *Early Spring* enjoyed great regard as a model in court art for centuries following its creation.[1] Attitudes and ideas of the Song era were promoted by the Ming court to influence the intellectual and artistic trends of the day, and Song-inspired paintings found generous patronage in the court. Many paintings, whether faithfully imitating Song works or pursuing new styles, used the essential framework of Song landscapes. As a result, fifteen works from the imperial collection in addition to "Mountain villa and lofty retreat" have been attributed to Guo Xi, most of which were likely actually created by Ming artists.[2]

This painting is now attributed to the Ming court painter Li Zai, who painted a similar composition that also bears the signature of Guo Xi.[3] The composition and narrative both follow a line zigzagging up from the foreground: entering a mountain villa, painting inside the villa, fishing on a boat, traveling on a donkey,

and dining in a country inn. The arrangement of peaks along the central axis, the strokes described in historical texts as "cloud-head strokes" that give volume to the rocky peaks, and the crab-claw-shaped tips of the tree branches all reveal a mastery of Song techniques. Yet, the apparent fidelity to Song styles is deceptive. The artist included several elements that add drama to the depiction but could never have appeared in a Northern Song painting: a Song-style pagoda, a thatched pavilion from the Yuan dynasty, Ming-era

houses showing active people inside, and several scattered narrative episodes.

INSCRIPTION AND SEAL MARK
"Painted by Guo Xi from Heyang." A seal is illegible. Both inscription and seal were added after Guo Xi's time.
JJC WITH HL

1. NPM 2006, 72–77.

2. NPM 1990–2010, vol. 1, pp. 215–46.

3. He and Knight 2008, 210.

CAT. 66

明朝 倪端 繪 捕漁圖軸 絹本設色

Catching fish, approx. 1459–66

By Ni Duan (active approx. 1436–1505)
Ming dynasty (1368–1644)
Hanging scroll, ink and color on silk
H: 117.8 cm, W: 42.3 cm
Guhua 000423

Shown at the Museum of Fine Arts, Houston, only

Yuan artists painted fishing scenes in country landscapes to convey a complex psychological state: they felt anxious under Mongol rule and longed to avoid the bureaucracy of the court. Those dreary and solitary scenes differ from the sophisticated treatment this subject would receive 200 years later in paintings such as this. These later paintings—whether depicting a fisherman casting a fishing net in the morning fog or shrouded in the light of the setting sun and returning home with his catch—express leisure and peace and reflect the halcyon days of Ming society. Such depictions supported the Ming monarchy's claim of benevolence, which was considered an essential attribute of good government. This painting by Ni Duan is a manifestation of that goal.

Ni Duan, a native of Hangzhou, Zhejiang province, served as a court painter between 1449 and 1505 and specialized in Daoist and Buddhist figures. He pursued the Southern Song styles mastered by Ma Yuan (active approx. 1160–after 1225; see cat. 8) and Xia Gui. This work unfolds from the vantage point of the riverbank and moves upriver. The wind blows dank, drooping reeds toward distant slopes as a fisherman draws his bobbing nets from the rippling river. The use of empty space, echoing Ma Yuan's atmospheric compositions, suggests an expansive body of water. The work is accented with curving edges formed by large boulders and gentle hills. The reeds, either outlines filled in with ink or directly applied solid brushstrokes, accentuate the dreamlike effect created by the vapor and mist. A few heavy brushstrokes on the rocks show Ni

Duan's skill with techniques derived from Song painting.

INSCRIPTION
"Painted by Ni Duan."
WRL WITH QN, HL

CAT. 67

明朝 戴進繪 太平樂事冊
絹本設色

Illustrations of pleasures in times of peace and prosperity

By Dai Jin (1388–1462)
Ming dynasty (1368–1644)
Album leaves, ink and color on silk
H: 21.7 cm, W: 22.2 cm
Guhua 003145

CAT. 67.2

This set of illustrations epitomizes Ming taste in the fifteenth and sixteenth centuries, a time marked by stunning developments in material culture and growth in urban centers. The ten paintings in this album depict scenes full of amusement and freshness, such as children playing, a magic performance, fishing, archery, the aftermath of plowing, an opera performance, a wooden-horse show, and the return from herding. Some of these scenes are derived from the early masterworks of Song masters: The piece showing a woman nursing baby on a buffalo (67.2) re-creates a detail from a painting by the Southern Song court painter Li Song (1166–1243) in the National Palace Museum. The scene of a wooden horse being presented to a court official (67.9) is adapted from a Yuan masterpiece by Ren Renfa (1254–1327; see cat. 35) that depicts Zhang Guolao (active approx. 650–750), one of the Eight Immortals of Daoism, having an audience with the emperor (Palace Museum, Beijing). These works employ a distinctive brushstroke—beginning with a triangle, ending in a tapered line, and known as "nail head with a rat tail"—that was characteristic of Dai Jin's style.

Despite a short period of service at court, Dai Jin, a native of Qiantang (now Hangzhou, Zhejiang province), won fame for his versatile talents, which included skill in metalwork, jewelry, and painting. His sensibilities are illustrated by the broad range of themes he addressed: landscapes, figures, religious subjects, and flower-and-bird paintings. At the peak of

CAT. 67.1

CAT. 67.3

his career Dai Jin was a key representative of the Zhe school, associated with the academic style. As the Wu school of literati painting—originating in the Wu region (now Suzhou)—rose in popularity, the Zhe school and what some called its down-to-earth, "vulgar," and coarse brushwork were gradually overshadowed. Nevertheless, Dai Jin was one of the most influential artists of the Ming period, and his style continued to be copied widely.

YJL WITH QN, HL

CAT. 67.4

CAT. 67.5

CAT. 67.6

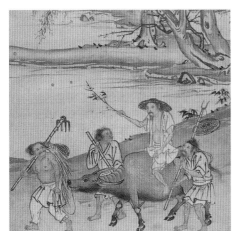

CAT. 67.7

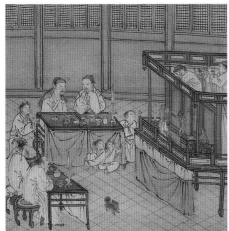

CAT. 67.8

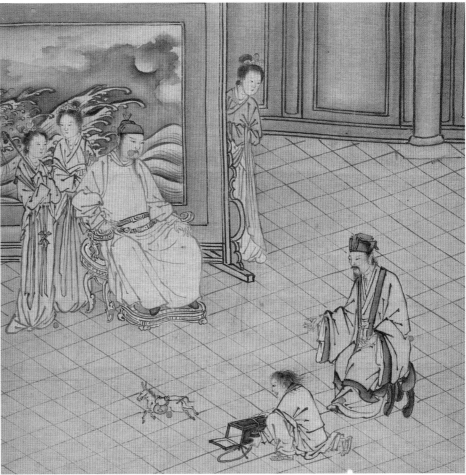

CAT. 67.9

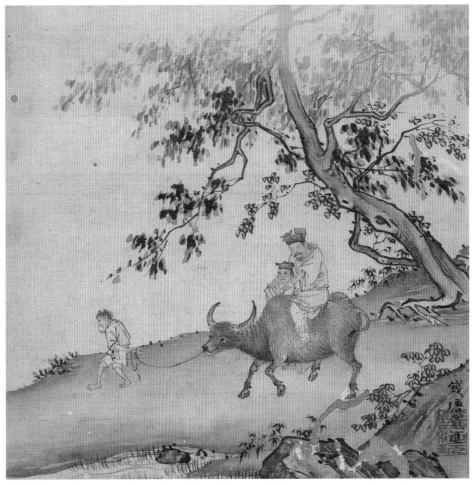

CAT. 67.10

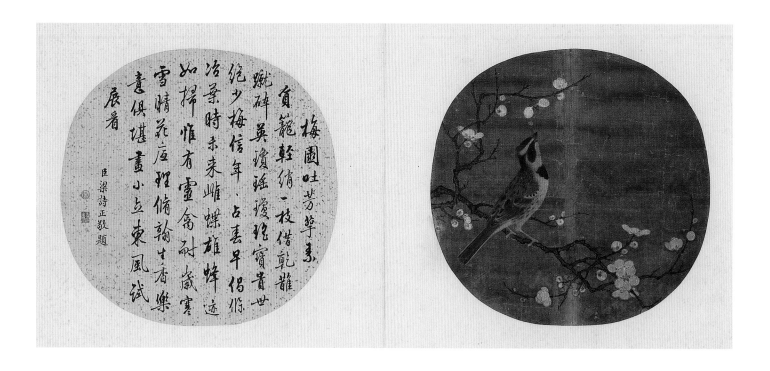

CAT. 68

明永樂−宣德朝 邊文進繪
梅花幽鳥 絹本設色冊頁

Bird and plum blossoms

Attributed to Bian Wenjin (active 1403–35)
Ming dynasty (1368–1644)
Album leaves, ink and colors on silk
H: 23.8 cm, W: 24.7 cm
Guhua 001265

Shown at the Museum of Fine Arts, Houston, only

This painting comes from an album titled *Famous Paintings from Past Dynasties*, and it extends the Song dynasty tradition of bird-and-flower painting. This exquisite composition is novel for its poetic treatment and realistic manner. A yellow-browed bunting with an eager expression perches on a branch of white flowering plum. The plum branch twists and turns as it extends across the composition and is filled with flowers and buds in various stages of bloom. The artist used thin white lines to render the shape of the petals. Despite some slight loss of pigment in the flowers, the painting still conveys the effect of a white plum bursting into blossom. Every feather of the bird is rendered in fine detail that contributes to its charm, elegance, and lively spirit.

Bian Wenjin was a native of Sha county, Fujian province. He joined the ranks of imperial court painters during the reign of Yongle and was appointed painter-in-attendance in the Hall of Military Eminence (*Wuying dian*) under Xuande. He specialized in flowers, fruits, and birds and was the best-known early Ming court bird-and-flower painter. Bian was one of the so-called Three Peerless Masters within the Forbidden Palace (along with landscape and figure painter Jiang Zicheng [active 1403–24] and tiger painter Zhao Lian [1402–24]). At the left of this composition two slightly smeared characters—"*Jingzhao,*" Bian Wenjin's nickname—suggest that he was the creator of this painting, though that attribution is not definitive. The brushwork in the plum branches bears some resemblance to Bian's, but this could also be the work of a follower, of which he inspired many.

WRL WITH SKN

CAT. 69

明宣德朝《妙法蓮華經觀世音菩薩
普門品》附《心經》
摺裝紙本泥金書寫經

*Marvelous Scripture of the Lotus
Sutra*, 1432

Translated by Yao Qin (Kumārajīva, 344–413)
Ming dynasty (1368–1644), reign of
Emperor Xuande (1426–35)
Accordion-mounted albums, gold on
indigo paper
Frame: H: 26.9, W: 12.3 cm
Gufo 000706

Shown at the Museum of Fine Arts, Houston, only

Two important works, written in gold ink, appear in this sutra: a passage on Guanyin, the bodhisattva of compassion, from the twenty-fifth chapter of *The Marvelous Scripture of the Lotus Sutra*, and the *Heart Sutra*, which condenses the *Prajnaparamita sutra*. The section on Guanyin was translated by Kumārajīva, a Buddhist monk from the kingdom of Kucha (now Xianjiang), during the time he lived in Chang'an (now Xi'an in Shaanxi province). This work falls naturally into paragraphs and has been singled out as an independent sutra. Kumārajīva describes Guanyin's compassion and the merit of reciting his names. The most common and influential translation of the *Heart Sutra* in China is the version by Xuanzang (approx. 602–64), shown in this album.

The fabric mounting of this album suggests it is the work of the Imperial Household Department. The sutra, written in elegant regular script, is accompanied by forty-two illustrations in gold, depicting the various forms of Guanyin—the common form carrying a willow; another incarnation, Amitābha Buddha, holding a lotus; esoteric representations of the bodhisattva with numerous heads and arms—rescuing sentient beings from the seven calamities: drowning, fire, weapons,

wind, demons, false imprisonment, and bandits. The lively figures are drawn with fine lines, undoubtedly the work of a court artist. Although this sutra is from the Chinese Buddhist tradition, its illustrations bear artistic elements of Tibetan Buddhist art. Later Chinese images were definitely influenced by the Sino-Tibetan art of this era.

KWL WITH TB

CAT. 70

明宣德朝 江西景德鎮 寶石紅僧帽
壺(底刻乾隆乙未仲春月御題詩)

Ewer in the shape of a monk's cap
with poem by Emperor Qianlong
carved on the bottom

Jingdezhen, Jiangxi province
Ming dynasty (1368–1644), reign of
Emperor Xuande (1426–35)
Porcelain with red glaze
H: 19.2 cm, L: mouth 16.1 cm, W: mouth 11.2 cm,
Diam: foot 7.6 cm, Depth: 16.6 cm
Guci 017764 Lü-1804-30

This Ming is the only surviving red-glazed work of its kind. So called because its mouth is shaped like a monk's cap, vessels of this sort had been produced since the Yuan dynasty, though they became even more popular during the reigns of Yongle and Xuande. This work has a sharp spout, an ornamental piece decorating the top of the flattened handle, a straight neck, round body, short foot ring, and an unglazed white foot. The lid is adorned with small rings that allow a thin rope to be affixed and secure it to the body. The surface is glazed in red, while the inside and bottom are glazed in white, with the edges left bare.

Three Qing emperors—Kangxi, Yongzheng, and Qianlong—fervently wished to make porcelain that surpassed the products of the official Ming shop. This piece was one of the most alluring to Qianlong. In the poem he engraved on the base, Qianlong stated that this piece was made during Xuande's reign and was once stored in the Studio of Supreme Harmony (*Taihe zhai*) in the residence of his father, Emperor Yongzheng, the Palace of Harmony and Peace (*Yonghe gong*), northwest of the Forbidden City. There the vessel was evidently shown in a painting depicting one of Yongzheng's concubines reading by willows.[1] Qianlong praised the ewer's smooth cinnabar-red glaze as being like "thick evening mist" and said its shape was like "a cloud top of a monk's cap." From Qianlong's poem we know that this object was produced in one of Xuande's official kilns and was universally admired for its glaze.

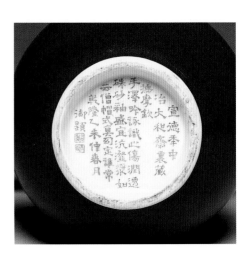

INSCRIPTION

Qianlong's poem "Sacrificial red monk's cap ewer" is engraved on the base and closes with the words "Spring of the fortieth year of Emperor Qianlong [1775]."

SEAL MARKS

"Ancient incense" (or "Classical fragrance)" (*Guxiang*) and "Great unpolished gem" (*Taipu*) carved on the base.
PCY WITH JC

1. NPM 2009, 126.

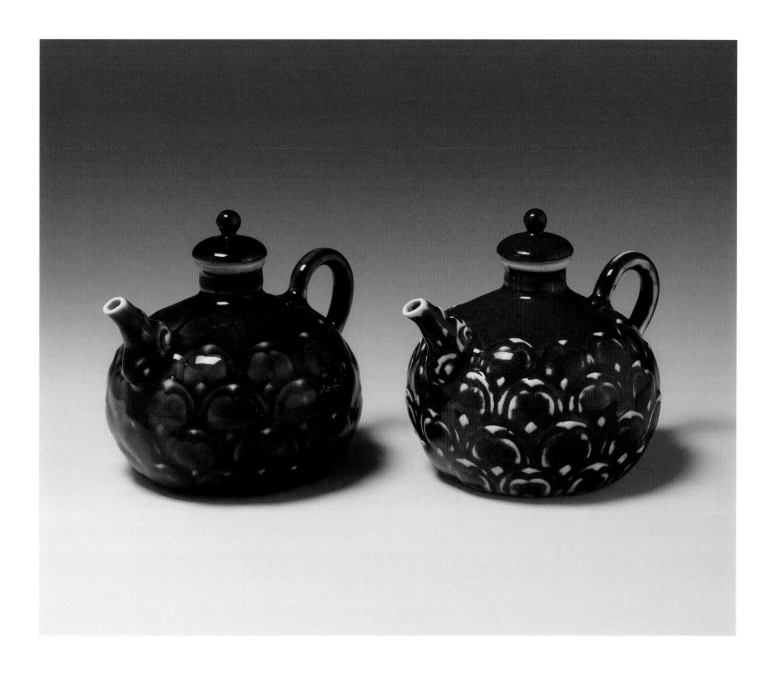

CAT. 71

明宣德朝 江西景德鎮 霽紅、霽青 蓮瓣滷壺一對

Pair of teapots with lotus petals

Jingdezhen, Jiangxi province
Ming dynasty (1368–1644), reign of
Emperor Xuande (1426–35)
Porcelain with "sacrificial" red and blue glaze
Red H: 10.5 cm, W: 14 cm
Guci 017769 Lü-1970-97-2
Blue H: 10.1 cm, W: 14 cm
Guci 017770 Lü-1970-97-1

These are the only two surviving vessels of their kind. Their intended function has not been established, though they were perhaps used as teapots, water droppers, or vessels for sauces. The painting titled *Hongli (Emperor Qianlong) Examining a Painting* by Giuseppe Castiglione (also known as Lang Shining; 1688–1766; see cat. 129) in the Palace Museum, Beijing, shows these two pots set on a table where the emperor rests his elbow—evidence that the works were appraised and collected by Qianlong.[1] A similar blue-glaze specimen of this shape was discovered in an archaeological excavation of the site of the Ming imperial kilns in Zhushan, Jingdezhen, establishing that this type of vessel was a product of the official kilns.

These oblate teapots have short spouts and curved handles, and their round lids are topped by jeweled knobs. The arched bodies are decorated by four layers of protruding lotus petals. White elements clearly show through parts of the glaze on the red teapot: near the mouth and the spout, on both sides of curved handle, as well as around the lotus petals—a distinctive characteristic of red-glazed porcelain during the reign of Xuande. The blue-glazed teapot shows traces of paste used to mend a slip in engraving.

INSCRIPTIONS

"Produced during the reign of Xuande in the Great Ming" written in regular script on the bottom of each teapot.

PCY WITH DH

1. PMB, 2008, p. 127, pl. 54.

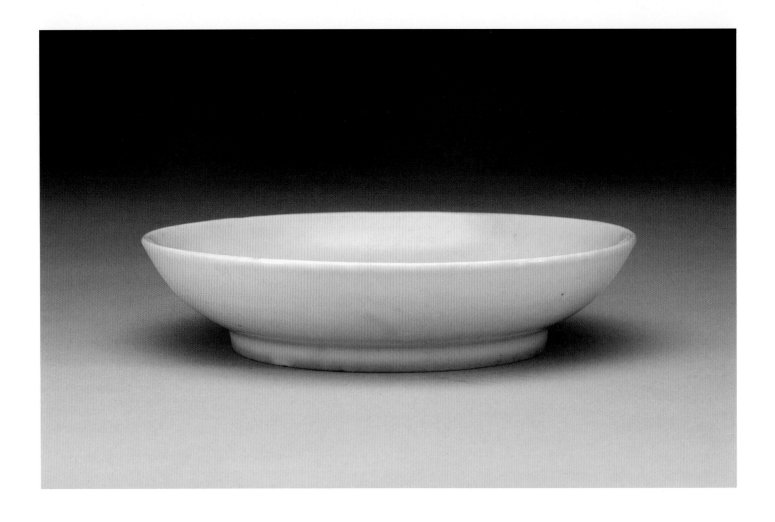

CAT. 72

明宣德朝 江西景德鎮 嬌黃釉盤
Plate with "delicate yellow" glaze

Jingdezhen, Jiangxi province
Ming dynasty (1368–1644), reign of
Emperor Xuande (1426–35)
Porcelain with "delicate yellow" glaze
H: 4.7 cm, Diam: mouth 18.3 cm, base 11.7 cm
Guci 012233 Zhen-226-5

The color yellow was imbued with great significance during the Ming dynasty and was reserved for imperial and religious purposes. The Ming *Official Clothing Codes* (1391) forbade court officials from using yellow, black, or purple clothing or tent fabric.[1] In 1446 the *Records of Ming Emperor Yingzong* (*Ming Yingzong shilu*) stated: "It is forbidden for the Raozhou [Jiangxi] government seat to privately manufacture porcelain with yellow, purple, red, green, light blue, dark blue, and white glaze." Penalties included death by dismemberment and banishment. The *Great Law of the Ming* (1502), the principal code of law during the Ming dynasty, described how sacrificial offerings required vessels of different colors: light blue for the heavens, yellow for the earth, red for the sun, and white for the moon. This plate is wide and shallow with a short, round base. It bears many scratches, evidence of its use at the time. The bottom reveals a white glaze tinged with light blue. Originally fired at a high temperature to set the white porcelain, the piece was covered with a glaze containing ferric oxide and then fired again at lower temperatures to produce the yellow glaze. During the reign of Emperor Xuande yellow glazes were poured over porcelain, resulting in an uneven surface. The subtle luster of this glaze has been termed "delicate yellow."

INSCRIPTION

"Produced during the reign of Xuande in the Great Ming" inscribed in regular script on the bottom of the dish and surrounded by two circles.

YSC WITH DH

1. Zhang Tingyu (1739) 1969, chap. 67, p. 7235.

CAT. 73

明宣德朝 江西景德鎮 青花纏枝蓮鏤空花薰

Perfumer with lotus scrolls

Jingdezhen, Jiangxi province
Ming dynasty (1368–1644), reign of
Emperor Xuande (1426–35)
Porcelain with underglaze cobalt-blue decoration
H: 40 cm, Diam: mouth 17.3 cm, base: 13.5 cm,
Circum: 58.3 cm
Guci 017815 Jin-281-47

Designed to allow the scent of perfume to escape through perforations, this ingenious perfumer is both practical and beautiful. A solidly round abdomen is divided into upper and lower parts. The top half of the vessel is crowned by decorative knobs with beads, edges, a small neck and sloping shoulder, and three layers of perforated decoration below. The lower half of the vessel tapers to a high, round flaring base. The entire vessel is divided into twelve levels of decoration that are skillfully matched. Not only is this very rare among extant perfumers, but such a piece has never been excavated from an archaeological site.

Porcelain with underglaze cobalt decoration made during the reigns of Emperors Yongle and Xuande was dazzlingly beautiful—a marked contrast to the grayish-blue porcelain from the time of Emperor Hongwu and the cool bright blue works that would be produced during the reign of Emperor Chenghua (1465–87). The major source of cobalt during the Yongle and Xuande periods was in Western Asia, as discovered by the mariner Zheng He during one of his expeditions. Starting in the mid-fifteenth century, profits from indigenous cobalt subsidized the ceramics manufacture, allowing Jingdezhen to produce massive amounts of blue-and-white wares.

LYH WITH DH

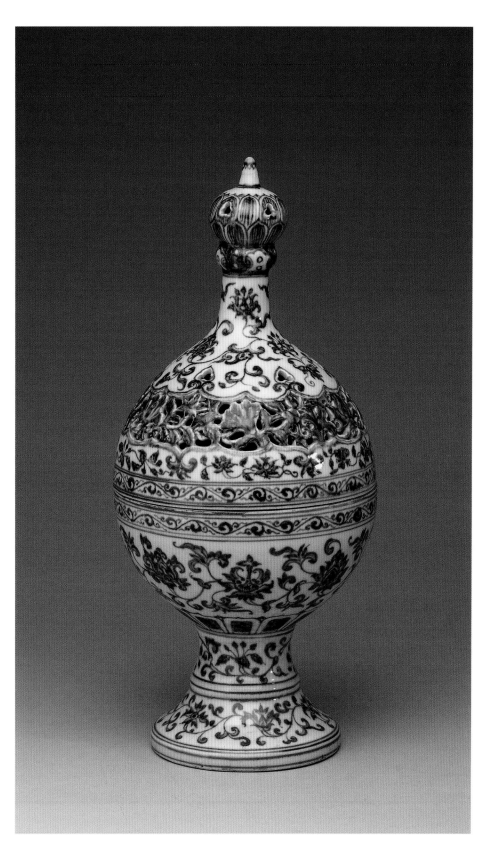

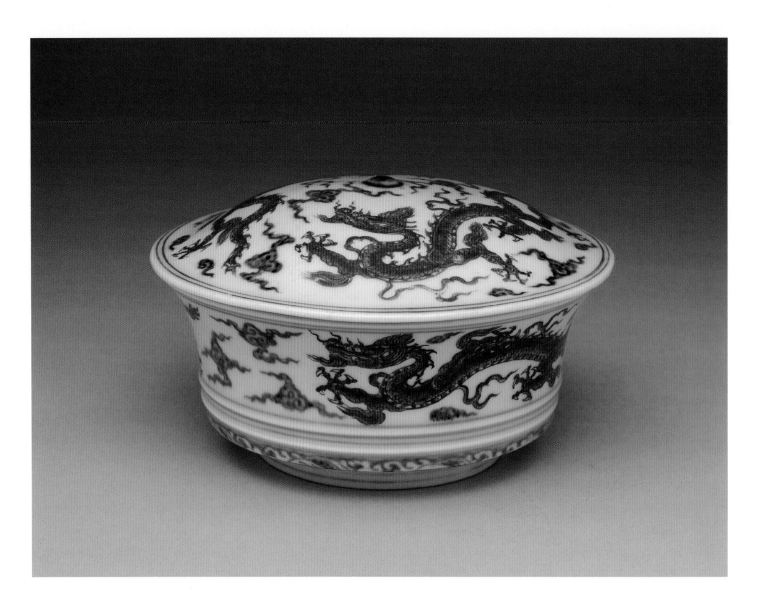

CAT. 74

明宣德朝 江西景德鎮 青花
描紅雲龍紋合碗

Lidded bowl with design of red
dragons and blue clouds

Jingdezhen, Jiangxi province
Ming dynasty (1368–1644), reign of
Emperor Xuande (1426–35)
Porcelain with underglaze cobalt-blue and
overglaze red decorations
H: 10.2 cm, Diam: mouth 17.4 cm
Guci 00802) Lü 102 3/1

This lidded bowl is a wonderful example
of underglaze blue with overglaze red
decoration first produced during the reign
of Emperor Xuande. The underglaze blue
assumes a slightly gray tinge that gently
disperses, while the overglaze red carries
orange overtones—contrasting colors
that dazzle the eye. This combination of
under- and overglaze decoration is the
result of a complex process: First, cobalt
was applied to make cloud patterns. Then,
after the waves and dragon eyes were
painted on, the piece was covered in a
transparent glaze and fired at a high tem-
perature. Once this step was complete, the
dragon was painted in red, and the piece
was fired at a low temperature. The bowl
has an exaggerated mouth, deep wall, flat
bottom, and short foot ring, and it comes
with a domed lid. Its body is well propor-
tioned, and the bowl and lid feet expose
refined unglazed clay that meets the glaze
in a faint orange color.

LYH WITH JC

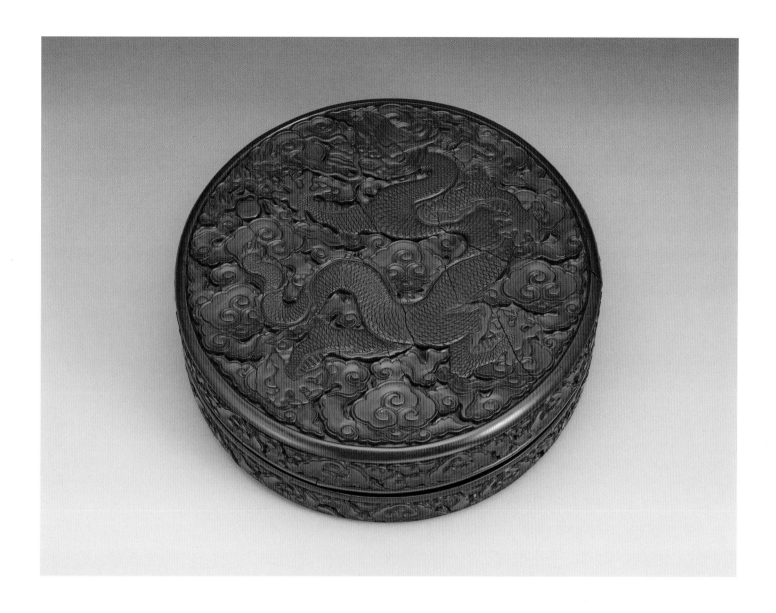

CAT. 75

明宣德朝 朱漆剔紅 雲龍圓盒

Round box with a dragon-and-cloud design

Ming dynasty (1368–1644), reign of
Emperor Xuande (1426–35)
Carved red lacquer (*tihong*)
H: 7.5 cm, Diam: mouth 23.6 cm, base 22.2 cm
Guqi 000373 Lü 1702

Shown at the Museum of Fine Arts, Houston, only

This box is the best extant example of officially produced lacquerware from the Ming dynasty. Cloud patterns fill the sides of the box, while a dragon-and-cloud design covers the lid. The five-clawed dragon, full of vigor and vitality, stretches across the lid—a detail characteristic of the era—while dense cloud patterns convey a sense of order. Each lobed cloud comprises three *ruyi* mushroom heads shaped like bean sprouts that merge in a triangular pattern—a stylized cloud design common to the period. Rigorous technique is evident in the distinct layering and positioning of the dragon-and-cloud pattern. The care taken in polishing the red lacquer—built up over a solid base of yellow lacquer—shows off its gentle and vivid texture.

INSCRIPTION
"Produced during the reign of Emperor Xuande in the Great Ming" on the base.
HHC WITH DH

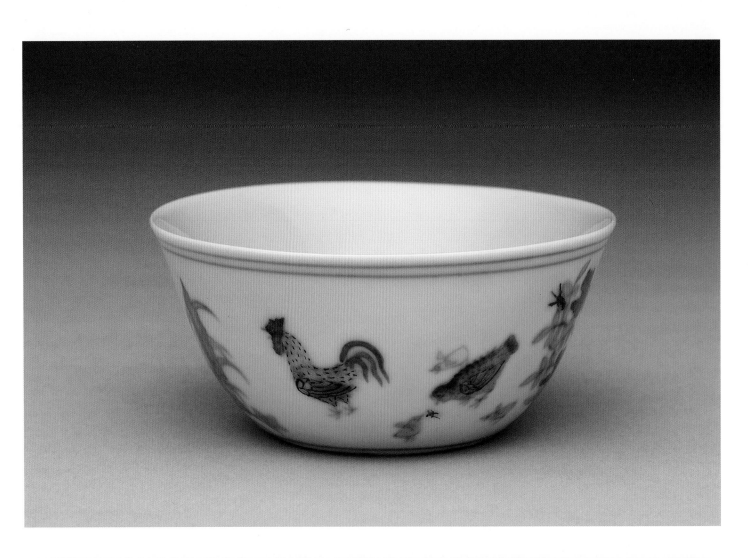

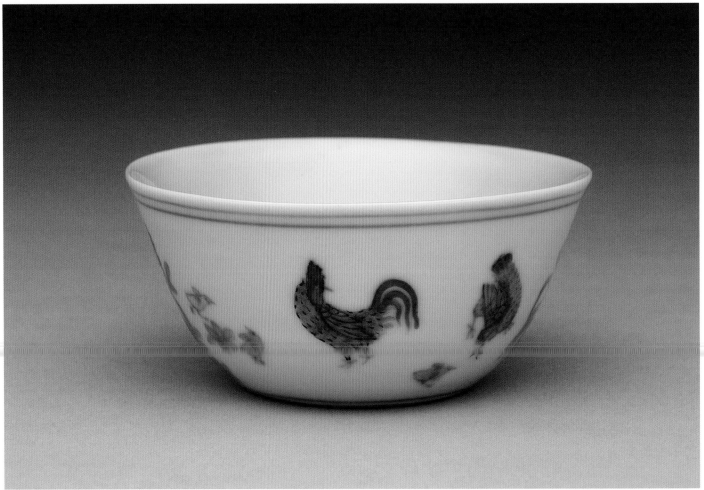

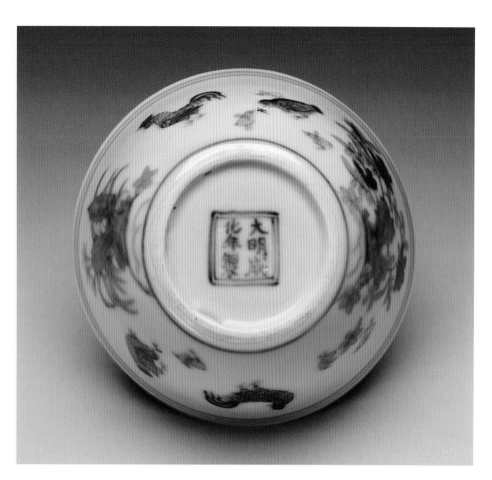

CAT. 76

明成化朝 江西景德鎮 鬥彩雞缸杯

Cup with chicken design

Jingdezhen, Jiangxi province
Ming dynasty (1368–1644), reign of
Emperor Chenghua (1465–87)
Porcelain with underglaze and overglaze
polychrome decoration
H: 3.8 cm, Diam: mouth 8.1 cm, base 4 cm
Guci 005189 Cang-164-19-1

Renowned as the "chicken cup," this small vessel represents the most extraordinary type of Ming porcelain with polychrome decorations. Two chicken families, each headed by a hen and a cock, gather near alternating rock-and-orchid and rock-and-peony compositions. The cocks—one crowing, one looking at his family—are presented as confident masters; the hens show their chicks how to find tiny insects in the grass. Nobility, wealth, and good fortune are suggested by this scene, as the Chinese word for "chicken" is a pun on the word for "luck." Further, the rock-and-peony combination was commonly used in China to represent auspiciousness.

This enchanting scene is filled with red, green, yellow, and blue, creating a marvelous elegance. Products of this type from the Ming imperial shop in Jingdezhen were called "multicolors" (*wucai*), later known as "competitive colors" (*doucai*) for the clashing colors of the under- and overglazes. This method of decoration involved applying cobalt on the raw clay to outline a design, after which the cup was glazed and fired. Then the blue outlines were filled with numerous colors on top of the glaze and fired a second time. The best examples possess a thin body that is translucent when held up to the light. The origins of this technique can be traced to an early Ming workshop, as attested to by *doucai* shards from the reign of Emperor Xuande excavated from Jingdezhen (see two images at right).[1] The porcelain was highly treasured by Xuande, and he bestowed a *doucai* bowl on the Buddhist Sa-skya Monastery in Tibet.[2] The production of *doucai* porcelain at

the factory flourished during Chenghua's reign, resulting in works of stunning quality in form and finish. By the sixteenth century Chenghua-era *doucai* porcelain commanded large sums in the art market, and in the eighteenth century it won the hearts of the Manchu emperors, with the chicken cup being copied by the Qing Imperial Workshop.

SEAL MARK
"Produced during the Chenghua reign of the Great Ming," six-character reign mark in underglaze cobalt blue within a double-lined square on the bottom.
PCY WITH HL

1. Jinquan He and Yuanjie Situ 1989, p. 260, pl. 89.

2. Shanghai Museum 2001, 183.

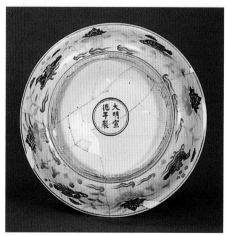

Xuande porcelain dish with underglaze and overglaze polychrome decoration.

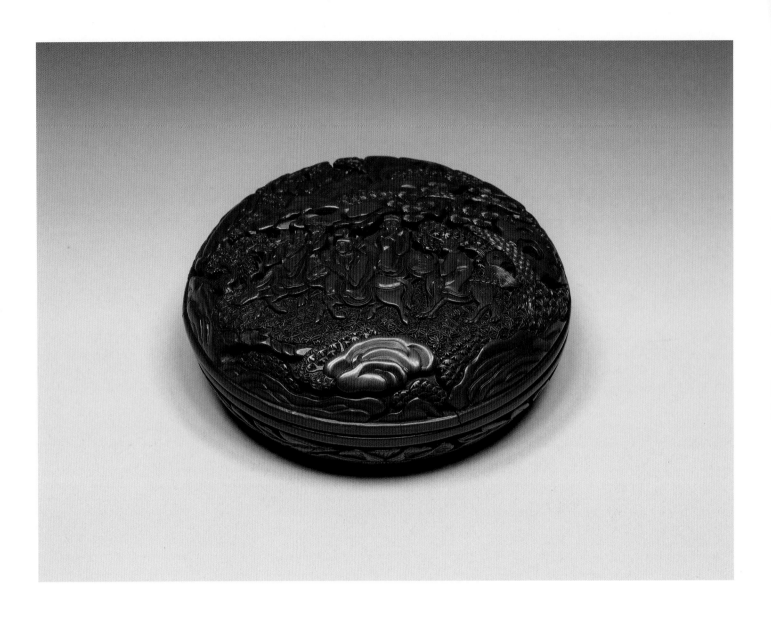

CAT. 77

明宣德款 朱漆剔紅
七賢過關圖圓盒

Round box with a scene of the seven sages crossing a mountain pass

Ming dynasty (1368–1644)
Carved red lacquer (*tihong*)
H: 3.8 cm, Diam: 8.9 cm
Guqi 000385 Lü 179-033

Shown at the Asian Art Museum only

The lid of this slender box features an engraved landscape scene of forested hills with seven figures: one is riding an ox; one rides a *qilin*, or unicorn; the rest are riding horses or mules. On the top left two riders are about to reach a pass in the mountains that tower in the background. This scene most probably depicts the Southern dynasties (317–589) legend of the Seven Sages of the Bamboo Forest crossing the pass of Emperor Di in order to visit the Dragon Gate Temple (*Longmen si*). Many Ming paintings deal with a similar theme, meaning this must have been a popular legend in the latter part of the dynasty.

The outer ring on the bottom of the case shows flower stems in partial view laid out in interconnected series, a design that differs from the floral patterns on the sides of the other cases in this exhibition. Further, the dense composition—with twisting heaps of mountain rocks generating a sense of movement under the deep,

oblique cuts—is utterly different in style and mood from the calm solidity of earlier Yongle- and Xuande-period lacquerwares. While early Ming pieces aimed to hide incision marks, here evidence of the blade is deliberately displayed. All of this—along with the harder lacquer and more detailed craftsmanship of this piece—suggests that this piece comes from the sixteenth century.

INSCRIPTION

"Produced during the reign of Xuande in the Great Ming" on the base, possibly carved at a later date.

HHC WITH DH

明景泰款 銅胎掐絲琺瑯
鹿鶴長春圖紋花插

Flower vase

Ming dynasty (1368–1644)
Copper alloy with cloisonné enamel inlays
H: 14.5 cm, Diam: mouth 8 cm, base 8 cm
Gufa 000761 Lü 1847-38

This is a splendid example of a type of metalware designed for flowers consisting of a cylindrical body and a cover pierced by seven holes. The multicolored enamel decoration of deer and cranes symbolized prosperity and immortality. These are set among plantains, sculptural rocks, and bamboo against a light blue background, evoking the traditional Chinese phrase "celebrating the vitality of spring." The vase is richly adorned with gilt metal reliefs: a high-relief mythical *kui* dragon accompanies the cranes, while three mythical creatures form feet at the base. Vessels of such richness and fine craftsmanship would have been deemed appropriate only for use in the imperial palace.

Originating in the Islamic world, the cloisonné technique was introduced to China during the Yuan dynasty (1271–1368). By the fifteenth century its elaborate inlays and colorful decorations were so highly prized that pieces were often presented to the court as tributes. The best Chinese cloisonné was made of blue enamel during the reign of Emperor Jingtai (1450–56); indeed, "Jingtai blue" (*Jingtailan*) became the common Chinese term for cloisonné. Although this vase bears the mark of Jingtai, its pictorial theme, curving cloud-like motifs, and balanced color scheme all suggest that the work came from a slightly later period, likely the late fifteenth or early sixteenth century.

SEAL MARK
"Made in the Jingtai reign of the Great Ming," six-character mark incised and filled with black enamel on the base.
YLH WITH LJ

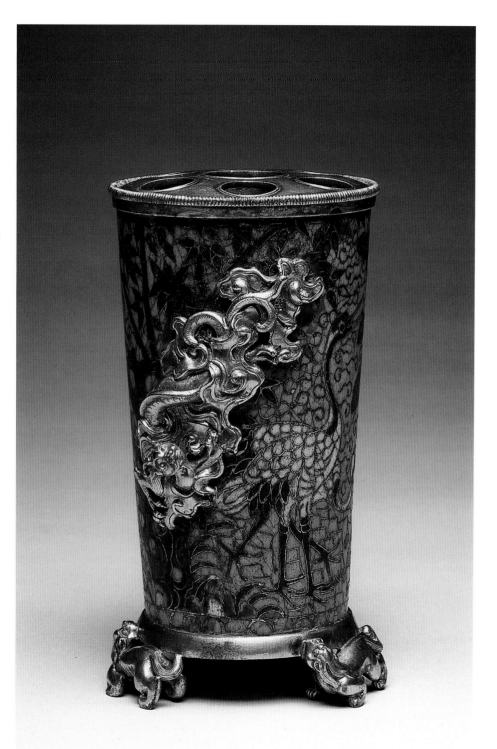

CAT. 79

明朝 白玉 魚龍花草紋帶飾二十塊

Belt ornament set with dragons, fish, and flowers

Ming dynasty (1368–1644)
Nephrite
L: 5.14–9.7 cm each
Guyu 003477–003496 Tian-1228

An important component of the ancient court uniform system, a belt set represented its owner's official rank and social status. During the Yuan and Ming dynasties, jade belts were a privilege of royalty and high-ranking officials. Since we know from historical records that Ming emperors awarded jade belt plaques to many officials and military commanders, it is difficult to determine from belt plaques alone the owner's exact rank.

Here, pure whitish jade has been fashioned into twenty plaques. Although every plaque has a different shape, the decorative motifs on each are identical, consisting of a flying dragon against a background of spiral clouds and flowers. The curvature of central veins on the leaves is finely polished. With its short, scaled body and fin, the dragon here is traditionally identified as the "fish-dragon." The fish-dragon flying among flowers was a popular motif during the middle Ming dynasty, establishing the time the set was completed. The dragon's claws are wide open, and its tail is supported by rocks and ocean waves.

The multilayered openwork of these plaques creates an extravagant visual

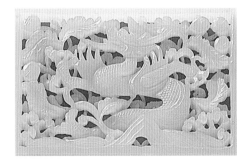

effect. Jade carving techniques reached new heights during the Yuan dynasty and only increased in sophistication during the Ming, as these artifacts prove. These jade belt ornaments and related objects were unearthed from the tomb of King Zhuang (1411–41) of the Liang Kingdom of the Ming dynasty.[1]

CLT WITH TLJ

1. Hubei Provincial Institute of Archaeology 2007, pp. 42–45.

明晚期−清初 白玉 韘形佩飾

Ornament in the shape of a thumb ring (*she*)

Ming dynasty or Qing dynasty (1368–1911)
Nephrite
L: 6.4 cm, W: 5.5 cm
Guyu 003267 Cang-161-13

Archery was the main form of combat on ancient battlefields, and archers wore leather or stone thumb rings to help shoot arrows and prevent pain from pulling the bowstring. During the Eastern Zhou period (771–221 BCE) these rings featured elegant decorations and a hook protruding from the edge. In the Western Han dynasty (206 BCE–9 CE) many high-quality jade rings, both flat and worked into intriguing designs, were not used in warfare but were collectible items associated with personal wealth.

This greenish-white jade was originally crafted into the form of a thumb ring in the Western Han period; it was later augmented by designs from the Ming dynasty and transformed into a pendant. The rectangular flange at the top right is an imitation of the hook on a Han ring. The carved animal and bird on either side of the flange were adapted from a Western Han design, but careful comparison reveals that the creatures lack the energy and strength seen in their models; visually they are rather dull, likely because their body parts are out of proportion. Further, Han thumb rings usually had clouds surrounded by circles, so choosing to decorate this ring with animals was an obvious misunderstanding of the Han style. Yet a similar style of animal ornament had been popular since the Song and Yuan dynasties, which likely inspired the jade cutter who made this piece.

CLT WITH TLJ

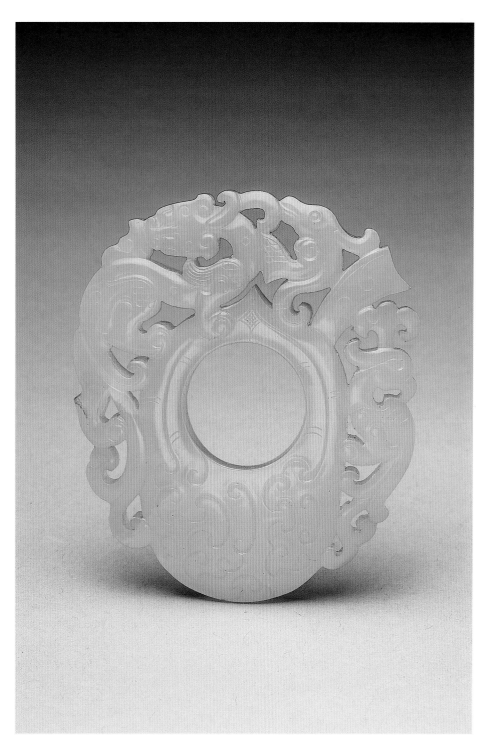

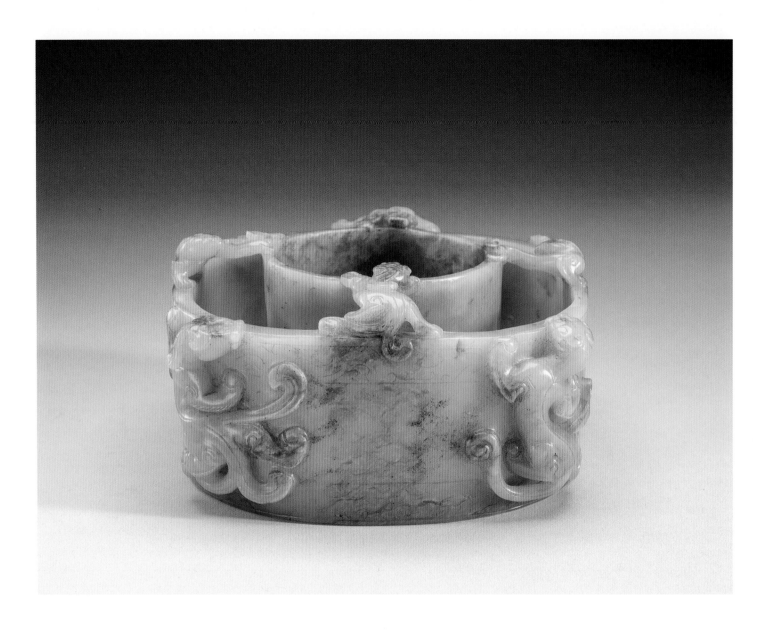

CAT. 81

明朝 青玉 仿古琮式筆洗

Brush washer with dragons

Ming dynasty (1368–1644)
Nephrite, wooden stand
H: 5.1 cm, W: 10.3 cm
Guyu 005674 Lü-1804-69

This brush washer was designed to sit on a scholar's table. Reflecting the growing popularity of scholars' curios at the time, it combines an archaic form with a contemporary design. This is an interesting example of the type as it reveals layer upon layer of multifaceted historical allusions. Made of a greenish-brown nephrite, this piece was partially dyed to give its surface an aged appearance. The body and the decoration were based on a variety of ancient objects: The form of a hollow cylindrical core set in a square exterior was adapted from a jade *cong*-tube form from the neolithic Liangzhu culture (3400–3060 BCE) in southeast China and the Qijia culture (approx. 2200–1800 BCE) in northwest China (see cat. 27). The mystical creatures at the four corners and the birds and beasts around the opening were inspired by Han-period artworks. This blending of details from different time periods reflects the Ming jade cutters' limited knowledge of ancient jades.

Han artisans often modified ancient jade *cong* tubes into new containers, reworking the base or adding extra decorations. Close examination indicates that this jade most likely originated as a neolithic *cong* tube that was then reworked during the Han period. The bottom and body of this piece bear traces of cutting tools from pre-Han times, suggesting they were made at the same time. Ming artisans, probably with no awareness of the long history of jade modifications, remade this object as a scholarly tool to appeal to the literati during the Ming period.

CLT WITH TLJ

CAT. 82

明朝 青玉 玉鰲魚形花插

Flower vase in the form of a fish

Ming dynasty (1368–1644)
Nephrite
H: 15.6 cm, W: 9.6 cm
Guyu 002171 Lü-1949

Auspicious motifs have been a power-ful inspiration in design and decoration throughout Chinese history. Expressing the human wish for happiness and suc-cess, they have been pursued over time by artists who have employed richly diverse artistic styles. This flower vase is one of the most creative examples of the use of jade's naturally occurring colors. Made of a greenish nephrite with dark infusions, the fish is shown striving to leap out of the water, its dorsal fin erect. The portrayal of the fish—with its pointed horns, long beard, authoritative snout, wide-open eyes—is so dramatic that it almost looks like a dragon head. The piece is set on an elegant wooden base carved with layers of waves, enhancing the movement sug-gested by the pose of the fish.

This work recalls the proverb "A fish jumps over the dragon gate" from a leg-end recorded in *The Record of the Three Qins (San Qin Ji)*: "Both river and ocean fish gathered under the Dragon Gate (*long men*), the one that jumped over became a dragon." The Dragon Gate is thought to be one of the most dangerous passes in the Yellow River, and fishes struggle to escape these extremely rapid currents. This serves as a metaphor encouraging those who study hard in order to succeed in civil service examinations, thus affecting their transformation from an ordinary citizen to a high-ranking official.

LTC WITH TLJ

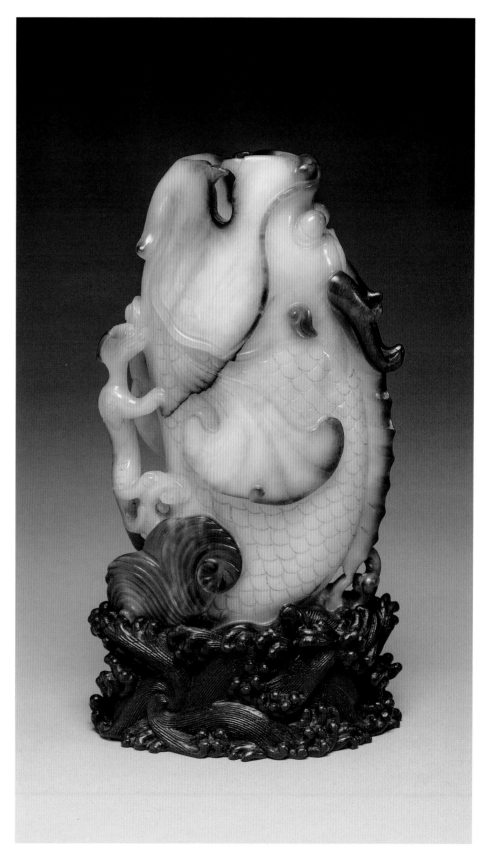

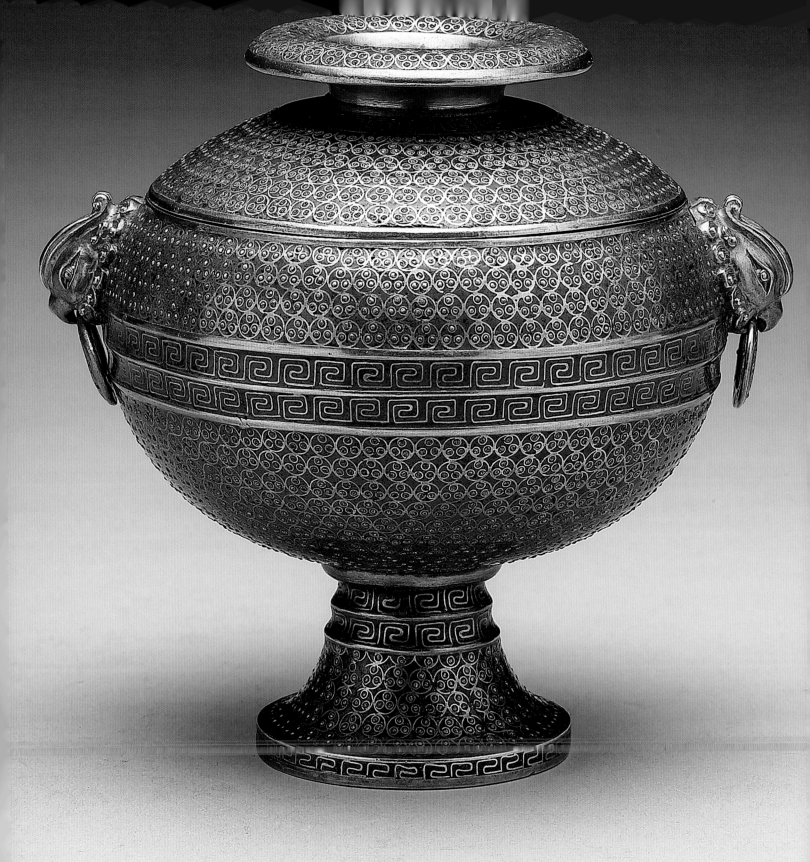

HE LI

Qing Dynasty (1644–1911): Manchu Emperors and an Empress Attain Extravagant Art

The last imperial Chinese dynasty was the Manchu-ruled Qing. Foreign influence was an important factor in stimulating the atmosphere of the court and its arts, which reached a striking level of modernism under the Qing. Eighteenth-century Chinese culture was in large part defined by three emperors: Kangxi, Yongzheng, and Qianlong. Driven by their passionate belief in the primacy of personal experiences with art, they amassed an eclectic collection of classical and contemporary art. With a confidence ensured by a prosperous economy and an understanding of Europe's technical and aesthetic advances, the three emperors shared an enthusiasm for engaging European Jesuits—some of whom were sent by King Louis XIV of France (1638–1715)—in the artistic enterprises of the Qing court and established a monopoly on the creation of cultural materials.

EMPEROR KANGXI

Kangxi (fig. 1)—who had blood ties to the Manchu, Mongols, and Han Chinese—developed a broad vision that incorporated cultural excellence, curiosity about science, and a great tolerance for different cultures. The first step in his strategy to revive China's cultural glory came in 1680, when he sought to restore the ceramics industry in Jingdezhen, which had ceased production in 1660. The court sent officials headed by Zang Yingxuan (active 1670–1700) from the Ministry of Works to Jingdezhen to restart the pottery.[1] Within three years the kilns were producing high-quality ceramics notable for a "refined biscuit, thin body, and beautifully colored glaze."[2]

In 1669 Kangxi appointed his tutor, the Flemish Jesuit Ferdinand Verbiest (also known as Nan Huairen; 1623–88), to work with Yang Guangxian (died 1669) and the German Jesuit Johann Adam Schall von Bell (also known as Tang Ruowang; 1591–1666) at the Directorate of Astronomy (*Qintian jian*) to check the solar calendar that had been translated into Chinese during the reign of Emperor Wanli (1573–1620) and improve astronomical instruments. In this role Verbiest achieved significant accomplishments in astronomy (see cat. 92). Beginning in 1670 China used the new solar calendar along with the Chinese lunar calendar.[3] Verbiest published this Chinese contribution to modern astronomy in Europe, and Kangxi and his East Asian noblemen were introduced to the West through European-language publications.

Ritual *dou* vessel with phoenix-head-shaped handles, Qing dynasty (1644–1911), reign of Emperor Yongzheng (1723–35), cat. 110

Between 1691 and 1693 Kangxi expanded engineering and arts administration by relocating the Imperial Workshop to the Palace of Benevolent Tranquility (*Cining gong*). Subworkshops were arranged by specialty and staffed by Chinese craftsmen recruited from throughout the empire as well as by Jesuits with proven abilities. In 1696, under the supervision of German Jesuit Kilian Strumpf (also known as Ji Li'an; 1655–1720), the Glass Workshop, staffed by glassmakers from Shandong, was set up in the section of southwestern Beijing that Kangxi had allocated to the Jesuits for a parish and residence.[4] The Jade Workshop primarily employed southern artisans: jade-, stone-, and ink-carvers, including the renowned Gu Gongwang (active 1710–40), hailed from Suzhou in southeastern China. The art of growing gourds in molds (see cat. 97) was perfected by the eunuch Liang Jiugong (approx. 1680–1720), who had a knack for crafts and gardening.[5]

Kangxi was enamored of the soft hues and rich shades of European glass-compound enamels, known in the Qing palace as "Western colors" (*yangcai*). Kangxi was determined to make new enamels of his own. Around 1700 the Enamel Workshop developed techniques for making new colors modeled after European samples. The French Jesuit Jean Baptiste Gravereau (also known as Chen Zhongxin; active 1710–30), a master craftsman who had worked in Limoges, was key to the establishment of Chinese enamel. By 1720 the workshop was able to produce a variety of colors.

Italian Jesuits Giuseppe Castiglione (also known as Lang Shining; 1688–1766; see cat. 129) and Matteo Ripa (also known as Ma Guoquan; 1682–1746) played an important role in the development of new painting styles in the Qing court. Castiglione was described as "a skillful artisan . . . [who] could assist the heavenly court" in a 1715 report from the governor of Guangdong to Kangxi. The emperor promptly responded: "Hurry in sending him to the capital."[6] Other Jesuits such as Pierre Jartoux (also known as Du Demei; 1668–1720), Jean Laureati (also known as Li Guo'an; 1666–1727), and Dominque Parrenin (also known as Ba Duoming; 1665–1741) published works that introduced Chinese herbs to Europe.[7] Their scientific approach stimulated Kangxi's fascination with plants, which in turn popularized botanical subjects in the arts.

FIGURE 1
Emperor Kangxi reading. Qing dynasty (1644–1911), reign of Emperor Kangxi (1662–1722). Hanging scroll, color on silk.

EMPEROR YONGZHENG

The most intriguing and multifaceted of the Qing emperors, Yongzheng (fig. 2) was notable for the marked contradictions in his personality. Before his ascension to the throne he was reputed to be "lazy Prince Yong," but he never idled during his reign. As emperor he was almost too frugal; when his subjects submitted their routine memorials, he criticized their "too luxurious materials."[8] Yongzheng may not have possessed the great executive skill of his father, Kangxi, nor did he compose many literary works as his son Qianlong did. Yet no Qing emperor cultivated as refined an aesthetic as Yongzheng. His hundreds of comments and decrees on art were faithfully documented by the Imperial Household Department in the inventory archives. His comments were rich with detail on subject, media, size, style, design, angle, method, and skill—matters that no other emperor had ever pursued. His comments were short and simple: "Not good work." "Not good seal mark." "Bad motifs." "Too thick." "The mouth is not evenly round." "Modify it." "Polish it." "Select better material." "Cut off the ear." The standard he used to judge all artworks, regardless

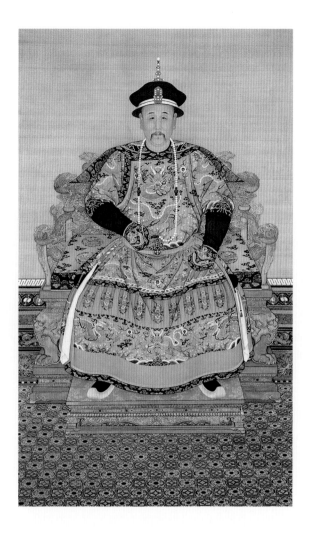

FIGURE 2

Portrait of Emperor Yongzheng in formal court attire. Qing dynasty (1644–1911), reign of Emperor Yongzheng (1723–35). Hanging scroll, color on silk.

of media, was "elegance." Themes of court art under Yongzheng were largely drawn from Daoism, mythology, legends, and auspicious symbolism, a world in which the emperor was deeply immersed.

Specialized workshops set up under the Imperial Household Department during Yongzheng's reign increased to more than thirty, including workshops specializing in jade, ivory, enamel, glass, bows for archery, brass, metal for armor, painting, porcelain, snuff bottles, *dong* pearl, filigree, firearms, flowers, landscaping, platters, gold, wood, lacquer, ink, leather, weaving, maps and drawing, keys, silver mounts, chariots, clocks, engraving, large wares, and miscellaneous works. While porcelain was based in Jingdezhen and weaving was spread across regions where those traditions flourished, most of these workshops were located in the capital: in the Forbidden City, in the Garden of Perfect Brightness (*Yuanming yuan*) about fifteen kilometers from the Forbidden City, and even Yongzheng's brother's manor adjacent to the Forbidden City. Catholic churches and residences for Jesuits may have been set up as small-scale workshops. A 1726 account records that six enamelers who used to work in the Catholic church were recalled to the Imperial Workshop.[9]

Court painters received the highest wage at eight *liang* (one *liang* = fifty grams) of silver per month and irregular bonuses. Craftsmen "runners" (*xingzou*) were paid according to their level of skill and experience: the "diligent runner" was paid six or six and half *liang* of silver monthly, the "runner on probation" three. If an artisan's work pleased the emperor, he might be awarded an extra honorarium in silver (as much as thirty *liang*) or an artwork. Skilled artisans were assigned

tasks as needed or transferred to the most privileged posts in the Studio of the Wish-Granting Wand (*Ruyi guan*), an entity with branches in both the Forbidden City and the Garden of Perfect Brightness and used by Yongzheng and Qianlong to display, collect, study, and create all kinds of artwork.[10] In general, court artisans were indentured to their workshops for years, though they were allowed to go home for special occasions such as weddings and funerals. Upon retirement or illness, a good painter or enameler was honored with a one-time sum of 100 to 120 *liang* of silver as a pension.[11]

Yongzheng delegated responsibility for art administration to his trusted brother, Prince Yi (Yunxiang; died 1730), who arranged key personnel, sought out fine artisans, calculated budgets, and worked closely with Yongzheng as the emperor's spokesman, transmitter of orders, and mediator with the Jesuits, artists, and administrators. In addition to multiple other roles in the government, Nian Xirao (died 1738) supervised the Imperial Workshop and the Jingdezhen porcelain manufacture. He was responsible for producing important drawings and wooden samples as well as for recruiting artisans. Prince Yi was assisted by three capable and dedicated officials: Shen Yu (active 1710–40), chief manager of the Imperial Workshop, concentrated his efforts on enamels;[12] Hai Wang (died 1755) ran between Prince Yi and the workshops, transmitting messages and fixing technical problems; and Tang Ying (1682–1756), a man of strong will and tenacity, was dispatched to Jingdezhen to find new ways of making fine porcelain, a role in which he made important contributions.

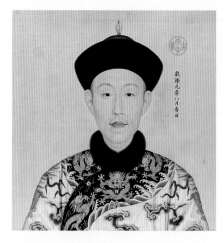

FIGURE 3

Portraits of Emperor Qianlong, the empress, and eleven imperial consorts (detail), 1736–approx. 1770s. Qing dynasty (1644–1911), reign of Emperor Qianlong (1736–95). Hand scroll, ink and color on silk.

EMPEROR QIANLONG

In 1792, after winning ten major military campaigns, Emperor Qianlong (fig. 3) gave himself a new title—"Old Man of Ten Perfections"—to glorify himself as a successful emperor blessed by "heavenly mandate."[13] Qianlong first showed signs of genius at the age of eleven, when he was first brought before his grandfather, Kangxi, who decided to keep him nearby in the Forbidden City. There, he was provided with the best education to groom him as a monarch. Taught by some of the greatest scholars of the time, Qianlong studied literature, history, and the arts. Besides excelling in outdoor activities, he was an accomplished painter, calligrapher, tea master, art connoisseur, and critic. Having composed more than 40,000 works—many of which were inscribed or carved on other artworks—Qianlong has been recognized as the most prolific poet-monarch in Chinese history, and his reign saw the highest output of artwork in Chinese history.

Like other Manchu rulers seeking to reinforce their identity as descendants of the Mongol imperial line, Qianlong devoted himself to Tibetan Buddhism. In 1745 Qianlong appointed Rolpay Dorje (1717–86), the incarnate lama of the Gelug sect and a religious adviser to Kangxi, his personal teacher. Under Qianlong's direction the two magnificent architectural centers of Tibetan Buddhism—the eight temples in the Mountain Villa for Summer Retreat in Chengde, Hebei province, and the Temple of the Precious Form (*Baoxiang si*) just west of Beijing—were completed. Religious vessels made by the Imperial Workshop reveal the adoption of the distinct styles of Tibetan Buddhist ceremonial vessels. Qianlong ordered that Jesuit, Chinese, Tibetan, and Mongol artists cooperate in creating objects and paintings—notably iconographic portraits of Qianlong and portraits of the emperor dressed as a Tibetan Buddhist monk.[14]

Qianlong's synthesis of Tibetan, Mongol, Chinese, and Western cultures was
pursued throughout the empire. His fascination with literati culture (painting, callig-
raphy, poetry, music, and board games) was rooted in his proficiency in the classics.
Scenes from stories about historical elites Wang Xizhi (approx. 303–361), Bai Juyi
(772–846), and Su Shi (1037–1101) and subjects such as tea, music, legendary sages,
and auspicious motifs were common in court arts. Qianlong cultivated a classical
aesthetic and sought delicateness or exquisiteness and a density of decoration while
denouncing signs of vulgar or low taste he perceived in jade pieces from Suzhou.[15]

More than forty workshops were mobilized to meet his demands and aimed
to orient decorative methods and artistic techniques toward Western approaches.
"Western enamels" remained a top priority. By 1720s the availability of the new,
native enamels allowed the potters at Jingdezhen to execute enameling on por-
celain. Yet the court still ordered glazed ware from Jingdezhen to be decorated at
the Enamels Workshop in the capital. The workshops continued to make enamel
materials and attained an output of 185,000 kilograms in 1743.

Jesuits who had worked for Qianlong described the emperor as someone
whose interests changed unpredictably: one day the focus would be music, the
next, engineering or architecture. Nevertheless, painting was his foremost interest,
and his routine observation of painting put heavy pressure on the Jesuit artists.[16]
Qianlong appreciated their art for its delicateness, exquisiteness, and use of color
shading to create visual effects, though he dictated that there was "no need to incor-
porate the Western style"[17] and ordered court artists to maintain the subtlety and
plainness of presentation that characterized Chinese art.

Besides painting and drawing, Qianlong charged the Jesuit artists with
decorating objects with enamel, repairing damaged enamel works, designing and
building edifices, and making clocks, tools, and mechanical animals. Jesuit and
Chinese painters collaborated by dividing responsibilities: the faces of members
of the imperial family were executed by Western masters, while surroundings and
landscapes were the responsibility of Chinese court painters. A direct manifesta-
tion of Qianlong's connection with the Jesuits was the Garden of Perfect Brightness
(fig. 4), a Western-style complex where a zodiac fountain designed by the French
Jesuit missionary Michel Benoist (also known as Jiang Youren; 1715–74) was an
evocative representation of the unity of East and West. Unlike Yongzheng, who often

granted gifts to those he favored, Qianlong usually granted honorary titles, such as "Master to the Regal Manor" (*Fengchen yuanqing*) for Castiglione, the Bohemian Jesuit Ignatius Sichelbart (also known as Ai Qimeng; 1708–80; see cats. 130–31), and Tang Ying.

Tang Ying was promoted in 1736 to concurrently oversee taxation in Jiangnan and supervise the official kiln in Jingdezhen. Visiting Jingdezhen only twice a year, Tang handed routine tasks over to Lao Ge (active 1730–60) and Liushi Yi (active 1740–70), who were appointed assistants at the official kiln in 1741. Tang Ying was motivated to experiment, and the emperor gave him specific instructions on form, design, glaze, color, marks (usually in seal script), number of items, and literary content. Sketches or wooden samples remained a required first step in the process. The official archives offer a detailed account of the correspondence between Qianlong and Tang Ying, which suggests they ran into difficulty as Qianlong became increasingly demanding. He wanted Tang to transform classical types into "new styles," while of certain new designs, such as a revolving vase (cat. 144), the emperor wrote, "no need to make it as you would common wares." Qianlong rebuked Tang Ying for "not expressing his loyalty to the utmost" and rejected requests for costly reimbursements and even demands for compensation.[18] Pieces rejected by the court were shipped back to Jiujiang to be sold wholesale.

EMPRESS DOWAGER CIXI

Compared with the three great Qing emperors, Empress Dowager Cixi (fig. 5) received scant education in literature and the arts. History portrays Cixi as a woman who enjoyed a luxurious lifestyle and had a penchant for extravagance as well as a fondness for the splendid porcelain of the eighteenth century.

The official ceramics manufacture in Jingdezhen had completely ceased production in 1855 in the aftermath of the first Opium War (1839–43). Yet on five

occasions Cixi attempted to revive production there. In 1867, for the upcoming wedding of her son, Emperor Tongzhi (reigned 1862–74), Cixi ordered the kilns at Jingdezhen to make banquet ware with the emperor's reign mark. The following year, she ordered utensils for his bride. These attempts resulted in more than 10,000 rejected products.[19] In 1873 she placed an order for an exclusive line of porcelain ware under the mark "Studio of Great Elegance" (*Daya zhai*; see cats. 157 and 158). Drawings of fifteen types of ware, mainly flowerpots and fish pots, and thirty-three designs were dispatched to Jingdezhen for execution. After an order of crane and deer sculptures was not fulfilled that year, Cixi did not place another order until 1882, in preparation for the wedding of Emperor Guangxu (reigned 1875–1908). This commission originated with forty drawings, from which 476 "delicately decorated, elegantly colored" utensils and tablewares were created. Cixi's final order, in 1890, made to mark her sixtieth birthday, was the last major official order Jingdezhen filled. Soon after, the turbulence of civil war, foreign intrusion, and peasant rebellion marked the end of the great kiln.

Cixi may not have succeeded in restoring Jingdezhen to its former glory, but she had a powerful influence on the taste of the court. Miao Jiahui (Suyun; 1841–1918), a female painting master from Yunnan, served at the Studio of the Wish-Granting Wand, tutored Cixi, and earned the Empress Dowager's patronage for more than twenty years. Not only did Miao write and paint, but she was the principal designer of the "Studio of Great Elegance" line of porcelain and the empress dowager's attire. Renowned for their blossoms, which were large in size and contrasting in color, the designs for the "Studio of Great Elegance" line served as a font of inspiration for female-dominated court fashion. Sketches of Miao's ornate porcelain patterns show dragons, flowers, auspicious motifs, and bright colors such as red, pink, green, yellow, and lavender.

Cixi's death in 1908 presaged the end of the imperial era, which officially came with the Xinhai Revolution in 1911. Thus ended imperial art in China.

NOTES

1. Zhang Xiaoyue 2007.

2. Lan Pu (1815) 1991, chap. 2.

3. *Qingshi* (1913–27) 1971, vol. 5, chap. 273, p. 3944.

4. Yang Boda 1983. Tsai Mei-fen 2011, 280–81.

5. Tsai Mei-fen 2011.

6. Zhang Xiaoyue 2007, 34. *Kangxi Hanwen zhupi zouzhe huibian* (A compilation of Kangxi's instructions written on imperial memorials in red ink in the Chinese language), Kangxi's red writing on the Yang Lin memorial on the ninth day of the ninth month in the fifty-seventh year (1718). First State Archives Library.

7. Yu Pei-chin 2014.

8. Zhongguo diyi lishi 2005, vol. 2, p. 327.

9. Ibid., vol. 1, p. 679

10. Ibid., vol. 3, p. 420.

11. Ibid., vol. 1, pp. 677–78; vol. 2, pp. 323–27.

12. Ibid., vol. 3, p. 160

13. *Yubi shiquan ji* (1792) 1971, 2575.

14. PMB 1996, 202–04.

15. NPM 1976, vol. 10, chap. 98, p. 24.

16. Zheng Dedi 2005.

17. Zhongguo diyi lishi 2005, vol. 15, p. 343.

18. Ibid., vol. 11, p. 513. Tang Ying 1735, recorded on seventeenth day of the ninth month in the eighth year of the Qianlong reign (1743).

19. Zhang Xiaoyue 2007, 41. See records of Miscellaneous, Imperial Household Department, First State Archives Library.

清康熙朝 聖祖康熙行書軸 紙本

Calligraphy in running script by Emperor Kangxi

By Xuan Ye (Emperor Kangxi, 1654–1722)
Qing dynasty (1644–1911), reign of
Emperor Kangxi (1662–1722)
Hanging scroll, ink on gold-dust paper
H: 111 cm, W: 43.2 cm, Gushu 001126

Shown at the Asian Art Museum only

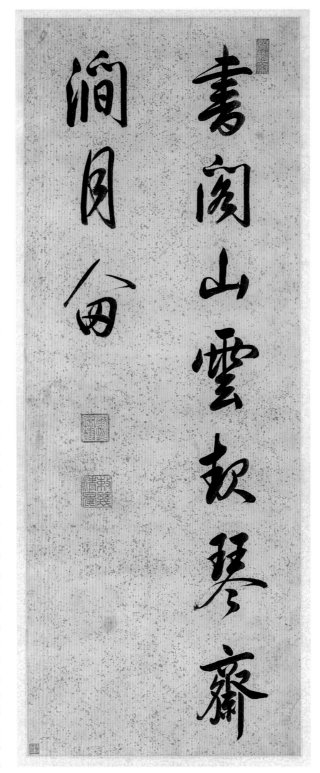

Emperor Kangxi was recognized as a child prodigy and a meticulous student. He was said to have begun his education at five and read until late at night, enjoying it tremendously and never becoming exhausted. At the age of nineteen, the young emperor told scholar Fu Dali that he felt he should do nothing but read and write in his spare time, rejecting Fu's plea to quit his lectures in the summer and stating, "The way to better learning is not by stopping."[1] Kangxi's training in calligraphy was in many ways typical of a Chinese monarch. By the time he turned twenty-eight, he was well versed in all the major styles, from that of Emperor Taizong (reigned 626–49) of the Tang dynasty to members of the Song elite, such as poet and artist Huang Tingjian (1045–1105), poet and calligrapher Mi Fu (1051–1107), and artists Zhao Mengfu (1254–1322; see cat. 42), and Dong Qichang (1555–1636). Kangxi's precociousness and talent were fostered by his instructor, Shen Quan (1624–84), a scholar famous for his painting and writing. Quan held Dong Qichang in high esteem for his calligraphy, which in turn influenced the entire court.

This work of calligraphy presents two lines of poetry, each containing five characters, from a poem by the Tang poet Cui Qiao (active approx. 700–50): "The library pavilion rises up to the clouds over the mountain; the zither (*qin*) chamber between streams renders the moon immobilized." Kangxi's mellow and smooth strokes, well-balanced forms, and naturally organized components reveal his substantial mastery of the techniques of Mi Fu and Dong Qichang. It is known that copies of this poem by Cui Qiao—or at least these two lines—were granted by Kangxi to meritorious officials and carved on a wooden board and hung on a gate on the way to his summer retreat northeast of Beijing.[2]

INSCRIPTION

A tag attached to the work reads, "Presented by a Baton Guard of the Imperial Guard, Heng Yong on bended knees." This message indicates that Kangxi had once given this work to his subject Heng Yong, who later donated it back to the imperial household.

SFW WITH QN

1. *Qingshi* (1913–27) 1971, vol. 1, chap. 6, p. 70.
2. NPM 2001, IB–11.

CAT. 84

清康熙朝 王翬繪 仿趙孟頫
江村清夏圖軸 紙本設色

*Whiling Away the Summer in a
River Village,* dated 1706

By Wang Hui (1632–1717)
Qing dynasty (1644–1911), reign of Emperor
Kangxi (1662–1722)
Hanging scroll, ink and colors on paper
H: 117.9 cm, W: 61.5 cm, Guhua 000725

Shown at the Museum of Fine Arts, Houston, only

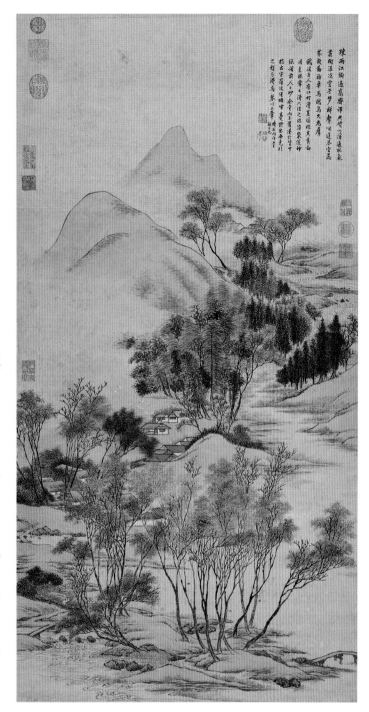

This painting is a superb example of Wang Hui's late work. It captures the scene of a river village in south China. Swallows shuttle back and forth among the trees, herons hover above and gather in the water, and the mountain slopes and riverbank reach toward the sky. Winding, meandering paths connect the homes in the rustic village. Light shades of malachite green cover the painting and enhance its cool, refreshing, delicate spirit. Areas of cloud and water are left unpainted, creating a contrast with the solid forms of the slopes, hills, and distant mountains. The dynamic arrangement of positive and negative forms is a hallmark of the dominant style of early Qing painting. In a comment following the poem he inscribed on this painting, Wang confesses that he was deeply drawn to Zhao Mengfu's painting of the same title for its integration of the classical principles of the old masters. Here Wang created a copy of the earlier masterwork, humbly noting that he "captured just a little" of Zhao's manner.

With Wang Shimin, Wang Jian (1598–1677), and Wang Yuanqi (1642–1715; see cat. 86) Wang Hui was known as one of the Four Wangs. Together they represented the orthodox school of painting in the early Qing period. Wang Hui exhibited exceptional talent for painting at a young age and received instruction from Wang Jian and Wang Shimin. He dedicated his art to integrating the best aspects of earlier painting: Yuan ink washes, Song rocks, and Tang mood.[1] Wang Hui was one of the many famous artists hired by the court to

participate in the monumental painting *The Southern Tours of Emperor Kangxi* (1691). No one else dared to begin, so Wang Hui took charge, dividing the long hand scroll into parts and allocating sections to different artists. Kangxi praised the work and bestowed upon it the characters for "landscape clear and bright" (*shanshui qinghui*—"*Qinghui*" being the emperor's nickname). The emperor wanted Wang Hui to remain at court, but the artist declined and returned to his hometown. After his death, his paintings gained even greater significance and earned him the title "painting sage."

INSCRIPTION
Wang Hui's eight-line poem describing the scene on this painting and his comment on its origins, signed "Wang Hui from Zither Stream [*Qinchuan*] on the first day of the fifth month in the year *bingwu* [1706]."

SEAL MARKS
"Seal of Wang Hui" (*Wang Hui zhiyin*); "Shi Guzi" (Wang Hiu's nickname).
YJL WITH SKN

1. *Qingshi* (1913–27) 1971, vol. 7, chap. 503, p. 5460.

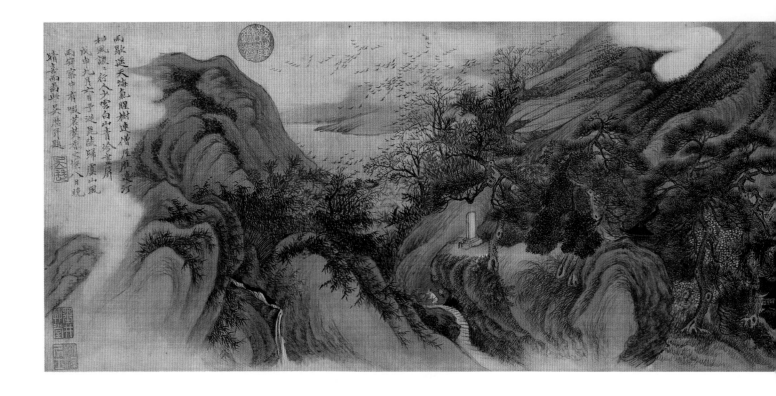

CAT. 85

清康熙朝 吳歷繪 雲白山青圖卷
絹本設色

White clouds and green mountains, 1668

By Wu Li (1632–1718)
Qing dynasty (1644–1911), reign of
Emperor Kangxi (1662–1722)
Hand scroll, ink and color on silk
H: 25.9 cm, W: 117.2 cm
Guhua 001095

Shown at the Asian Art Museum only

With its unusually intense use of green pigment, this spectacular landscape departs from the dominant style at the time. The blue-and-green landscape, which employed thick applications of indigo and green, was fully developed by Li Sixun (653–718) during the Tang dynasty but was obsolete by the fourteenth century. During the Ming dynasty, some scholar-artists attempted to revive this classical style. By Wu Li's time, the blue-and-green mountain was a popular subject in literati painting. Here, he presents a landscape composed of a series of intricate streams and mountain ranges. With the scale, breadth of vision, imposing perspective, and dramatic mountain peaks of this piece, Wu Li established a new interpretation of the blue-and-green landscape style. We know from Wu Li's inscription that he created this work in a studio, meaning that he combined actual scenery he saw on a short journey to his hometown of Changshu (near Shanghai) with fantastic scenes from his imagination.

Wu Li studied with Wang Shimin (1592–1680)—one of the so-called Four Wangs, who dominated and defined early Qing painting (cats. 85 and 86)—but Wu pursued a very different style and technique. Highly esteemed by his contemporaries, Wu's precocious talents in and mastery of the zither (*qin*), poetry, painting, and calligraphy allowed him to break with tradition in many respects. In his later years he followed a Catholic priest to Macau, where he spent seven years studying the religion and Latin. Wu devoted the rest of his life to preaching in and around Shanghai. His religious devotion prevented him from producing a large number of works.

INSCRIPTION

A poem by Wu Li: "The high sky is shrouded with sea air after the rain / trees connect the houses while wild geese roam the shores / Few men travel through the desolate pines / white clouds float on green mountains to form a painting-like screen Returning from Piling [Changzhou, Jiangsu province] to Yushan / feeling lonesome in the wind and rain / enjoying tea and incense. / It grew clear on the eighth evening; pleased, I painted this."

YLT WITH HL

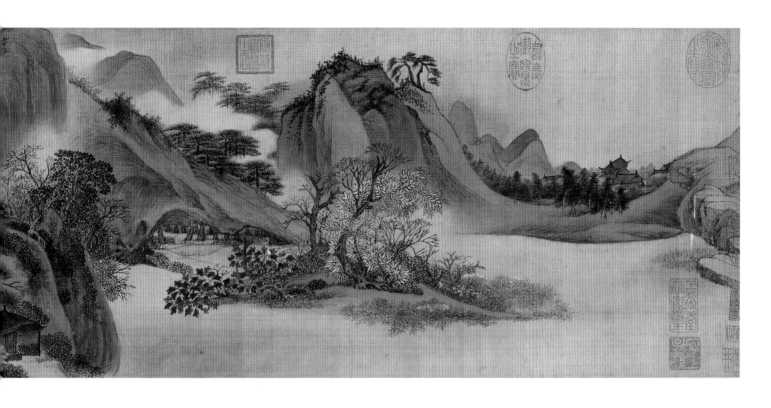

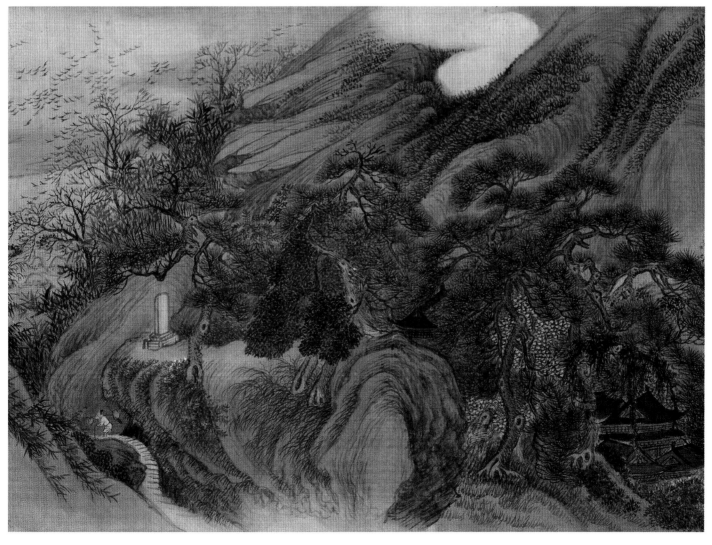

CAT. 86

清康熙朝 王原祁繪 春雲出岫軸
絹本設色

Peaks emerging from spring clouds

By Wang Yuanqi (1642–1715)
Qing dynasty (1644–1911), reign of
Emperor Kangxi (1662–1722)
Hanging scroll, ink and color on silk
H: 124 cm, W: 71 cm, Zhonghua 000052

Shown at the Asian Art Museum only

Wang Yuanqi was one of the Four Wangs, the influential and innovative group of painters who combined traditional themes with new methods and earned the patronage of the court. Wang Yuanqi pursued an intensive study of blending ink and color, achieving a heightened level of blue and green in his works. His work particularly interested Emperor Kangxi, who commented that his "paintings were a legacy to be appreciated by later generations" and often observed the artist as he worked.[1] Here, Wang Yuanqi's composition followed a traditional mode known as the "coiling dragon" arrangement (see cat. 37), setting the hills in a zigzag along a central axis. His carefully formed strokes and washes of rich ink were suffused with greens, giving the scene a fresh, spring-like atmosphere. The clouds are largely unpainted, producing an ingenious effect in an ordinary composition.

Born into a prominent family from Taicang, Jiangsu province, Wang Yuanqi was an apprentice to his grandfather, Wang Shimin, the eldest of the Four Wangs. Wang Shimin had adopted the aesthetics and principles of the late Ming official-artist Dong Qichang and later became determined to raise the status of the Yuan master Huang Gongwang (1269–1354). Wang Yuanqi served at the court of Emperor Kangxi as an expert on painting and was appointed editor in chief of *The Book of Model Paintings from Peiwen Studio* (*Peiwen zhai shuhua pu*; 1708); he also participated in drawing the work *First Anthology of the Grand Celebration of the Imperial Birthday* (cat. 91).

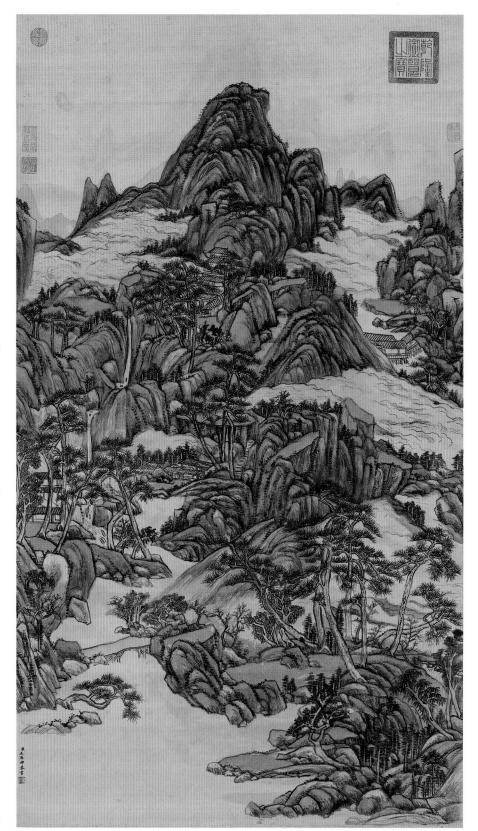

INSCRIPTION
"Respectfully painted by your subject Wang Yuanqi."

SEAL MARKS
Five seals mark the work as part of Emperor Qianlong's collection.
YJL WITH HL

1. *Qingshi* (1913–27) 1971, vol. 7, chap. 503, p. 5499.

清康熙朝 蔣廷錫繪 康熙皇帝御題
詩文 桂花圖軸 絹本設色

Osmanthus, with an inscription by Emperor Kangxi

By Jiang Tingxi (1669–1732)
Qing dynasty (1644–1911), reign of
Emperor Kangxi (1662–1722)
Hanging scroll, ink and colors on silk
H: 172.8 cm, W: 74.5 cm
Guhua 002489

Shown at the Museum of Fine Arts, Houston, only

This work is an early example of an emperor bringing a poetic element to the artwork of his officials, and it is a precursor to Emperor Qianlong's extensive inscriptions and commentaries on calligraphies and paintings. Jiang Tingxi was a high-ranking official during the reigns of Emperors Kangxi and Yongzheng. He held the post of grand secretary to Kangxi, and under Yongzheng he served in the Ministry of Rites and the Ministry of Revenue and as tutor to the crown prince.[1] He was also one of the foremost bird-and-flower painters of his time. In this painting of an osmanthus branch, Jiang drew on a diverse range of painting styles. He rendered the flowers using the "boneless" (*mogu*) technique—that is, without outlines. The shading of the leaves was expertly handled to reflect subtle variations in color as well as a feeling of restraint and transparency. Clusters of orange flower petals contrast effectively with the leaves of light and dark green. The bottom of the branch was painted using the "flying-white" technique, which left natural, uninked gaps in the paint and expressed the coarse, rough texture of the bark and the break in the branch.

To this painting Kangxi added a poem. According to archival records, this poem was written in 1678, before Jiang Tingxi entered the palace. The emperor, therefore, must have selected and inscribed on the painting a previously composed poem. The resonance between the poetic and painted imagery enhances the meaning of each. These associations are further augmented by the fact that the Chinese characters for the osmanthus plant (*yuegui*) are homonyms for the Chinese words for "moon" and "nobility," making the osmanthus branch a symbol of the moon as well as high rank.

INSCRIPTIONS

"Respectively painted by your subject Jiang Tingxi" and Tingxi's poem, "Moon Viewing at Mid-Autumn": "Sitting to view the full, round autumn moon / The exquisite osmanthus reaches high into the sky / Boundless brilliance shines wide across the barren land / Its bright, pure light illuminates to the cloud's edge."

SEAL MARKS

"Tingxi" and "Every morning playing with ink" (*Zhaozhao ranhan*).

SHC WITH SKN

1. *Qingshi* (1913–27) 1971, vol. 5, chap. 289, p. 4038.

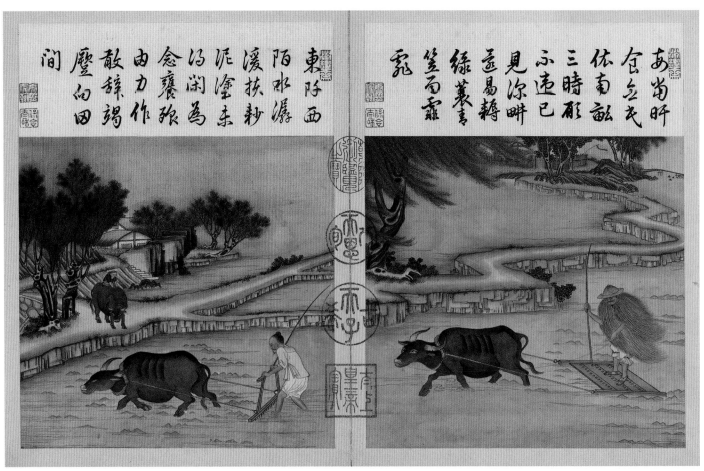

間麼的田 散辭竭 念饔飧 由力作 泥塗為 溪溪秒 陌水潺 東阡西 | 霏 筐百霏 綠蓑衣 遠易耧 見凓畔 三時那 依南畝 食出衣 安當昕

CAT. 88.1

CAT. 88

清康熙朝 冷枚繪 耕織圖冊
絹本設色

Illustrations of farming and weaving, approx. 1696

By Leng Mei (1662–1742)
Qing dynasty (1644–1911), reign of
Emperor Kangxi (1662–1722)
Album leaves, colors on silk
H: 22.8 cm, W: 24 cm
Guhua 003383

This album provides an excellent window into Kangxi's political views on governing his vast empire, which had a Han Chinese majority. His respectful attitude toward farming and weaving strengthened the ties binding the Chinese to the Manchu court. Kangxi's early realization of the importance of agriculture was deepened after his experience of plowing fields in 1672.[1] He released his first decree to produce illustrations on this subject after his inspection of Jiangnan in the southeast (1689), where he acquired an eleventh-century woodblock-printed book called *Farming and Weaving*. Based on this Song edition, the court painter Jiao Bingzhen (active 1689–1726; see cat. 90) completed a set of drawings used as models for prints and paintings.[2] This series painted by Leng Mei, produced in 1696 or soon after, was one such set.

The forty-six illustrations in this album are evenly divided between farming and weaving subjects. The section on farming illustrates the entire process, from planting to harvest. Women played the main roles in weaving, which involved caring for silkworms, spinning yarn, weaving cloth, and dyeing fabrics. These depictions—featuring compelling narratives and such precise details as a haystack, multistoried weaving machine, and waterwheel—are gorgeously executed by Leng Mei. His technical refinement, combined with the new methods of shading and coloring he learned from European-born Jesuit artists, made him one of the most capable court artists, to the point that he was given some important commissions directly by the emperor. Leng Mei was from Jiaozhou, Shandong province. He studied with Jiao Bingzhen and specialized in pictures of court ladies, landscapes, and architecture. In his long career he served Emperors Kangxi, Yongzheng, and Qianlong.

INSCRIPTIONS

The album opens with a preface by Kangxi titled "Imperial Illustrations of Farming and Weaving" (1696); attached to each page of illustrations are woodblock-printed quotations from Kangxi's poems.

LNL WITH QN, HL

1. *Qingshi* (1913–27) 1971, vol. 1, chap. 6, p. 70.
2. NPM 2011, IB-14.

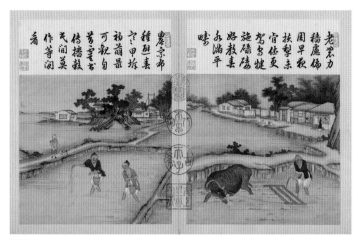

CAT. 88.2

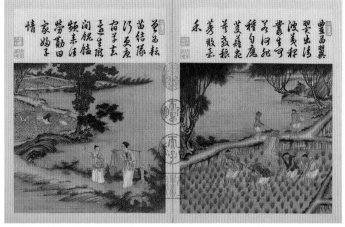

CAT. 88.3

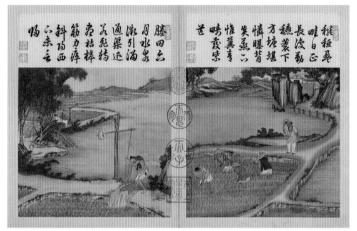

CAT. 88.4

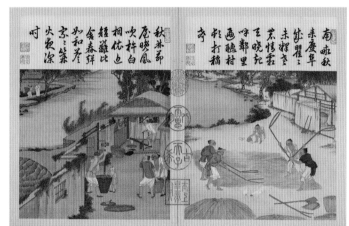

CAT. 88.5

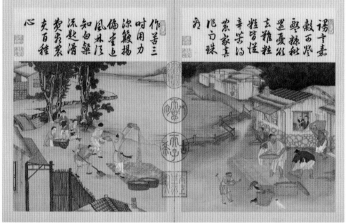

CAT. 88.6

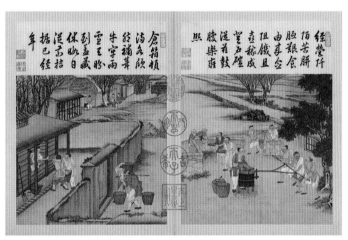

CAT. 88.7

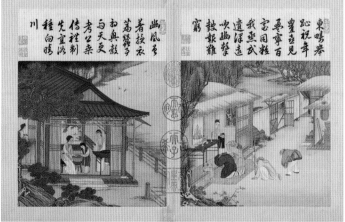

CAT. 88.8

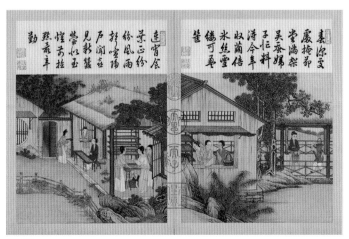

CAT. 88.9

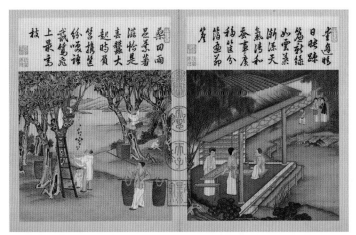

CAT. 88.10

CAT. 88.11

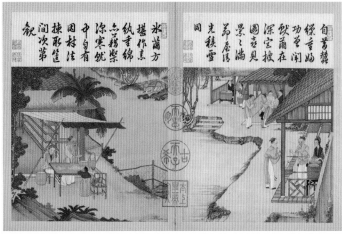

CAT. 88.12

CAT. 88.13

CAT. 88.14

CAT. 88.15

CAT. 88.16

CAT. 89

清康熙四十八年 (1709) 江西巡撫
郎廷極 奏報西洋人殷弘緒
恭進西洋葡萄酒等物送京摺 紙本

Memorial on the delivery of
Western wine to the capital, 1709

By Lang Tingji (1663–1715)
Qing dynasty (1644–1911), reign of
Emperor Kangxi (1662–1722)
Ink on paper
H: 21.7 cm, W: 10.2 cm folded
Gugong 001973

Emperor Kangxi was not initially fond of alcohol, but over time he developed an appreciation for Western wines. Age, exhaustion, and intrigue over which prince would succeed him had sapped Kangxi's health when a Western missionary who was serving as a palace adviser urged the emperor to start drinking wine. As his health improved and his spirit was restored, Kangxi began to appreciate the restorative properties of wine. In 1708 he ordered officials of the Imperial Household Department to tell governors in the south to send him wines brought into China by Westerners.

A Han Chinese soldier from Inner Mongolia, Lang Tingji served as governor of Jiangxi province and supervisor of the official kiln at Jingdezhen and was committed to developing new varieties of porcelain. The emperor valued Lang's contributions in all of his roles. This work commemorates the gifts given to the emperor by the French Jesuit scholar François Xavier d'Entrecolles (also known as Yin Hongxu; 1664–1741), including sixty-six bottles of wine. D'Entrecolles arrived in China in 1699 and went to Jiangxi to preach. After several trips to Jingdezhen, he became familiar with the process of porcelain production and sent letters back to Europe providing a systematic introduction to the porcelain technology he encountered in China. He was, thus, a key figure in instigating European imitations of Chinese porcelain.

INSCRIPTION

Emperor Kangxi's comment, in red ink: "Good job. From now on you must report to me on all the tributes from the west."

WCC WITH JC

CAT. 90

清康熙朝 焦秉貞繪 仕女圖冊
絹本設色

Court ladies

By Jiao Bingzhen (active 1689–1726)
Qing dynasty (1644–1911), reign of
Emperor Kangxi (1662–1722)
Album leaves, set of eight pages, ink and
colors on silk
H: 30.9 cm, W: 20.4 cm
Guhua 003218-0

This album depicts court ladies engaged in various leisure activities—reading books, playing chess, enjoying the view, playing instruments—around the inner palace. This subject had been popular in court painting since the eighth century, but Jiao Bingzhen revitalized the genre by incorporating Western painting techniques, rich colors, and vibrant narratives into his pictures. For example, he used Western perspective to realistically render the gardens and architectural elements through which the ladies move. The manner in which Jiao rendered his female figures—with wide foreheads, pointed chins, and open faces—helped set the standard for beauty in the Qing dynasty.

Jiao Bingzhen was a native of Jining, Shandong province, and served in the Directorate of Astronomy, which was responsible for studying celestial phenomena and calculating the calendar. The skills he employed in that role allowed him to become the first Kangxi-period court artist to incorporate Western techniques into his paintings. Jiao's refined and feminine style found favor with Emperor Kangxi and within the mainstream of early Qing court painting.[1]

WMH WITH SKN

1. *Qingshi* (1913–27) 1971, vol. 6, chap. 503, p. 5463.

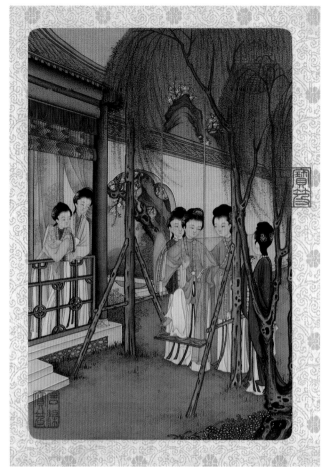

CAT. 90.1

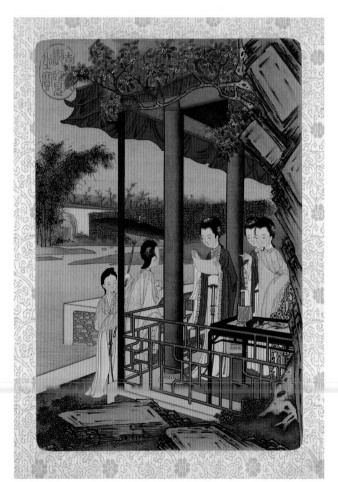

CAT. 90.2

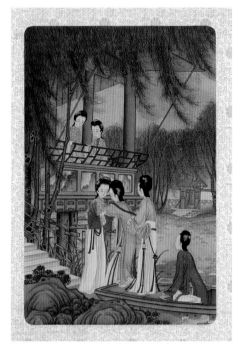

CAT. 90.3

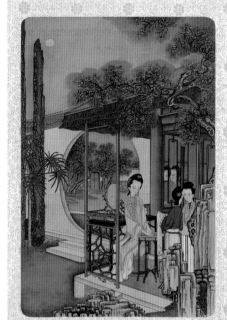

CAT. 90.4

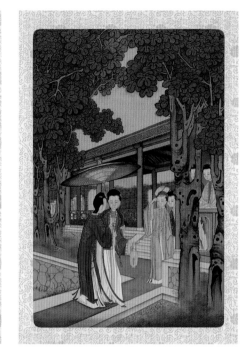

CAT. 90.5

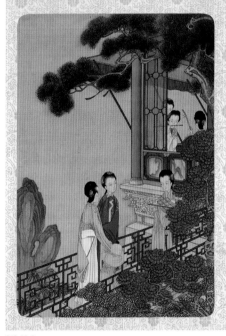

CAT. 90.6

CAT. 90.7

CAT. 90.8

CAT. 91

清康熙朝 王原祁/王掞/王弈/冷
枚/蔣廷錫/張廷玉/陳邦彥/趙熊
詔/王圖炳/張照/薄海/等奉敕撰
朱圭刻版 康熙五十六年
武英殿刊本 萬壽盛典初集

First Anthology of the Grand Celebration of the Imperial Birthday

By Wang Yuanqi (1642–1715), Leng Mei (1662–after 1742), Zhu Gui (1644–1717), and others
Qing dynasty (1644–1911), reign of Emperor Kangxi (1662–1722)
Woodblock-printed book, based on the 1717 Hall of Military Eminence edition
H: 23.4 cm, W: 17 cm
Gudian 004585, 004586

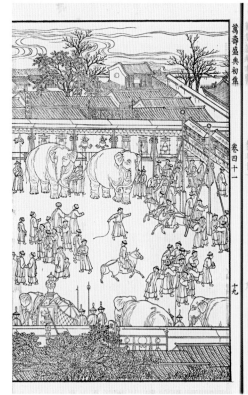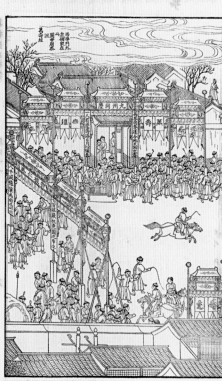

This book was commissioned in celebration of Emperor Kangxi's sixtieth birthday, on the eighteenth day of the third month (May 4) in 1713. The palace launched a sixty-day celebration that filled Beijing with great liveliness. Lanterns and ribbons decorated everything from the Garden of Enchanting Spring (*Changchun yuan*) in the Old Summer Palace northwest of the city to the Gate of Martial Prowess (*Shenwu men*) in the Forbidden City, portraying a country of great prosperity and peace. At the suggestion of his advisers, Kangxi ordered Wang Yuanqi (see cat. 86) and other artists to paint scenes recording this significant event.

The project suffered many setbacks. After the death of Wang Yuanqi in 1715, it was completed by his descendant Wang Yiqing (died 1737), Leng Mei, and others. In 1717 the paintings were etched into wood by master woodcutter Zhu Gui and published in *First Anthology of the Grand Celebration of the Imperial Birthday*. The 1717 edition was lost; the current edition was reprinted in two volumes during the Qianlong period and included a total of 142 illustrations.

The book contains prints after Wang Yuanqi's work in the section called "Celebration." Other sections include "Poetry and Literature," "Virtue," "Ceremony," "Gifts," and "Homage." This last section contains paeans from royals and officials praising Kangxi's achievements, making the book a most realistic portrayal of the emperor's sixty-day celebration festivities.[1]

SYL WITH JC

1. Chen Pao-chen 2013.

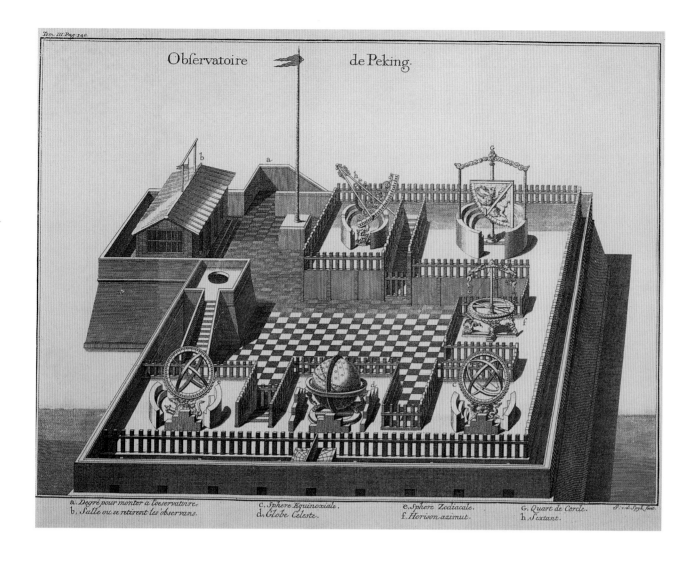

Obſervatoire de Peking.

a. *Degré pour monter a l'obſervatoire.*
b. *Salle ou se retirent les obſervans.*
c. *Sphere Equinoxiale.*
d. *Globe Celeste.*
e. *Sphere Zodiacale.*
f. *Horison azimut.*
G. *Quart de Cercle.*
h. *Sextant.*
P. v. d. Spyk fecit.

CAT. 92

清朝 1736 年 法國杜赫德製
銅板刻印 北京觀象臺

Beijing Observatory (Observatoire de Peking), 1736

By Jean-Baptiste Du Halde (French, 1674–1743)
Qing dynasty (1644–1911)
Etching and engraving on paper
H: 28 cm, W: 36 cm
Zengtu 000032

Emperor Kangxi's interest in Western science and technology led him to initiate a series of projects updating old facilities and creating new ones. Since these projects were unfamiliar to most of his Chinese subjects, Kangxi enlisted the support and assistance of Jesuit missionaries. In 1669 Kangxi granted his personal tutor, the Flemish Jesuit Ferdinand Verbiest, the authority to adapt the Western calendar system to the Chinese lunar calendar and to reequip the Beijing Ancient Observatory, built in 1442.[1] Verbiest published an account of the project in "On Astronomical Instruments and Apparatus" (1673–74) and later included eight illustrations of the new instruments from the observatory in the book *Liber Organicus* (1677–78). His *Astronomia Europea*, published in Europe in 1687, made the Beijing Ancient Observatory a great hit in European astronomical circles, and Europeans made many editions of prints of the observatory and its instruments. This particular view of the observatory—a popular one that was engraved and printed

several times—is by the French Jesuit Jean-Baptiste Du Halde.

The key at the bottom of this etching identifies the equipment depicted: a. stairway to the terrace, b. staff lounge, c. equatorial theodolite (instrument for measuring horizontal and vertical angles), d. celestial body, e. zodiac theodolite, f. altazimuth, g. quadrant, and h. sextant. The two theodolites were mislabeled (c. is the zodiac theodolite and e. is the equatorial theodolite), and two Chinese devices were left unlabeled: a flagpole and flag to determine the direction and power of the wind and a sundial, a device used by the Chinese for more than 2,000 years.

This particular work was based on page 340 in the third volume of *Description géographique, historique, chronologique, politique, et physique de l'empire de la Chine et de la Tartarie chinoise* (La Haye: H. Scheurleer, 1736).

WQZ WITH HL

1. *Qingshi* (1913–27) 1971, vol. 5, chap. 273, p. 3944.

CAT. 93

清康熙朝 造辦處 銅胎畫琺瑯
牡丹玉蘭玉堂富貴圖紋瓶

Vase with a scene of a flower-and-rock garden

By the Imperial Workshop, Beijing
Qing dynasty (1644–1911), reign of
Emperor Kangxi (1662–1722)
Copper alloy painted with enamel
H: 13.5 cm, Diam: mouth 4.2 cm, belly 7.5 cm,
base 4.4 cm, Gufa 000384 Lie-360-39

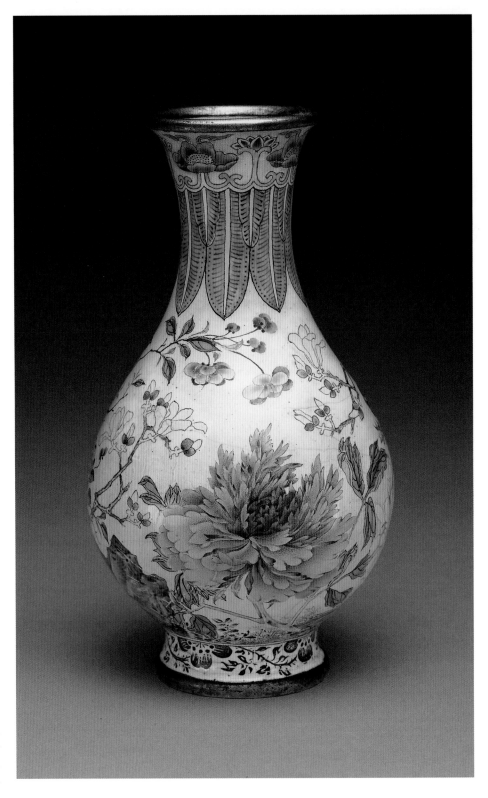

This is a superb example of copper ware with painted enamel from the Kangxi period. The mouth is decorated with camellia flowers and lotus scrollwork on a yellow background. Below them are layered banana leaves that wrap around the neck, while magnolias, Chinese crabapples, peonies, and sculptural rocks decorate the body over a white background. Black branches on a white background adorn the foot ring, and the interior of the vase is a light blue. The design employs scenic illusion techniques and alludes to the phrase wishing luck upon a person seeking high government office, wealth, and honor (*Yutang fugui*).

While the decoration on this vase is relatively simple, it is stately and striking. Color was applied to the precisely painted peonies with delicate brushstrokes, much like the depictions of peonies by Qing dynasty painter Yun Shouping (1633–1690), which are known for their elegance. Newly available pink pigments were used to render the fragile flowers, and they pair especially well with the crystal blue of the sculptural rocks. Other flower blossoms and buds are equally vivacious. Close evaluation of the floral decorations shows the painted strokes emphasize the play of light, creating a three-dimensional effect. This piece was registered and allocated to be used at the Palace of Heavenly Purity (*Qianqing gong*) during Emperor Qianlong's reign.

SEAL MARK

"Produced during the Kangxi reign," four-character underglaze cobalt-blue seal with a double-lined border on a white background on the bottom.

YLH WITH JC

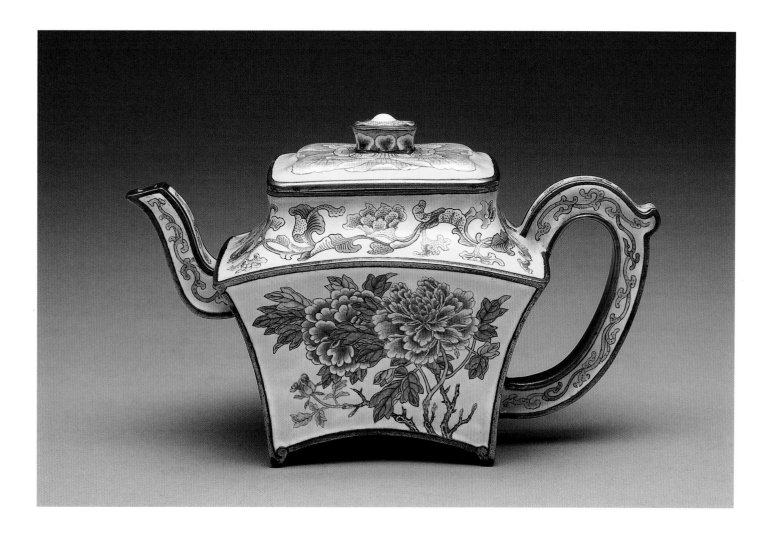

CAT. 94

清康熙朝 造辦處 銅胎畫琺瑯
牡丹紋方壺

Square teapot with peony design

By the Imperial Workshop, Beijing
Qing dynasty (1644–1911), reign of
Emperor Kangxi (1662–1722)
Copper alloy painted with enamel
H: 9 cm, L: 14.4 cm, W: 7.3 cm
Gufa 000224 Lie-360-60

The enamel painting technique originated in France and was introduced to China by European merchants and Jesuit missionaries in the sixteenth century. The first Chinese metalwork painted with enamels was made in Guangzhou. Those works combined rich ground colors with delicately painted flowers, and they soon aroused Emperor Kangxi's curiosity. With help from the Jesuits, Kangxi established an enamel studio or studios overseen by the Imperial Workshop in Beijing. Craftsmen from Guangzhou were then summoned to the studio to produce painted enamelware for the emperor and his family.

This teapot, with its unique form and bright color scheme, is an excellent example of work produced by the Imperial Workshop during the Kangxi period. One of the charms of this piece is the manner in which round and square forms meet in gilded flanges. The painted sprays of peonies on all four sides are enriched by the floral scrolls on the shoulder, swirling scrolls along the spout, and a single embossed peony in full blossom on the

top of the lid. The Qing imperial household archives recorded that, starting in 1738, all objects with new enamel decorations made during the reigns of Emperors Kangxi, Yongzheng, and Qianlong were to have matching containers made and were to be placed in the Hall of Dignified Concentration (*Duanning dian*), a secondary hall within the Palace of Heavenly Purity (*Qianqing gong*).

SEAL MARK
"Made for the Kangxi court," four-character reign mark in red standard script framed by a double-lined square against a white enamel background on the base.
YLH WITH LJ

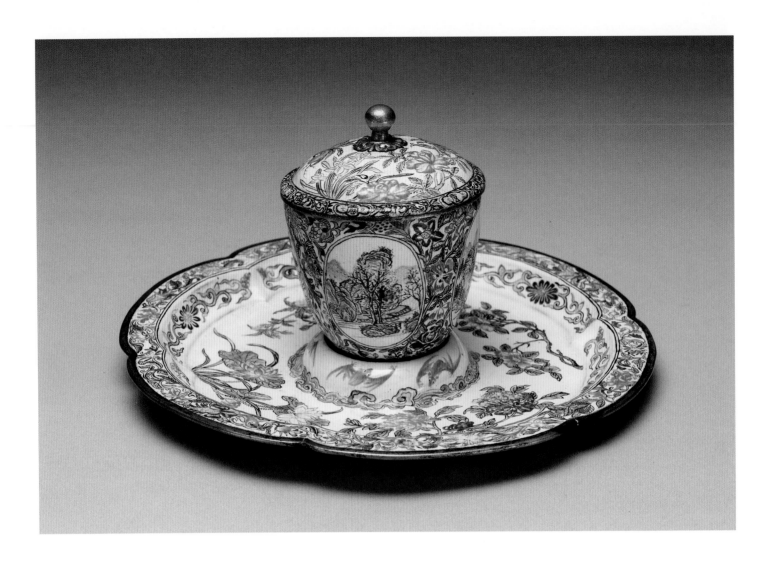

CAT. 95

清康熙朝 銅胎畫琺瑯 五蝠捧壽、
鴻福齊天圖紋 盃盤

Cup and saucer set

By the Imperial Workshop, Beijing
Qing dynasty (1644–1911), reign of
Emperor Kangxi (1662–1722)
Copper alloy painted with enamel
Cup H: 6.8 cm, Diam: 5.3 cm
Saucer H: 1.4 cm, Diam: 15.1 cm
Gufa 000550, 000551 Lie-360-54

With the influx of European-born Jesuits during the reign of Emperor Kangxi, trade between China and the West resulted in a new sharing of art and technology. For example, Chinese dishes that made their way to Europe during this era strongly influenced European tableware. By the seventeenth and eighteenth centuries, Europeans had become accustomed to using the cup and saucer sets they received from China and started their own production of the paired style, such as in the wares produced by the royal Saint-Cloud factory in France.

This tea set includes a conical lidded cup and a shallow, six-petal, flower-edged saucer that is densely and diversely decorated with floral designs reminiscent of European enamelware. Adorning both the cup and the saucer are brown floral designs, lucky red bats for good fortune (the Chinese word for "bat" is a pun on "blessing"), and symbols for the Chinese character *shou*, meaning "longevity." The cup is painted with four landscape designs

set among intertwining foliage. The lid is painted with peach branches, narcissus flowers, Chinese roses, and other flora that represent spring, youth, and auspiciousness; its edge is gilded and further decorated with an outer ring of yellow enamel. The gold lotus-petal topper with bright yellow enamel edging makes this piece even more beautiful. Sky-blue enamel pigments are used on the inside wall of the cup and the bottom of the saucer, while the outside surfaces have an underglaze of white enamel.

During the reign of Emperor Qianlong this cup and saucer set was placed in a wooden box with the inscription "set of copper and Western-style enamel of the Kangxi period."

SEAL MARK

"Produced by imperial order of Emperor Kangxi," four-character mark in deep-blue regular script on the base of the saucer.
HWC WITH JC

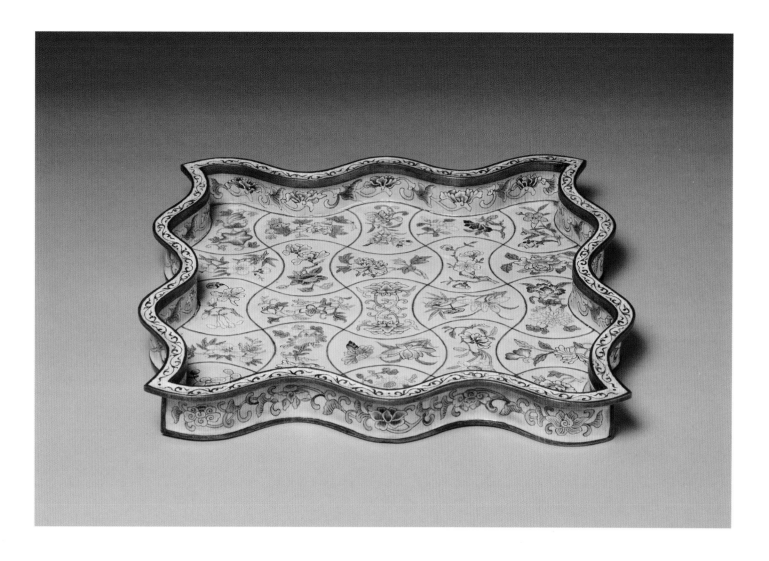

CAT. 96

清康熙朝 銅胎畫琺瑯 四季花卉
繁盛圖紋方盤

Square plate with floral decoration

By the Imperial Workshop, Beijing
Qing dynasty (1644–1911), reign of
Emperor Kangxi (1662–1722)
Copper with polychrome enamels
H: 2.2 cm, L: 18.8 cm, W: 18.8 cm
Gufa 000375 Lie-360-36

Advances in the production of copper painted with enamel during the Kangxi period are exquisitely demonstrated in this elaborate plate. The arcs of the outer wall and edges make the copper base appear soft and relaxed, varying greatly from traditional Chinese flower or polygonal dishes. The entire piece is decorated with a mix of Chinese and Western imagery that is meticulously and finely painted. The body is thickly pigmented in rich enamel colors with very few bubbles, demonstrating the expert skill and innovation of craftsmen in the Imperial Workshop during Kangxi's reign.

Each of the plate's twenty-five gridded sections is painted with flowers or matching blossoms. There are more than fifteen varieties of plants depicted on the plate, alluding to imagery of lush imperial gardens, and no floral design or pairing is repeated. The center of the grid includes two entwined lotus flowers that are filled with auspicious meaning. The inner and outer walls are also surrounded by flowers whose patterns reflect one another by flowing in the opposite direction.

The bottom of this plate has the same vertical and horizontal curved lines dividing the twenty-five sections, each with repeated inverted drumlike bottle shapes. Each section has a white base with pale blue, yellow, green, purple, and peach decorations of hornless dragons, banana leaves, flowers, flowing scrolls, and other patterns. The contrast of the deep hues and light colors within the interlocking sections produces an ethereal, prismatic effect.

SEAL MARK
"Produced by imperial order of Emperor Kangxi," four-character mark in regular script at the center of the base.
HWC WITH JC

清康熙朝 壺蘆番蓮紋瓶

Gourd vase with a design of lotus scrolls

Qing dynasty (1644–1911), reign of
Emperor Kangxi (1662–1722)
Mold-grown gourd, hawksbill turtle-shell band
H: 23.5 cm, Diam: 11.5 cm
Gudiao 000309 Tian-398

The gourd was the most common of every-day items in ancient times. Many famous Tang-era (618–907) poets praised the wine gourd for its natural beauty, affordability, and utility. Nevertheless, it had never been viewed as a vessel worthy of the impe-rial court until Emperor Kangxi's day. Responding to the interest of Kangxi and Emperor Qianlong, the Qing court experi-mented with growing a considerable quan-tity and variety of gourds in the Fengze Garden in the royal park to the west of the Forbidden City. Young gourds were placed in wooden or ceramic molds that imprinted relief patterns on the gourds as they grew.[1] The court made elaborate gourd molds to fashion bottles, basins, bowls, and boxes.

This long-necked bottle is a fine exam-ple from the Fengze Garden. The four ver-tical seams show that the gourd was grown in a four-piece mold. A graceful shape, echoing contemporary porcelain, features exquisite lotus scrolls around the middle of the body that are set off by bands of floral scrollwork and wish-granting wand (*ruyi*) mushroom heads. A band of hawksbill tur-tle shell was set into the mouth rim.

INSCRIPTION
"The depiction is a relief but not by carv-ing / the piece was molded but not of a porcelain / all can be man-made / only due to excellent crafting," poem by Emperor Qianlong carved on the edge of the foot ring in 1781.

SEAL MARK
"Ancient fragrance" (*Guxiang*).
YLH WITH TLJ

1. Wang Shixiang 1992, 46.

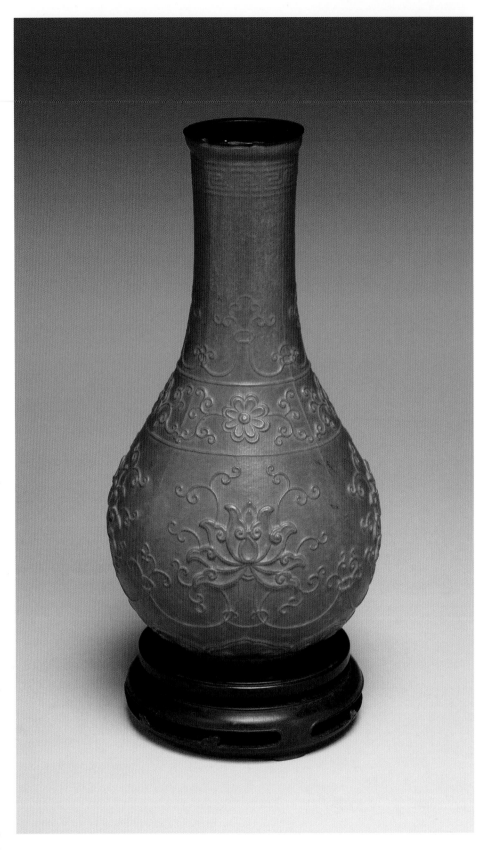

CAT. 98

清康熙朝 造辦處 玻璃胎畫琺瑯
藍地牡丹紋膽式瓶

Glass vase with peony blossoms

By the Imperial Workshop, Beijing
Qing dynasty (1644–1911), reign of
Emperor Kangxi (1662–1722)
Glass painted with enamel
H: 12.6 cm, Diam: mouth 3.1 cm, base 3.8 cm
Guci 017588 Lie-360-73

Qing dynasty glasswork factories were established in 1696, and glass objects painted with enamel were highly revered by Emperor Kangxi. He presented them as gifts to an envoy of the pope and, according to the account of Gao Shiqi (1644–1703), saw court glassware as proof of the "Great Qing's superiority over the West."[1]

This white glass vase—with its exaggerated mouth, long neck, and drooping belly—has a rich blue background that is painted with intertwined peonies. Pale yellow-green enamel petals alternate with darker leaves that fade to pale pink where they meet the outline of the flower. Leaf veins are clearly visible, guiding the eye from the bottom as the foliage climbs the vase. The mouth and foot are left with a white rim, while the top and bottom feature painted gold bands. The painting on this vase is exquisite, all the more so as it was done entirely on glass.

The vase was accompanied by a wooden box whose lid was engraved with the words "One glass vase with painted enamel flowers on a blue background produced during the Kangxi reign." Emperor Qianlong issued an edict for pairing wooden boxes with painted-enamel objects, including this vase, as confirmed in the Qing imperial document "Display files of enameled glassware."[2]

PCY WITH JC

1. Gao Shiqi (1644–1703) 1964.

2. Record from 1835, Archives of Display Wares of Enameled Glass and Porcelain, Imperial Household Archives, National Palace Museum.

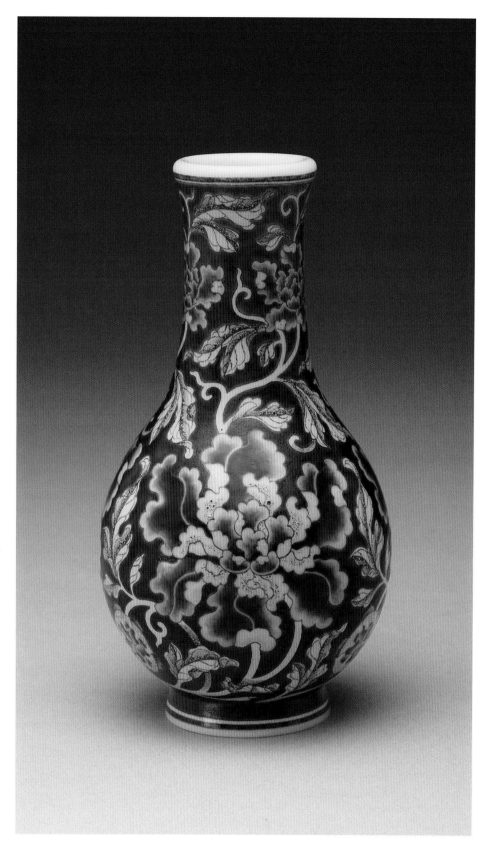

CATS 99, 100, AND 101

清康熙朝 江西景德鎮 豇豆紅 菊瓣瓶 、 柳葉瓶、印盒

Vase with chrysanthemum petal design and "bean-red" glaze

H: 20.9, Diam: mouth 5 cm, base 4 cm
Zhongci 000656 T3596

Bottle in the shape of a willow leaf with "bean-red" glaze

H: 14.6 cm, Diam: mouth 3.2 cm, base: 2.2 cm
Zhongci 001444 T1248

Seal-paste box with "bean-red" glaze

H: 3.7 cm, Diam: mouth: 7.2 cm, bottom: 3.5 cm
Zhongci 004421 T1592

Jingdezhen, Jiangxi province
Qing dynasty (1644–1911), reign of
Emperor Kangxi (1662–1722)
Porcelain with copper-red glaze

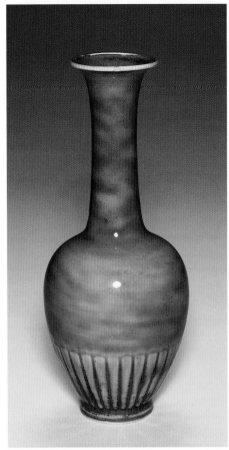

CAT. 99.1

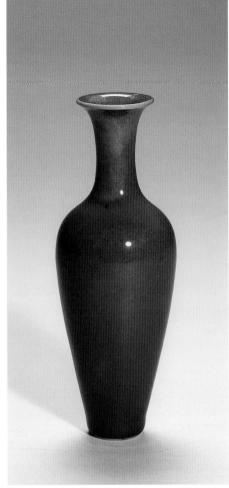

CAT. 100

CAT. 99.2

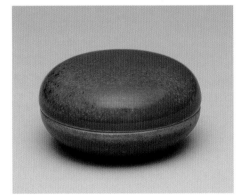

CAT. 101

Monochrome glaze porcelain was very popular during the reign of Kangxi. The "bean-red" glaze was an innovation of the Imperial Workshop in Jingdezhen that employed copper as a coloring additive. The letters of François Xavier d'Entrecolles, a French Jesuit missionary, reveal that it was applied as a blown soufflé glaze and then fired at a high temperature. Trace amounts of copper in the glaze produced light apple-green and dark moss-green speckles due to oxidation and reduction during the firing process. These specks are scattered irregularly throughout the glaze and resemble interesting bean shapes—hence the name "bean-red" glaze.

These vessels are excellent examples of "bean-red" glaze porcelain ware. The vase with the chrysanthemum petals has a flaring rim and a narrow, long neck, and toward the bottom are stamped thirty neatly organized chrysanthemum petals. The willow-leaf bottle also has a flaring rim and a narrow neck, but its shoulders slope more gently. The seal-paste box, meanwhile, is in the shape of a steamed cake. The glaze of all three vessels show speckles of green, while the interior and bottom of the base of each has a transparent glaze.

INSCRIPTIONS
"Produced during the reign of Kangxi in the Great Qing" on the base of each vessel.
LYH WITH DH

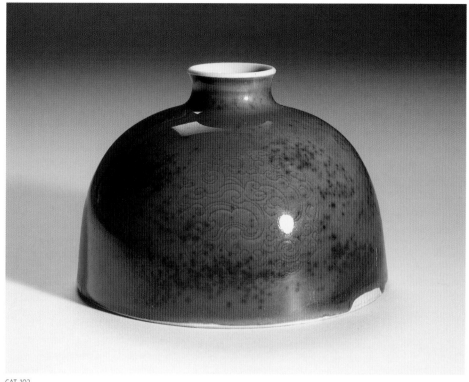

CAT. 102

CATS. 102 AND 103

清康熙 江西景德鎮 豇豆紅
太白尊、萊菔瓶

Water container with "bean-red" glaze

H: 8.6 cm, Diam: mouth 3.3 cm, bottom 12.5 cm
Zhongci 000011 T4022

Turnip-shaped vase with "bean-red" glaze

H: 20.2 cm, Diam: 3 cm
Guci 0014126 Wei-379-7

Jingdezhen, Jiangxi province
Qing dynasty (1644–1911), reign of
Emperor Kangxi (1662–1722)
Porcelain with copper-red glaze

Kangxi-era "bean-red" glaze porcelain, intended for the use of the inner court, was produced in small quantities in official kilns due to the technical difficulties of the firing process. Extant pieces are mostly small, delicate items, mainly designed for everyday use or for display in the studios of scholars. Both items here have a fine, glossy glaze and superb, dignified forms that convey the graceful elegance of objects made for the Kangxi court.

The water container has a small flared rim and a recessed base. A white glaze was applied along the rim, inside the vessel, and on the bottom of the base, while the rest of the exterior is covered with "bean-red" glaze, beneath which are subtly imprinted three round sets of stamped, coiling dragons. This vessel may have been used to hold water in a literary studio and resembles the wine vessel used by the Tang-era poet Li Bai (701–62), who was renowned for composing excellent lines when drunk.

The turnip-shaped vase, with its wide shoulders, does indeed resemble a root vegetable. It might have been used to hold flowers on a tabletop. The vase has a small flared rim that descends into a narrow

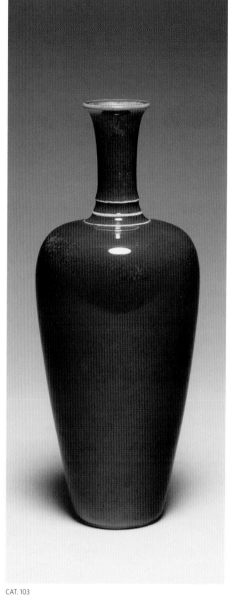

CAT. 103

neck. A translucent glaze was applied to the vase's interior and the bottom of the base, with the "bean-red" glaze covering the exterior. Three protruding ridges decorate the neck, with the white of the porcelain visible through the thinner glaze there.

INSCRIPTIONS
"Produced during the reign of Kangxi in the Great Qing" on the base of both vessels.

LYH WITH DH

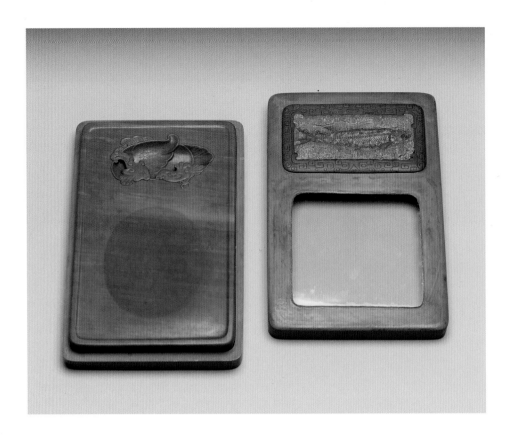

CAT. 104

清康熙朝 綠松花石雙鳳硯
附嵌魚化石、玻璃面灰綠松花石
外盒

Inkstone featuring phoenix
decoration with fitted case and
fish-fossil inlay

By the Imperial Workshop, Beijing
Qing dynasty (1644–1911), reign of
Emperor Kangxi (1662–1722)
Songhua stone, fish fossil, and clear glass
Inkstone H: 1.6 cm, L: 17.1 cm, W: 11.2 cm;
case H: 3.9 cm, L: 18.3 cm, W 12.4 cm
Guwen 001372 Teng-98-14

The Manchus were especially partial to materials from their homeland, such as Songhua stone from the Songhua River of Jilin province in northeastern China. Songhua stone is a green limestone with colorful veins that was often used as a whetstone. Emperor Kangxi found the hard but extremely smooth mineral ideally suited for the manufacture of inkstones and restricted its mining and use to the Imperial Workshop. Songhua stone inspired creative designs, and the manufacture of inkstones reached its height during the Kangxi, Yongzheng, and Qianlong eras.

This rectangular inkstone was once owned and used by Emperor Kangxi. It has a raised edge, with the depression in the center forming the grinding area. Two openwork phoenixes are carved above the ink pool. On the reverse is a poem by the emperor, carved in relief, praising the stone's fine quality. The case is also made of Songhua stone but of a different color. It is in the form of a partitioned frame with a fish fossil set in the upper part and the lower frame fitted with a piece of clear glass. Kangxi found the lifelike fish fossil interesting, and in the section on "stone fish" in *The Emperor's Compilation on Astrology, Geography, Paleontology, Zoology, Botany, Medicine, and Philosophy* (*Kangxi ji xia gewu bian*), he mentioned that this type of fossil came from Horqin, Inner Mongolia. The use of a fossil as an ornament and the application of window glass using Western techniques in the construction of the case reflect the emperor's interest in nature and science.

YLH WITH CYY, TB

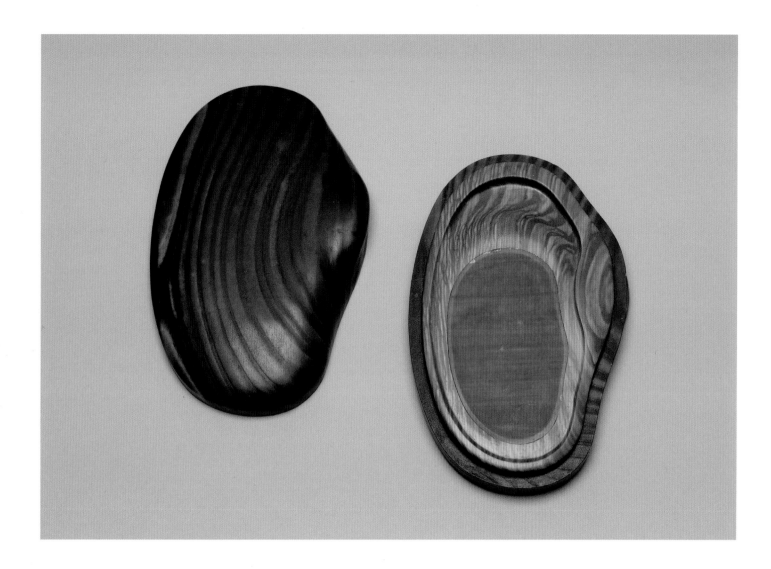

CAT. 105

清康熙朝 松花石蚌式硯
附松花石硯盒

Inkstone with case in the shape
of a clam

By the Imperial Workshop, Beijing
Qing dynasty (1644–1911), reign of
Emperor Kangxi (1662–1722)
Songhua stone
Inkstone H: 0.8 cm, L: 11.4 cm, W: 6.8 cm;
case H: 2.6 cm, L: 12.3 cm, W: 7.9 cm
Guwen 001654 Lü-1689-4

Taking the shape of a clamshell, the cover of this inkstone is carved from a piece of black-and-gray Songhua stone. The shape is simple, and the lines are flowing. The ingenious selection of this material to match the shape of a clamshell gives this object a natural appearance. The stone's texture and its natural, banded ripples of black, golden-brown, and green tones vividly resemble the surface and interior of a clam. Beneath the cover the vertical stripes of the ochre-colored Songhua stone contrast with the parallel lines of the green ink pool. The combination of different colors and textures in the Songhua stone makes this inkstone strikingly realistic. Many extant Songhua stone inkstones from the Kangxi reign are based on natural objects such as melons, bamboo shoots, magnolias, and so forth—all of which are highly detailed, reflecting Emperor Kangxi's enthusiasm for and close observation of nature.

INSCRIPTION
"For use in quietude, to bring everlasting years," engraved by Emperor Kangxi in seal script on the bottom of the inkstone.

SEAL MARK
"Imperial signature of the Kangxi emperor," a square seal in seal script carved in intaglio on the bottom of the inkstone.

YLH WITH CYY, TB

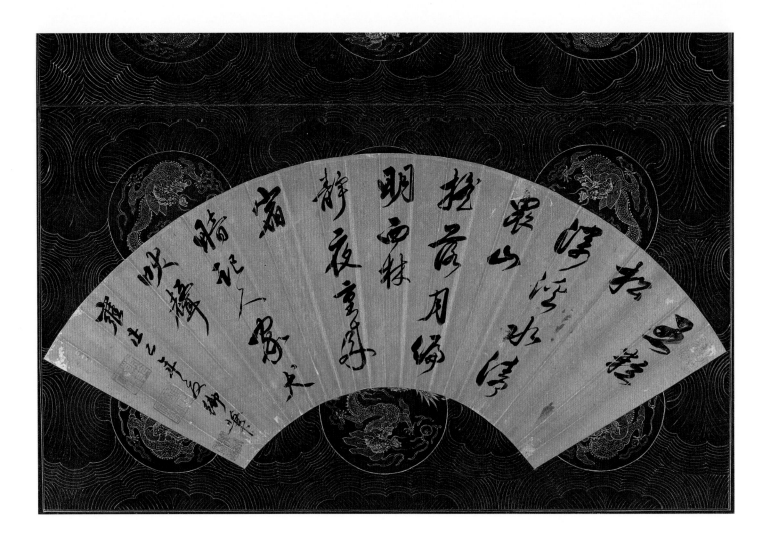

CAT. 106

清雍正朝 世宗雍正皇帝胤禛書 行草七言絕句 紙本扇面

A four-line poem in running script

By Yin Zhen (Emperor Yongzheng, 1678–1735)
Qing dynasty (1644–1911), reign of
Emperor Yongzheng (1723–35)
Fan, ink on paper
H: 17.8 cm, W: 53.1 cm
Cengshu 000327-3

Shown at the Museum of Fine Arts, Houston, only

After the Manchu established the Qing dynasty, they embraced traditional Chinese cultural pursuits. Emperor Kangxi admired calligraphy, especially the work of the eminent late Ming scholar, painter, calligrapher, and connoisseur Dong Qichang, and calligraphy became part of the education and training of young princes. Kangxi personally instructed his successors, son Yongzheng and grandson Qianlong.

Yongzheng devoted himself to the art from a young age, copying and practicing the masterworks from previous dynasties. His calligraphy can be found on large screens, small fans, and long horizontal scrolls. He often inscribed his own compositions—poetry and prose—or emulated ancient work. Yongzheng also provided inscriptions for numerous monuments and tablets for temples and shrines and provided couplets for pillars and title plaques for great halls. When Qianlong ascended to the throne, he ordered that his father's calligraphic works be carved into stone steles. Copies of rubbings taken from

these carvings were compiled into the publications *Calligraphy Models from the Pavilion of Clear Recitation* (*Langyinge fatie*) and *Calligraphy Models at the Hall of Four Benefits* (*Siyitang fatie*; 1736).

On this fan Yongzheng wrote a poem by the hermit poet Xu Ning (active 820–40) called "Returning to the Former Hermitage by the Pine Creek at the Western Forest." The distribution of the twenty-eight characters from the four-line poem, each line containing seven characters, shows careful consideration. At the center of the fan are three characters: "bright," "west," and "forest" (*ming, xi,* and *lin*). On either side of these characters Yongzheng balanced columns of one, two, and four characters. The fluid brushwork, calm execution, and graceful expression of this work shows that the emperor put brush to paper with confidence and thoughtfulness, striving not for perfect symmetry but for equilibrium.

SFC WITH SKN

CAT. 107

清雍正朝 高其佩繪 山水圖軸
絹本設色

Landscape painting, with an inscription by Zhang Tingyu

By Gao Qipei (1660–1734)
Qing dynasty (1644–1911), reign of
Emperor Yongzheng (1723–35)
Hanging scroll, ink and color on silk
H: 222.7 cm, W: 109.1 cm, Guhua 00952

Shown at the Asian Art Museum only

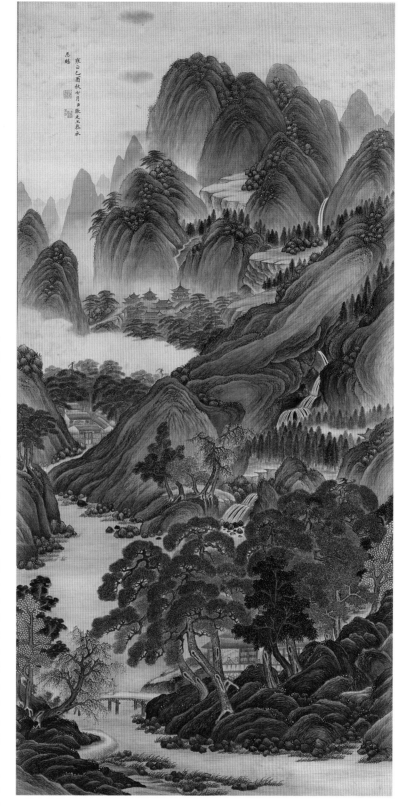

This painting was a gift from Emperor Yongzheng to the Han Chinese official Zhang Tingyu (1672–1755) in 1729. Zhang, a native of Tongcheng, Anhui province, served Emperors Kangxi, Yongzheng, and Qianlong and rose to high rank. The emperors trusted him—especially Yongzheng, who made him a member of his grand council—and Zhang was the only court official honored by a memorial tablet in the west wing of the Hall of Ancestral Worship (*Fengxian dian*) in the Forbidden City.

The painting was done for the Qing court by the renowned painter Gao Qipei. The heavy, forceful mountain forms are depicted with well-structured texture strokes and somber colors. The work reflects the ideal of a mountain retreat with people engaged in the activities of reading and visiting friends. Its large size and grand composition reflect the magnificent atmosphere of the imperial court. Originally from Gaomi, Shandong province, Gao's family later relocated to Tieling, Liaoning province. He entered official service and at one point held the position of vice minister in the Ministry of Punishments. He later joined the Qing palace painting workshop and served in the Studio of the Wish-Granting Wand.[1] As an artist, Gao is best known for cultivating the eccentric technique of using his fingers and hands in place of a brush.

This painting is evidence of the emperors' practice of giving paintings as gifts to worthy officials—just as it illustrates the fickle nature of imperial favor. In 1750

Emperor Qianlong ordered the return of the painting along with other imperial gifts and awards when Zhang was included in the punishment for the crimes of his in-laws.

INSCRIPTIONS

"Respectfully painted by humble subject Gao Qipei" at the lower right; "Yongzheng *jiyou* year [1729] autumn, seventh month, loyal subject Zhang Tingyu respectfully received imperial favor" at the top.

YJL WITH SKN

1. Xia Yuchen 1982, 84. *Qingshi* (1913–27) 1971, vol. 7, chap. 503, p. 5462.

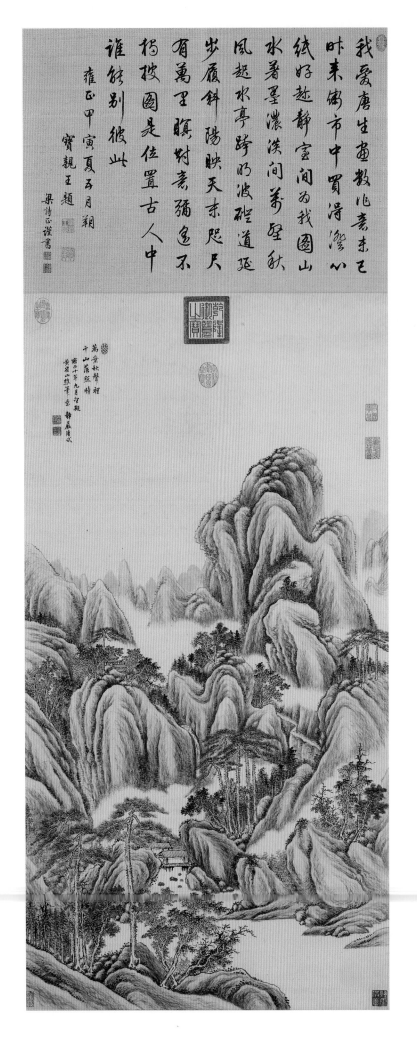

清雍正朝 唐岱繪 千山落照圖軸
紙本設色

*Myriad of Peaks Shine under the
Setting Sun*, 1732

By Tang Dai (1673–after 1752)
Qing dynasty (1644–1911), reign of
Emperor Yongzheng (1723–35)
Hanging scroll, ink and color on paper
H: 118.2 cm, W: 63.3 cm, Guhua 002711

Shown at the Museum of Fine Arts, Houston, only

This is one of the finest paintings created in response to the eighteenth-century movement to revive classicism. Court artists of the Qing dynasty were encouraged to seek inspiration from the art of the Song (960–1279) and Yuan (1271–1368) dynasties when producing creations catering to the emperors' interests. Tang Dai, a renowned court painter, had enormous success, earning the title of "First among Painters" from Emperor Kangxi. Throughout his career, Tang painted lyrical scenes embodying the spirit of classical landscapes. Here the tightly organized, slender peaks and the delicate strokes used to build the texture of the rocks recall the style of the Yuan master Wang Meng (1308–85; see cat. 37); indeed, Tang noted in his inscription that he modeled his brushwork on that of Wang. He applied touches of reddish brown to represent the colors of autumn and the setting sun, also referenced in his inscription (below).

Above the painting is mounted calligraphy quoting a 1674 entry from an account by Prince Bao (later Emperor Qianlong) in which he confesses that he very much "admired Tang's paintings" and once commissioned the artist to produce a landscape. More than fifty years later the scholar Liang Shizheng (1697–1763) copied them onto this painting. The mounting of this text with the painting to which it refers shows that the Imperial Household Department (which Tang Dai once directed) kept thorough records related to items in the imperial collection.[1]

Tang Dai trained with Wang Yuanqi (see cat. 86), one of the Four Wangs. His skill as an artist and shrewd business sense impressed three emperors—Kangxi, Yongzheng, and Qianlong—enabling him to become a trusted courtier with administrative posts in addition to his main role as a painter. His stature was such that on cosigned paintings, Tang Dai's signature took precedence over those of all the other court artists, even Giuseppe Castiglione (see cat. 129).

INSCRIPTIONS

"Boundless leaves fall in autumn; a myriad of peaks shine under the setting sun" and "The ninth month of the tenth year [1732] of the Yongzheng reign / modeling the brushwork of Huanghe shanqiao [Wang Meng]" written at the top by Tang Dai.

SEAL MARKS

Four seals of Tang Dai—"An old clan of the Tangkuo" (*Gu Tangkuo shi*), "Named Dai with the sobriquet Yudong" (*Dai zi Yudong*), "Northern window" (*Bei chuang*), and "Offering smoky clouds" (*Yanyun gongyang*)—and three seals of Emperor Qianlong.

SHC WITH HL

1. *Qingshi* (1913–27) 1971, vol. 7, chap. 7, p. 5462.

CAT. 109

清雍正朝 木雕嵌琺瑯片 "戒急用忍" 掛屏

Hanging plaque with enamel inlays

By the Imperial Workshop, Beijing
Qing dynasty (1644–1911), reign of
Emperor Yongzheng (1723–35)
Wood with cloisonné enamel inlays
H: 1.3 cm, L: 36.4 cm, W: 27.9 cm
Gufa 000759 Xian-1-88

When Emperor Yongzheng was a prince, he was temperamental and impatient and was repeatedly admonished by his father, Emperor Kangxi, to "heed rashness and use perseverance." Yongzheng had plaques of enamel, wood, and lacquer inscribed with this motto and hung them in various places in the palace as a reminder to be vigilant against his faults.

This wooden plaque was once hung in the Hall of Spiritual Cultivation (*Yangxing dian*) in the Forbidden City and is inlaid with beautiful five-color cloisonné enamel in the shape of clouds, enclosing the six characters in seal script reading, "A kind edict: heed rashness and use perseverance." Continuing the design of the enamel, the wooden panel is carved with auspicious clouds in low relief. The character for "kind" at the top of the plaque is enclosed in a red circle and resembles the rising sun above the clouds, shining over the universe. It demonstrates Emperor Yongzheng's gratitude for his father's admonition.

The cloisonné enamel technique was widely used in China in the fourteenth century, and by the Yongzheng era it had developed fully both technically and artistically. The colors of the enamel on this work are toned down, fitting harmoniously with the wood. In all, this plaque embodies Yongzheng's preference for artifacts reflecting the refined taste of the literati and the highest level of delicacy.

YLH WITH CYY, TB

CAT. 110

清雍正朝 造辦處 銅胎掐絲琺瑯
仿古銅禮器鳳耳豆

Ritual *dou* vessel with phoenix
head–shaped handles

By the Imperial Workshop, Beijing
Qing dynasty (1644–1911), reign of
Emperor Yongzheng (1723–35)
Copper alloy with cloisonné enamel inlays
H: 10.1 cm, Diam: mouth 7.1 cm, body 8.8 cm,
base 4.6 cm
Gufa 000116 Lie-427-16

In this piece Western-style enamels meet a traditional Chinese bronze vessel shape to produce a completely innovative object full of artistic charm. It is a rare example of Yongzheng-era enamel inlay, and it demonstrates the advanced technical skills of artisans of the period. Similar pieces from the Qianlong period are based on this object's shape, size, decoration, and color.

Emperor Yongzheng was notorious for his involvement in the design and production of imperial objects. His order to have the Imperial Workshop imitate Western-style cloisonné was well documented in the imperial archives. He demanded that enamels be used to decorate a sheet of metal with "white beads on a green ground" and later requested that this style be made into a tripod censer. This metal *dou* vessel with green cloisonné decoration, whose shape is based on an Eastern Zhou dynasty (approx. 771–221 BCE) bronze vessel, was the result.

The vessel's body, foot ring, and interior are gilded, and its handles are phoenix heads with rings in their mouths, making it distinct from sacrificial *dou* vessels of the Qin and Han dynasties (221 BCE–220 CE). The dark green color and multiring ornamentation of this piece also make it particularly noteworthy. Inlayed enamel with staggered ring ornamentation appears all over the body as well as on the lid and foot among six lines of meander motifs. Each large ring encompasses three inside it, and within each of those three small rings are beads of white enamel that create a unique decorative effect. The inlay of wires is uniform and delicate, and the curves are smooth. Green enamel both inside and outside the outlines produces a translucent sheen as if set with precious stones.

SEAL MARK
"Produced during the Yongzheng reign," four-character reign mark in regular script engraved on the base.
HWC WITH JC

CAT. 111

清雍正朝 內務府造辦處
玻璃胎畫琺瑯彩 竹節式鼻煙壺

Snuff bottle in the shape of a bamboo stalk, 1728

By the Imperial Workshop, Beijing
Qing dynasty (1644–1911), reign of
Emperor Yongzheng (1723–35)
Color enamel on glass, enameled copper,
and ivory
H: 6.5 cm, L: 2.2 cm, W: 1.9 cm
Gufa 000931 Lü-2033-10

This is the only example of enameled glass with a reign mark of Emperor Yongzheng in the collection of the National Palace Museum. Made from milky white glass that is shaped like a stalk of bamboo, this snuff bottle is painted to resemble spotted bamboo, with young leafy stalks rising from the joints and brownish spots marking the greenish-yellow background. The stalk is slightly bent as if blown by the wind. The bottle is fitted with a lid of enameled copper depicting two butterflies among flowers against a black background and a spoon of ivory. The colors are fresh and refined, exemplifying the outstanding quality of the enameled glass of the Yongzheng era. Its shape is unusual, and the workmanship is delicate.

Two spiders are painted on the glass just below the lid. In some parts of China they are called "spiders of happiness," and so the two spiders are a pun on "double happiness." Bamboo has joints, and the Chinese word for "joints" is a homonym for "festivals." Spiders and bamboo together convey the sentiment "may there be double happiness at every festival." A document from the Imperial Workshop dated the twelfth day of the seventh month of the sixth year of the reign of Yongzheng (1728) mentions the completion of a single snuff bottle of enameled glass bearing the design "double happiness at every festival" (*jiejie shuangxi*). This snuff bottle could very well be the piece mentioned in the document. The design was repeatedly employed by Yongzheng to decorate gilt metal and ivory objects.[1]

SEAL MARK
A *lingzhi* mushroom painted on the bottom contains the red characters reading "Produced during the Yongzheng reign."
YLH WITH TB

1. Zhongguo diyi lishi 2005, vol. 3, pp. 124, 269, 273.

CAT. 112

清雍正朝 江西景德鎮
仿鈞釉獸耳弦紋壺

Vase in the shape of an ancient bronze vessel, with classic jun glaze

Jingdezhen, Jiangxi province
Qing dynasty (1644–1911), reign of
Emperor Yongzheng (1723–35)
High-fired ceramic with a copper-red glaze
H: 26.1 cm, Diam: mouth 10 cm, base 11.2 cm
Zhongci 000562 JW579

This well-proportioned vessel with classic jun glaze may have been intended for Emperor Yongzheng, who particularly liked jun ware. Reflecting the revival of classical Chinese art that Yongzheng favored, this vase drew its inspiration from an earlier era. With raised bands encircling the neck and two appliquéd animal masks each carrying a ring, the form mirrors a ritual bronze *hu* vessel from the Han dynasty (206 BCE–220 CE) that was once registered in the *Antiquities Catalogue of Xuanhe* (*Xuanhe bogutu*; 1119–25).[1]

The thick opaque glaze, mixed with blue, gray, and red in-glaze stripes and speckles, is intense—richer and brighter than the jun glaze of the Song (960–1279) and Yuan dynasties (1271–1368) (see cat. 25). The body of the vessel was thickly built to provide a good base for such a thick glaze. A buff color shows through the unglazed areas on the bottom, while an opaque whitish-blue glaze fully covers the interior. A coat of brownish glaze was randomly applied to the base and is typical of the finishing on Song jun ware. In sum, this vessel is a brilliant combination of ancient ritual vessel form, classical jun style, and a contemporary jun glaze.

Emperor Yongzheng issued several decrees in 1729 and 1730 ordering Nian Xiyao (died 1738), supervisor in chief of the Imperial Household Department and official in charge of porcelain production at Jingdezhen, to have jun reproductions made at the imperial shop there.[2] Yongzheng gave specific instructions to Nian on form, glaze, presentation, and design. Sometimes the emperor chose existing works as models and passed these on to Nian, or he might have told Nian to submit a drawing or a wooden sample for approval before conveying an order to Jingdezhen.

SEAL MARK
"Produced during the Yongzheng reign," four-character reign mark in seal script stamped on the bottom.
PCY WITH HL

1. Wang Fu (1119–25) 1752, vol. 5, chaps. 11–13.
2. Zhongguo diyi lishi 2005, vol. 4, pp. 197, 198, 536.

CAT. 113

清雍正朝 江西景德鎮
仿乳（汝）釉五管花插

Five-spouted vase, with classic ru glaze

Jingdezhen, Jiangxi province
Qing dynasty (1644–1911), reign of
Emperor Yongzheng (1723–35)
Porcelain with grayish glaze
H: 19.8 cm, Diam: base 7.2 cm
Zhongci 001605 T1723

Yongzheng commissioned many copies of ancient ceramic styles from the imperial kilns at Jingdezhen, including the ru wares that were once the official ware of the Song court. This is one such ru-inspired work. The vase is painted in an unobtrusive grayish-blue-green glaze with fine crackles all over the body, giving it a jade-like quality. The foot rim is unglazed and has been given a light brownish-red wash to imitate the "iron foot" commonly seen in Song celadon ware (see cats. 21 and 26).

Vases with multiple spouts had appeared before the Yongzheng era, but the form regained popularity then with two, four, or six spouts, sometimes decorated with multicolor enamels and occasionally produced in metal and cloisonné. It is difficult to deduce from the few extant records the function of this type of vase, but it may have been inspired by Western-style tulip vases. Western flower vases with multiple spouts were illustrated in the book *Perspectiva pictorum et architectorum* (1693–98) by Italian artist Andrea Pozzo (1642–1709), which was translated into Chinese in 1729 by the Qing official Nian Xiyao. The increasing influence of the West on decorative styles and techniques enhanced innovation and exploration in the porcelain industry at the Qing court.

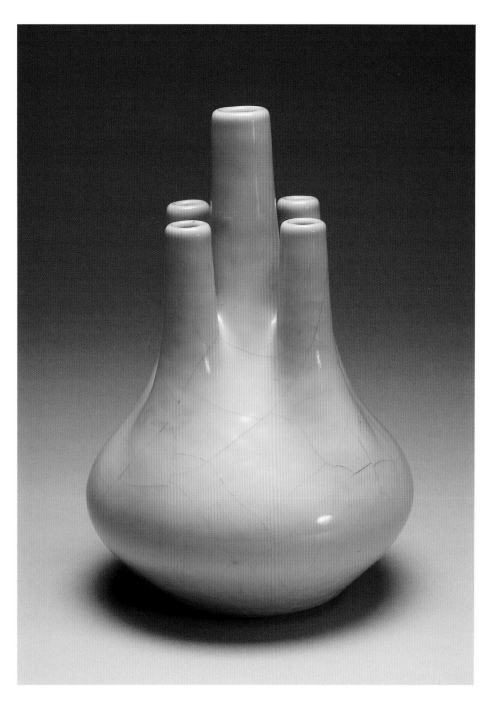

SEAL MARK
"Produced during the Yongzheng reign of the Great Qing," six-character reign mark on the base.
PCY WITH CYY, TB

CAT. 114

清雍正朝 江西景德鎮
仿哥釉獸耳折方瓶

Multifaceted vase with beast-
shaped handles and classic
ge glaze

Jingdezhen, Jiangxi province
Qing dynasty (1644–1911), reign of
Emperor Yongzheng (1723–35)
High-fired ceramic with crackled gray glaze
H: 24.1 cm, Diam: mouth 8 cm, base 13 cm
Zhongci 004621 T3826

Yongzheng's fascination with the creations
of earlier periods—particularly the wares
from the famous Ru, Guan, Ge, and Jun
kilns of the Song, Jin, and Yuan dynasties
(960–1368)—brought the art of imitation
to new heights. This vase imitates ge-type
high-fired stoneware, which traditionally
features a creamy gray glaze with golden
lines and iron-red crackles crossing over
its entire body. The wide-spaced cracks
resemble a repeated ice-crack design, and
the unglazed foot rim has been covered
by a dark slip to emulate the "iron foot,"
a major characteristic of the Song official
celadon ware.

This work gives us a good indication
of how Ming-era forms inspired imitation
ware in the official kiln of the Yongzheng
era. The shape of this vase, one favored by
Yongzheng, imitates a blue-and-white vase
with morning-glory motif made during
the reign of Emperor Xuande of the Ming
dynasty (1426–35). A good depiction of
such a vase can be seen in a hanging scroll
by Giuseppe Castiglione (see cat. 129)
titled *Flowers in a Vase* in the collection
of the National Palace Museum.[1] Slightly
bigger than its Ming prototype, the square
body with chamfered corners rests on a
splayed foot, all beneath a wide cylindri-
cal neck below the thick-lipped rim. The
neck is flanked by a pair of curved han-
dles issuing from the mouths of molded
animals with short horns, bulging eyes,
and prominent fangs.

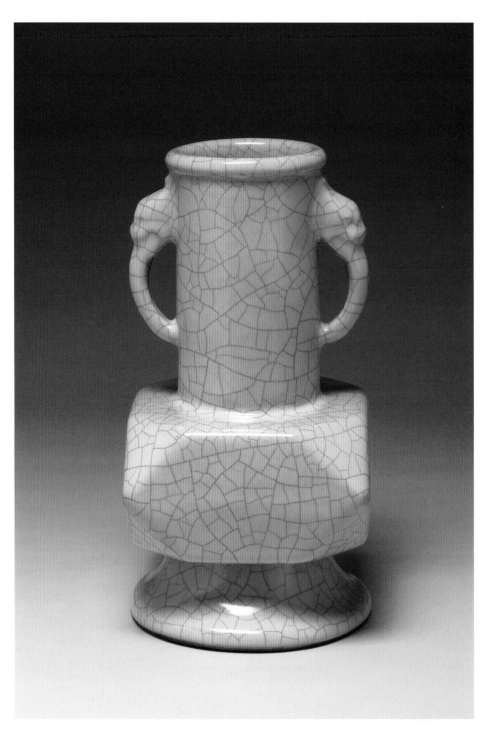

SEAL MARK
"Produced during the Yongzheng reign of
the Great Qing," six-character underglaze
cobalt-blue reign mark enclosed within a
double ring on the base.
PCY WITH CYY, TB

1. NPM 1990–2010, vol. 14, p. 57.

清雍正朝 江西景德鎮
茶葉末釉龍把執壺

Ewer with a dragon handle

Jingdezhen, Jiangxi province
Qing dynasty (1644–1911), reign of
Emperor Yongzheng (1723–35)
Porcelain with tea-dust glaze
H: 16.7 cm, Diam: base 5.5 cm, mouth 8 cm
Zhongci 003720 JW-797

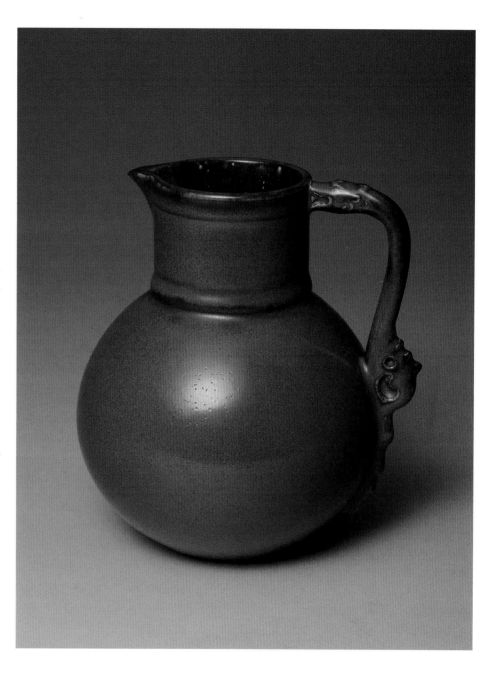

During the early Ming period the imperial kiln at Jingdezhen produced porcelain wares with a spout and a single handle modeled after the Islamic jade and metalwork that explorer Zheng He (1371–1433/35) brought back from Central Asia. Such Islamic-influenced products became prototypes for Qing porcelain ware such as this single-handled ewer. The single-handled form was registered as a "flowerpot" (*huajiao*) in the eighteenth-century imperial inventory, suggesting the function of such ewers.

This work has a long neck and a short spout. The handle was modeled separately before being attached to the body. A thin layer of brown slip was applied over the white porcelain body at the edge of the foot ring. The glaze is known as tea-dust glaze, a product created during the Kangxi period by ceramic official Tang Ying. Also called "eel-yellow ware," this glaze reached a superb level of quality in the eighteenth century.[1] The coating here is even, though drips show in thicker areas under the spout. Tiny in-glaze pits are visible, giving the vessel a sense of austere beauty.

SEAL MARK
"Made during the Yongzheng reign," four-character reign mark in seal script on the base.
PCY WITH LJ

1. Tang Ying 1735.

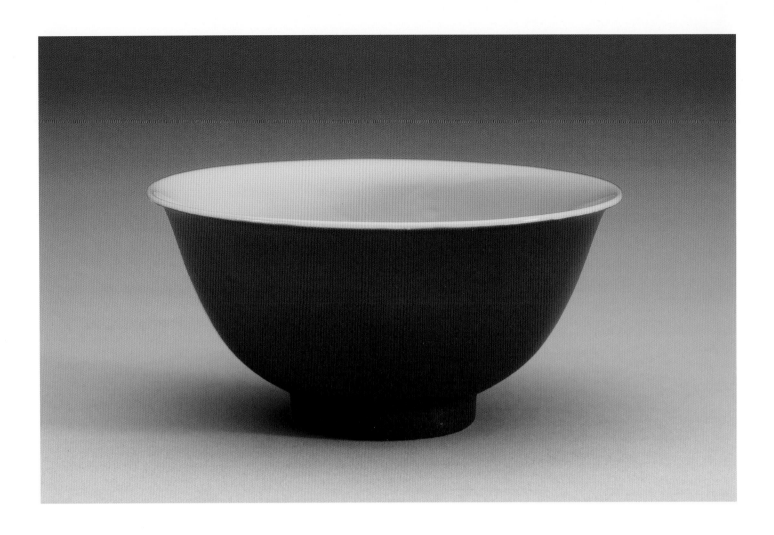

CAT. 116

清雍正朝 江西景德鎮/內務府
造辦處 胭脂紅釉碗

Bowl with hidden design of dragon
and cloud

Glazed bowl made in Jingdezhen, Jiangxi
province; decorated by the Imperial Workshop,
Beijing
Qing dynasty (1644–1911), reign of
Emperor Yongzheng (1723–35)
Porcelain with rouge-red glaze
H: 4.8 cm, Diam: mouth 9.5 cm, base: 3.5 cm
Zhongci 005498 T-1274

This delicate tea bowl epitomizes the level of luxury available to Yongzheng, who invested heavily in the porcelain factory in Jingdezhen in the form of court patronage from the beginning of his reign. It features the design of a dragon amid clouds that is visible when held up to the light. Known as a "hidden design" (*anhua*), this meticulous technique involved stamping or (in this case) incising a design on the porcelain.

This bowl is an early example of rouge-red monochrome glaze, which covers only its exterior. During the reign of Emperor Kangxi, new decorative styles and techniques inspired by glass from Europe had been developed at the imperial glass factory. One such advance was a glaze formula with a colloidal gold component showing pink, rose, or rouge red on porcelain. Such colors must have enraptured Yongzheng, for in winter 1726 he ordered a set of tea bowls with "light red [i.e., pinkish glaze] on the outside, white inside, hidden designs, and a well-written reign mark." With this memorandum the emperor sent two red teacups with a hidden design of dragons as samples.[1] Prince Yi dedicated strenuous effort to ensuring the quality and quantity of these inventions. In 1728 Prince Yi had the glassmaker Bai Tang'a select two apprentices to learn how to produce the new reds.[2] In 1735 ceramic official Tang Ying mentioned one of these new products, calling it "Western red ware," likely referring to the rouge red of this cup.[3]

SEAL MARK
"Produced during the Yongzheng reign," four-character underglaze cobalt-blue reign mark in standard script enclosed within a double-lined square on the bottom.
PCY WITH HL

1. Zhongguo diyi lishi 2005, vol. 2, p. 328.

2. Ibid., vol. 3, p. 122.

3. Tang Ying 1735.

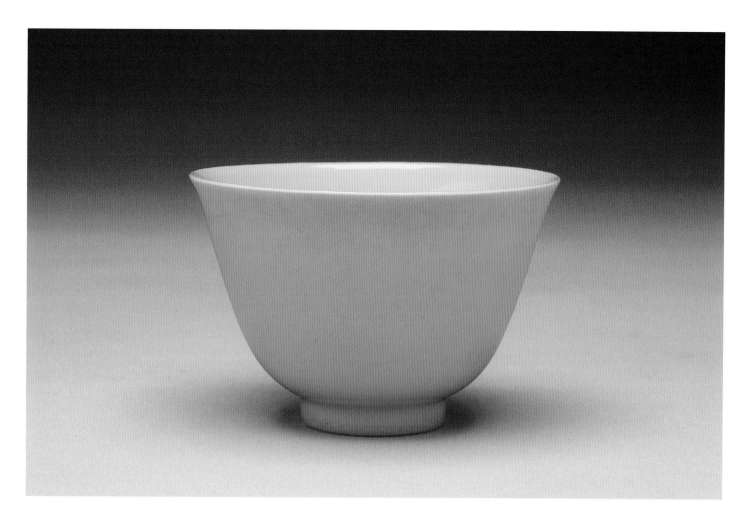

CAT. 117

清雍正朝 江西景德鎮 吹綠小碗

Small bowl with green enamel glaze

Jingdezhen, Jiangxi province
Qing dynasty (1644–1911), reign of
Emperor Yongzheng (1723–35)
Porcelain with green enamel glaze
H: 5.7 cm, Diam: mouth 9 cm, base 3.5 cm
Guci 002908 Lü-8531-1

During the early Qing period, the Imperial Workshop used European enamels to embellish native porcelain ware. Those costly imported materials were carefully allocated by the Imperial Household Department. The glassy compounds containing boride and arsenic acid melted at low temperature and were known for their soft, opaque quality. Eventually, in 1700, the Qing Imperial Workshop was able to produce its own enamel pigments. In 1728, Emperor Yongzheng ordered that the new bluish-white (*yuebai*) and pastel green (*songhua*) colors be given to the imperial factories for use on ceramics. The Jingdezhen imperial factory soon adopted use of the Chinese-produced enamels, allowing both the Imperial Workshop and the imperial factories to produce identical colored wares.

This bowl has a spacious mouth, deep arching walls, and a short foot ring. The interior is glazed in white, while the outside is entirely covered with a pastel green with fine crackles, revealing the low-temperature characteristics of the glaze after initial firing. This green pigment was

rarely seen during Kangxi's reign, so to have this new color in enameled porcelain during Yongzheng's reign for comparison sheds light on the exchanges between the court and the workshops.

SEAL MARK
"Produced during the Yongzheng reign of the Great Qing," six-character underglaze cobalt-blue reign mark in regular script enclosed within a double-lined circle on the bottom.
PCY WITH JC

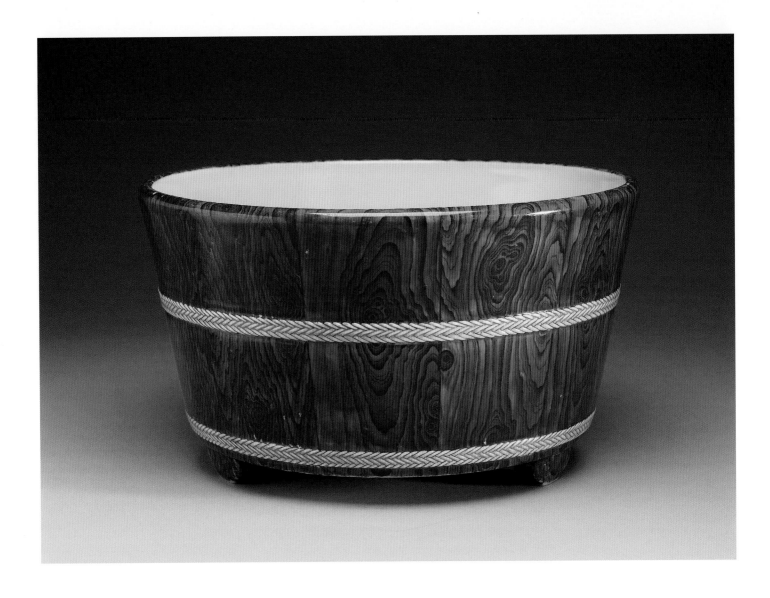

CAT. 118

清雍正朝 江西景德鎮 倣木紋花盆

Flowerpot with a design imitating
a wooden basin

Jingdezhen, Jiangxi province
Qing dynasty (1644–1911), reign of
Emperor Yongzheng (1723–35)
Porcelain with polychrome decoration
H: 16.2 cm, Diam: mouth 30.1 cm, base 23.5 cm
Guci 006715 Cang-313

This flowerpot represents an experimental design developed under Tang Ying at the Qing imperial ceramic workshop in Jingdezhen. One of Tang's goals was to use colored pigments to expand decorative schemes in porcelain manufacture. Wood-like porcelain pieces such as this enchanted Emperor Yongzheng, who sought to create beautiful and comfortable interiors for his palaces. According to records in the Imperial Household Department, Yongzheng ordered the Imperial Workshop to make a stand for a porcelain bucket adorned with "rosewood veins"[1] for the decor at his manor, the Garden of Perfect Brightness, fifteen kilometers northwest of the Forbidden City. Although many objects imitating subjects from the natural world were produced during the Qianlong period, Yongzheng-era products are known as the most lifelike.

The exterior of this vessel is decorated with wood-vein glaze and is encircled by two cord-like fringes enhancing the resemblance to an actual wooden basin. The interior of the vessel is glazed in pale bluish white, and the outer part of the bottom is decorated with three rectangular tenons. The walls taper to a base on three cloud-head lugs.

SEAL MARK
"Made during Yongzheng reign of the Great Qing," six-character mark in cobalt blue on the base.
PCY WITH LJ

1. Zhongguo diyi lishi 2005, vol. 3, p. 704.

CAT. 119

清雍正朝 江西景德鎮/內務府造辦
處 瓷胎畫琺瑯 綠竹長春碗

Bowl with red-billed blue magpies in a bamboo-and-rock garden

Glazed bowl made in Jingdezhen, Jiangxi province; decorated by the Imperial Workshop, Beijing
Qing dynasty (1644–1911), reign of Emperor Yongzheng (1723–35)
Porcelain with overglaze multicolor enamel
H: 6.8 cm, Diam: mouth 14.5 cm, base 6.2 cm
Guci 017541 Lie-229

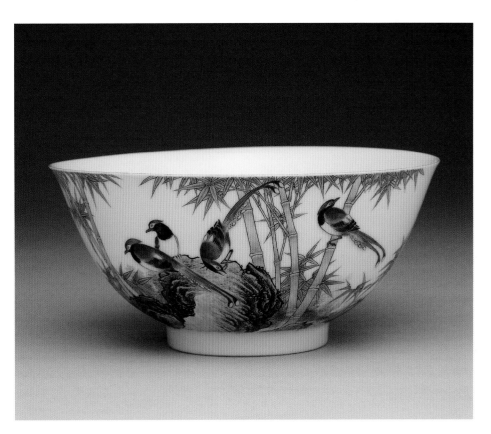

Bearing a large mouth and narrow lip, this bowl has a deep curved wall and a narrow foot. Except for the foot rim, the bowl is glazed entirely in white. One side is painted with a scene of verdant green bamboo with four red-billed blue magpies. The three birds on the rocks and the one perching on the bamboo are shown in various poses, a lively composition imbued with auspicious meaning. These long-tailed birds are variously called ribbon-tailed or longevity-tailed birds in China. They are symbols of longevity and thus represent "eternal spring."

On the other side is an excerpt, in excellent calligraphy, of two lines taken from a poem called "Ink Bamboo" by the Ming dynasty poet Shang Luo (1414–86): "Luxuriantly green [birds] are found among the bamboo, phoenix feathers appear with the rising sun." The last line of the poem alludes to the lively and cheerful phoenix, the king of birds. A red painted seal reading "splendor of the phoenix" precedes the poem, referring to the four birds painted on the porcelain. At the end of the poem are two seals reading "tranquil and calm" and "man of noble character," as bamboo was a common metaphor for a man of integrity in China. This type of porcelain thus unites the arts of poetry, calligraphy, painting, and seal writing. Records show that this bowl is one of a pair, that Emperor Qianlong had wooden containers made for them, and that he called them "Palace bowls of porcelain

with painted enamel, [with design of] green bamboo and eternal spring [against a] white ground."

SEAL MARK
"Produced during the Yongzheng reign," four-character blue enamel reign mark in the calligraphy style of the Song dynasty enclosed by a double square border on the base.
PCY WITH CYY, TB

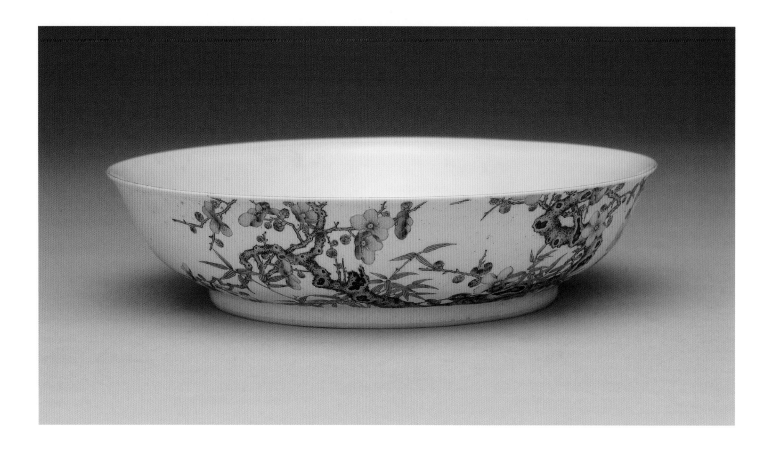

CAT. 120

清雍正朝 江西景德鎮/內務府
造辦處 瓷胎畫琺瑯 紅梅花黃地碟

Plate with bamboo and plum, 1732

Glazed plate made in Jingdezhen, Jiangxi
province; decorated by the Imperial Workshop,
Beijing
Qing dynasty (1644–1911), reign of
Emperor Yongzheng (1723–35)
Porcelain with overglaze polychrome decoration
H: 4.1 cm, Diam: mouth 17.4 cm
Guci 017036 Lie-438

This plate was one of a set of six commissioned by Emperor Yongzheng. Using materials created at the Imperial Workshop, this plate introduces a fresh color scheme in its depiction of vibrant plums on a lemon-yellow ground—a first for Chinese porcelain. Yellow and primrose are among the most difficult colors to control in the kiln. The off-white and pink flower petals, along with the subtle apple-green-accented leaves, were individually mixed using new formulas created at the Enamel Workshop, as recorded by Prince Yi in 1728.[1]

As these new colors attracted the emperor's attention, he invented designs for porcelain products and commissioned them from the Imperial Workshop. In the fifth month of 1732 the eunuch Tai Cong from the inner palace gave Samula, a manager of the Imperial Household Department, a sample plate painted with a hibiscus design. Yongzheng ordered him to make six plates identical to the sample in size and form but with a different design: plum blossoms against a yellow ground. A month later Samula presented the completed pieces to the eunuch.[2]

The decoration on this plate is an example of a subject from classical painting executed in porcelain. An old ebony tree with stretched-out branches is dotted with primrose and white plum blossoms. Inscribed on the opposite side of the plate are two lines from the poem "Spring" by the Tang dynasty poet Du Mu (803–52) linking the season's flowers to a romantic scene: "The light, delicate spring flowers are reflected in the stream, as if concealing their beauty as they float down to the Jade Terrace."

SEAL MARKS
"Produced during the Yongzheng reign," four-character overglaze blue enamel reign mark in standard script enclosed within a double-lined square on the base; "Early spring" (*Xianchun*); "Long-lived ancients" (*Shougu*); and "Aromatic clearness" (*Xiangqing*).
PCY WITH HL

1. Zhongguo diyi lishi 2005, vol. 3, p. 423.

2. Ibid., vol. 5, p. 477.

CAT. 121

清雍正朝 江西景德鎮／內務府
造辦處 瓷胎畫琺瑯 芝仙祝壽圖碗

Bowl with cranes and long-tailed birds amid camellias and rocks

Glazed bowl made in Jingdezhen, Jiangxi
province; decoration by the Imperial Workshop,
Beijing
Qing dynasty (1644–1911), reign of
Emperor Yongzheng (1723–35)
Porcelain with overglaze polychrome decoration
H: 6.7 cm, Diam: mouth 15 cm, base 6.2 cm
Guci 017543 Lie 226

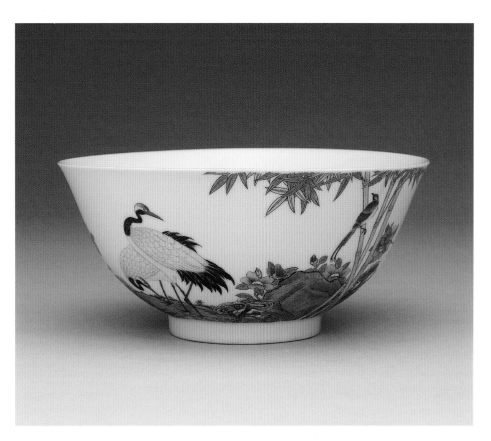

Yongzheng was deeply involved in the
production of enamel painted porcelain
and paid particular attention to their decorative motifs and designs. He frequently
required his artists to provide proofs for
him to critique and so further developed
the unique imperial style of porcelain
with painted enamel. Yongzheng ordered
the workshop to make large numbers of
porcelain works painted with auspicious
symbols celebrating longevity, as shown
on this bowl.

The decoration here is elaborate, and
its execution required professional painting skills. It presents two red-crowned
cranes standing upon rocks in a blue lake
and among green bamboo, *lingzhi* mushrooms, and pink camellia flowers. A pair
of Asian paradise flycatcher birds—one
perched on a branch, the other soaring through the air—look longingly at
each other. The posture and details of
the cranes echo the works of Giuseppe
Castiglione, a Jesuit missionary who
became a court painter to the emperor
(see cat. 129). A two-line excerpt from
"Crane," a Tang-dynasty masterpiece by
poet Zheng Gu (851–910)— "Sleep lightly
and wake up among whirls of falling flowers, / Dance briskly and listen leisurely to
the flow of stream water"—adds a flourish
to the piece. Incorporating poetry, calligraphy, painting, and seal elements—and
reflecting direct imperial influence—
this ordinary bowl was transformed
into an exquisite and refined piece with
literary charm.

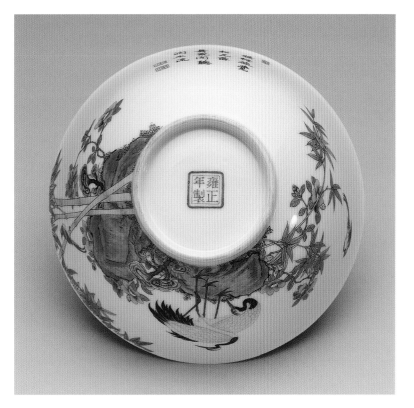

SEAL MARKS

"Produced during the Yongzheng reign,"
four-character blue reign mark within a
double rectangular border on the base;
"Splendor of the phoenix" (*Fengcai*);
"Tranquility" (*Danran*); and "Gentleman"
(*Junzi*).

PCY WITH JC

CAT. 122

清雍正朝 江西景德鎮／內務府
造辦處 瓷胎畫琺瑯 綠地桃竹碟

Dish with peach blossom and bamboo motifs

Glazed bowl made in Jingdezhen, Jiangxi
province; decoration by the Imperial Workshop,
Beijing
Qing dynasty (1644–1911), reign of
Emperor Yongzheng (1723–35)
Porcelain with overglaze polychrome decoration
H: 3 cm, Diam: mouth 13.5 cm, base 8.2 cm
Guci 017054 Lie-486

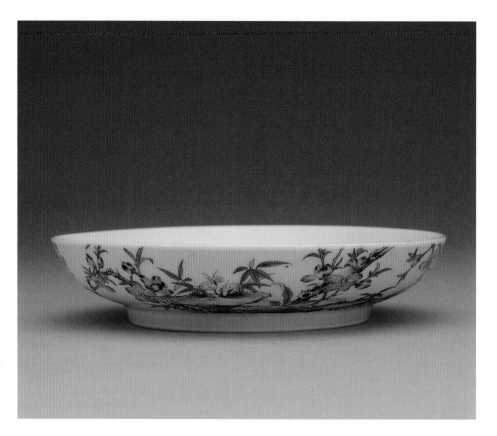

The integration of painting, calligraphy,
and poetry is one of the characteristics
of Yongzheng-era multicolor enamel por-
celains. This shallow plate with a wide
mouth rests on a short foot ring. The out-
side is covered with a pale green glaze
and is decorated with peach blossoms,
bamboo, rocks, and *lingzhi* mushrooms in
polychrome enamels. The floral scene is
followed by two lines of poetry excerpted
from the poem "Peach Blossoms" by the
Ming-dynasty poet Shen Shixing (1535–
1614) that describe the painted motifs. The
red painted seals appended to the inscrip-
tions read "golden success" (*jin cheng*)
and "shining brilliantly" (*xu ying*) and
reflect the great accomplishment of the
Yongzheng court in creating rose enamel
works using gold as a colorant.

According to Yongzheng-era invento-
ries, the Imperial Workshop succeeded
in fashioning "Chinese-made colors" and
no longer relied on imported "European
enamels" as it had during the Kangxi era.
The light green ground is one of these
native colors. Historical records show that
this vase is one of a pair and that Emperor
Qianlong had wooden containers made
for them.

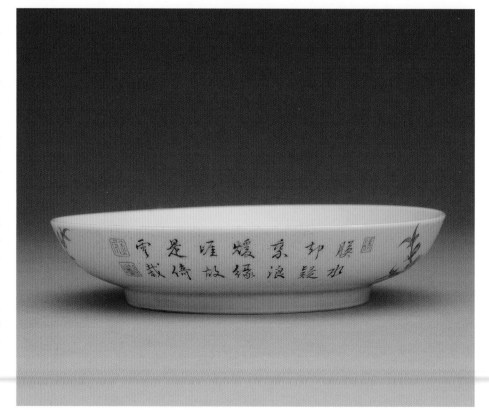

SEAL MARK
"Produced during the Yongzheng reign,"
four-character blue reign mark on the
base.

PCY WITH CYY, TB

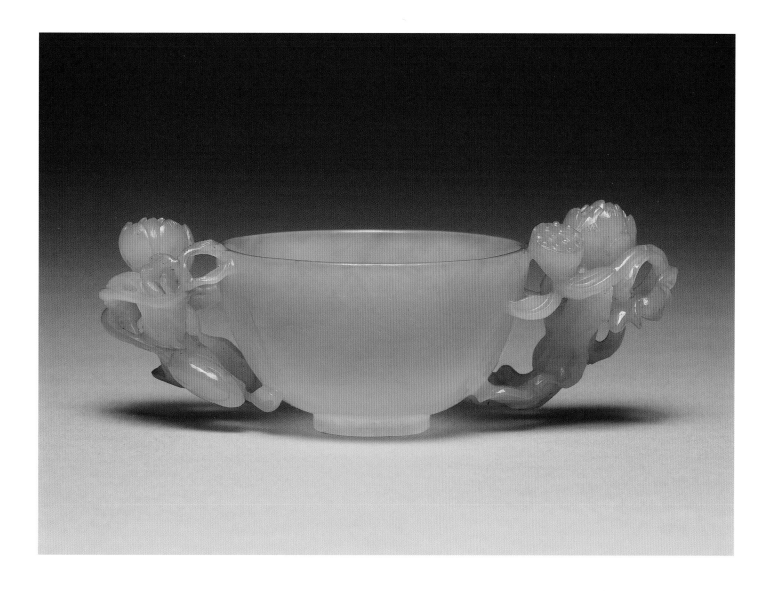

CAT. 123

清雍正朝 四字款 玉 花式耳盃

Cup with floral handles

Qing dynasty (1644–1911), reign of
Emperor Yongzheng (1723–35)
Nephrite
H: 2.6 cm, L: 9.4 cm, W: 5 cm
Guyu 006125 Lü-1964-11

Worked from nephrite into a thin and delicate cup, this vessel bears two handles resembling lotus blossoms intertwined with seedpods and weeds. Ming-dynasty influence can be seen here and, together with a few jade pieces and a large number of agate vessels, it reflects a revival of an older aesthetic movement that flourished in the Qing court. The elegance of Yongzheng-era art is due to the emperor himself, whose preference for refined artifacts was reinforced by his brother Prince Yi.

Also notable about this cup is its reign mark. Except for important court objects such as imperial seals, few extant jade artifacts from the Yongzheng era bear such marks, possibly owing to the fact that the court did not own a sufficient supply of jade as source material. This situation was rectified when Emperor Qianlong gained control of the jade-producing area in newly conquered regions in the northwest (now Xinjiang). Therefore, this nephrite

cup of excellent craftsmanship and design is particularly important as a source for studying Yongzheng's taste in jade objects.

SEAL MARK
"Produced during the Yongzheng reign," seal mark in seal script carved in intaglio on the base.
LTC WITH CYY, TB

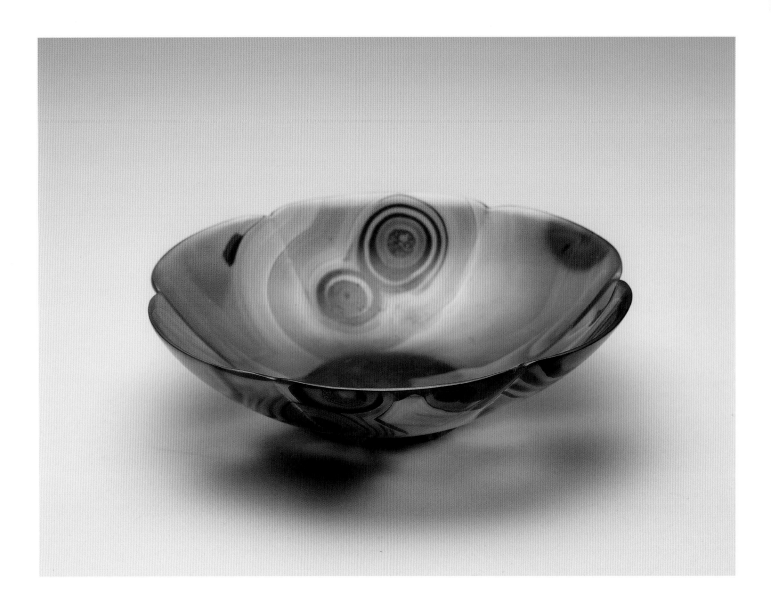

CAT. 124

清雍正朝 內務府造辦處
瑪瑙葵花式碗

Hibiscus-shaped bowl

By the Imperial Workshop, Beijing
Qing dynasty (1644–1911), reign of
Emperor Yongzheng (1723–35)
Agate
H: 3.2 cm, Diam: mouth 11.4 cm, base 3.9 cm
Guza 000108 Tian-168-16

This agate bowl represents the height of Yongzheng-era agate carvings and reflects the emperor's exceptional taste. The glossy, translucent stone with natural banded ripples of black and red tones on a sepia ground was superbly carved in the form of a hibiscus-shaped bowl rising steeply from a short splayed foot. The rim is delicately carved into the form of a blooming flower with six furled petals.

There are many agate vessels from the Yongzheng period in the collection of the National Palace Museum. These are delicate and elegant pieces, lacking decoration and reflecting Yongzheng's taste. Records reveal that the emperor repeatedly ordered the Imperial Workshop to rework bowls, having it grind and polish the agate in order to bring forth the stone's natural patterns and translucence.[1]

SEAL MARK
"Produced during the Yongzheng reign," seal mark in seal script inside the foot ring.
YLH WITH CYY, TB

1. Zhongguo diyi lishi 2005, vol. 2, pp. 197, 199, 202, 210–12.

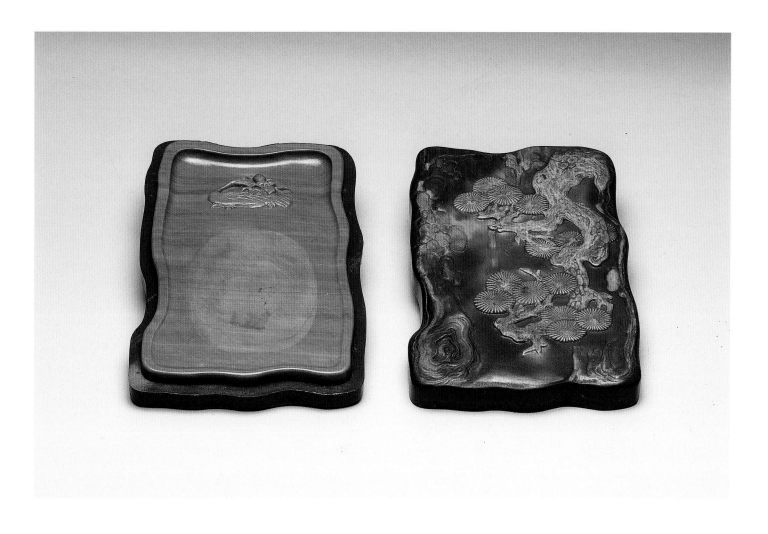

CAT. 125

清雍正朝 內務府造辦處
松花石松樹硯、附松花石硯盒

Inkstone with case in the shape of a pine-tree segment

By the Imperial Workshop, Beijing
Qing dynasty (1644–1911), reign of
Emperor Yongzheng (1723–35)
Songhua stone
Inkstone H: 0.7 cm, L: 10.7 cm, W: 6.7 cm;
case H: 2 cm, L: 11.4 cm, W: 7.6 cm
Guwen 000301 Lie-4-63

This grayish-green Songhua inkstone and its dark purple cover are carved to imitate a segment of a pine tree, with the top part of the inkstone bearing the image of a crane holding a peach branch depicted in low relief. Pine trees and cranes are symbols of longevity. While the purple layer of the cover depicts the scales and burls of the pine trunk, the higher green layer shows the branches and pine needles. The different colors and hues of the Songhua stone help give these depictions a lifelike quality. Unlike the plainly conceived Songhua inkstones of the Kangxi era, the ones made during Yongzheng's reign exude an air of classic elegance.

INSCRIPTION
"For use in quietude, to bring everlasting years," quoting the late Emperor Kangxi, carved in script on the inside of the cover.

SEAL MARK
"Produced during the reign of Emperor Yongzheng," seal mark carved on the inside of the cover.

YLH WITH CYY, TB

CAT. 126

清乾隆朝 高宗乾隆帝弘曆繪
仿明宣宗開泰圖軸 紙本水墨設色

An auspicious start, after
Emperor Xuande's (Xuanzong's)
"An auspicios start," 1772

By Hongli (Emperor Qianlong, 1711–99)
Qing dynasty (1644–1911), reign of
Emperor Qianlong (1736–95)
Hanging scroll, ink and color on paper
H: 127.7 cm, W: 63 cm
Guhua 000762

Shown at the Asian Art Museum only

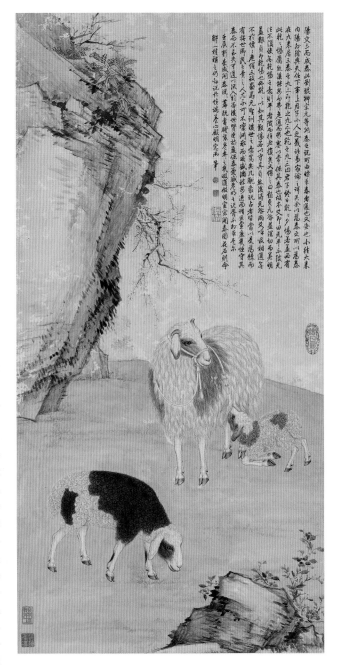

Qianlong was an accomplished painter. He did a considerable number of flower-and-bird paintings and landscapes and aimed to improve his skills through copying classical Chinese masterworks. Further, his freestyle works, based on "painting the mind," demonstrate his ability to paint spontaneously. This painting of sheep—a close study of a painting with the same title by the Italian-born court artist Giuseppe Castiglione (see cat. 129)—is very different from those paintings. Castiglione's painting combined Chinese iconography with European techniques—such as a focus on minute details and an emphasis on three-dimensional effects—that challenged the emperor with their technical difficulty. Painted in a traditional style, the sheep here are set in a garden on a bright day. The ram, showing irregular black mottles on its white body, eats grass in the foreground. An ewe is nursing a lamb that kneels on its front legs. The symbolic theme, warm tones, and meticulously painted figures reflect Qianlong's careful observation and shadowing of Castiglione's brushwork. The mood of harmony and enjoyment is enhanced by green bamboo and pink plum blossoms, which signal the arrival of spring.

In Chinese *yang* has many different meanings, including "sun" and "sheep," words that carry auspicious associations. The ancient *Book of Changes* (*Yijing*) contains the phrase "three *yang* bring a change in fortune" and is related to the Chinese concept of *yin* and *yang*, in which two seemingly contrary forces (female-male, dark-light, cold-hot, wet-dry) are actually complementary and interconnected in the natural world. *Yang* was understood as the active, male force, and each spring it was celebrated with wishes for blessings, wealth, and prosperity. In art, the phrase "three *yang* bring a change in fortune" is commonly depicted by three sheep. Although a classical Daoist concept, this theme was relatively late in influencing court arts, and it is seen more commonly in Ming and Qing artworks.

According to Qianlong's inscription (below), the painter Zou Yigui (1686–1772) added complementary touches to the work. Further, the emperor claimed that he copied a work by Emperor Xuande of the Ming dynasty, thereby expressing reverence for his Chinese ancestors (rather than a foreign-born artist such as Castiglione). Regardless of whether Xuande painted this subject, Qianlong's work was done in the manner of Castiglione.

INSCRIPTION

In a note at the top of the painting Qianlong wrote, "In spring of the year *renchen* [1772], copied Xuanzong's [Xuande's] Three Tranquility again on my day of leisure, instructed Zou Yigui to complete the flowers and rocks, and recorded the event on the top, by the emperor in the Hall of Intellectual Cultivation."

LNL WITH QN, HL

CAT. 127

清乾隆朝 畫院 十二月月令五月
圖軸 絹本設色

The fifth month, from scenes of "The twelve lunar months," approx. 1737

Qing dynasty (1644–1911), reign of
Emperor Qianlong (1736–95)
Hanging scroll, ink and colors on silk
H: 175 cm, W: 97 cm
Guhua 003110

Shown at the Museum of Fine Arts, Houston, only

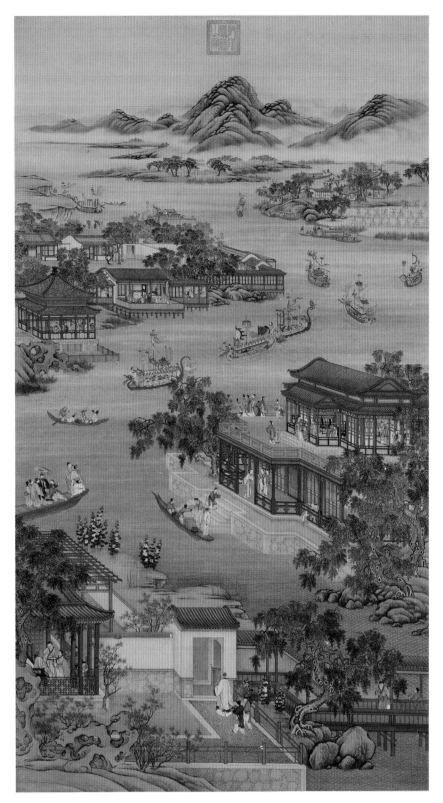

In 1737 the Qing painting academy presented at court this grand scene, created in celebration of the Duanwu festival that takes place on the fifth day of the fifth lunar month. On this spring holiday, people spend time by the river, racing dragon boats and eating sticky-rice dumplings. They decorate their homes with flowers and herbs to ward off pestilence in order to protect the soul of Qu Yuan (died 278 BCE), who drowned himself in a river in an act of patriotism. All of these details are recorded in this painting, one of twelve depicting activities and historic events of each month. The series was completed between 1736 and 1738. Chen Mei (active 1726–42) was the principal artist in charge of this project, though many court artists were involved, and the rocks in this painting clearly show the hand of court artist Tang Dai (see cat. 108).

A meandering, S-shaped river traversed by dragon boats unites the composition. Beautifully bedecked with hangings and lanterns, the dragon boats are propelled by six paddles on each side. These boats, some with stages with billowing flags, are decorated with images of immortals, including that of Zhongkui, the demon queller. These boats are like floats in a parade, attracting the attention of the people in the painting. Pomegranates and hollyhocks blossom in the foreground, where two young servants carrying a vase of sweet flag and hollyhock (herbs for warding off evil on this day) and a plate of dumplings follow an elderly person as he enters a gateway. To the left another older

man is inspecting herbs in a room lined with a medicine cabinet. A young servant is pounding herbs with a tall pestle, perhaps in preparation for making sachets or wine.

The series of paintings that includes this work is a companion to "The twelve merry months of Emperor Yongzheng" paintings in the collection of the Palace Museum, Beijing.[1] Both sets of paintings portray architecture in the style of the court artist Jiao Bingzhen (see cat. 90), revealing that his original drawings were used as sources for paintings throughout the century.[2]

SHC WITH TB

1. NPM 1990–2010, vol. 14, pp. 126–39.

2. Chen Yunru 2005. Chiu 2014, 414–23.

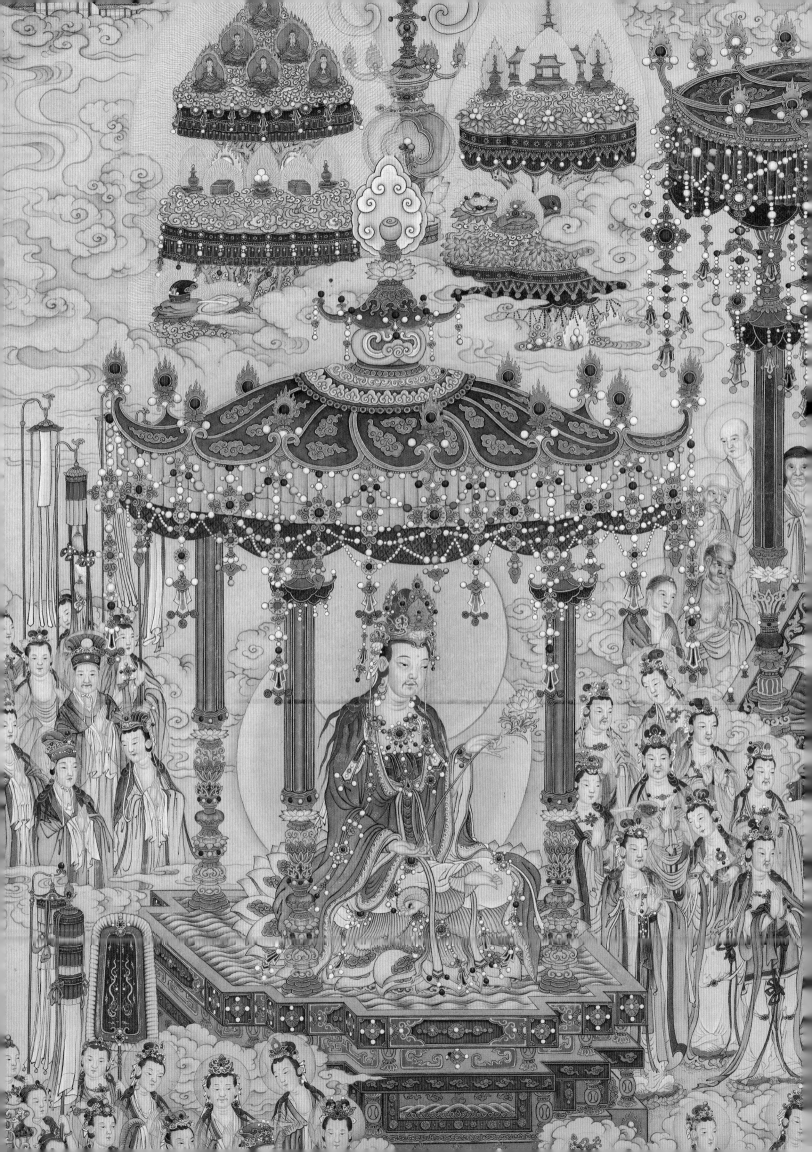

CAT. 128

清乾隆朝 丁觀鵬繪 極樂世界圖軸
紙本設色

Paradise scene, 1759

By Ding Guanpeng (active 1736–95)
Qing dynasty (1644–1911), reign of
Emperor Qianlong (1736–95)
Hanging scroll, ink and color on paper
H: 295.8 cm, W: 148.8 cm, Guhua 003705

Shown at the Asian Art Museum only

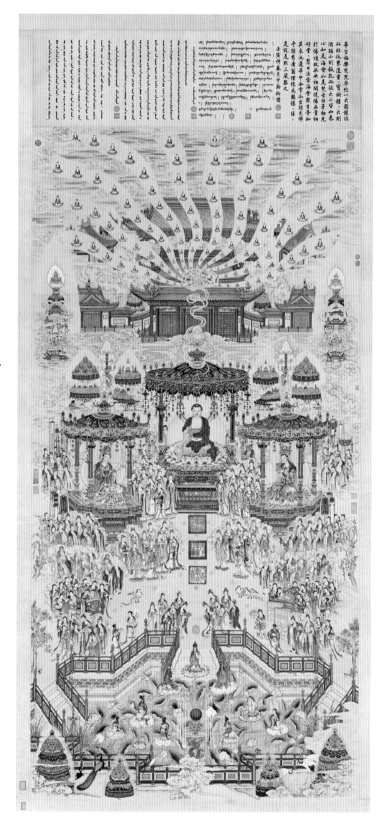

Illustrated here is a scene from *The Sutra on Contemplation of Buddha Amitāyus*, one of the three important sutras of Pure Land Buddhism, showing Buddha Amitābha preaching in his Western Paradise. Buddha Amitābha sits with his hands held in the gesture of meditation on a precious lotus throne on a lotus terrace under a fancy canopy. Emerging from his head are the Buddhas from the ten directions, who fill the top part of the painting. Seated next to him are the bodhisattvas Guanyin and Mahasthamaprapta. The bottom half of the painting depicts the various bodhisattvas, arhats (*luohans*), and heavenly beings listening to the preaching in front of the Lotus Pond of Seven Precious Jewels as well as fabulous and colorful birds, all reflecting descriptions found in the sutra. Inside the pond, lotus blossoms support souls being reborn in paradise.

Ding Guanpeng painted this spectacular rendition of Amitābha paradise in the second month of 1759. According to palace documents, this work was given to the imperial weaving service in Jiangning (now Nanjing) as the source painting for a cut-silk tapestry (*kesi*) version of the subject. Emperor Qianlong must have been delighted with this painting, because three *kesi* weavings, in addition to other embroidered textiles, on the same subject were registered in the imperial inventory. It is clear that Qianlong was fascinated with the subject of paradise and commissioned works on this theme to be made in various media.

A native of Beijing, Ding Guanpeng was painting in the Imperial Workshop by 1726 and enjoyed even greater prestige during the reign of Emperor Qianlong. Ding created paintings that reveal a colorful and detailed style reinforced by early Qing court painters such as Jiao Bingzhen (see cat. 90) and Leng Mei (see cat. 88). Ding learned Western perspective and chiaroscuro from Giuseppe Castiglione (see cat. 129), which enabled him to achieve three-dimensionality and texture in his figure painting and accompanying objects. Ding had an important influence on Buddhist subjects, maintaining excellent brushwork and bright color schemes in these paintings.

SHC WITH TB

CAT. 129

清乾隆朝〔意大利〕郎世寧繪
白鷹軸 絹本設色

White Falcon

By Lang Shining (Giuseppe Castiglione, 1688–1766)
Qing dynasty (1644–1911), reign of Emperor Qianlong (1736–95)
Hanging scroll, color on silk
H: 188.9 cm, W: 97.9 cm, Guhua 000958

Shown at the Asian Art Museum only

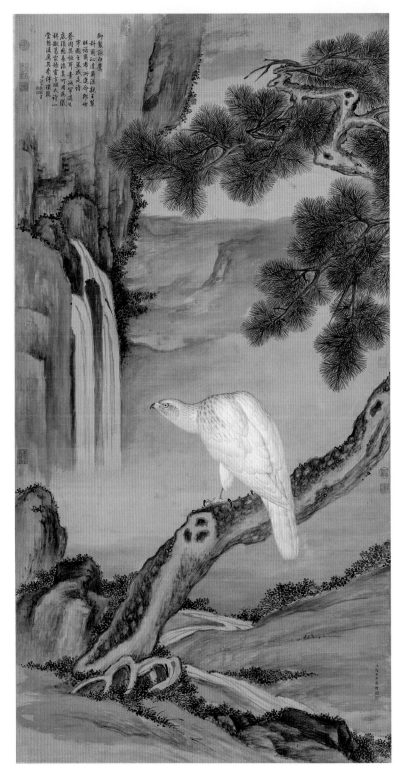

Quite a few works with images of eagles and falcons were produced for and collected by Emperor Qianlong, who espoused heroism. These birds of prey were regarded as the ultimate symbol of the nomadic spirit of the Manchu horsemen from the chilly northeast: they were valiant in nature but could be tamed and taken hunting. Further, the Chinese word for "eagle" is a homonym for "hero." Manchu and Mongolian noblemen would bring Qianlong living birds of various breeds from their homelands to add to the imperial menagerie. The bird depicted here (actually a Siberian Goshawk, not a falcon as per its title) was a gift from a Mongol prince. Qianlong commissioned Castiglione to produce this painting and charged the scholar Wang Youdun (1692–1758) with copying the emperor's poem "Ode to the White Eagle" (1755) above it.

Castiglione depicted the bird with broad wings, sharp black talons, and an off-white body—an appropriately august portrayal of a cherished breed from the northeastern region of China. The artist's very fine touch on the feathers here (and on animal furs and other subjects elsewhere) was appreciated by the emperor and greatly stimulated Chinese artists. Castiglione's use of traditional Chinese elements—an old, gnarled pine tree and a waterfall gushing profusely out of straight cliffs—perfectly sets off the bird, an icon of bravery, power, and sensuality. His talent in chiaroscuro, vigorous portrayal, and substantive textures no doubt led to his appointment as a court painter.

Giuseppe Castiglione was born in Milan and became a member of the Society of Jesus at age nineteen and was sent to Genoa, where he painted religious themes. In 1715 the Portuguese Evangelical Society dispatched him to China. Through the Jesuit court official Matteo Ripa, he gained the protection of Emperor Kangxi and befriended Chinese court artists by instructing them in the brush techniques he had learned in Europe. After his service

as a court artist under three emperors, he died in Beijing and was buried in the Jesuit cemetery outside the city's Fucheng Gate with the posthumous title of "Master to the Regal Manor" (Fengchen yuanwang qing) granted by Qianlong.

INSCRIPTION

"Respectfully painted by your subject Lang Shining."

LNL WITH QN, HL

CAT. 130

清乾隆朝（波西米亞）艾啟蒙繪
土爾扈特白鷹圖軸 絹本設色

White Falcon, 1773

By Ai Qimeng (Ignatius Sichelbart, 1708–80)
Qing dynasty (1644–1911), reign of
Emperor Qianlong (1736–95)
Hanging scroll, ink and colors on silk
H: 147 cm, W: 89.5 cm, Guhua 003085

Shown at the Museum of Fine Arts, Houston, only

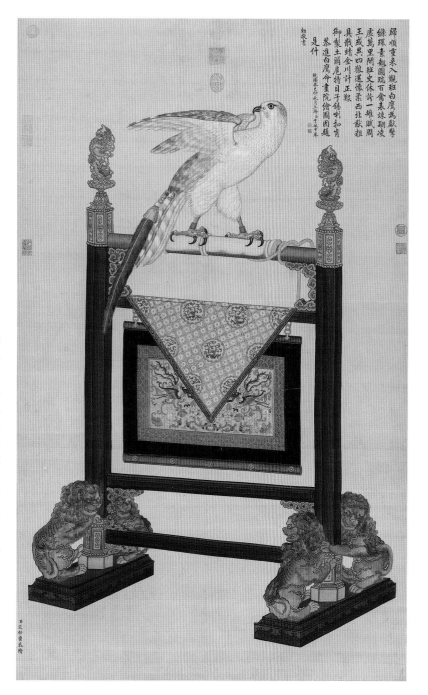

In 1771 the Torguts, a Mongol tribe living on the banks of the Volga River, escaped Russian oppression and returned to China under the command of Ubashi Khan (1742–75). Emperor Qianlong compared the Torguts' situation to a Confucian tale of a barbarian horde abandoning an unprincipled ruler and returning to a just one. He immediately held a formal banquet at his summer palace in Chengde to welcome and confer titles on Ubashi and his people. Qianlong received a white falcon as tribute from a Torgut prince and ordered a painting of it in 1773.

The falcon here is shown tethered to a wooden stand with jesses. Turning its head and raising its wings, the bird seems about to take flight. The artist highlighted the hard black talons and beak that are characteristic of this raptor. He also paid attention to the bell and feather ornaments attached to the bird's tail. The elaborately decorated stand, with its gilt finials set with a demon-on-a-lotus pedestal and bronze lions supporting the base, shows the luxury even pets enjoyed in imperial settings. Other details—the brocade of a phoenix among peonies and the hanging brocade wrapper with dragonet roundels against a background of a tortoise-shell pattern with swastikas framed by a black border of scrolling grass—are all meticulously depicted.

Sichelbart was born in Bohemia (now the Czech Republic), became a member of the Society of Jesus in 1736, entered the Manchu bureaucracy in 1745, and studied under Giuseppe Castiglione (see cat. 130). He was summoned to paint in the Imperial Household Department, starting at the lowly position of "runner" (*xingzou*). He focused on the human figure, animals, and birds. In 1762 Sichelbart, together with fellow foreign-born painters Castiglione and Jean Denis Attiret (also known as Wang Zhicheng; 1702–68), completed the monumental drawings for copperplates made to celebrate Qianlong's victory in settling Zunghar in the north. They introduced Western elements to Chinese art that had a significant influence on the court painting style. The emperor granted Sichelbart the title of "Master to the Regal Manor" in 1767 and, in 1778, two years before his death, the emperor personally wrote the characters "Honorable Senior from Overseas" in calligraphy to celebrate the artist's seventieth birthday.

INSCRIPTIONS

"Respectfully painted by your subject Ai Qimeng" at the lower left corner; the artist also signed the left post of the stand in the painting.

SEAL MARKS

Two seals of Ignatius Sichelbart—"Respectfully" (*Gong*) and "Painting" (*Hua*)—and eight seals of Emperor Qianlong.

SFW WITH TB

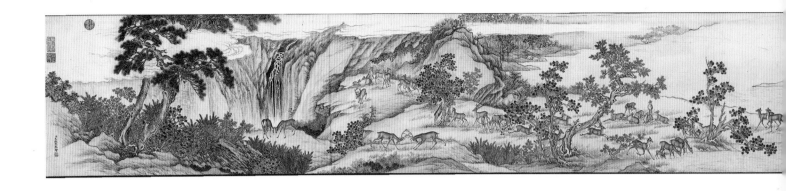

CAT. 131

清乾隆朝（波西米亞）
艾啟蒙繪 百鹿圖卷 紙本設色

One hundred deer

By Ai Qimeng (Ignatius Sichelbart, 1708–80)
Qing dynasty (1644–1911), reign of
Emperor Qianlong (1736–95)
Hand scroll, color on paper
H: 42.5 W: 423.7 cm
Guhua 001735

This long horizontal scroll introduced a
new subject—"one hundred deer"—into
the court art of Emperor Qianlong. The
deer carried many symbolic meanings,
including blessings, good fortune, and
longevity. The Chinese word for "emol-
ument" (*lu*) was represented in art by
the deer, probably starting in the Tang
dynasty, because the two characters are
homonyms. The deer thus proved a highly
adaptable subject for all kinds of art at the
time.

Here a herd of deer is depicted relaxing
along idyllic hillsides; dun-colored stags
shake their horns while shy does tread the
grass; some of the stags butt each other
with their antlers or browse near the dale.
The artist intended to convey the joy and
harmony in the deer's various actions and
movements. This work, one of Ignatius
Sichelbart's most moving and tender
depictions, captures a mood of peace and
enchantment. His style is loose and deli-
cate in tonality, employing soft contours,
light colors, and fine details. Interspersed
with green pines, a red cypress, and amber
bushes—all classic signs of the golden
autumnal season in the north of China—
the deer were rendered in a traditional
manner, making it likely they were actu-
ally painted by Chinese artists. This work
exemplifies the collaboration of Eastern
and Western techniques in artistic cre-
ations of the Qing court.

INSCRIPTIONS

"Respectively painted by your subject Ai
Qimeng." A colophon written at the top of
the painting gives a summary of the series
of campaigns in which Qianlong subdued
nomadic tribes and expanded the frontiers
of his empire.

LNL WITH QN, HL

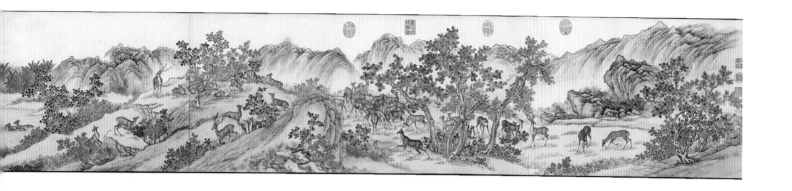

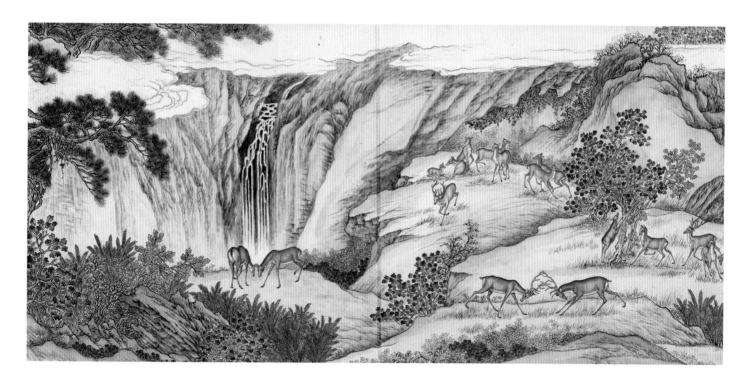

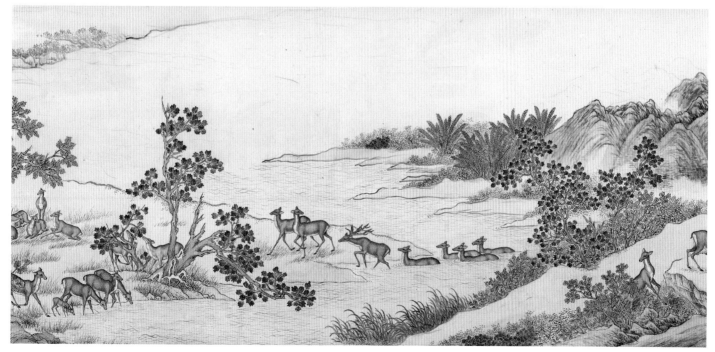

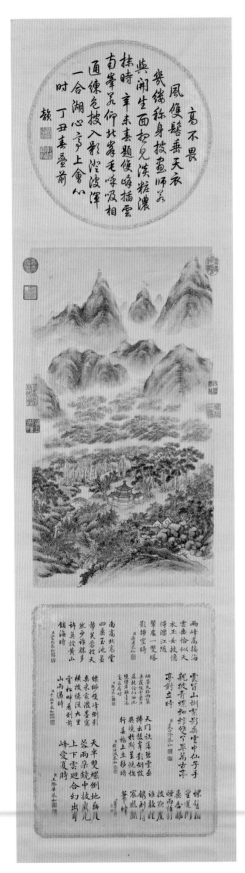

清乾隆朝 董邦達繪 高宗乾隆御題
雙峰插雲軸 紙本設色

Twin Peaks Penetrating Clouds,
approx. 1751–57

By Dong Bangda (1699–1769)
Qing dynasty (1644–1911), reign of
Emperor Qianlong (1736–95)
Hanging scroll, ink and color on paper
H: 68.4 cm, W: 37.8 cm
Guhua 002914

Shown at the Museum of Fine Arts, Houston, only

In 1751 and 1757 Emperor Qianlong traveled to Jiangnan in the southeast to promote imperial might, solidify his personal authority, and display his munificence. Like his grandfather, Emperor Kangxi (who had visited the region himself), Qianlong enjoyed visiting legendary places he had learned of from books. A spot that enchanted both emperors was West Lake in Hangzhou, Zhejiang province, the old Southern Song capital. Kangxi chose his ten favorite spots around the lake and wrote eulogies on the particular features of each. In his time, Qianlong studied Kangxi's landmarks and commissioned paintings and verses commemorating their beauty and history.

Several of these paintings were assigned to Dong Bangda, probably owing to his familiarity with Zhejiang, where he grew up. Dong was one of the chief editors of the major records of the imperial collections; the highest position he achieved was Minister of Rites.[1] This composition, with the two peaks flanking atmospheric mist, presents one of Kangxi's ten spots around West Lake. Dong attempted to depict the actual landscape there by including as references Hongchun bridge, a stone stele, and a villa built for Kangxi. To convey the mild climate and green landscape of Jiangnan, Dong applied the crisp, dry brushwork and loose, wet washes of the Yuan masters.

This work is mounted along with two others on landmarks around West Lake. The unusual format of this scroll—three sheets of different sizes mounted together—presents works by the emperor and his eight key scholars on a single subject, which is extremely rare and greatly enhances the work's importance as well as its decorative appeal. Two poems by Emperor Qianlong (1751; 1757) are quoted in the circle above the painting. The lower portion of the scroll features compositions by eight high-ranking scholar-officials: Jiang Pu (1708–61), Wang Youdun (1692–1758), Qiu Yuexiu (1712–73), Qian Rucheng (1722–79), Yu Minzhong (1741–79), Wang Jihua (1717–76), Jin Deying (1701–62), and Guan Bao (1711–76).

SEAL MARKS
Five seals of Emperor Qianlong.
SHC WITH HL

1. *Qingshi* (1913–27) 1971, vol. 6, chap. 306, p. 4149.

CAT. 133

清乾隆朝 金廷標繪 歲朝圖軸
紙本設色

Celebrating the New Year, 1797

By Jin Tingbiao (active 1757–67)
Qing dynasty (1644–1911), reign of
Emperor Qianlong (1736–95)
Hanging scroll, ink and color on paper
H: 96 cm, W: 65.9 cm
Guhua 002822

Shown at the Museum of Fine Arts, Houston, only

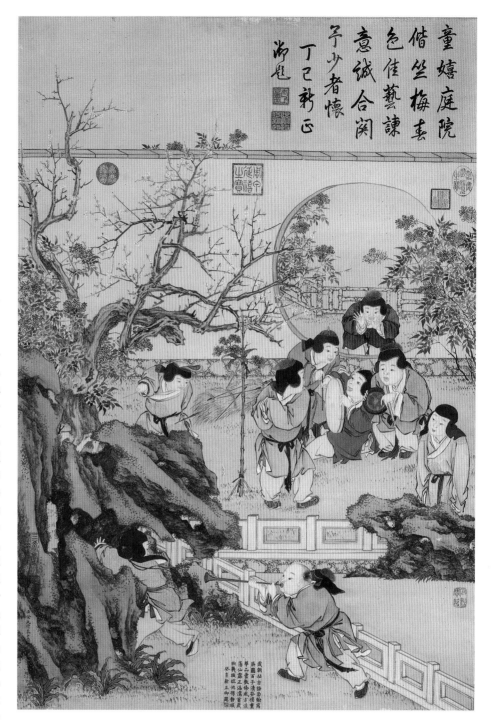

The theme of this painting is the joyful celebration of the Chinese lunar New Year. The first day of the first month, known as "Spring Festival," is the most important of the four major festivals of China. Beginning in the Shang dynasty (approx. 1600–1050 BCE) the Chinese worshiped the heavens and their ancestors on this day. Throughout the centuries, more customs were added to the New Year's celebration, such as lighting firecrackers, staying up late on New Year's Eve, and writing spring couplets. Legend had it that a man-eating wild animal named "Year" (*Nian*) appeared with the New Year. In order to protect themselves from this beast, people gathered together and lit firecrackers and posted New Year's couplets on red paper. After the beast had been scared off in the early hours of the morning, everyone, young and old, got up to wish each other a happy New Year while thanking heaven for protecting them from the beast.[1]

In the painting nine boys are playing in a garden. Two are striking a gong and beating a drum, one is blowing a glass trumpet, and, following a New Year's tradition, one is about to light a bamboo rod. Lighting firecrackers is a symbol for "announcing peace." The heavenly bamboo (*nandina*), with its red berries and plum blossoms blooming among the rocks, enhance the cold winter scene. The white marble balustrades and the spotted-bamboo fence define the space. Typical of the work of Jin Tingbiao, the boys' features are lively,

and the drapery folds are depicted with powerful strokes. A colophon penned by Emperor Qianlong in 1797 describing the scene appears above the painting.

Jin Tingbiao (also known as Shikui) was a native of Tongxiang, Zhejiang province. He presented an album of line drawings of arhats (*luohans*) to Emperor Qianlong during his southern tour, which resulted in an invitation to join the royal atelier. Jing's vivid narratives, sentiment, and the fine quality of his figures and settings were much admired by Manchu and

Chinese nobles. Qianlong continued to write poetic colophons on Jin's paintings, even after the artist's death.[2]

WET WITH TB

1. Guo Xingwen and Han Yangmin 1989. Liu Fangru 1990.

2. *Qingshi* (1913–27) 1971, vol. 7, chap. 503, p. 5463.

清乾隆朝 緙絲刺繡 九羊啟泰圖軸

Nine goats bring peace to the New Year

Qing dynasty (1644–1911), reign of
Emperor Qianlong (1736–95)
Silk tapestry (*kesi*) with embroidery
H: 218 cm, W: 111.7 cm
Gusi 000096

Shown at the Asian Art Museum only

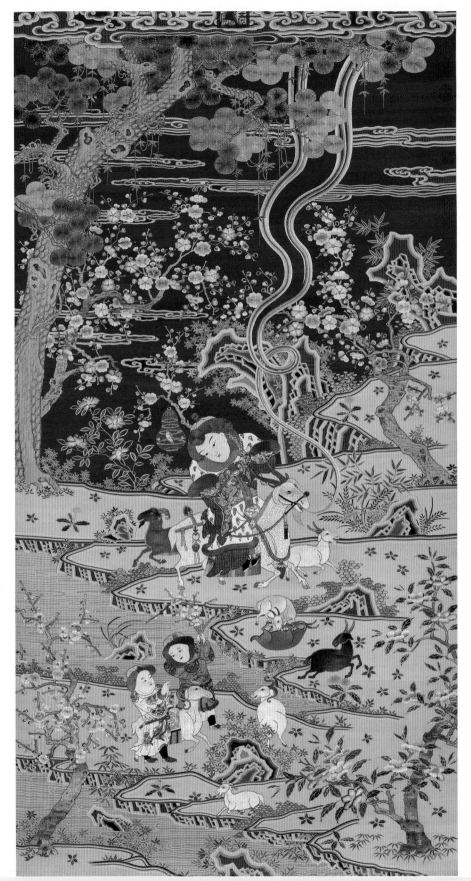

This tapestry depicting three boys, nine goats, and pine, bamboo, and plum trees (known as the "three friends of winter") involve a web of puns and associations that was a popular theme for paintings hung in the palace during the New Year. The ancient Chinese used diagrams to represent the rising and falling of positive and negative forces of nature during the twelve months. The diagram representing the first month of the year refers to peace (*tai*). Because the numeral nine is the most positive number in Chinese culture and a homonym for the auspicious word for "eternity" (*jiu*), the phrases "the nine positive forces of nature are the beginning of peace" and "the nine goats bring renewal to the New Year" over time became conflated into a single common saying: "The nine positive forces of nature bring renewal and peace to the New Year." The nine goats in the tapestry are a pun on the word for the nine positive forces of nature (*jiuyang*). The three richly clad boys represent princes, a pun on triple peacefulness (*santai*). Altogether, the goats and the boys convey the sentiment that winter is ending and spring will arrive, ushering in renewal and a change of fortune.

Qing dynasty *kesi*, or cut-silk, tapestries are known for their large formats and complicated compositions (see cats. 17 and 18). They reveal impressive technical skill, a colorful palette, and a variety of weavings. Sometimes embroidery or even painting was added to the weaving to heighten artistic effects and realism. Here the basic *kesi* technique was used for the blue ground, the auspicious five-colored cloud, the ground, and the water, while embroidery was added to the figures, animals, and plants. The plum blossoms and pine needles and branches are further embroidered and painted, reflecting the quest for complexity and perfection in the decorative arts of the Qianlong era.[1]

WET WITH TB

1. Hu Sailan 1994.

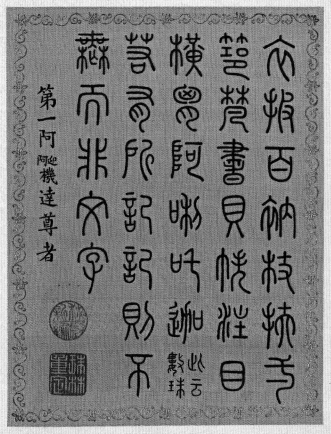

CAT. 135.1

CAT. 135

清乾隆朝 彩繡 畢沅書
御製十六羅漢贊

Sixteen *Luohans* (arhats)

Based on the portraits by Ding Guanpeng (active
1736–95) and calligraphy by Bi Ruan (1730–97)
Qing dynasty (1644–1911), reign of
Emperor Qianlong (1736–95)
Album of sixteen leaves, silk with embroidery
H: 21.8 cm, W: 17.1 cm
Gusi 00083-0

In 1756 Emperor Qianlong made a dis-
covery in Buddhist iconography. Citing
Sanskrit sources and the words of Rolpay
Dorje, the chief teacher of Buddhism in
the Qing court, Qianlong argued that the
number of the *luohans*—or arhats, dis-
ciples of the Buddha Shakyamuni who
had achieved spiritual perfection, or nir-
vana—should be sixteen instead of the
commonly accepted eighteen. During his
southern tour in 1757, the emperor care-
fully studied the well-known painting
of the sixteen *luohans* by the monk and
painter Guanxiu (832–912) at Sheng'en
Temple in Hangzhou. He had the court art-
ist Ding Guanpeng (see cat. 128) copy the
set and titled the paintings in his own hand
"Praise to the Sixteen *Luohans* by Guanxiu
and copied by Ding Guanpeng." Thanks to
Qianlong's deep affection for these works,
images of the *luohans* spread swiftly in
paintings, stone carvings, reliefs, porce-
lain plaques, and ink-stick decorations,
many of them still extant.

This album was commissioned by
Emperor Qianlong. On the left side of each
leaf, *luohans* based on Guanxiu's paintings
are embroidered in colorful threads; on
the right are inscriptions in blue thread
written by Qianlong in 1757 and the names
of the *luohans* in seal script, based on the
calligraphy of Bi Ruan. Bi won the title
of "First Scholar" in the palace exam-
ination in 1760 and was later assigned
to the Hanlin Academy. From 1766 until
his death in 1797, he served as a regional
official. While the album was not dated,
Bi must have inscribed the piece between
1760 and 1766, when he was an official
in Beijing.

JJC WITH TB

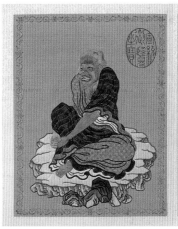

CAT. 135.2

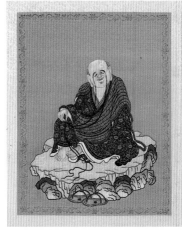

CAT. 135.4

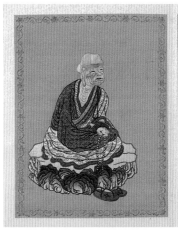

CAT. 135.6

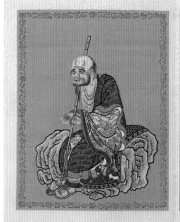

CAT. 135.7

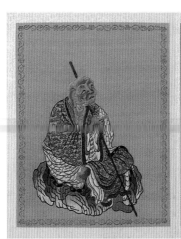

CAT. 135.8

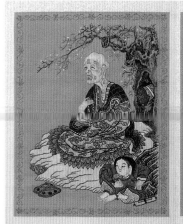

CAT. 135.9

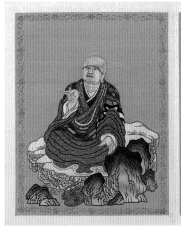

CAT. 135.10

CAT. 135.11

CAT. 135.12

CAT. 135.13

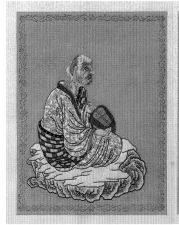

CAT. 135.14

CAT. 135.15

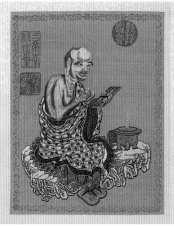

CAT. 135.16

CAT. 136

清乾隆朝 新疆哈密札薩克郡王貢
御用金碗

Gold bowl

Tribute from Prince Erdeni Deshi-e
Qing dynasty (1644–1911), reign of
Emperor Qianlong (1736–95)
Gold
H: 7.5 cm, Diam: mouth 14.5 cm, base 7 cm
Guza 001241 Tian 399

In 1784, Prince Erdeni Deshi-e, a sixth-generation Jasagh from Hami, a territory in Xinjiang, gave this bowl to Emperor Qianlong to express his appreciation for an edict that gave his clan the hereditary rank of nobility. It employs filigree decoration on the rim and a floral design on the foot ring. The bowl is also engraved with pomegranates, a symbol of fertility, while finely soldered gold beads decorate the entire wall, making for novel texture. The elaborate design required the combined skills of soldering, engraving, repoussé, and ring-punching. The bowl was stored in a round wooden box whose inner lid has Chinese, Manchurian, Mongolian, and Tibetan writing on white silk recording that this tribute bowl was presented to the Qing court by the duke on the twenty-seventh day of the twelfth month in 1794.

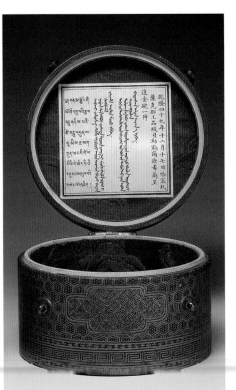

SEAL MARK

"Made for use by Emperor Qianlong," four-character mark incised in regular script with a double-line hook inside the foot ring.

YLH WITH JC

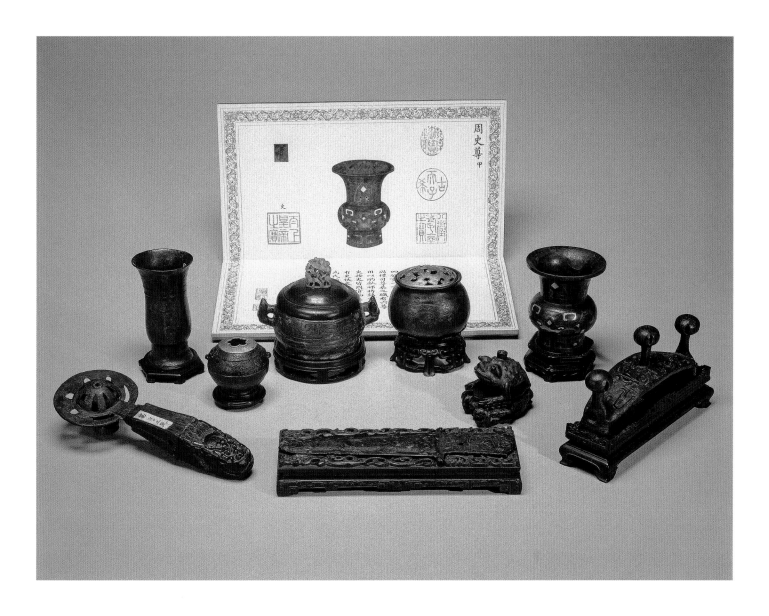

CAT. 137

清乾隆朝 青銅、紫檀木
「笵金作則」古銅文玩

Set of ancient bronze vessels

Qing dynasty (1644–1911), reign of
Emperor Qianlong (1736–95)
Bronze, sandalwood (*zitan*)
Various dimensions
Gutong 000453-000461 Yu-1176-2-10

Emperor Qianlong often commissioned
treasure boxes to hold his favorite antique
pieces. These nine bronze vessels, each
with a custom-made sandalwood base,
were meant to be a set contained in one
box. One of the vessels was removed by
Emperor Xianfeng (reigned 1851–61) for
his personal use, so nine remain.

As illustrated in the album accompa-
nying the artifacts, Emperor Qianlong
arranged this set of "Examples of Fine
Bronzes" chronologically by dynasty.
While the album lists these works as
from the Zhou (approx. 1050 BCE–
256 BCE), Han (206 BCE–220 CE), and
Tang (618–907 CE) dynasties, close exam-
ination reveals that the bronzes are actu-
ally from the Shang and Zhou dynasties
(approx. 1600–256 BCE) together with
archaic-style vessels made in the Ming
and Qing dynasties. Three of the objects
were published in the bronze catalogue
Sequel to Antiquities of Western Clarity

(*Xiqing xu jian*), compiled by Qianlong's
decree and completed 1791.

Owing to Qianlong's interest in the
Song dynasty, these ritual vessels were
modified into scholars' or decorative
objects for placement in his studio. For
instance, the bronze *zhi* wine vessel dating
from the Western Zhou dynasty (approx.
1050–771 BCE) was used as a vase, and the
works in the style of the Zhou and Han
dynasties were used as an incense burner,
vase, and water container. The toad-
shaped vessel is a water dropper. The fra-
grance of flower, incense, and ink along
with the curious Shang-era bronze-hal-
berd decoration, bow-shaped chariot
fitting, and small Western Zhou bell all
came together in a study that combined
the styles of several periods ranging from
the Bronze Age to Qianlong's own time.
HYW WITH TLJ

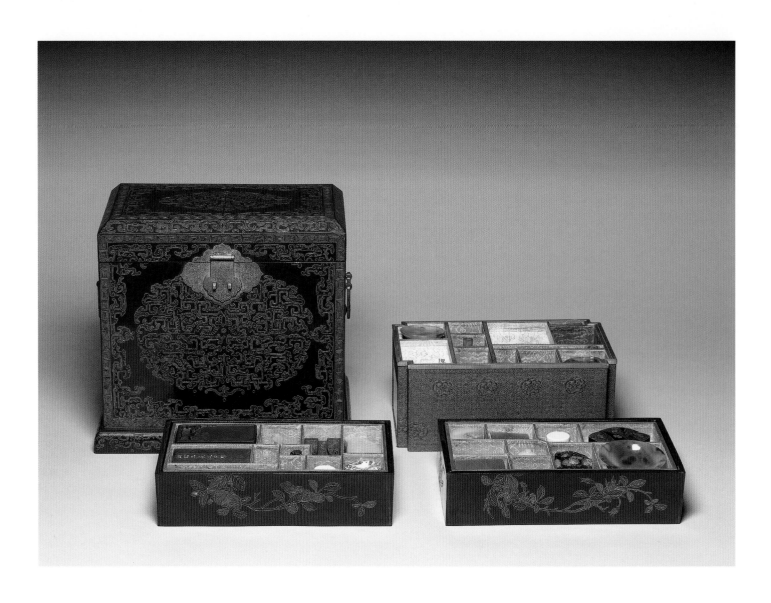

CAT. 138

清乾隆朝 紅漆戧金龍鳳紋
小櫃多寶格、四十四件文玩

Rectangular treasure box with
forty-four objects

Qing dynasty (1644–1911), reign of
Emperor Qianlong (1736–95)
Lacquered wood painted with gold and
polychrome pigment, brass, and miscellaneous
materials
H: 25.7 cm, L: 19.2 cm, W: 28.6 cm
Guqi 000482 Lü 2033

By the eighteenth century the multiple-storied box was an important type of furniture for studios. It was used in the palace to contain a variety of small precious objects. Qing documents tell us that many such boxes were designed by the Imperial Workshop in order to organize treasures, curios, and scholars' materials. Some of the boxes are as big as large pieces of furniture, while others are small enough to be easily carried.

The exterior of this treasure box is covered with red lacquer bearing floral designs decorated with etched gold and polychrome pigments; the interior features lacquer scattered with particles of gold. The main design is that of a stylized phoenix filled with little units of dragons and phoenixes and painted in such colors as deep green and orange. Incorporating ancient decorative elements into a new design was typical of the Qianlong period. The container is further ornamented with a large metal lock and square handles on the sides, exemplifying the grand style and taste of the palace. The lid is shaped like an ancient rooftop whose edges are decorated with borders of meanders.

Within the box are three smaller boxes, the tallest one on the bottom, containing a total of forty-four objects. These smaller boxes consist of an ingenious series of compartments and drawers made to the size of particular objects. The majority of these are nineteen jade pieces dating from ancient times to the Ming and Qing dynasties. In addition, there are vases, small containers, and animals made of porcelain, bronze, and carnelian as well as miniature carvings made from ivory and seedpods and tiny hand scrolls and album leaves. The treasure box even sports its own small catalogue recording the contents and their location within.

HHC WITH TB

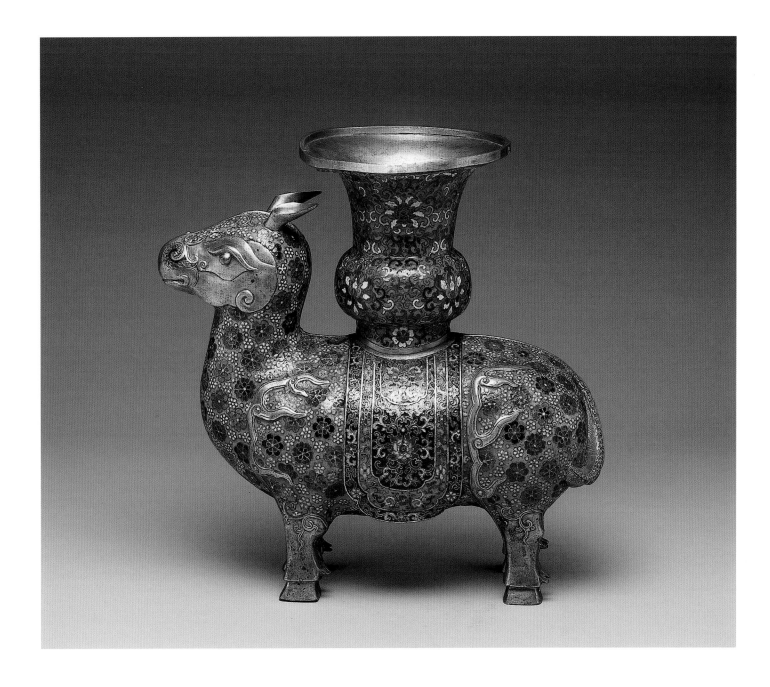

CAT. 139

清乾隆朝 造辦處 掐絲琺瑯
仿古銅犧尊

Vessel in the shape of a mythical
beast (*xizun*)

By the Imperial Workshop, Beijing
Qing dynasty (1644–1911), reign of
Emperor Qianlong (1736–95)
Copper alloy with cloisonné enamel inlays
H: 27.7 cm, L: 13.6 cm, W: 26.4 cm
Zhongfa 000236 JW-175

This object takes the shape of an ox-like mythical beast called a *xizun* presenting a vase on its back and was based on a classical Bronze Age ritual wine-serving vessel. The form of this object is recorded in the *Illustrated Ritual Implements of the Imperial Dynasty (Huangchao liyi tushi)*, a comprehensive manual compiled by the Qianlong court in 1764.[1] The first chapter addresses the vessels used in ritual ceremonies and includes an illustration of an ox-like vessel similar to this one; an annotation confirms that in 1759 it was set on an altar in the main hall of the Imperial Ancestral Temple.

This lavish object features a metal surface meticulously engraved with detailed outlines of designs and filled with multicolor enamel cloisonné. The entire body is inlayed with a series of six-petal flowers alternating with smaller yellow blooms. The stylized floral patterns and the vibrant colors represent the outstanding cloisonné technique mastered by the court craftsmen in the mid- and late Qing dynasty.

SEAL MARK
"Produced during the Qianlong reign," four-character mark incised horizontally in standard script on the lower neck of the ox.
YLH WITH LJ

1. Yunlu 1766, chap. 2.

CAT. 140

清乾隆朝 造辦處 金胎掐絲
畫琺瑯 多穆壺

Tibetan-style ewer

By the Imperial Workshop, Beijing
Qing dynasty (1644–1911), reign of
Emperor Qianlong (1736–95)
Cloisonné, painted enamel, coral, turquoise,
lapis lazuli
H: 52.4 cm, W: 23.5 cm, Diam: mouth 15.5 cm,
base 14 cm
Zhongfa 001462

This type of vessel, known as a *duomu* (Tibetan for "butter bucket") pitcher, was originally used by Mongolian, Tibetan, and other ethnic groups for drinking yak-butter tea. Only later did the Qing court begin manufacturing ewers in this form using a variety of rich materials.

The mouth is in the shape of a monk's cap, and the green lid is decorated with a lotus-petal finial inlaid with coral. The spout is carved with a dragon head and a dragon mouth, while a slightly coiled tail comprises the handle. Five bands of inlaid precious stones encircle the ewer, with the band on the mouth and first band on the body conjoined. These top two bands are engraved with lotus-scroll patterns inlaid with coral, turquoise, lapis lazuli, and other precious stones. By contrast, the other three bands are somewhat less ornate and are similar to the band that runs vertically down the side of the body and accents the handle. These bands divide the vessel into three sections filled with blue enamel and wire inlayed with polychrome enamels. Each section contains three white panels outlined with metal trim and featuring intricate enamel paintings of a mother and child, a scene of lake stones and butterflies, and a landscape with sheep. A lotus scrollwork brocade pattern decorates the ewer's base. The resplendence of this ewer illustrates the taste of the imperial family; in fact, it may be one of the most lavish and representative enamel works of the Qianlong period.

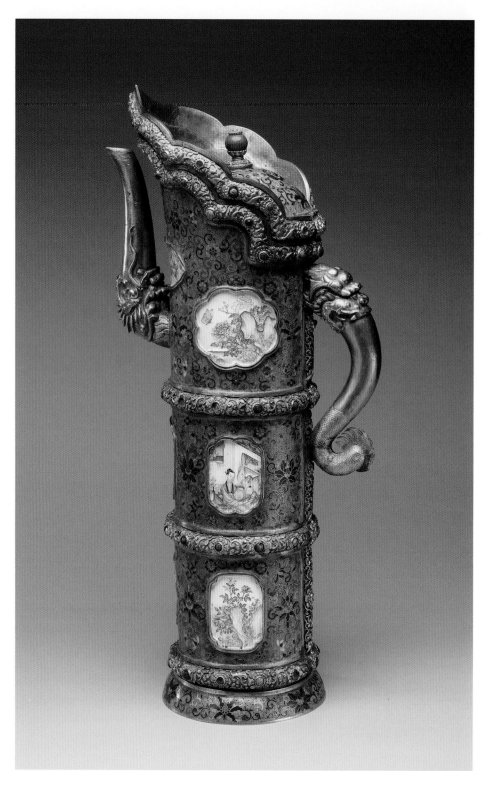

SEAL MARK
"Produced during the Qianlong reign of the Great Qing," horizontal six-character seal incised in the metal on the bottom of the foot ring.

YLH WITH JC

CAT. 141

清乾隆朝 造辦處 金胎填琺瑯
西洋母子圖執壺

Champlevé ewer with European figures in landscape

By the Imperial Workshop, Beijing
Qing dynasty (1644–1911), reign of
Emperor Qianlong (1736–95)
Gold with inlays of enamel
H: 18.7 cm, W: 12.85 cm, base 3.8 cm, L: 3.2 cm,
Diam: mouth 2.6 cm
Gufa 000110 Lie 375-5

Qing dynasty court art featured a range of pioneering subjects, including Western characters and landscapes. This exquisite ewer combines incised metal filled with enamel and painted enamel. The elaborate fusion of Chinese and Western ornamentation styles and techniques demonstrates the magnificence of imperial objects.

The body of the ewer is incised with an intricate relief scrollwork motif and filled with a green enamel base. A pair of large panels, one on the front and one on the back, feature painted portraits of a European mother and child. Panels on the neck, one on the front and one on the back, are decorated with floral branches. Two pairs of panels, placed above and below the points where the handle and spout meet the body, feature Western landscapes in monochromatic rouge. Bands on the neck boast carved lotus, banana, and curly leaf scrollwork. The spout is carved with a dragon head and has a cloud-patterned prop that joins the neck. The handle is in the shape of a wish-granting wand (*ruyi*); the lid is attached to the handle with a small chain and is decorated with lotus petals and a coral finial. The lid and foot ring each have four small panels that are painted white and decorated with flowers. The foot ring also has curly leaf scrollwork; the neck and foot are both filled with purple enamel.

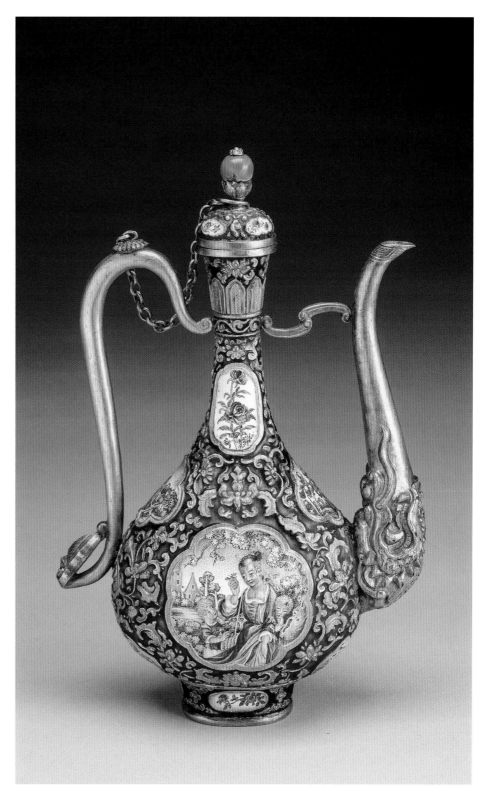

SEAL MARK
"Produced during the Qianlong reign," four-character mark in regular script with a double-lined border engraved on the base.
YLH WITH JC

CAT. 142

清乾隆朝 造辦處
銅胎嵌寶石、琺瑯 靶碗

Champlevé-covered high-stem bowl, 1780

By the Imperial Workshop, Beijing
Qing dynasty (1644–1911), reign of
Emperor Qianlong (1736–95)
Gilt copper alloy with inlays of precious stones
and enamel
H: 28.2 cm, Diam: mouth 14.3 cm
Guza 001318 Lü-1158

This piece, produced by the Imperial Workshop, is a replica of a silver champlevé stem bowl (now in the Palace Museum, Beijing) given by the Sixth Panchen Lama (1738–80) to Emperor Qianlong on his seventieth birthday in 1780. This beautiful object, a fine example of the excellence achieved by the metalsmiths of the Qianlong era, consists of a lid, bowl, and stand. The base metal is chiseled, showing a flower bud on the lid, petals below, and borders of flowers and leaves inlaid with precious stones of red and blue. Other spaces are filled with enamel. Latticework leaves, each filled with transparent green enamel resembling a fully opened blossom, radiate from the center of the interior of the lid and the bowl.

SEAL MARK
"Made in the reign of Emperor Qianlong of the Qing dynasty," reign mark engraved in the center of the interior of the bowl.
YLH WITH TB

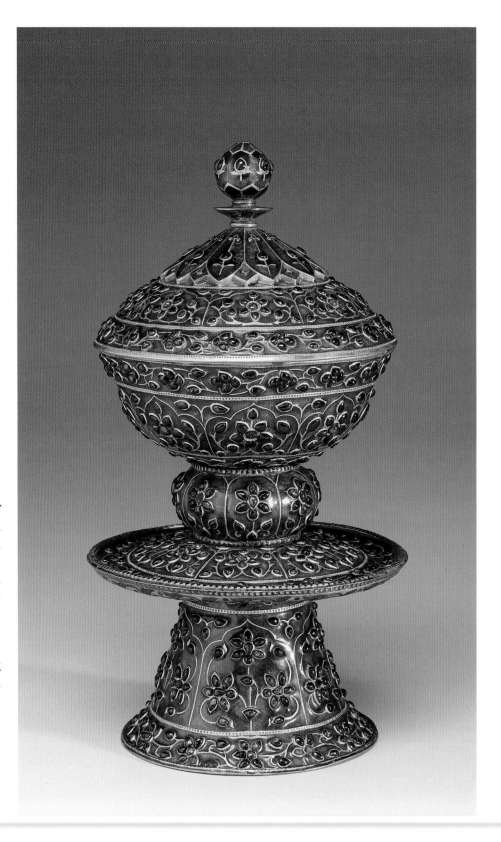

CAT. 143

清乾隆朝 造辦處 玻璃胎畫琺瑯
嬰戲圖鼻煙壺

Glass snuff bottle with scenes of children playing

By the Imperial Workshop, Beijing
Qing dynasty (1644–1911), reign of
Emperor Qianlong (1736–95)
Glass painted with enamel and copper-alloy
lid and ivory spoon
H: 5.4 cm, W: 3.7 cm
Guci 14072 Cheng-85-14

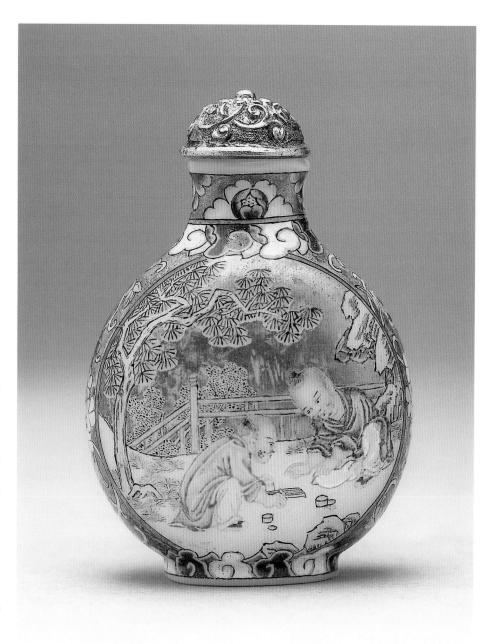

Snuff bottles made of glass, particularly ones with gold-enamel backgrounds, were among the most highly prized objects during the Qing dynasty. Recent research has shown that the melting point of glass and enamel is roughly the same, making the firing process of such pieces especially complex, and perfect examples are exceptionally rare. During the first lunar month of 1737, Emperor Qianlong issued an imperial edict requiring the Glass Workshop to manufacture fifty snuff bottles, including this piece. Qianlong then gave explicit instructions to have this piece placed with forty-two other snuff bottles in a Japanese *maki-e* lacquer box.[1] The Glass Workshop's accomplishment did not last more than four decades. In 1779 Emperor Qianlong investigated why enameled glass snuff bottles were so difficult to manufacture.[2]

The scene depicted here of boys playing was a popular one. One side shows boys bent over fighting crickets, while the other side has two children playing among flowers in a setting of sculptural rocks, balustrades, and trees before a courtyard. The treatment of this scene reveals that the artisan who painted it was still under influence of Song figure painting. The neck and shoulder of the bottle are painted with lines, flowers, and clouds, while its sides are decorated with floral patterns and hydrangeas. The copper lid features a carved flower design and an ivory spoon. The mouth and foot retain a white edge, while the top and bottom are decorated

with thin bands. The finely detailed decoration reflects Qianlong's high standards for this type of work.

SEAL MARK
"Produced during the Qianlong reign,"
four-character mark in seal script carved
on the bottom.
PCY WITH JC

1. Zhongguo diyi lishi 2005, vol. 7, p. 802.

2. Ibid., vol. 8, p. 147.

CAT 144

清乾隆朝 江西景德鎮 洋彩瓷
錦地番蓮 "交泰" 八卦紋轉心瓶

Vase with revolving core and
eight-trigram design, approx. 1744

Jingdezhen, Jiangxi province
Qing dynasty (1644–1911), reign of
Emperor Qianlong (1736–95)
Porcelain with golden glaze, polychrome
decoration, and appliquéd sculpture
H: 19.6 cm, Diam: mouth 6.4 cm, base 6.8 cm
Guci 017215 Lie-408

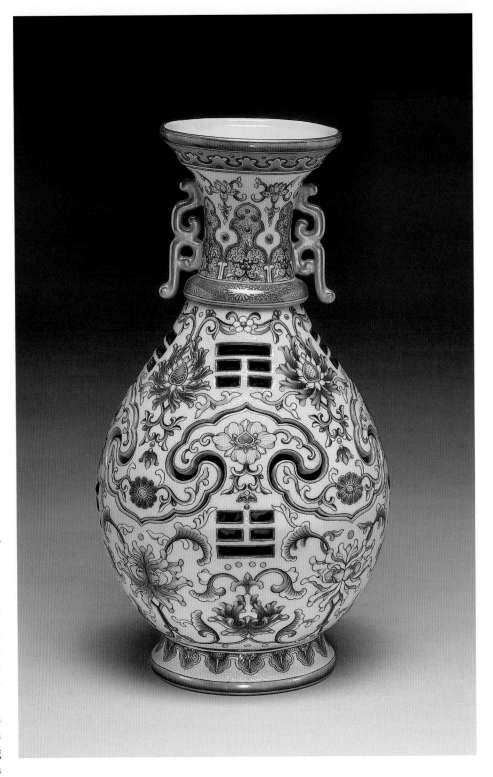

This complex piece—one of a pair—consists of several parts: neck, upper and lower body, and inner vase. Each component was fired independently and, once finished, assembled in such a way that the inner vase rotates when the neck is turned. The vase has an exaggerated mouth, broad lip, short neck, slanted shoulders, large belly, and short foot ring that angles outward. Adorning golden ears complement the neck above a high-relief edge on the shoulders. The inside and bottom of the piece are glazed in light green. The inner vase features a painted blue-and-white floral pattern. The body is glazed in yellow and painted with lotus scrollwork, banana leaves, acanthus patterns, and eight wish-granting wand (*ruyi*) mushroom and cloud-head motifs that feature trigram cutouts.

The basis of ancient divination in Daoism, trigrams consist of combinations of broken and unbroken lines symbolizing yin and yang energy. The eight cutouts on the vase are arranged in four corresponding pairs. Between each pair is an openwork *ruyi* mushroom head, a motif associated with longevity and heaven in Daoism. The combination of traditional trigrams with the innovative cutouts and openwork makes this vase a notable piece of eighteenth-century porcelain.

Revolving vases were developed when the ceramic official Tang Ying responded to Qianlong's request for innovative designs. Records show that in 1744 the emperor commissioned a pair of "Western-style"

yellow revolving vases with designs of eight trigrams in a wooden box, ordering that upon completion they be sent to the Palace of Heavenly Purity (*Qianqing gong*) in the Forbidden City.[1]

1. Tang Ying 1735. Zhongguo diyi lishi 2005, vol. 12, p. 374.

SEAL MARK
"Produced during the Qianlong reign of the Great Qing," six-character reign mark in underglaze cobalt-blue seal script on the bottom.

PCY WITH JC

CAT. 145

清乾隆朝 江西景德鎮 仿雕漆描金
暗八仙纏枝蓮紋冠架

Porcelain hat stand with imitation carved lacquer design

Jingdezhen, Jiangxi province
Qing dynasty (1644–1911), reign of
Emperor Qianlong (1736–95)
Porcelain with overglaze red and gold decoration
H: 27.2 cm, Diam: base 15.8 cm
Zhongci 003543 T1830

This hat stand belongs to an innovative type of porcelain that likely emerged from the exchange of Chinese and Western cultures. Since the seventeenth century, Dutch Delft pottery factories had manufactured spherical hat stands that closely resembled this one, and the official kilns during Qianlong's reign were deeply affected by foreign influences.

This hat rack consists of a spherical top with a small lid, a pillar, and a base. With its red-glaze background and high-relief meandering patterns in gold, the entire piece resembles traditional multilayer carved lacquer and reveals the Qing skill in using glazes to suggest different materials and textures. The top features intertwining lotus scrollwork and emblems of the Eight Immortals. The pillar has four prominent ridges, while flower designs decorate the Chinese crabapple–shaped base, which supports four large blue-and-white fixtures with dragon-and-cloud motifs.

SEAL MARK
"Produced during the Qianlong reign of the Great Qing," six-character gold seal on the bottom.
PCY WITH JC

清乾隆朝 江西景德鎮 洋彩瓷 嬰戲圖瓶

Vase with scenes of children playing

Jingdezhen, Jiangxi province
Qing dynasty (1644–1911), reign of
Emperor Qianlong (1736–95)
Porcelain painted with overglaze enamel
H: 19.2 cm, Diam: mouth 5.5 cm, base 6 cm
Guci 017169 Lie-547-1

Around 1700, the Imperial Workshop in Beijing was able to produce supplies of soft, opaque European-style enamels and shared them with the imperial kilns in Jingdezhen. The Jingdezhen kilns, in turn, began to employ what Tang Ying described as a "new imitation of painting methods with 'Western-style enamels.'"[1] These new pigments resulted in richly decorated enameled porcelains such as this one.

This vase shows joyous children celebrating the arrival of spring by leading a musical procession, raising lanterns, lighting firecrackers, and other activities. The craftsmen at Jingdezhen rendered the details in this scene carefully, and their brushstrokes rivaled those of the court artists in Beijing. The inside and bottom of the vase are painted with a pale blue glaze, and the mouth and foot have a thin gold border. The vessel has an exaggerated mouth with a narrow lip, a short neck, a long belly, and a short foot ring. The body is relatively thick to prevent the piece from bursting during the second firing after the application of the enamel decoration. This was a common trait of enameled ceramics made in the official Qing kilns.

SEAL MARK
"Produced during the Qianlong reign," four-character underglaze cobalt-blue seal with double-lined border on the bottom.
PCY WITH JC

1. Tang Ying 1735.

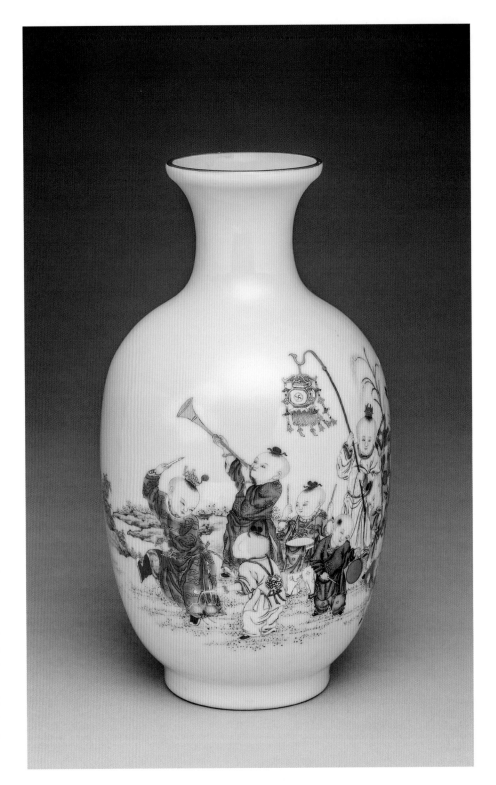

CAT. 147

清乾隆朝 江西景德鎮/造辦處
瓷胎畫琺瑯 西洋牧羊女圖長方盒

Rectangular box with Western shepherd girl

Glazed box made at Jingdezhen; decoration by
the Imperial Workshop, Beijing
Qing dynasty (1644–1911), reign of
Emperor Qianlong (1736–95)
Porcelain painted with overglaze enamel
H: 3.8 cm, L: 6.8 cm, W: 5.1 cm
Guci 017959 Lie-613

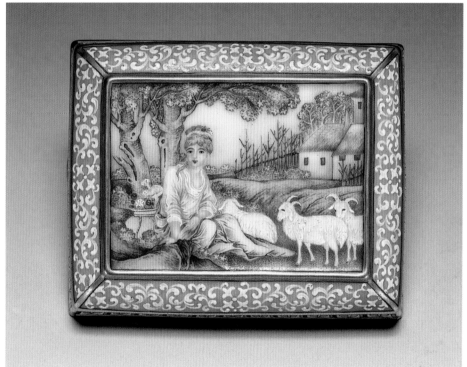

This exquisite box is typical of early eighteenth-century imperial porcelain made jointly at the Jingdezhen kilns and the Imperial Workshop in Beijing. Although Jingdezhen had produced porcelain with fine enamel painting since the reign of Emperor Yongzheng, on occasion the court commissioned plain pieces from Jingdezhen and then had the design and overglaze decorations executed at the Imperial Workshop.

The painting on the cover of the box depicts a landscape with a shepherd girl dressed in a pink skirt seated under trees. This subject had a special appeal as the ram is a sign of the zodiac and a symbol of auspiciousness in China. The use of Western perspective and the treatment of light and shadow enhance its realistic presentation. The decorations on this box imitate cloisonné wares. The slanting border of the cover is molded with stylized tendrils in off-white enamel and decorated with gilded flanges. A band of pink meander design encircles the foot ring.

Objects such as this box—with its innovative design and realistic painting, and despite its small size—were favored by the emperor and the imperial family. The style and subject of this painting were far from unknown in Qing decorative arts. The Imperial Household Department records show that Qianlong ordered Western-style scenes on porcelain wares as early as 1737,[1] by which time European shepherd girls had begun to appear on cloisonné objects.

SEAL MARK
"Produced during the Qianlong reign,"
four-character mark within a double-lined
rectangular border in blue enamel in the
center of the base.
PCY WITH LJ

1. Zhongguo diyi lishi 2005, vol. 7, p. 708.

CAT. 148

清朝 十八世紀 朱漆剔紅
蘇東坡遊赤壁圖插屏

Table screen with a scene of
Su Shi traveling at Red Cliff,
approx. 1700–1800

Qing dynasty (1644–1911)
Carved red lacquer (*tihong*)
H: 63.6 cm, L: 16.5 cm, W: 59.9 cm
Zhongqi 000044 T6713

Shown at the Asian Art Museum only

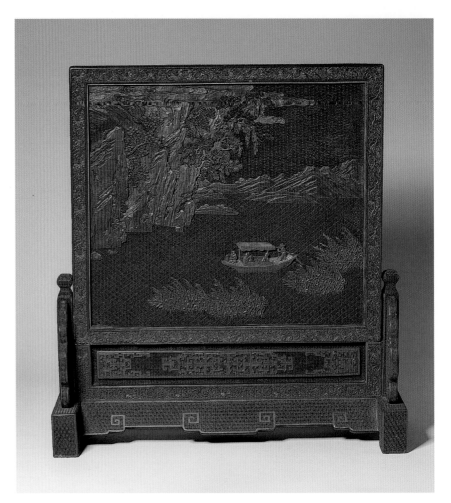

The literati of the Ming dynasty enjoyed employing classical themes in their paintings, and Emperor Qianlong continued this tradition by making literary themes a primary subject of his court art. This large screen exemplifies such taste and is engraved with a scene inspired by the Ming-era literary drama "Touring Red Cliff" by Xu Chao (active 1534–50), which dramatized a historical event involving the Song official and poet Su Shi, who, owing to his satirical political verses, was demoted by the court in 1080 to be a minor official in Huangzhou, Hubei province. One night Su Shi invited fellow poet Huang Tingjian and a Zen monk to boat along the famous Red Cliff.

The design of this work encompasses an expansive space centered on the boat; Su Shi sits in front of the other two men in the center on the boat. A young servant boils tea on the prow, and a man can be seen sculling at the stern. The meticulous engraving in this piece showcases the landscape in perspective, with distinctive chiaroscuro effects in the limpid waves and twinkling stars. The reverse of the screen depicts three dragons tumbling fiercely amid the detailed ripples of the river; dragon patterns highlight the user's royal status. While the work features a variety of complex decorative motifs, they do not conflict, and the work as a whole reveals the court's taste for the solemn and magnificent.

HHC WITH DH

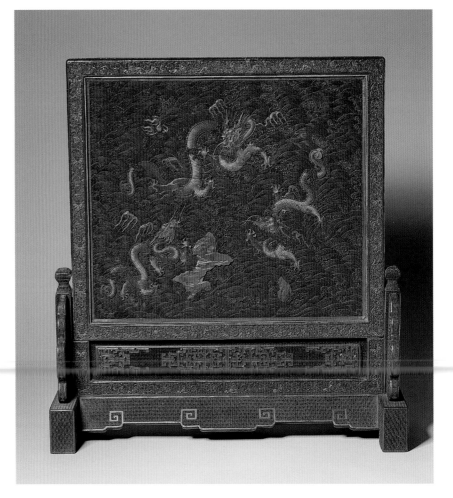

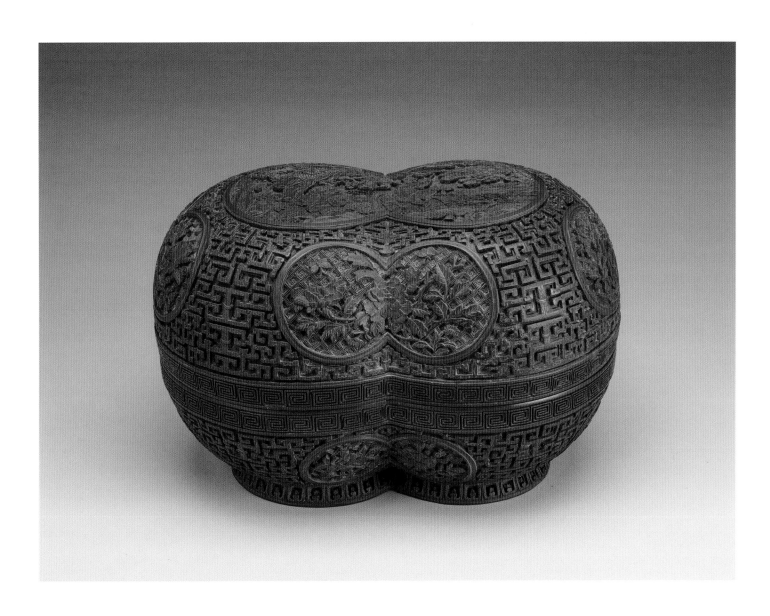

CAT. 149

清乾隆朝 剔彩雕漆 雙緣寶盒

Box in the shape of conjoined spheres

Qing dynasty (1644–1911), reign of
Emperor Qianlong (1736–95)
Carved polychrome lacquer (*ticai*)
H: 18.6 cm, L: 29 cm, W: 19.8 cm
Guqi 000093 Que 815

Shown at the Museum of Fine Arts, Houston, only

This lidded box is fashioned in the form of two partially overlapping spheres. The top and sides of the lid feature carved panels depicting a Westerner on horseback advancing with a porter who carries tribute gifts. Portraits of tributary offerings had been popular since the Tang dynasty and symbolized peace and prosperity, with barbarians from all corners of the world offering tribute to the emperor. Indeed, Emperor Qianlong ordered court painters to produce a hand scroll containing portraits of emissaries bearing tribute.

The main decorative scheme of the box is executed in red lacquer, with layers of green and yellow lacquer beneath. In the tribute scene on the lid, yellow patterns show in the ripples of water, while green lacquer frequently cuts through at the edges of trees, rocks, and clouds. The overall decorative pattern is regularly laid out and features delicate and detailed engraving, and little emphasis

has been given to polishing the lacquer. On the bottom of the box are decorative motifs of lotus petals, a frequent subject in court decoration. Inside the box, golden foliage, peaches, and bats—which signify good fortune and longevity—are painted on black lacquer.

INSCRIPTIONS

"Produced during the Qianlong reign of the Great Qing dynasty," inscribed on the bottom of the base, and "Treasured box with double lot," written in gold by Emperor Qianlong. Qianlong's inscription gives the work a punning title, as the word for "round" in Chinese is a homonym for the words "abundance" and "fate."

HHC WITH DH

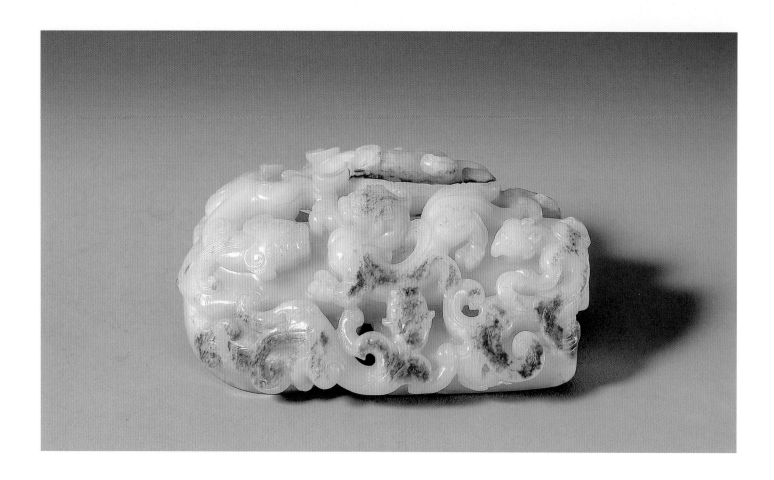

CAT. 150

清乾隆朝「乾隆」璽印

Imperial seal of Emperor Qianlong

Qing dynasty (1644–1911), reign of
Emperor Qianlong (1736–95)
Nephrite
H: 16.7 cm, W: 11.5 cm
Guyu 003475 Tian-1208

This jade seal of Emperor Qianlong shows the classical taste that permeated the emperor's collection of scholars' objects. The inscription has two characters—*Qian* and *Long*—set opposite each other. The convexly carved *Qian* is set off by stylized dragons within a flat roundel at the top of the seal; the concave *Long* is flanked by two dragons framed by a flat square at the bottom. Owing to the traditional astrological concept that the "sky is round, and the earth is square," the circle came to symbolize heaven, and the rectangular shape,

earth. The heaven-earth-ruler synthesis was thus established with the aim of portraying the emperor as the rightful holder of the mandate of heaven. Such identification fit the old custom of seeing unusual celestial phenomena as divine responses to the emperor's reign.

Parts of this seal have retained original brownish infusions in the white nephrite. The knob of the seal consists of three mystical animals and the form of an ancient tablet (*gui*), all imitating Han dynasty–style jade. The three mystical animals reflect Qianlong's taste for the ancient and demonstrate the endurance of traditional Chinese culture. Qianlong believed that the jade tablet functioned as a sacred object for worshiping the heavens, and he commissioned a tablet with similar motifs for this purpose. The tablet on this seal is exquisitely decorated with the heaven-earth motifs, complete with details representing the seven-star constellation, clouds, ocean waves, and cliffs. A similar concept can be found in the support of a jade ring commissioned by Qianlong, which bears a poem by the emperor: "Holding the ring in the middle, how graceful it is; with Heaven's blessing, thousands of states shall come to pay

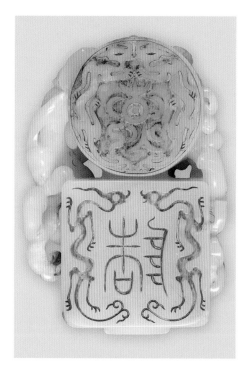

tribute." The design of this jade seal probably also symbolized a unified China that was respected by the world.

CLT WITH TLJ

新石器龍山文化晚期–商代二里頭
文化 乾隆帝弘曆題詩玉圭

Tablet (gui) with animal mask design and Emperor Qianlong's poems

Tablet: approx. 2500–1500 BCE; design and poems: Qing dynasty (1644–1911), reign of Emperor Qianlong (1736–95)

Nephrite

L: 27 cm, W: 4.79 cm, Depth: 1.1 cm

Guyu 001847 Lü-1501-13

This piece is another example of an ancient jade piece that was redesigned for Emperor Qianlong. Emerging in the late Neolithic period, the rectangular jade tablet (gui) was used by necromancers in ritual ceremonies, where heavenly blessings were sought or ancestors were worshiped. The form became associated with dynastic power and the absolute authority of the Son of Heaven, and tablets of this sort were often possessed by the wealthy.

The line work encircling the animal mask near the hole was done at the time this tablet was originally made, sometime between 2500 and 1500 BCE. The rest of the decorations and inscriptions were added by an eighteenth-century jade cutter. Each side was inscribed with poems by Emperor Qianlong written in 1756 and 1773. Qianlong believed that this tablet was an important ritual object used for calendar compilation and the investiture of nobles. Metaphorically, Qianlong considered this straight and long tablet to be a jade yardstick, serving not only as a benchmark for measuring talent, but also a personal set of standards for proper conduct and governance. The sentiment is reflected in a line of poetry carved on another jade tablet in the National Palace Museum collections, which states, "To measure talent, I must borrow the [metaphoric] jade ruler, while cautioning myself to also maintain such worthy attributes."[1]

On this tablet the emperor's poem is upside down in relation to the engraved animal mask, indicating that Qianlong's understanding of the mask's orientation differed from that common in ancient times. Archaeological finds indicate that the circular hole in Zhou era jade gui was placed at the bottom of such artifacts; however, Ming and Qing jade tablets typically feature a similarly circular-shaped sun, moon, or star motif at the top. Therefore, Qianlong naturally considered the circular hole in this ancient tablet to be a representation of the sun and moon, and in light of the belief that the sun and moon should reign paramount in the sky, the orientation of the animal mask became a secondary concern. Qianlong had his own set of principles regarding the appreciation of both ancient artifacts and later imitations, and the stylistic elements of this piece clearly reflect this aesthetic philosophy.

SEAL MARKS

"Son of Heaven in his seventieth year" (Guxi tianzi), "Retired emperor" (Tai Shang Huangdi), and "A man at age eighty years" (Bazheng maonian).

CLT WITH TLJ

1. Guyu 2784.

CAT. 152

清乾隆朝 青玉 英雄(鷹熊)雙聯瓶

Eagle and bear "hero" vessel

Qing dynasty (1644–1911), reign of
Emperor Qianlong (1736–95)
Nephrite
H: 18 cm, L: 12 cm, W: 5.6 cm
Guyu 003388 Dan-35-6

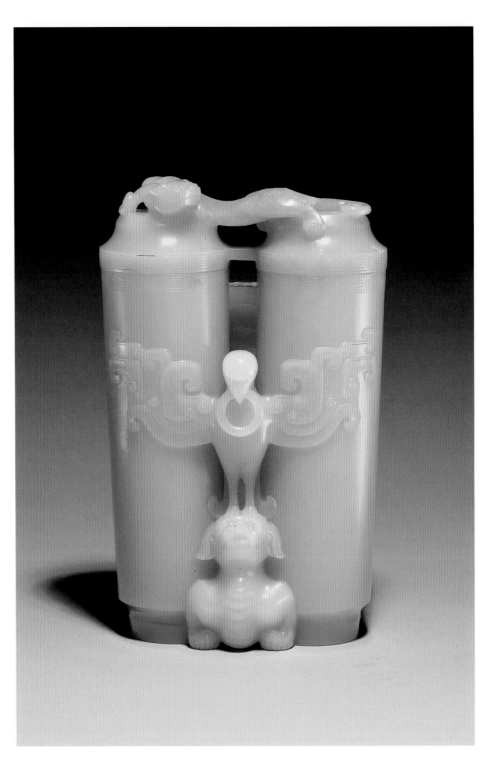

Made of a single piece of pale greenish jade, this vase consists of two compartments flanking an eagle and a bear. Together the two beasts symbolize heroism, as the Chinese words for "eagle" (*ying*) and "bear" (*xiong*) form a pun on the word for "hero" (*yingxiong*). The so-called hero vessel was particularly favored by Emperor Qianlong, who generously rewarded bravery and patriotism. In several of his verses on the eagle-and-bear theme, he found inspiration in classical art: "The inlay of a Han jade eagle and bear on a wooden wish-granting wand [*ruyi*] is a metaphor for pride and heroism"; and the culture of "the Shang and Zhou years convey infinity. The eagle and bear carved on a pendant portrays the hero."[1]

Derived from a Western Han vessel, this piece reveals a well-balanced proportion, and the powerful depiction of the animals conveys a spirit of the heroism.[2] The lids for each compartment are connected by a dragon. The integration of every element into a rational whole is typical of the art of the Qianlong period.

INSCRIPTION
"Modeled after an ancient work, in the Qianlong reign of the Great Qing" (*Da Qing Qianlong fanggu*), carved on the bottom.
CLT WITH TLJ

1. See the inscription on the jade piece in the collection of the National Palace Museum (Guyu 1865).

2. Gu Fang 2005, vol. 6, pp. 101–02.

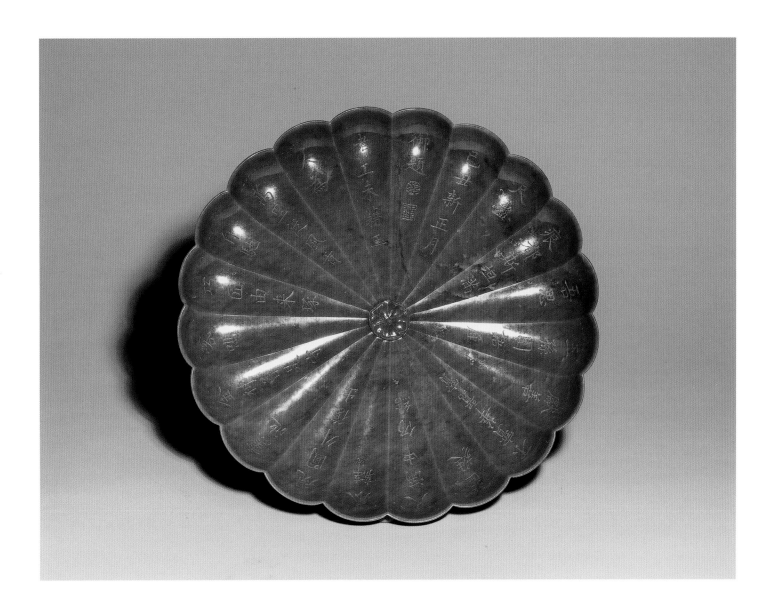

CAT. 153

十八世紀 印度蒙兀兒帝國
碧玉花式盤

Plate in a form of a flower blossom
with Emperor Qianlong's poem,
1769

Mughal, India, approx. 1700–1800
Dark green nephrite
H: 3.5, Diam: mouth 32.3, base: 24.7 cm
Guyu 003238 Tian-325

Emperor Qianlong's campaigns to quash
the Zunghars (in what is now Xinjiang)
in the mid-eighteenth century assured
the expansion of Qing possessions into
Central Asian territories with Mongol
cultural affiliations. The result was not
only access to new lands for horse breed-
ing, mining, jade quarrying, and farm-
ing, but also firm control of old and new
routes along the Silk Road. An inventory
of the Qing court recorded more than
270 jade items from the Muslim region
of China (Xinjiang), the Mughal Empire
(1526–1857), and the Ottoman Empire
(1300–1923). Qianlong's appreciation of
those jades is attested to by the seventy-
four poems composed for these works.[1]
An early example presented to Qianlong
by the chieftain of a Muslim tribe from
Kashi (west of Xinjiang) was carved with
the emperor's poem dating 1756.[2]

This dark greenish jade plate was pre-
sented to Qianlong in 1769 by General
Yiletu, the military commander stationed
in Yili (northwest Xinjiang). This plate is
formed by twenty petals radiating from an
exquisite flower in the center. Qianlong's
poem, praising the Islamic jade artisan
"Kama," is inscribed along the interior
of the petals. High officials such as Dong
Bangda (1699–1769) and others appended
remarks corresponding to Qianlong's
words on the exterior of the petals.
YCL WITH TLJ

1. NPM 2007, 11.

2. NPM 2007, p. 30, pl. 2.

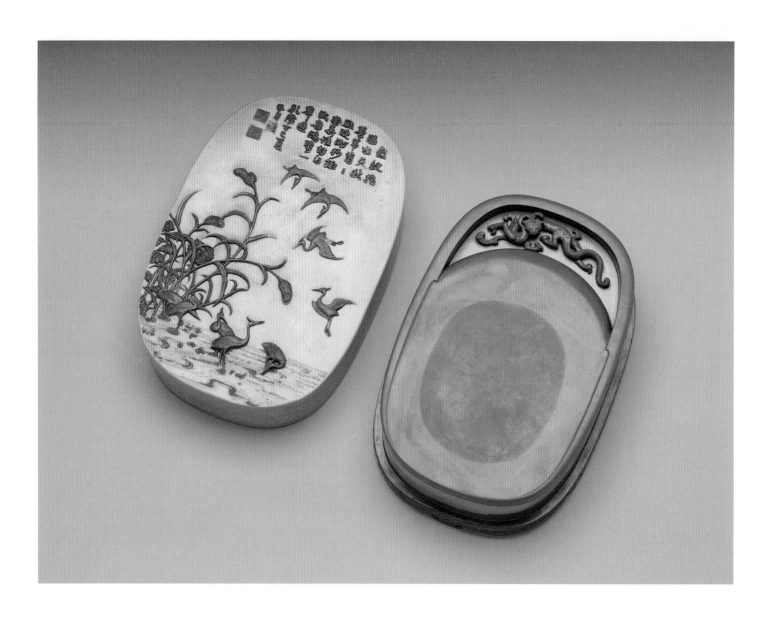

CAT. 154

清乾隆朝 松花石 御題蟠螭硯

Inkstone carved with Qianlong's inscription, 1737

By the Imperial Workshop, Beijing
Qing dynasty (1644–1911), reign of
Emperor Qianlong (1736–95)
Songhua stone
Inkstone H: 4.8 cm, L: 17.3 cm, W: 11.4 cm;
cover H: 5.5 cm, L: 18.4 cm, W: 12.4 cm
Guwen 001272 Tong 98-19

Recorded in the catalogue of the imperial collection of inkstones (*Xiqing yanpu*), this oval work was once owned and used by Emperor Qianlong. The inkstone and lid are carved from Songhua stone of a deep chestnut-yellow with a vein of light green. The surface of the inkstone is deep yellow, and in the ink-pool section are carved two coiling dragonets, exposing the light green stone beneath. The cover has a darker layer on top, cleverly utilized to show a low-relief carving depicting a scene of egrets flying and standing among reeds as well as a poem by Qianlong. The poem, inscribed in the emperor's semi-cursive script, relates to the scene of reeds and egrets. The base has six feet in the shape of wish-granting clouds. On the underside of the base is a relief carving of three dragons contending for a flaming pearl among clouds, which set off the two seals (below).

SEAL MARKS AND INSCRIPTIONS
"The one and only essence," engraved in two lines of seal script, and "From the Qianlong brush," square seal in relief on the cover. "Eternally treasured and used," square seal in two lines of seal script on the inside of the cover. "Pure curio of Qianlong," in relief clerical script, and "Presented to the three altruisms," engraved in two lines of seal script on the base.

YLH WITH CYY, TB

清乾隆朝 楊維占雕伽楠木
香山九老座雕

Nine elders gathering at Mount Xiang, 1741

By Yang Weizhan (active 1730–50)
Qing Dynasty (1644–1911), reign of
Emperor Qianlong (1736–95)
Aloeswood
H: 18 cm, L: 12 cm, W: 9 cm
Gudiao 000247 Tian-1278

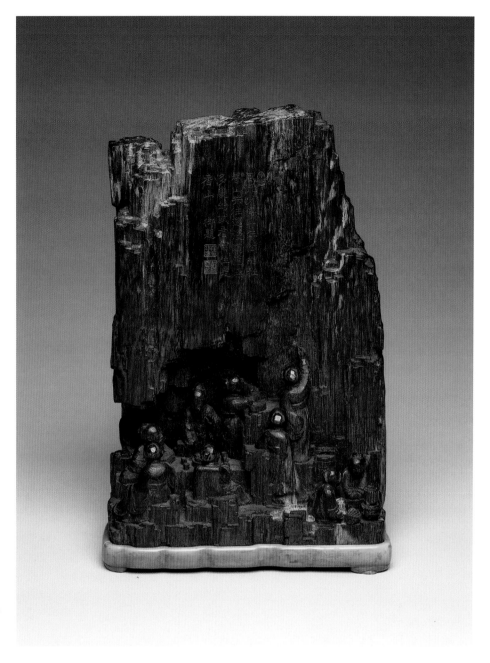

This mountain scene depicts the historic gathering of Bai Juyi (772–846) and eight others in 845 at Mount Xiang in Luoyang, Henan province. Between 841 and 846, Bai, a famous poet, resigned his honored position as tutor to the princes in order to exclusively serve the Ministry of Justice. Seeking religious cultivation, Bai joined his mentor, Monk Ruman, and seven elders, all over the age of seventy, in a literati group based deep in the mountains.[1] Not only did Bai write a poem called "The Nine Elders," but he also gave himself a new name: "Retired Scholar of Mount Xiang" (*Xiangshan jushi*). A long-standing symbol of the scholar's reclusiveness, scenes of the nine elders became a popular theme in painting during the Southern Song dynasty (1127–1279).

Nine hundred years later, the gathering on Mount Xiang captured the imagination of Emperor Qianlong, who ordered Yang Weizhan, a court artisan from Guangdong, to carve the scene from the aloeswood (*jia nan mu*) in November 1741. When this piece was presented to him in December, Qianlong lamented, "The world moves unpredictably, and the irreversible occurs on Mount Xiang." These words were subsequently carved on one of the cliff faces of the work.[2]

Yang Weizhen intended to make the most of this precious piece of aloeswood. He took advantage of the wood's vertical grain to suggest the mountain cliffs and placed the elite group under the rocks in an intimate array. The old men—seated or standing, painting on the cliff or fanning stoves—complement one another in their pursuit of the pleasures of the literati, while two young servants make tea at the foot of the hill. Yang integrated the figures and rocks, alluding to the natural harmony of the gathering. Sharp stone clusters and round, polished figurines in randomly positioned poses all contribute to make this piece one of the most elegant decorative objects of the period. A 1742 entry in the Imperial Archives records that this piece entered the household estate in the Palace of Heavenly Purity (*Qianqing gong*).

INSCRIPTIONS
"Respectfully produced by your minor subject Yang Weizhan, the year *xinyou* [1741] of the Qianlong reign," carved near the bottom; four-line poem by Emperor Qianlong recalling the Mount Xiang gathering.

SEAL MARKS
"Only perfection; only number one" (*Weijing weiyi*) and "Qianlong imperial inkwork" (*Qianlong chenhan*).
YLH WITH TLJ

1. Ouyang Xiu (1060) 1969, vol. 4, chap. 166, pp. 3511–12; vol. 5, chap. 119, pp. 3950–51.

2. NPM 1976, vol. 2, chap. 7, p. 25.

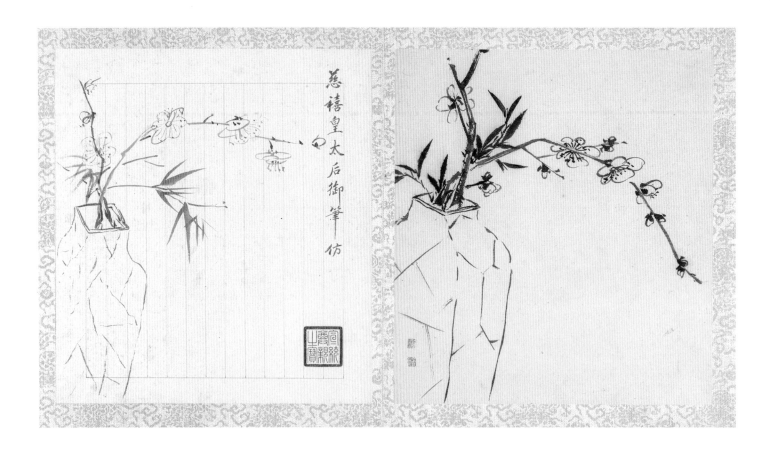

CAT. 156

清同治朝 慈禧繪 無款瓶梅冊頁
紙本設色

Plum blossoms

By Empress Dowager Cixi (1835–1908)
Qing dynasty (1644–1911), reign of
Emperor Tongzhi (1862–74)
Album leaves, colored ink on paper
H: 25.2 cm, W: 23.2 cm
Guhua 001278-8

Shown at the Museum of Fine Arts, Houston, only

Empress Dowager Cixi was the *de facto* ruler of China during much of the late nineteenth and early twentieth centuries. For forty-seven years she ruled from behind a silk screen as regent at the Qing court during the reigns of Emperors Tongzhi and Guangxu (1862–1908). She supported a policy of grandiose imperial patronage, and her lifestyle yielded splendid decorative art that continues to be relevant today.

Cixi was surrounded by flowers. Peony, plum, camellia, magnolia, cymbidium, narcissus, chrysanthemum, osmanthus, and lotus blossoms adorned her life with the changing of the seasons. Everything she used—from undergarments to outer robes, hair ornaments to footwear, the interiors and exteriors of buildings—was richly decorated with auspicious motifs and elaborate floral designs. The plum—a flower of winter and a symbol of staunchness and tenacity—was a subject that Cixi practiced painting several times. The two works here form a comparison between an unknown painter's work on the right and Cixi's study in red on the left. The simple drawing on the left offers a stable sense of form with fluid drawing. Cixi's red plum shows hesitantly executed lines, stiff-looking flower petals, and bamboo leaves rendered in a way that lacks perspective.

Little is known about Cixi's interest or training in art. Some of her extant works verify that she did not have much talent. Nevertheless, she did practice ink painting in her free time, and in later years she painted flowers more frequently. In calligraphy, she routinely wrote one or more large characters for happiness or long life, often on colorful or gold-flecked paper, either for practice or as gifts for her subjects. Certainly, she could not have been very productive because few works by her have survived. Two female court artists, Miao Jiahui and Ruan Pingxiang (active approx. 1875–1925), are known to have painted on Cixi's behalf. Recent attention to Cixi's artwork is mainly due to the increasing historical interest in this female dictator.

SFW WITH QN, HL

CAT. 157

清光緒朝 江西景德鎮 綠地墨彩
「大雅齋」款葵花渣斗

Spittoon with floral decor,
approx. 1875–76

Jingdezhen, Jiangxi province
Qing dynasty (1644–1911), reign of
Emperor Guangxu (1875–1908)
Porcelain with overglaze polychrome decoration
H: 9 cm, Diam: mouth 9.6 cm
Guci 018353 Jin-1213-8

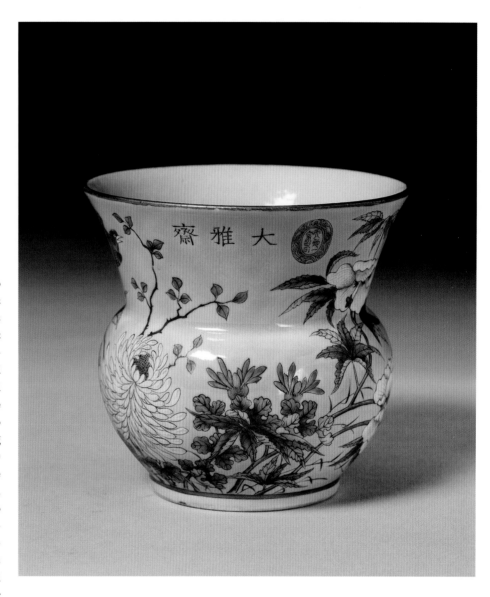

In 1862 Empress Dowager Cixi moved into the Palace of Lasting Spring (*Changchun gong*) in the Forbidden City, where plaques reading "Studio of Great Elegance" (*Daya zhai*) and "Eternal prosperity and enduring spring" (*Yongqing changchun*) had been hung. In 1873, as part of a planned restoration of what is now known as the Old Summer Palace, Cixi prepared to move into the Whole World Celebrating as One Family Palace (*Tiandi yijia chun*) there. In order to decorate her new abode (and to celebrate her fortieth birthday), she ordered the Imperial Workshop to prepare thirty-three designs for thousands of porcelain vessels to be manufactured at Jingdezhen. However, her plans were thwarted by the court in 1874, and Cixi never moved into the Old Summer Palace. The order for the porcelain, however, went forward, and the finished works were finally delivered to Cixi in 1876. These works and subsequent products commissioned for Cixi's studios and residences bear the seal "Studio of Great Elegance" (*Daya zhai*) and characterize the empress dowager's influential taste.

This spittoon—along with a round box in this exhibition (cat. 158)—is part of Cixi's "Studio of Great Elegance" line of porcelain. It is painted with black enamel on a turquoise-green ground and features chrysanthemums, yellow hibiscus, branches of osmanthus, and the profile of the myna bird (from southeastern China) rendered in a relatively realistic manner. The practice of using various shades of black to decorate porcelain

had been in existence since the Kangxi era (1662–1722), but contrasting it with a bright enamel background was quite a departure from tradition. The flowers here are all autumnal and symbolize "the three autumns offering auspiciousness"—or the bringing of blessings on the empress's birthday. The rim of the spittoon is decorated with gold. This batch of porcelain vessels met the court's specific requirements for themes and designs and are excellent examples of late Qing imperial porcelain.

SEAL MARKS
"Studio of Great Elegance" (*Daya zhai*), hallmark in red; "The whole world celebrating as one family" (*Tiandi yijia chun*),

seal enclosed within a small oval panel and framed by two dragons; "Eternal prosperity and enduring spring" (*Yongqing changchun*), four-character mark in two lines of regular script in red on the base.
YSC WITH CYY, TB

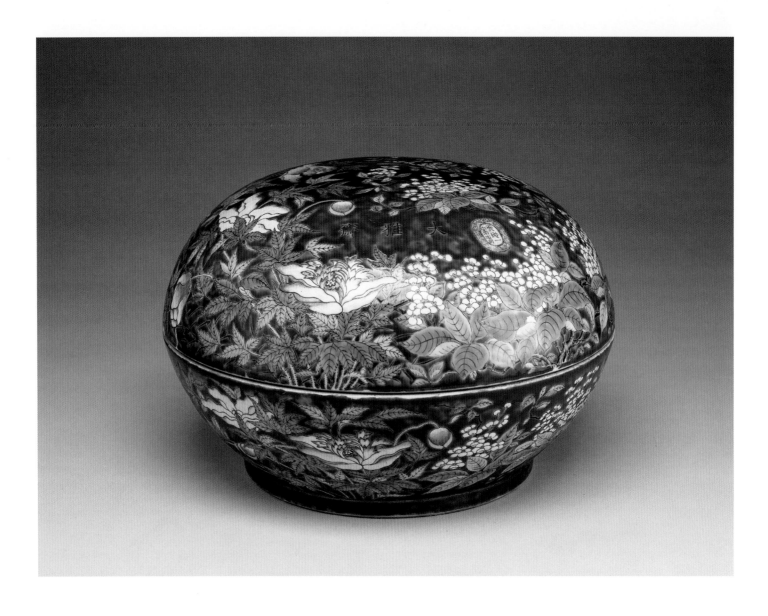

CAT. 158

清光緒朝 江西景德鎮 粉彩
「大雅齋」款紫地瓷捧盒

Round box with floral and magpie design, approx. 1875–76

Jingdezhen, Jiangxi province
Qing dynasty (1644–1911), reign of
Emperor Guangxu (1875–1908)
Porcelain with overglaze polychrome decoration
H: 19.5 cm, Diam: mouth 29.5 cm
Guci 004661 Jin 280.86

Another item from Empress Dowager Cixi's "Studio of Great Elegance" line, this covered box has a flat bottom, rests on a foot ring, and is painted all over with pink peonies (*shaoyao*), poppies (*yumeiren*), leafy branches with tiny white blossoms (*xiuqiu*), and, adding a realistic and lively touch, magpies flying between the flowers on the top and bottom. A sketch found in Cixi's Studio of Great Elegance combined these two blooms, and the combination became a standard design on porcelain ware at the studio.[1] This flamboyant piece echoed the empress's opulent lifestyle.

SEAL MARKS

"Studio of Great Elegance" (*Daya zhai*) mark in regular script in red; "The whole world celebrating as one family" (*Tiandi yijia chun*), mark enclosed within a small oval panel and framed by two dragons; "Eternal prosperity and enduring spring" (*Yongqing changchun*), four-character mark in two lines of regular script in red on the base.

YSC WITH CYY, TB

1. PMB 2007, 200.

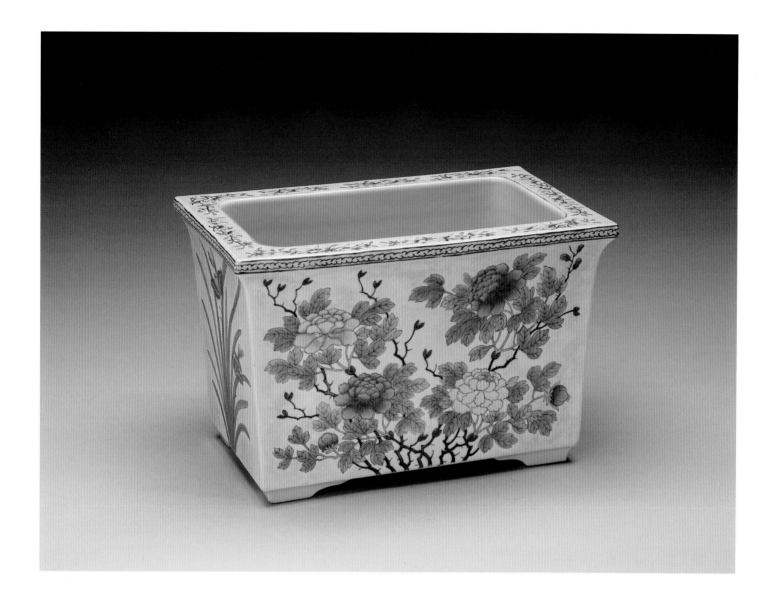

CAT. 159

清光緒朝 江西景德鎮 粉彩
「體和殿製」款 黃地牡丹長方盆

Rectangular flowerpot with peony
and cymbidium design, 1884–86

Jingdezhen, Jiangxi province
Qing dynasty (1644–1911), reign of
Emperor Guangxu (1875–1908)
Porcelain with overglaze polychrome decoration
H: 13.7 cm, L: mouth 21.3 cm, base 18.6 cm,
W: mouth 14.2 cm, base 11.4 cm
Guci 001683 Niao-998

In preparation for the celebration of the Empress Dowager Cixi's fiftieth birthday in 1884, her parts of the Palace of Reserving Elegance (*Chuxiu gong*) were renovated and the Palace of Systematic Harmony (*Tihe dian*) was constructed. The empress occupied the spacious and beautifully decorated palace in 1884, using it for meals and tea drinking and as a place for relaxation. In 1886 the official in charge of porcelain production at Jingdezhen received an order from Cixi that included forty designs, two examples of seals, one sample flowerpot (as shown here), one sample of spittoon, and more. The vessels were to be made as soon as possible and sent to the palace without delay. This batch of porcelain—more than 400 pieces, including this flowerpot—was delivered to the palace in 1886, just in time for the empress dowager's fifty-second birthday.

The richly colored design, created for rectangular flowerpots,[1] is on display here with a lemon-yellow ground and floral motifs of peonies in pink, white, and purple and purple cymbidium orchids. This vessel was heavily potted, and its base shows two circular spur marks where it was supported to prevent it from collapsing during firing. The pot has a base layer of high-fired white glaze with a lemon-yellow glaze on top. The decoration is identical on both sides, with flowers and leaves first outlined in black glaze, then filled in with overglaze enamel of various colors.

SEAL MARK
"Produced for the Palace of Systematic Harmony," red mark in seal script on the base.

YSC WITH TB

1. PMB 2007, 249.

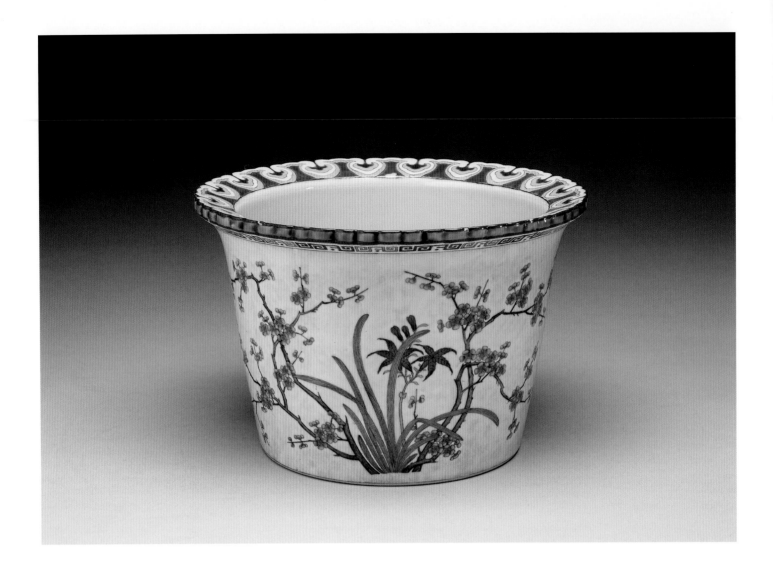

CAT. 160

清光緒朝 江西景德鎮 粉彩
「體和殿製」款黃地萱草盆

Flowerpot with daylily flowers,
1884–86

Jingdezhen, Jiangxi province
Qing dynasty (1644–1911), reign of
Emperor Guangxu (1875–1908)
Porcelain with overglaze polychrome decoration
H: 16.2 cm, Diam: mouth 24.7 cm, base 16.9 cm
Guci 000672 Niao-156-5

This flowerpot was commissioned to celebrate the fifty-second birthday of Empress Dowager Cixi. It has a detailed lobed mouth, a deep interior, a flat foot, and two holes in the bottom for drainage. Red and black draft lines were filled with white glass and then colored with different pigments. Decorations on the rim include stylized wish-granting wand (*ruyi*) mushroom heads and meander patterns, and the outer surface boasts a warm yellow ground with brown branches and pink plum blossoms, malachite green daylily leaves, and red ocher daylily flowers. These auspicious flowers and the characters for longevity and happiness are typical of the lavishly decorated works produced for Cixi.

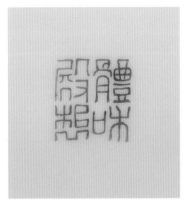

SEAL MARK
"Produced for the Palace of Systematic Harmony," four-character seal on the base.
YSC WITH JC

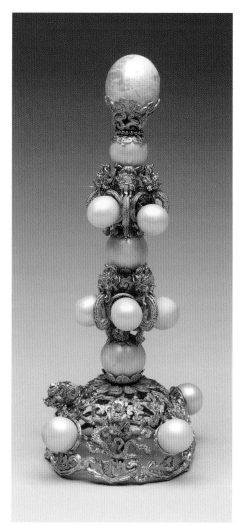

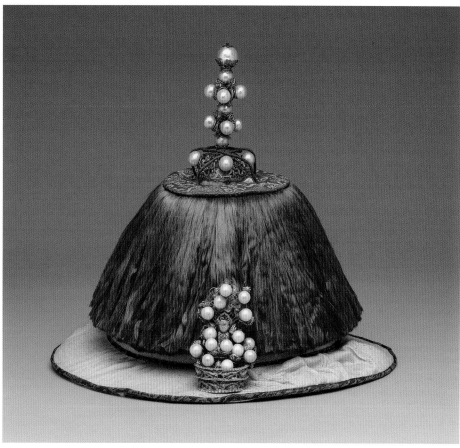

CAT. 161

清康熙朝 金鑲東珠 朝冠頂

Finial of a hat for Emperor Kangxi

Qing dynasty (1644–1911), reign of
Emperor Kangxi (1662–1722)
Gold and eastern (*dong*) pearls
H: 12.8 cm, Diam: 6.8 cm
Guza 001770 Lüte-10-1

Two types of formal court hats were worn
during the Qing dynasty: a winter hat of
warm fur and a cool, light summer hat
of woven bamboo, rattan, or jade grass
(native to the Manchu homeland in north-
eastern China). This multilevel gold orna-
ment is set with a total of sixteen eastern
pearls and was designed to be mounted on
top of a hat worn by Emperor Kangxi. It
corresponds precisely with the specifica-
tions for headdresses to be affixed to the
emperors' winter court hats as described
and illustrated in regulations on Qing
court uniforms.[1] Finials were associated
with the highest imperial power, as can
be seen in portraits of Emperor Kangxi,
and they first appeared on the gold-topped
summer headgear awarded to high offi-
cials by Nurhaci (1559–1626), the Jurchen
chieftain whose descendants started the
Manchu Qing dynasty. After many revi-
sions, it became standardized during the
reign of Emperor Qianlong.

The levels of this treelike ornament
are separated by three pearls, with a large

eastern pearl at the top. Each level con-
tains four five-clawed dragons alternating
with a pearl. The dome-shaped base con-
sists of openwork dragons set over twelve
wish-granting wand (*ruyi*) mushroom
heads. Intricately constructed of woven,
openwork, and beaded gold, this piece was
part of a new phase craftsmanship that
called for the increasingly elaborate art-
istry, workmanship, and creative inven-
tion that distinguished Chinese metalwork
and design of this period.

Pearls represent regal supremacy in
iconography that originated in Daoism,
in which the heavenly paradise comprises
a dragon playing with a pearl over the
Eastern Ocean. The highly treasured east-
ern pearls (*dongzhu*) here are of superb
quality and come from Wula, the Manchu's
ancestral land along the Songhua River in
northeast China.

HWC WITH TB

1. *Qing huidian tu* (1690–1886) 1990, vol. 1, p. 601.

CAT. 162

清乾隆朝 金鑲東珠 夏季朝冠 冠前金佛

Gold Buddha for the front of a summer court hat, approx. 1790

Qing dynasty (1644–1911), reign of
Emperor Qianlong (1736–95)
Gold and eastern (*dong*) pearls
H: 8.8 cm, W: 3.7 cm
Guza 006014 Jin-1520

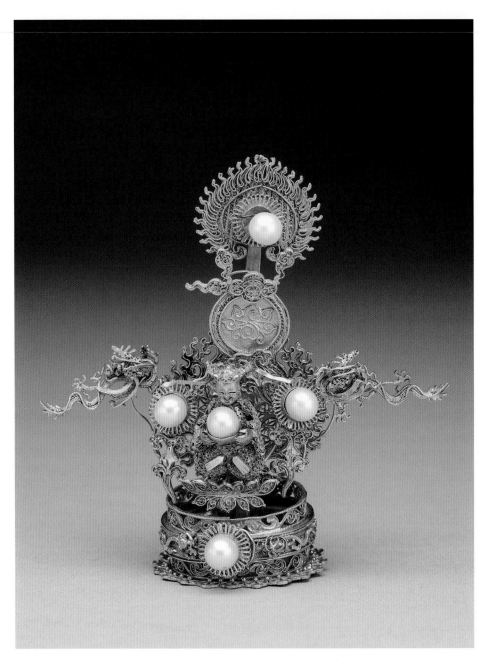

Only the emperor could wear a hat decorated with a gold Buddha such as this one, set with five eastern pearls at the front and a gold Buddhist halo (*shelin*) with seven pearls at the rear. Princes and titled nobles would wear an ornament composed of a gold nimbus with five pearls at the front and a gold flower with four pearls at the back.[1]

This Buddha, worn at the front of a summer court hat, is made of gold filigree. The pearl alms bowl identifies him as Amitābha, the Buddha of Boundless Life. He is seated on lotus petals, with the lotus pond base shrouded with auspicious clouds and grass and *lingzhi* mushrooms appearing here and there. Flames rise to the top of his halo, and set there is an eastern pearl that nicely balances the pearls on either side of the Buddha and the one ornamenting the running dragon on the base. A lotus blossom is lightly incised on the halo. Five-clawed dragons, reserved for use by the emperor, emerge vigorously from the sides of the Buddha, reflecting the close association of imperial power and religion during the Qing dynasty.

1. *Qing huidian tu* (1690–1886) 1990, vol. 1, pp. 602, 603, 634.

INSCRIPTIONS

A yellow tag accompanying the work reads, "One gold Buddha from the front of a hat, inlaid with five eastern pearls of the third class, weighing one *liang* and eight *qian* [40 grams]" and "Received on the second day of the eighth month, the fifty-fifth reign year [1790] of Emperor Qianlong, from Rehe [Mountain Villa for Summer Retreat, Chengde]."

HWC WITH TB

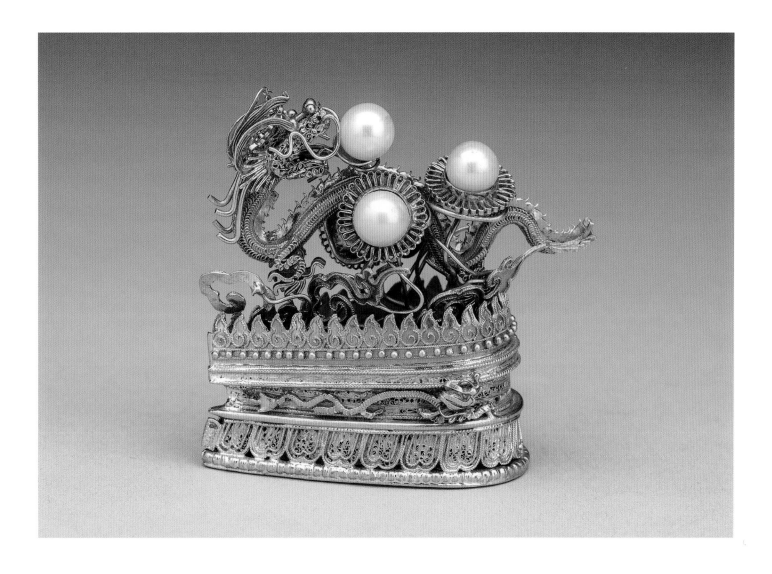

CAT. 163

清乾隆朝 金鑲東珠 夏季朝冠
冠後金龍

Gold dragon for the back of a
summer court hat, approx. 1790

Qing dynasty (1644–1911), reign of
Emperor Qianlong (1736–95)
Gold and eastern (*dong*) pearls
H: 4 cm, W: 2.3 cm, L: 4.8 cm
Guza 006013 Jin-1519

A three-tiered pedestal supports a five-clawed gold dragon striding among auspicious clouds and mushrooms of immortality (*lingzhi*). The dragon's body is lithe and supple, its head turned, its mane flowing, its mouth opened to spit out a flaming pearl. Auspicious flowers surround the dragon's body, with an eastern pearl set in each. Lotus petals decorate the lowest level of the pedestal; young dragons encircle the middle level; and the top is ornamented with flames and pearls. Wrought of fine filigree, this ornament decorated the back rim of the emperor's formal summer headgear. It was paired with the golden Buddha intended for the front of the emperor's hat (cat. 162).

Qing sumptuary laws specified the following for the emperor's summer hats: a hat of woven Manchurian "jade grass" or strips of rattan or bamboo with a rim of two strips of dark blue and gold brocade and red fringes on top, lined with red and gold brocade or red gauze, a golden Buddha ornament in front, a gold dragon ornament with seven eastern pearls behind, and a three-tiered top similar to the one for the winter hat (cat. 161).

INSCRIPTIONS
Two yellow tags attached to the work read, "A golden dragon for the back of the hat" and "Received on the second day of the eighth month, the fifty-fifth reign year of the Qianlong emperor [1790], from Rehe [Mountain Villa for Summer Retreat, Chengde]."
HWC WITH TB

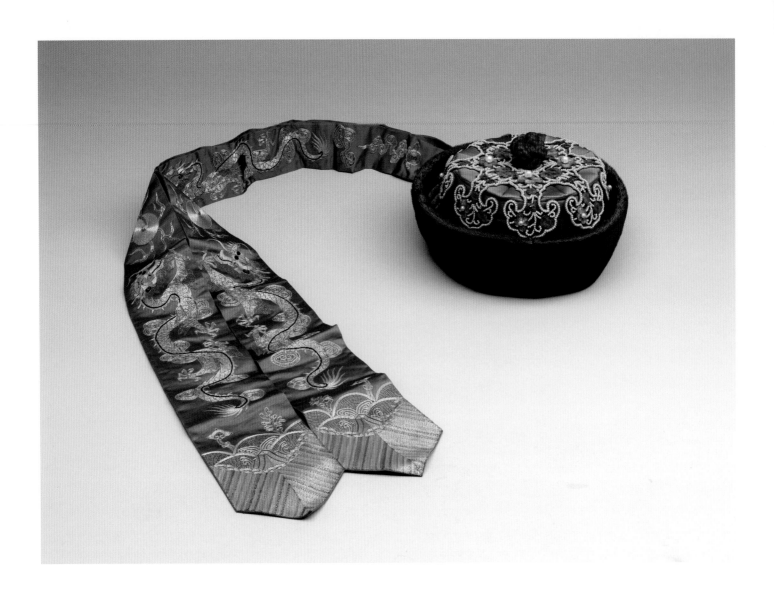

CAT. 164

黑貂便帽 飾八辦如意日月東海、
雙龍戲珠紋圖
貂皮紅絨結頂、藍緞彩繡、
碧璽、翠玉、米珠等

Sable hat for a man, approx. 1800–1900

Qing dynasty (1644–1911)
Black sable, tiny pearls, tourmaline, jadeite, silk floss finial, and satin bands embroidered with silk and gold- and silver-wrapped threads
Hat: H: 12.5 cm, Diam: 23 cm; Ribbon L: 91 cm

Guza 005973 Jin-74-13

Worn by a young male Manchu aristocrat in the winter, this hat was tailored to fit snugly on the top of the head. The style, with a braided vermillion velvet knot at the top, was adapted from a casual cap worn by Manchu emperors. The blue satin crown is sewn with pearls, gemstones, and beads to form an eight-lobed wish-granting wand (*ruyi*) mushroom surrounding the red knot; within the beaded contours of each lobe, pink flowers with lustrous pearl calyxes set off by ruby buds and green jadeite leaves evoke a sense of grandeur. The outer brim is completed with black sable.

The two blue satin ribbons at the rear bear designs nearly identical to those used by Qing monarchs and enhanced the hat's suitability for a young monarch at informal or celebrative occasions. Gold, silver, and multicolored embroidery presents two five-clawed dragons playing with flaming pearls amid clouds and under the midday sun. The lower borders bear parallel rows of arcs and lines setting off three mountain peaks standing upright in the Eastern Ocean, a design that echoes Qing imperial attire. The ribbons are completed by sacred *lingzhi* mushrooms, coral, and other treasures that symbolize the eternal world of the Son of Heaven.

According to documents from the Imperial Household Department, the headdresses, robes, belts, shoes, and bed sheets of the emperor were managed and inventoried by the Four Executive Storehouses (*Sizhi ku*) in the Eastern Five Heavenly Houses (*Qian dong wusuo*), located northeast of the Forbidden City. This enterprise supplied the inner palace with hundreds of articles of clothing made of leather and fur each year. An inventory of the Four Executive Storehouses from the early 1950s listed several dozen hat boxes holding sable hats.[1]

HHC WITH HL

1. Zhang Naiwei (1941) 1990, 174, 722–25.

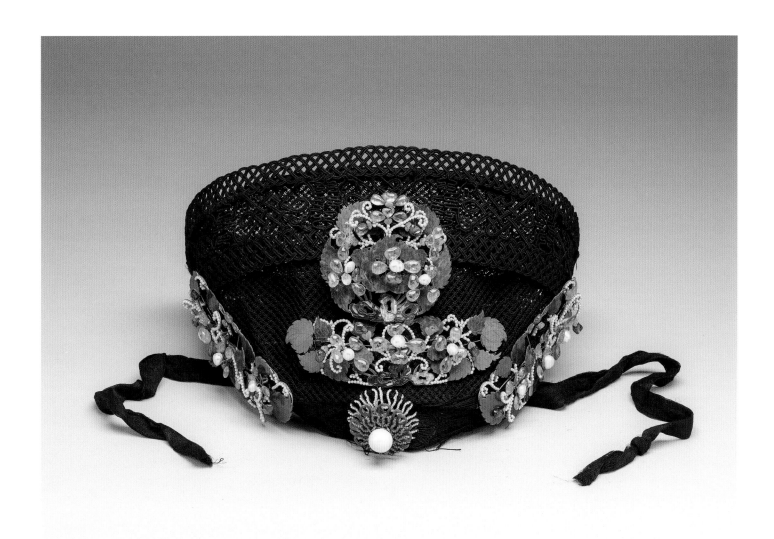

CAT. 165

清朝 十九世紀 百花集錦珠翠鈿子
碧璽、珍珠、米珠、青金石、
織品

Headdress for a court lady
(*dianzi*)

Qing dynasty (1644–1911)
Jade, tourmaline, pearls, tiny pearls, lapis lazuli,
and textiles
H: 20 cm, W: 20.5, L: 27.5 cm
Guza 005974 Jin-74-46

Shown at the Asian Art Museum only

This headdress, with a semispherical frontal crown and a flat oval top, was a new style, known as "filigree" (*dianzi*), worn by Manchu court ladies at celebrations or semiformal events. Late Qing photographs show Empress Dowager Cixi and her consorts in ceremonial attire (*jifu*) with headdresses like this. The status of court ladies was distinguished by the unique styles, materials, colors, and design patterns of their headdresses. High-ranking women were given the privilege of wearing headdresses adorned with beaded phoenixes and suspended strings of pearls. Headdresses lacking the phoenix indicated a lower rank. The least-adorned headdresses were reserved for concubines and widows. Fabric, embroidery, gemstones, and beading technique all played a part in defining court rank in headdresses.

The foundation of this headdress's crown is formed by black openwork fabric over which premade ornaments and individual pearls and jades were affixed to form the design. Here, the central pearl is surrounded by three circles of beaded tendrils of red coral, green jade, and tiny white pearls. Seven floral clusters forming roundels, ovals, and a basket were attached to the crown and top in a symmetrical layout. Each element—leaves of green jade, white pearl twigs, pink petals, and pearl pistils—reveals complicated weaving and beading. Such ornaments from the Imperial Workshop of Flowers (*Hua'er zuo*) featured prominently in the household inventories.

Eighteenth-century headdresses and hair ornaments had made considerable use of kingfisher feathers. As supplies from Southeast Asia became scarce in the late Qing period, feathers were replaced by a wide variety of gemstones—emeralds, rubies, garnets, pink quartz, amethyst, turquoise, sapphire, lapis lazuli—in these adornments.

HHC WITH HL

CAT. 166

清中晚期 珊瑚朝珠

Court necklace of coral beads, approx. 1750–1900

Qing dynasty (1644–1911)
Coral, jadeite, eastern *(dong)* pearls, lapis lazuli, and silk cords
L: 130 cm, Diam: bead 0.8 cm each
Guza 001786 Lüte-10-7

Shown at the Asian Art Museum only

The Manchu court formalized an elaborate uniform system that incorporated the beaded necklace as a display of spectacular grandeur at court and ritual ceremonies. Modified from the Buddhist rosary, the court necklace was designed to be worn with the formal court uniform (*chaofu*) or ceremonial attire (*jifu*) for celebrations. Those of high rank—such as members of the court, civil officials above the fifth grade, military officers above the fourth grade, and certain subjects in charge of court rites and education—had the privilege of wearing one strand of these beads.

The dress code stipulated that only the emperor, his parents, and consorts of the first grade could wear a court necklace of 108 eastern pearls—with lapis lazuli components worn when worshiping heaven, amber when worshiping earth, coral when worshiping the sun, and turquoise when worshiping the moon. The necklace's silk component was required to be imperial yellow.[1] Empress dowagers, empresses, and titled female members of the imperial family were entitled to wear three strands—one of eastern pearls and two of coral—with their court uniform.[2]

This court necklace consists of 108 coral beads, each worked into a roundel in the shape of the character for "longevity" (*shou*). Every twenty-seventh bead (four total) is accented with a jadeite bead called a "Buddhist head" (*fotou*). Three additional short strands, each comprising ten eastern pearls with an emerald finial, were attached to the main necklace, two

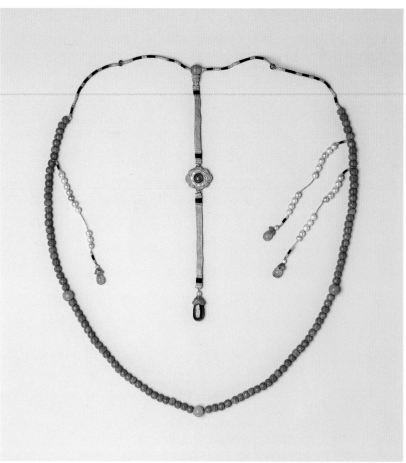

CAT. 166

on one side, one on the other; men wore the two strands to the left, while women wore them to the right. A few portraits of Qing empresses wearing the two to the left set an example in breaking the rule. A long yellow woven silk strip tied with a lapis lazuli drop called a "cloud back" (*beiyun*) hangs from the rear of the necklace and was worn down the back by both men and women.

HWC WITH TB

1. *Qing huidian tu* (1690–1886) 1990, vol. 1, p. 607.
2. Ibid., p. 621.

CAT. 167

清光緒朝 珊瑚數珠

Coral prayer beads, 1880

Qing dynasty (1644–1911), reign of Emperor Guangxu (1875–1908)
Coral and silk cords
L: 50 cm, Diam: bead 0.9–1.6 cm each
Guza 005242 Jin-1534-18-25

Shown at the Museum of Fine Arts, Houston, only

One hundred and fifteen flattened coral beads strung with three silk-wrapped pendant tubes form this string of prayer beads. According to a yellow cloth tag attached to the beads, the thirteenth Dalai Lama of the Gelug sect of Tibet paid his respects to Empress Dowager Cixi by having this gift sent to Beijing to mark his installation in 1879.

HWC WITH TB

CAT. 168

清乾隆朝 皇帝吉服帶鎏金青金石
珍珠寶石牛角綠松石織繡

Emperor's formal court belt, 1700–1800

Qing dynasty (1644–1911), reign of
Emperor Qianlong (1736–95)
Gold, lapis lazuli, pearl, ruby, ox horn, turquoise,
and silk weaving
Belt L: 164 cm; buckle H: 4.7 cm, L: 1.3 cm,
W: 5.35 cm
Guza 007335 Jin-218

Shown at the Asian Art Museum only

This belt was worn by the emperor at court sessions and other formal occasions. Its color, design, and materials—and the attached objects derived from the Manchu nomadic tradition—all reflect the wearer's rank. The narrow belt of bright yellow card-woven silk strap is strung with four oval plaques, each with a wired, grasslike base and inset with a blue precious stone and eight pearls. The bat-shaped rings attached to the plaques hold embroidered drawstring purses with dark blue grounds and another purse of blue and red on a yellow ground bearing the characters for "blessings" and "longevity" in Manchu script formed by pearls and embroidery in lockstitch. Another attachment is a dark blue tinderbox embroidered with the character for "longevity" and bats and clouds in gold and silver threads. Also fastened to the belt are a knife with a handle of buffalo horn and a flat box containing a toothpick and ear cleaner embellished with the character for "longevity," bats, clouds, and turquoise and rubies set in gold.

This belt matches the specifications for a formal court belt in the regulations of the imperial uniform: "The color should be bright yellow, with four plaques of engraved designs, they can be square or round, decorated with pearls, jades, and other stones, each according to his wish."[1] Sumptuary laws were an important part of the ritual specifications set down at the founding of the Qing dynasty in China. The laws were modified over time until they

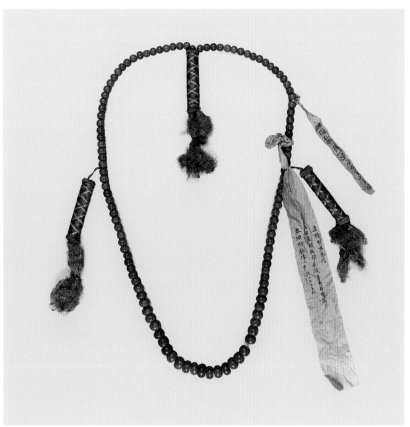

CAT. 167

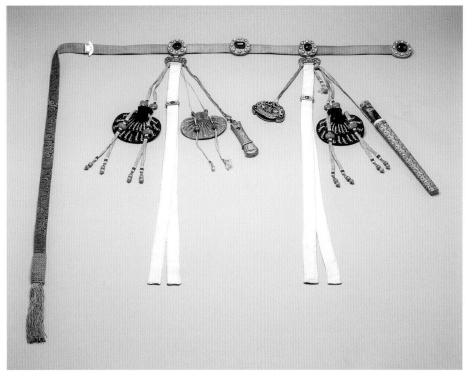

CAT. 168

were illustrated, published, and became paradigmatic.

HWC WITH TB

1. Yunlu 1766.

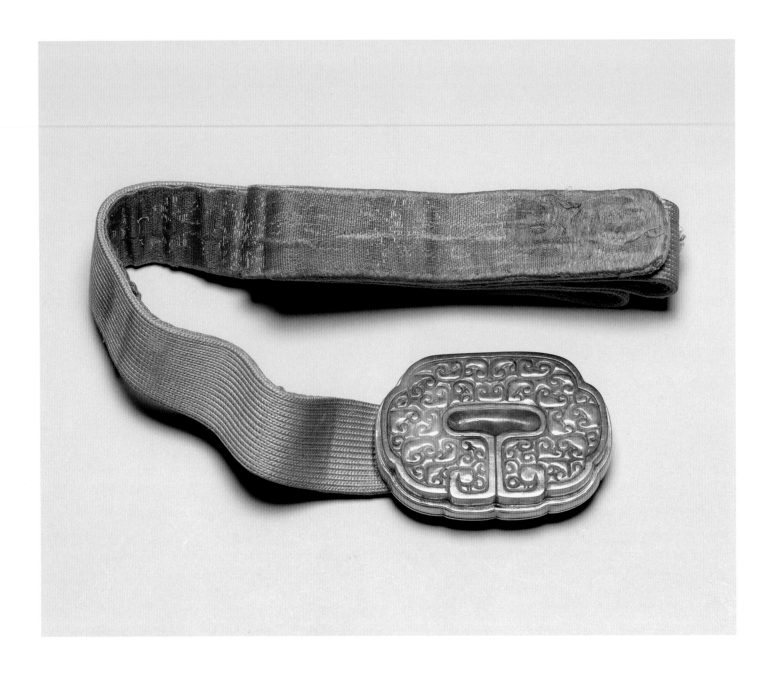

CAT. 169

清朝 漢代玉鑲翠 帶釦腰帶

Belt with jade-inlaid gilt buckle, approx. 1800–1900

Qing dynasty (1644–1911)
Gilt copper alloy, nephrite, jadeite, and yellow brocade
Belt L: 83.5 cm, buckle H: 1.7 cm, L: 7.5 cm, W: 4.6 cm
Guyu 009643 Lüte-28-3

Shown at the Museum of Fine Arts, Houston, only

The white nephrite buckle of this belt set is shaped like a wish-granting cloud. Inset in the center is a sparkling piece of richly colored jadeite surrounded by symmetrical motifs of wish-granting clouds. The nephrite shows areas of wear and, unlike the highly polished and finished carvings of the Qing palace, this piece shows distinct marks; it is possibly an older piece that was reworked. The bright yellow belt is decorated with gold brocade with a red ground in accordance with palace regulations. This type of narrow belt can be seen in portraits of Qing emperors wearing robes for ordinary occasions (*changfu*) and are smaller and simpler in appearance than the belts worn on formal occasions (see cat. 168).

HWC WITH TB

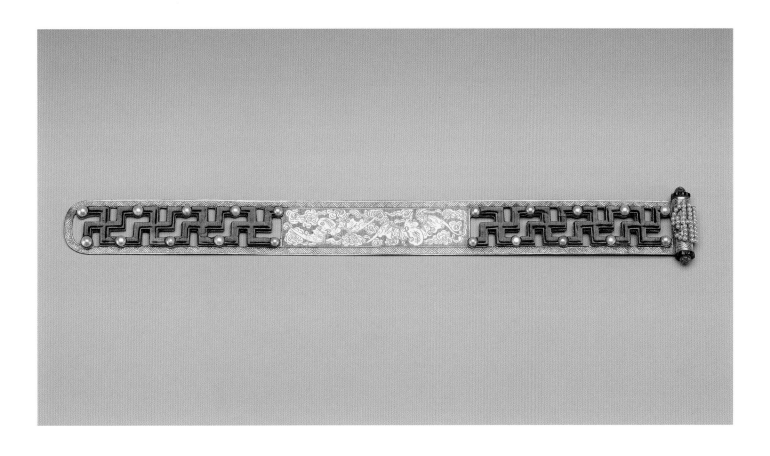

CAT. 170

清朝 金鑲玉 雲蝠萬字圖紋
"福壽萬年" 扁方

Headdress crosspiece for a court
lady, approx. 1800–1900

Qing dynasty (1644–1911)
Gold, jadeite, tourmaline, and pearls
H: 31.2 cm, W: 2.8 cm, D: 0.4 cm
Guza 004165 Lüte-1656-4

The hairdo of fashionable Manchu ladies during the nineteenth century was known as "large expanding wings" (*dalachi*) and was created by pulling hair back into two bunches that were then flattened and thicken with viscous vegetable oil and combed upward to the left and right. A black T-shaped headdress fashioned around a hard interior frame covered the hair. A crosspiece (*bianfang*) such as this one was inserted into the folded top edge of the headdress so as to stabilize it.[1]

This ornament resembles an opened hand scroll. Flowers made of jadeite and tourmaline decorate the top and bottom of the gilded, tubelike end of this "scroll," which is further ornamented by a circular character for "longevity" (*shou*) strung with tiny pearls. The central gold repoussé panel displays a bat among wish-granting clouds. The two opened ends are inset with four groups of swastikas (a pun on "ten thousand"), with the beginning and end of each swastika decorated with pearls. The narrow top and bottom borders are chased with a motif of stepped mountains. Taken together,

the various motifs expressed wishes for "ceaseless blessings and longevity" and "ten thousand blessings" and "may your wishes come true" (*wanfu ruyi*). These motifs, together with the luster of gold, jade, and pearls, made this hair ornament especially elegant.
HWC WITH TB

1. Li Jian 2014, p. 135, pl. 98.

Illustration of a headdress crosspiece in use

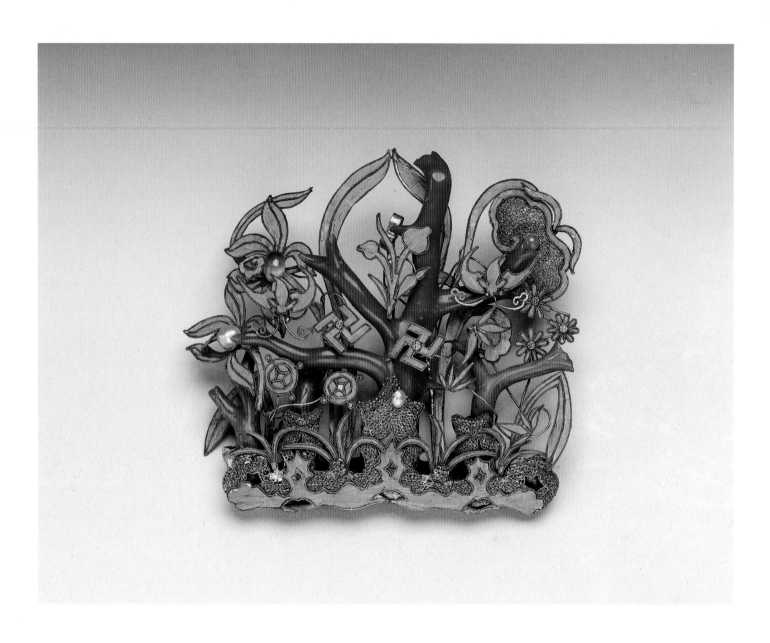

CAT. 171

清嘉慶朝 福壽如意面簪
銀鍍金、纍絲、點翠、嵌珊瑚

Hairpin ornament in the form of
auspicious symbols, 1805

Qing dynasty (1644–1911), reign of
Emperor Jiaqing (1796–1820)
Gilt silver, gold filigree, coral, kingfisher feather,
pearls, and other semiprecious stones
H: 11 cm, W: 9.3 cm
Guza 004941 Jin-1541-437

Shown at the Asian Art Museum only

Qing noblewomen wore this floral orna-
ment at the center of the forehead. It
combines a quiet scene of flowers and
trees with symbols containing auspicious
meanings. Gold, coral, kingfisher feather,
pearls, and other stones are layered to
show close and distant views of flowers,
grasses, trees, and rocks. Among the
rocks and the spreading branches of the
coral trees are grasses; cymbidium orchid
blossoms, their long leaves swaying above;
and a branch of longevity peaches. At the
right are *lingzhi* mushrooms, wild asters,
and bamboo. In the center are a variety
of auspicious symbols: swastikas, hats,
and coins.

Among the hairpin ornaments of the
palace, this piece is outstanding for its use
of fine filigree to depict the texture of the
rocks, bright kingfisher feather and coral
to create luxurious colors, and the gilt sil-
ver material that is both soft and lithe.

INSCRIPTION
A yellow tag accompanying the work
reads, "Tenth reign year [1805] of Emperor
Jiaqing."
HWC WITH TB

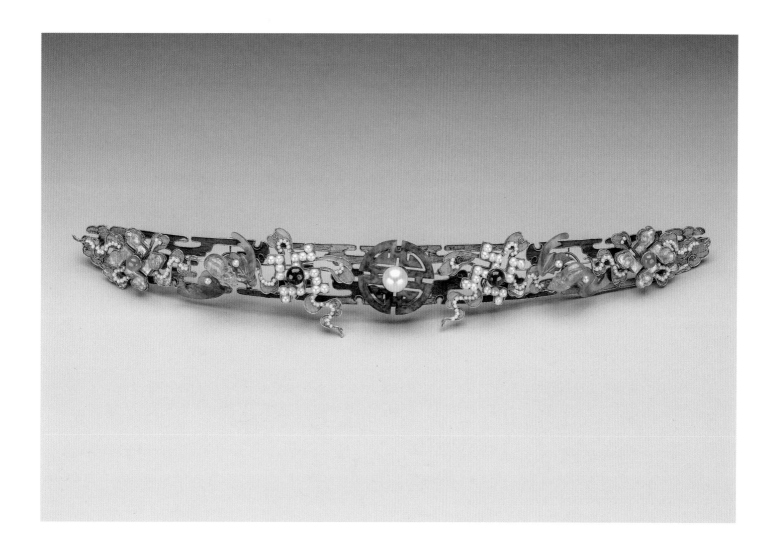

CAT. 172

清朝 福壽萬年鈿花
金 、 點翠、珠寶、翠玉

Gold headdress ornament in the
form of symbols for blessings and
longevity, approx. 1800–1900

Qing dynasty (1644–1911)
Gold, gilt silver, kingfisher feathers, pearls,
tourmaline, and jadeite
H: 1.1 cm, L: 22.5 cm, W: 2.45 cm
Guza 003212 Lüte-27-18

Shown at the Museum of Fine Arts, Houston, only

Manchu ladies wore a formal headdress
known as a *dianzi* (see cat. 165) that had a
flat top and resembled an inverted Chinese
winnowing basket.[1] This ornament, known
as *dianhua*, decorated the *dianzi*. Such
adornments differed in size depending
on where they were located on the head-
dress. Made of gilded silver, this open-
work piece features a circular longevity
character (*shou*) in jadeite supporting a
large pearl in the center. It is flanked by
two pearl swastikas with dark tourmaline
centers and ribbons of kingfisher feather;
two bats of tourmaline, jadeite, and pearls;
and two more tourmaline swastikas with
jadeite centers and ribbons of tiny pearls.
Altogether, the motifs expressed the
auspicious wish of "ten thousand years
of blessings and longevity" (*fushou wan-
nian*). The alternating combinations of
red, green, blue, and white set off the
lively design of the ornamentation and
line work, endowing the piece with a light
texture and bright colors.

HWC WITH TB

1. NPM 1986, 151.

CAT. 173

清同治朝 菊花髮簪
銀鍍金、綠松石、珍珠

Hairpin decorated with turquoise chrysanthemums, 1862

Qing dynasty (1644–1911), reign of
Emperor Tongzhi (1862–74)
Gilt silver, turquoise, and pearl
H: 20 cm, W: 8 cm
Guza 004937 Jin-1541-414

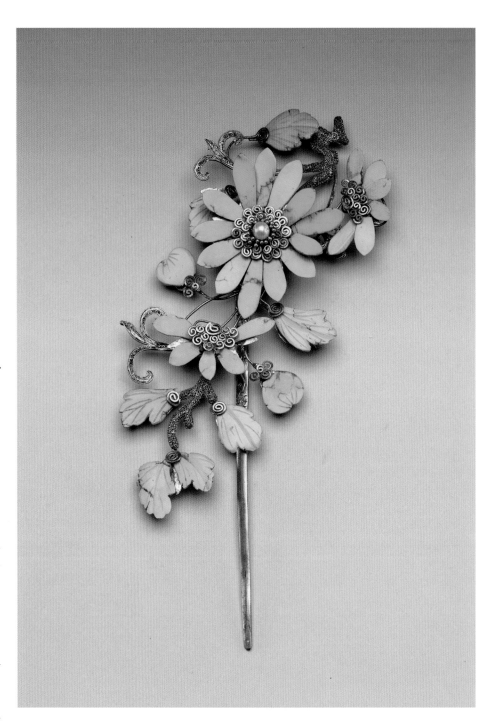

To fulfill its functions, the Imperial Household Department was obligated to either commission objects from workshops or collect tributes and gifts from coveted sources. Each piece so acquired was registered in an inventory document. This hairpin was inventoried as one of the ornaments brought into the palace shortly before the Lantern Festival (fifteenth day of the first lunar month) in 1862. We know from the imperial archives that a considerable number of ornaments were acquired by the Imperial Household Department in that year. Interestingly, the increasing number of jewelry acquisitions corresponded with the commencement of Empress Dowager Cixi's regency in November 1861, and the Lantern Festival of 1862 was among the very first celebrations that took place during her time as empress dowager.

This gilt-silver hairpin features chrysanthemum blossoms and leaves of turquoise, a color and stone favored by Manchu nobles. The chrysanthemum is the flower of autumn and a symbol of longevity. The thin slices of turquoise have been precisely cut, and the long and narrow petals surround the layers of intricately filigreed pistils; the central pistil bears a tiny elegant pearl. The buds and young shoots consist of concentrically wound coils, a technique not used in the main branch. The design and composition of this piece are not unlike that of paintings of the time.

INSCRIPTION AND SEAL
A yellow tag attached to the work states that it was delivered by Shen Kui on the fourteenth day of the second month, the first year of the reign of Emperor Tongzhi (1862). Remnants of a seal remain on the back of the shaft, indicating that this piece was made in a private workshop.
HWC WITH TB

CAT. 174

清朝 鏤空琺瑯梅枝 指甲套

Pair of fingernail guards with openwork plum blossom design, approx. 1800–1900

Qing dynasty (1644–1911)
Gilt silver with applications of enamel and pearl
L: 13.8 cm, Diam: 1.4 cm
Guza 003614, 003615 Wei-325-7

It was customary for noble ladies during the middle to late Qing period to let their nails grow long in order to show off the slender beauty of their fingers. As a result, it soon became fashionable for the ladies to wear nail guards when they were at leisure. Paintings of palace life from the reign of Emperor Daoguang (1821–50) often show concubines wearing beautiful clothing and golden nail guards. Empress Dowager Cixi was especially fond of them, as seen in an oil portrait by Katharine Augusta Carl (1865–1938) made for the 1904 Louisiana Purchase Exposition in St. Louis and in photographs taken inside the palace in 1903 and 1904 (right).

The fingernail guards collected by the Qing palace vary in shape and size: short ones are sharpened to a point, while longer ones are slightly curved like a bow; the guards narrow from base to tip, following the natural curve of the nail. The nail guards are decorated with numerous symbols, often bearing auspicious meanings: flowers, the motif of "three friends of winter" (pine, bamboo, and prunes), the characters for "blessings" and "longevity," the swastika, and eight auspicious symbols. Some nail guards were made with gold filigree, while others were chisel cut and filled with enamels or inlaid with pearls or precious stones or ornamented with kingfisher feathers, tassels, or other stringed decorations.

The front of this fingernail guard depicts plum blossoms in openwork. The thin branches are rugged and strong, and the petals, buds, and leaves are filled with thin and slightly transparent pink and green enamels. The back features an openwork crosshatched design, while the base is constructed in such a way that the width can be adjusted to fit one's fingers. The workmanship is excellent, and the colors are beautiful.

HWC WITH TB

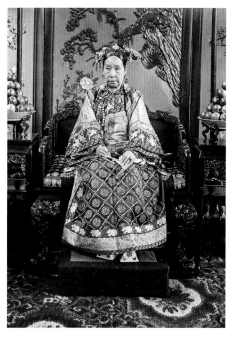

Empress Cixi wearing fingernail guards

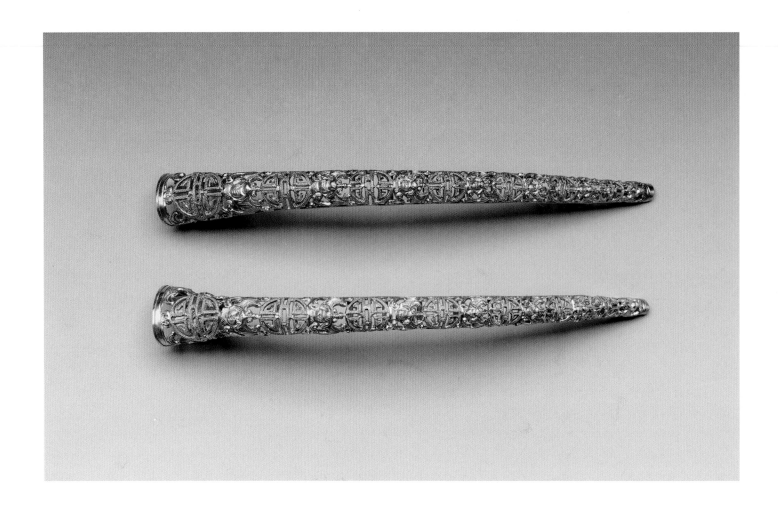

CAT. 175

清朝 鏤空福壽萬年 指甲套

Fingernail guards with openwork "bat" and "longevity" characters, approx. 1800–1900

Qing dynasty (1644–1911)
Gilt copper alloy and gold
L: 14.4 cm, Diam: 1.4 cm
Guza 003680, 003681
Wei-325-7

Auspicious bats and circular longevity characters (*shou*) alternate across the top of this pair of fingernail guards. The outlines of these figures have been chased with fine lines. The bottom features an openwork trellis, and the base can be adjusted to fit the size of the wearer's nails. Even though the guards lack inlaid decorations, their uneven surfaces give forth a sparkling appearance.
HWC WITH TB

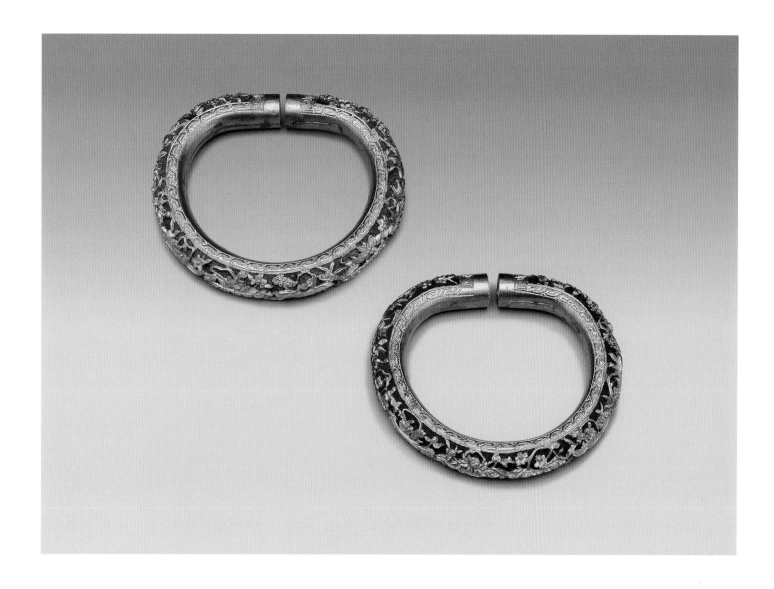

CAT. 176

清朝 金鏤空花卉鐲

Gold bracelets with openwork floral designs, approx. 1800–1900

By a private workshop called Hexisheng
Qing dynasty (1644–1911)
Gold
H: 1.1 cm, L: 8.0 cm, W: 7.1 cm
Guza 007141 Chu-137-34
H: 1.1 cm, L: 8.1 cm, W: 7.2 cm
Guza 007141, 007592
Chu-137-34 Lü 1691-28

The bracelets collected by the Qing palace are made from a variety of materials: besides gold, silver, jade, pearls, coral, ivory, and tortoise shell, there are examples made from wood that emit a fragrance when worn. These gold bracelets are also fragrant, with scent produced by powdered agarwood (*qie'nan xiang*) packed tightly within the openwork casings.

One bracelet shows ten groups of flowers representing the four seasons interconnected with mushrooms of immortality (*lingzhi*). The flowers and the fine veins of the leaves are chisel cut in such a way that they appear at various heights, making them look as if they are about to blossom. The other bracelet is decorated with scenes from various operas, a theme artisans had added to the repertoire of decorative motifs. The human figures are depicted in interior and exterior scenes in

a vivid and concise manner on the thin, narrow piece of metal.

SEAL MARK
"Hexisheng," rectangular mark of a private goldsmith stamped on the inside wall.
HWC WITH TB

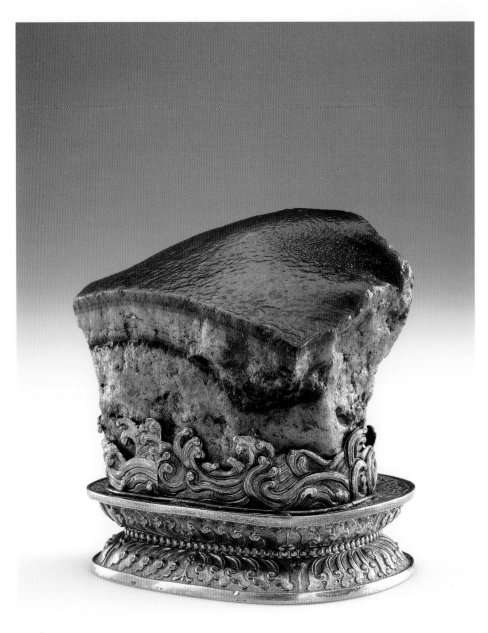

CAT. 177

清朝 肉形石、海濤蓮瓣紋金座

Meat-shaped stone

Qing dynasty (1644–1911)
Jasper, golden stand
H: 5.73 cm, L: 5.3 cm, W: 6.6 cm
Guza 00178 Lü-413

Shown at the Asian Art Museum only

This stone shaped like a piece of pork is—along with a famous work shaped like a cabbage—one of the most popular works at the National Palace Museum. The pursuit of balance and harmony between humans and nature has always been important in Chinese aesthetics, especially so in jade craftsmanship. This stone is made of jasper, a jade-like semiprecious stone. Jasper comes in different colors, contains both quartz and chalcedony deposits, and is multilayered in texture. A unique approach to design, dubbed "smart carvings" (*qiaodiao*), draws on the natural hues and forms of the stone to influence and determine the final work. The artist's deep contemplation of his material yields surprisingly original and natural pieces that are indeed "smart."

In this piece tiny holes were drilled in the surface to replicate pores in the meat and prepare the piece for dyeing. With a high-powered magnifying glass we find traces of dark brown pigment and can see that the top layer was artificially colored to a lustrous reddish brown, resembling pork rind marinated in soy sauce. Thus, this obviously cold, hard piece of stone is transformed into a tender, succulent piece of *dongpo rou*, a fatty pork dish named after the famous poet Su Shi (see cat. 148), whose nickname was Dongpo.

To accompany this piece, court craftsmen made a special golden stand. The surface of the stand is adorned with bas-relief decorations and resembles traditional bases for religious statues in form and design. Ocean waves wrap around the meat-shaped stone, and the top and bottom sections are separated by a line of beads and decorated with a symmetrical lotus-petal motif. The integration of metal and stone is typical of the work of the Qing Imperial Workshop.

LTC WITH JC

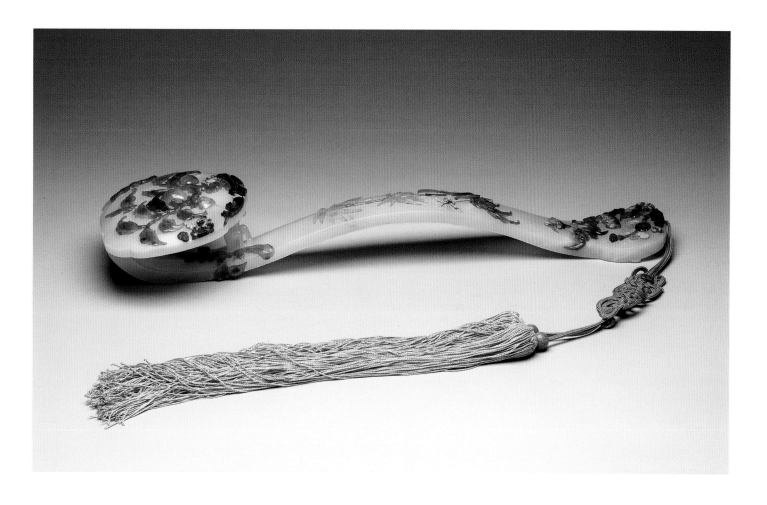

CAT. 178

清朝 玉嵌寶石 福壽如意

Wish-granting wand (*ruyi*) with auspicious motif, approx. 1770–1875

Qing dynasty (1644–1911)
Nephrite with gemstone appliqués, silk tassel
L: 41.2 cm, W: 12.1 cm
Guyu 003585 Xian-239

The wish-granting wand (*ruyi*) has a long history in China, and during the Qing dynasty it became an important gift item for the emperor and the royal family. This wand was made from a single piece of nephrite and is known as the "whole jade wand." Pieces of yellow glass, tourmaline of various colors, jades, coral, agate, lapis lazuli, and malachite ornament the head of the wand and its handle. They depict rocks of longevity, a fruiting peach tree, bats, narcissus, bamboo, and mushrooms of immortality (*lingzhi*), forming a colorful and auspicious motif of "blessings, longevity, and eternal good health."

According to his memoir, Emperor Qianlong did not favor wands made of solid jade, preferring those with gemstone decorations. The emperor went so far as to order that wands of solid jade not be included with tributes of local specialties. Even though they were not to the emperor's taste, solid jade wish-granting wands—dazzling in appearance, auspicious in meaning—commanded top prices and remained popular until the end of Qianlong's reign. During the late Qing era, in order to emphasize the wealth and status of their owners, such wands were even more elaborately decorated with colorful glass and precious stones than this one.

LTC WITH TB

All catalogue entries were contributed in Chinese by authors from the National Palace Museum, Taipei, and translated into English by a team of researchers and scholars from the United States.

AUTHORS FROM THE NATIONAL PALACE MUSEUM, TAIPEI

CLT	Ching-liang Tsai	蔡慶良	Department of Antiquities
FJL	Fang-ju Liu	劉芳如	Department of Painting and Calligraphy
HHC	Hui-hsia Chen	陳慧霞	Department of Antiquities
HWC	Hsiang-wen Chang	張湘雯	Department of Antiquities
HYW	Hsiao-yun Wu	吳曉筠	Department of Antiquities
JJC	Jie-jin Chen	陳階晉	Department of Painting and Calligraphy
JZC	Jian-zhi Chen	陳建志	Department of Painting and Calligraphy
KWL	Kuo-wei Liu	劉國威	Department of Rare Books and Historical Documents
LC	Li Chang	張莅	Department of Antiquities
LNL	Li-na Lin	林莉娜	Department of Painting and Calligraphy
LTC	Li-tuan Chang	張麗端	Department of Antiquities
LYH	Lan-yin Huang	黃蘭茵	Department of Antiquities
PCY	Pei-chin Yu	余佩瑾	Department of Antiquities
SFC	Shu-fang Cheng	鄭淑方	Department of Painting and Calligraphy
SFW	Sung-feng Wu	吳誦芬	Department of Painting and Calligraphy
SHC	Shih-hua Chiu	邱士華	Department of Painting and Calligraphy
SYL	Sheue-yann Lu	盧雪燕	Department of Rare Books and Historical Documents
WCC	Wing Cheong Cheng	鄭永昌	Department of Rare Books and Historical Documents
WET	Wen-e Tung	童文娥	Department of Painting and Calligraphy
WMH	Wen-mei Hsu	許文美	Department of Painting and Calligraphy
WQZ	Wei Qiang Zhou	周維強	Department of Rare Books and Historical Documents
WRL	Wan-ru Lin	林宛儒	Department of Painting and Calligraphy
YCH	Yan-chiuan He	何炎泉	Department of Painting and Calligraphy
YCL	Yu Chu Liu	劉祐竹	Department of the Southern Branch Museum Affairs
YJL	Yu-jen Liu	劉宇珍	Department of Painting and Calligraphy
YLH	Yi-li Hou	侯怡利	Department of Antiquities
YLT	Yi-ling Tann	譚怡令	Department of Painting and Calligraphy
YSC	Yuh-shiow Chen	陳玉秀	Department of Antiquities

TRANSLATORS FROM THE ASIAN ART MUSEUM

CYY	Claire Yi Yang	楊怡	Department of Chinese Art, Curatorial Associate
HL	He, Li	賀利	Department of Chinese Art, Associate Curator
JC	Jamie Chu	邱嘉藝	Department of Chinese Art, Curatorial Project Assistant
TB	Terese Bartholomew	謝瑞華	Department of Himalayan Art and Chinese Decorative Art, Curator Emeritus
TLJ	Tianlong Jiao	焦天龍	Department of Chinese Art, former Curator

OTHER TRANSLATORS

DH	Daniel Szehin Ho	何思衍	Freelance translator
HMS	Hou-mei Sung	宋后楣	Cincinnati Art Museum, Curator of Asian Art
LJ	Li, Jian	李建	Virginia Museum of Fine Arts, E. Rhodes and Leona B. Carpenter Curator of East Asian Art
QN	Quincy Ngan	顏亦謙	University of Chicago, Ph.D. candidate in Chinese Art and Architecture
SKN	So Kam Ng Lee	吳素琴	De Anza College, Professor of Art History

BIBLIOGRAPHY

Barnhart, Richard. 1991. "*Streams and Hills under Fresh Snow* Attributed to Kao K'o-ming." In Murck and Wen Fong 1991, 223–30.

Berger, Patricia. 2003. *Empire of Emptiness: Buddhist Art and Political Authority in Qing China.* Honolulu: University of Hawaii Press.

Bickford, Maggie. 2006. "Huizong's Paintings: Art and the Art of Emperorship." In *Emperor Huizong and Late Northern Song China: The Politics of Culture and the Culture of Politics,* edited by Patricia Buckley Ebrey and Maggie Bickford, 452–513, esp. 457–59. Harvard East Asian Monographs 266. Cambridge, MA, and London: Harvard University Asia Center.

Cai Tao (active 1011–25). 1991. *Tiewei shan congtan* (A series of discussions at Tiewei Mountain), chap. 1. Reprint based on the woodblock print from Zhibuzu Studio. Beijing: Zhonghua shuju.
宋。蔡條：鐵圍山叢談。北京：中華書局據知不足齋本影印1991。

Cai Xiang. (1064) 1968. *Cha Lu* (Record of tea). In *Shizhuan pulu* (Record of food), edited by Yang Jialuo, vol. 36, p. 366. Taipei: Shijie shuju.
宋。蔡襄：茶錄。收入楊家駱編：食饌譜錄。臺北世界書局，1968，36冊，366。

Chaffee, John W. 1999. *Branches of Heaven: A History of the Imperial Clan of Sung China.* Harvard East Asian Monographs 183. Cambridge, MA: Harvard University Asia Center.

Chang, K. C. 1986. *Archaeology of Ancient China.* 4th ed. New Haven, CT: Yale University Press.

Chen Pao-chen. 2013. "Kangxi Huangdi wanshoutu yu Qianlong huangdi baxun wanshoutu de bijiao yanjiu" (Comparative study of painting showing birthday celebrations of Emperor Kangxi and Emperor Qianlong of the Qing Dynasty). *Gugong xueshu jikan* 30 (3): 45–122.
陳葆真：康熙皇帝《萬壽圖》與乾隆皇帝《八旬萬壽圖》的比較研究。故宮學術季刊 2013 年 30 卷 3 期。

Chen Yunru. 2005. "Shijian de xingzhuang: Qing yuanhua shi'er yue ling tu yanjiu" (The shape of time: a study on the Twelve Months Paintings of the Qing Court). *Gugong xueshu jikan* 22 (4): 103–39.
陳韻如：時間的形狀：清院畫十二月令圖研究。故宮學術季刊 2005 年 22 卷 4 期。

Chiu, Shih-hua. 2014. "Western Impact on the Architecture and Landscape Paintings of the High Qing Court." In *Face to Face: The Transcendence of the Arts in China and Beyond—Historical Perspectives,* edited by Rui Oliveira Lopes, 414–23. Lisbon: Artistic Studies Research Centre, Faculty of Fine Arts University of Lisbon.

Chou, Ju-shi. 1985. "Qianlong shidai de huihua" (The paintings of the Qianlong era). In *The Elegant Brush: Chinese Painting under the Qianlong Emperor, 1735–1795,* edited by Ju-Hsi Chou and Claudia Brown. Phoenix: Phoenix Art Museum.

Clunas, Craig. 2013. *Screen of Kings: Royal Art and Power in Ming China.* Honolulu: University of Hawaii Press.

Clunas, Craig, and Jessica Harrison-Hall, eds. 2014. *Ming: 50 Years That Changed China.* London: British Museum.

Ebrey, Patricia Buckley. 1999. "Taking Out the Grand Carriage: Imperial Spectacle and the Visual Culture of Northern Song Kaifeng." *Asia Major* 12 (1): 33–65.

———. 2008. *Accumulating Culture: The Collections of Emperor Huizong.* Seattle and London: University of Washington Press.

———. 2014. *Emperor Huizong.* Cambridge, MA: Harvard University Press.

Elliott, Jeannette, and David Shambaugh. 2005. *The Odyssey of China's Imperial Art Treasures.* Seattle: University of Washington Press.

Fu, Shen C. Y. 1990. "Princess Sengge Ragi: Collector of Painting and Calligraphy," translated and adapted by Marsha Weidner. In Weidner 1990, 55–80.

Gao Bing. (1402–23) 1983–86. *Tangshi pinhui* (Selective collections of Tang poems). Vol. 1371 of *Wenyuan ge siku quanshu.*
明。高棅編：唐詩品彙，卷二十三。收入景印文淵閣四庫全書第一三七一冊。

Gao Shiqi (1644–1703). 1964. *Pengshan miji* (The Secret Records from Mountain Peng). In *Guxue conjikan* (A Series of Books on Classics' Study). Taiwan: Lixing shuju.
清。高士奇：蓬山密記。收入國粹學報社編古學彙刊-三（1912–14）初版。臺北：力行書局1964復刊。

Gu Fang. 2005. *Zhongguo chutu yuqi quanji* (Complete collection of jades unearthed in

China). 15 vols. Beijing: Kexue chubanshe (Science Press).
古方编：<u>中國出土玉器全集</u>，15冊。北京科學出版社 2005。

Gugong wenwu yuekan (*National Palace Museum Monthly of Chinese Art*). Taipei: National Palace Museum.
台北故宮博物院：<u>故宮文物月刊</u>。

Gugong xueshu jikan (*National Palace Museum Research Quarterly*). Taipei: National Palace Museum.
台北故宮博物院：<u>故宮學術季刊</u>。

Guo Ruoxu. (1074) 1993. *Tuhua jianwenzhi* (Paintings seen and heard). In *Complete Collections of Chinese Calligraphy and Painting,* vol. 1. Shanghai: Shanghai shuhua chubanshe.
宋。郭若虛：<u>圖畫見聞誌</u>。收入<u>中國書畫全書</u>，冊 1。上海書畫出版社，1993。

Guo Xingwen and Han Yangmin. 1989. *Zhongguo gudai jieri fengsu* (Festival customs of ancient China). Taipei: Boyuan.
郭興文、韓養民：<u>中國古代節日風俗</u>。台北市：博遠1989。

He, Fang. 2004. "A study of the imperial Qing collection." *Zhonghua wenhua luntan,* no. 1: 96–99.
何芳：清宮收藏研究《中华文化论坛》2004 第一期。

He, Li. 1996. *Chinese Ceramics: A New Comprehensive Survey.* New York: Rizzoli.

He, Li, and Michael Knight. 2008. *Power and Glory: Court Arts of China's Ming Dynasty.* San Francisco: Asian Art Museum of San Francisco.

HICRA (Henan Institute of Cultural Relics and Archaeology). 2008. *Ceramic Art Unearthed from the Ru Kin Site and Zhanggongxiang Kiln Site.* Beijing: Science Press.
河南省文物考古研究所：<u>汝窑与张公巷窑出土瓷器</u>。科学出版社 2008。

Ho Chuan-hsin. 1992. "Luetan Tang Xuanzong Chandi zhi yuce de shufa" (A discussion of the calligraphy by Emperor Xuanzong of the Tang dynasty on a jade tablet). *Gugong wenwu yuekan* 1 (106): 26–33.
何傳馨：<u>略談唐玄宗禪地祇玉冊的書法</u>。<u>故宮文物月刊</u> 1992.1，106 期，頁 26–33。

Ho, Wai-kam. 1980. "Aspects of Chinese Painting from 1100 to 1350." In *Eight Dynasties of Chinese Painting: The Collections of the Nelson Gallery-Atkins Museum, Kansas City, and the Cleveland Museum of Art,* xxv–xxxii. Cleveland: Cleveland Museum of Art.

HPM (Hunan Provincial Museum). 2009. *The Discovery and Research on Gold and Silver Wares Unearthed from Caches of Song and Yuan Dynasties in Hunan.* Beijing: Wenwu chubanshe.
湖南省博物館：<u>湖南宋元窖藏金銀器發現與研究</u>。文物出版社 2009。

Huang Tingjian (1045–1105). 1967. "Shangu tiba" (Colophons on a mountain valley). In *Yishu congbian* (Series of books on arts), edited by Yang Jialuo, ser. 1, vol. 22, chap. 4. Taipei: Shijie shuju.
宋。黃庭堅：<u>山谷題跋</u>。收入楊家駱編：<u>藝術叢編</u>，第1集第 22 冊，卷 4。台北：世界書局 1967。

Hubei Provincial Institute of Archaeology. 2007. *Liangzhuang wang mu* (The Tomb of Prince Liang). Beijing: Wenwu chubanshe.
湖北省考古研究所：<u>梁庄王墓</u>。文物出版社 2007。

Hu Sailan, ed. 1994. *Catalogue of a Special Exhibition on Embroidery.* Taipei: National Palace Museum.
胡賽蘭編：<u>刺繡特展圖錄</u>。台北：國立故宮博物院 1994。

IOA (Institute of Archaeology, Chinese Academy of Social Sciences, Zhejiang Provincial Institute of Cultural Relics and Archaeology, and Hangzhou Municipal Administration of Parks and Cultural Relics). 1996. *Southern Song Governmental Porcelain Workshop.* Beijing: Encyclopedia of China Publishing House.
中國社會科學院考古所、浙江省文物考古所、杭州市園林文物局：<u>南宋官窯</u>。中國大百科全書出版社 1996。

Jinquan He and Yuanjie Situ. 1989. *Imperial Porcelain of the Yongle and Xuande Periods Excavated from the Site of the Ming Imperial Factory at Jingdezhen.* Hong Kong: Urban Council.

Kaogu (Archaeology; journal). Beijing: Wenwu chubanshe.
考古。文物出版社。

Kleutghen, Kristina. 2015. *Imperial Illusions: Crossing Pictorial Boundaries in the Qing Palaces.* Seattle and London: University of Washington Press.

Lan Pu. (1815) 1991. *Jingdezhen tao lu* (Records of Jingdezhen ceramics). In *Zhongguo taoci mingzhu huibian* (The collections of famous articles on Chinese ceramics), 1–86. Beijing: Zhongguo shudian.
清。蘭浦撰：<u>景德鎮陶錄</u>(成書於 1815 年)。收入<u>中國陶瓷名著匯編</u>，中國書店再刊 1991。

Ledderose, Lothar. 1978–79. "Some Observations on the Imperial Art Collections in China." *Transactions of the Oriental Ceramic Society,* no. 43: 38–46.

Lee, Hui-shu. 2010. *Empresses, Art, and Agency in Song Dynasty China.* Seattle and London: University of Washington.

Li Dongyang et al. (1587) 1963. *Daming huidian* (A completed encyclopedia of the great Ming dynasty). Reprint, Taipei: Dongnan shubaoshe.
明。李東陽等：<u>大明會典</u>。台灣東南書報社再刊1963年。

Li Fang. (1924) 1986. *Huangqing shushi* (History of calligraphy from the imperial Qing). In *Qingdai zhuanji congkan* (Series of bibliographies of the Qing dynasties), vol. 83, pp. 20–23. Taipei: Mingwen shuju.
清。李放輯：<u>皇清書史</u>。收入<u>清代傳記叢刊</u>，第83冊，卷首頁20–23。台北：明文書局，出版年不詳。

Li Jian. 2014. *Forbidden City—Imperial Treasures from the Palace Museum.* Richmond: Virginia Museum of Fine Art.

Lin Lina. 1994. "Ming Xuanzong zhi shengping yuqi shuhua yishu" (Life of Emperor Xuande and his arts in painting and calligraphy). *Gugong wenwu yuekan* 136 (July): 66–87.
林莉娜：<u>明宣宗之生平與其書畫藝術</u>。<u>故宮文物月刊</u> 1994，136 期7月，頁 66–87。

———. 2002. "Cong yishu wenhua kan Qianlong huangdi yu xiyang ji zhoubian shubang de wanglai guanxi". In NPM 2002.
林莉娜：<u>從藝術文化看乾隆皇帝與西洋及周邊屬邦的往來關係</u>。

Liu Fangru et al., ed. 1990. *Yingxi tu* (Paintings of children at play). Taipei: National Palace Museum.
劉芳如等編：<u>嬰戲圖</u>。台北：國立故宮博物院 1990。

Liu Jiaju. 1992. "Kangxi huangdi de qimeng jiaoyu" (The enlightening education of Emperor Kangxi). *Gugong wenwu yuekan* 109 (April): 261–37.
劉家駒：<u>康熙皇帝的啟蒙教育</u>。<u>故宮文物月刊</u> 1992，109 期，頁 261–237。

Li Xinchuan (active 1195–1210). 1983–86. *Jianyan zaji* (Notes on events since 1127). In *Wenyuan ge siku quanshu*, section Jia, chap. 1.
南宋。李心傳：建炎雜記。<u>景印文淵閣四庫全書甲集</u>，卷1。

Li Zhiyan, Virginia L. Bower, and He Li. 2010. *Chinese Ceramics from the Paleolithic Period through the Qing Dynasty*. New Haven, CT: Yale University Press and Foreign Language Press.

Lorge, Peter. 2012. "Guang on Song Taizong: Politics, History and Historiography," *Journal of Song-Yuan Studies*, no. 42: 5–43.

Lu You (1125–1210). 1977. *Laoxue an biji* (Notes from the Elder Leaner Temple). In *Gujin tushu jicheng* (Collections of historical and modern books), vol. 78, chap. 151, p. 2350. Taiwan: Dingwen shuju.
宋。陸游：老學庵筆記。收入陳夢雷 1723–27：<u>古今圖書集成</u>，卷151磁器部。78 冊，考工典，2350 頁。鼎文書局 1977。

McCausland, Shane. 2003. *Gu Kaizhi and the Admonitions Scroll*. London: British Museum Press and Percival David Foundation.

———. 2011. *Zhao Mengfu: Calligraphy and Painting for Khubilai's China*. Hong Kong: Hong Kong University Press.

McNair, Amy. 1990. "Su Shih's Copy of the Letter on the Controversy over Seating Protocol." *Archives of Asian Art*, no. 43: 38–48.

———. 1998. *The Upright Brush: Yan Zhenqing's Calligraphy and Song Literati Politics*. Honolulu: University of Hawaii Press.

Mi Fu (1051–1107). 1966. "Shushi" (A history of books). In *Yishu congbian* (Series of books on arts), edited by Yang Jialuo, ser. 1, vol. 2. Taipei: Shijie shuju.
宋。米芾：書史。收入楊家駱編：<u>藝術叢編</u>。第1集第 2 冊。台北：世界書局 1966。

Ming Taizong shilu (A factual record of Emperor Taizong). 1966. Taipei: Zhongyang yanjiu yuan lishi yuyan yanjiu suo.
明太宗實錄。台北：中央研究院歷史語言研究所 1966。

Mowry, Robert D. 1995. *Hare's Fur, Tortoiseshell, and Partridge Feathers*. Cambridge, MA: Harvard University Art Museums.

Murck, Alfreda. 2000. *Poetry and Painting in Song China: The Subtle Art of Dissent*. Harvard–Yenching Institute Monograph Series 50. Cambridge, MA: Harvard University Asia Center.

Murck, Alfreda, and Wen Fong, eds. 1991. *Words and Images: Chinese Poetry, Calligraphy, and Painting*. New York: Metropolitan Museum of Art; Princeton, NJ: Princeton University.

Murray, Julia K. 1986. "The Role of Art in the Southern Sung Dynastic Revival." *Bulletin of Sung Yuan Studies*, no. 18: 41–59.

———. 1990. "Didactic Art for Women: The Ladies' Classic of Filial Piety." In Weidner 1990.

———. 1993. *Ma Hezhi and the Illustration of the Book of Odes*. Cambridge: Cambridge University Press.

———. 2007. *Mirror of Morality: Chinese Narrative Illustration and Confucian Ideology*. Honolulu: University of Hawaii Press.

Nie Chongzheng. 1996. "Qingdai gongting huihua jigou,zhidu ji huajia" (The painting institution, system, and painters of the Qing court). In *Gongting yishu de guanghui* (Glory of the court arts), 1–28. Taipei: Dongda tushu gongsi.
聶崇正：清代宮廷繪畫機構、制度及畫家。<u>宮廷藝術的光輝</u>。台北：東大圖書公司 1996。

NPM (National Palace Museum, Taipei; 臺北故宮博物院). (1793) 1971. *Midian zhulin Shiqu baoji xubian* (Sequel to Pearl Circles in the Secret Palace—Treasured Splendors from Stone Canals). Edited by Zhang Zhao and Liang Shizheng. Taipei: National Palace Museum.
張照、梁詩正等：<u>秘殿珠林-石渠寶笈續編</u>。

———. 1976. *Qing Gaozong yuzhi shiwen quanji* (Complete collection of poetry and compositions by Emperor Gaozong). 10 vols. Taipei: National Palace Museum.
清高宗御製詩文全集，影印木｜冊。

———. 1986. *Qingdai fushi zhanlan tulu* (Catalogue of the Exhibition of Ch'ing Dynasty Costume Accessories). Taipei: National Palace Museum.
清代服飾展覽圖錄。

———. 1989. *Song guanyao tezhan* (Catalogue of the Special Exhibition of the Sung Dynasty Kuan Ware). Taipei: National Palace Museum.
宋官窯特展。

———. 1990–2010. *Gugong shuhua tulu* (Collections of Painting and Calligraphy of the National Palace Museum). 29 vols. Taipei: National Palace Museum.
故宮書畫圖錄，29 冊。

———. 1995. *Songdaishuhua ceye mingpin tezhan* (Famous album leaves of the Sung dynasty). Taipei: National Palace Museum.
李玉珉、許郭璜編：宋代書畫冊頁名品特展。

———. 2002. *Qianlong huangdi de wenhua daye* (Emperor Ch'ien-lung's Grand Cultural Enterprise). Taipei: National Palace Museum.

———. 2006. *Bei Song shuhua tezhan* (Grand View: Special Exhibition of Northern Song Painting and Calligraphy). Taipei: National Palace Museum.
北宋書畫特展。

———. 2007. *Guose tianxiang Yisilan yuqi* (Exquisite Beauty—Islamic Jades). Taipei: National Palace Museum.
<u>國色天香-伊斯蘭玉器</u>。

———. 2009. *Qing Shizong wenwu dazhan* (Harmony and Integrity: The Yongzheng Emperor and His Times). Edited by Feng Ming-chu. Taipei: National Palace Museum.
馮明珠主編：雍正-清世宗文物大展。

———. 2011. *Kangxi Dadi yu Taiyang wang luyi shisi tezhan* (Emperor Kangxi and the Sun King Louis XIV). Edited by Chou Kungshin. Taipei: National Palace Museum.
周功鑫主編：<u>康熙大帝與太陽王路易十四特展</u>。

Ouyang Xiu et al. (1060) 1969. *Tangshu* (History of the Tang dynasty) and *Xin Tangshu* (New history of the Tang dynasty). Vols. 4 and 5 of *The Histories of Twenty-Five Dynasties*. Taipei: Kaiming shudian.
宋。歐陽修 1060：唐書; 新唐書。收入<u>二十五史</u> 4-5 冊。台灣开明书店铸版本 1969。

Pang, Huiping. 2014. "The Multiple *Siyin* Half Seals: Reconsidering the *Dianli jicha si* (1373–1384) Argument." *Journal of the American Oriental Society* 134 (3): 361–83.

———. 2016. "Imperial Violence and the *Siyin* Seal: A Hidden History of Prince Zhu Gang's Art Acquisitions." Unpublished manuscript.

PMB (Palace Museum, Beijing; 北京故宮博物院). 1996. *Paintings by the Court Artists of the Qing Court*. Vol. 14 of *The Complete Collection of the Treasures of the Palace Museum*. Hong Kong: Shangwu yinshu guan (Commercial Press); Shanghai: Kexue jishu chubanshe.
清代宮廷繪畫，故宮博物院文物珍藏品大系，香港商務印書館、上海科學技術出版社。

———. 2007. *Guanyang yuci (The Imperial Style of the Official Porcelain)*. Beijing: Zijincheng chubanshe 2007. 官樣御瓷。北京紫禁城出版社 2007。

———. 2008. *Genre Paintings of the Ming and Qing Dynasties*. In *The Complete Collection of the Treasures of the Palace Museum*. Hong Kong: Shangwu yinshu guan (Commercial Press); Shanghai: Kexue jishu chubanshe.
明清風俗畫，故宮博物院文物珍藏品大系，香港商務印書館、上海科學技術出版社 2008。

Qing huidian tu (Laws and regulations of the Qing dynasty). (1690–1886) 1990. 2 vols. Beijing: Zhonghua shuju.
康熙二十九–光緒十二年：清會典圖，上下兩冊。中華書局影印本 1990.

Qingshi (History of the Qing dynasty). (1913–27) 1971. 9 vols. Reprint of the Renshou edition. Taipei: Guofang yanjiu yuan; Chengwen chubanshe.
清史 9 冊。國防研究院，台灣成文出版社 1971。

Qiqi (Lacquerware). 1989. Vol. 8 of *Zhongguo meishu quanji* (Complete collection of Chinese artworks). Beijing: Wenwu chubanshe.
中國美術全集，八冊 漆器。文物出版社 1989。

Rossabi, Morris. 1988. *Khubilai Khan: His Life and Times*. Berkeley: University of California Press.

Shanghai Museum. 2001. *Xueyu zhencang Xizang wenwu jinghua (Treasures from Snow Mountains—Gems of Tibetan Cultural Relics)*. Shanghai: Shanghai Museum.
上海博物館 2001年：西藏文物精華。

Sima Qian (approx. 91 BCE). 1979. *Selections from Records of the Historian*, translated by Yang Hsien-yi and Gladys Yang, 173. Beijing: Foreign Languages Press.

Smithsonian Institution website. 2015. "New Acquisitions." http://www.asia.si.edu/collections/new-acquisitions/object-2015.asp?id=F2015.2a-b-alt2. Accessed September 14, 2015.

Song Lian (1369). 1969. *Yuanshi* (History of the Yuan dynasty). Vol. 8 of *The Histories of Twenty-Five Dynasties*. Taipei: Kaiming shudian.
明。宋濂 1369：元史。收入 二十五史8冊。台灣开明书店铸版本 1969。

Stuart, Jan, and Evelyn S. Rawski. 2001. *Worshiping the Ancestors: Chinese Commemorative Portraits*. Washington, DC: Freer Gallery of Art and the Arthur M. Sackler Gallery, Smithsonian Institution.

Sturman, Peter Charles. 1997. *Mi Fu: Style and the Art of Calligraphy in Northern Song China*. New Haven, CT, and London: Yale University Press.

Tang Ying. 1735. *"Taowu xulue beiji"* (Epitaph of a summary of ceramics affairs). In *Wenyuan ge siku quanshu*, vol. 517, pp. 811–21.
清。唐英：陶務敘略碑記(又稱：陶成紀事碑)。景印文淵閣四庫全書 冊 517，頁 811–21。

Tao Zongyi (1316–after 1403). 1993. "Shushi huiyao" (Collections of historical books). Vol. 3 of *Complete Collections of Chinese Calligraphy and Painting*. Shanghai: Shanghai shuhua chubanshe.
明。陶宗儀：書史會要。收入中國書畫全書，上海書畫出版社 1993，冊 3。

Tsai Mei-fen. 2011. "Yijing weiyong—Kangxi huangdi de yishu pinwei" (Benefit yielded from tranquility—the aesthetic taste of Emperor Kangxi). In NPM 2011, 275–83.
蔡玫芬：以靜為用–康熙皇帝的品味。台北國立故宮博物院 2011。

Tuo Tuo. (1344) 1969. *Liaoshi* (History of the Liao dynasty). Vol. 7 of *The Histories of Twenty-Five Dynasties*. Taipei: Kaiming shudian.
脫脫等撰：遼史。收入二十五史，7 冊。台灣开明书店铸版本 1969。

———. (1345) 1969. *Songshi* (History of the Song dynasty). Vols. 6 and 7 of *The Histories of Twenty-Five Dynasties*. Taipei: Kaiming shudian.
脫脫等撰：宋史。收入二十五史，6-7 冊。台灣开明书店铸版本 1969。

Wang Cheng-hua. 2010. "The Qing Imperial Collection, Circa 1905–25: National Humiliation, Heritage Preservation, and Exhibition Culture." In *Reinventing the Past: Archaism and Antiquarianism in Chinese Art and Visual Culture,* edited by Wu Hung, 320–41. Chicago: Center for the Art of East Asia, Department of Art History, University of Chicago; Art Media Resources.

Wang Fu, ed. (1119–25) 1752. *Bogu tu* (Catalogue of extensive antiquities), 16 vols. Yizhengtang.
宋。王黼（主編）：博古圖錄。十六冊。亦政堂萬曆 (1603) 藏版、乾隆壬申 (1752) 再刊。

Wang Shixiang. 1992. *Shuo Hulu* (The charms of the gourd). Hong Kong: Next Publishing.
王世襄：說葫蘆。香港：壹出版有限公司 1992。

Wang Yaoting. 1995. "Song ceye huihua yanjiu" (A study of painting albums of the Song dynasty). In *Songdaishuhua ceye mingpin tezhan* (Famous Album Leaves of the Sung Dynasty), edited by Li Yumin and Xu Guoheng. Taipei: National Palace Museum.
王耀庭：宋代頁繪畫研究。收入宋代書畫冊頁名品特展。台北國立故宮博物院 1995。

Wang Yinglin (1223–96). 1983. "Yuhai" (Jade ocean). In *Wenyuan ge siku quanshu*, vol. 944, chap. 45.
宋。王應麟：玉海。收入景印文淵閣四庫全書，第 944 冊，卷 45。

Wan Yi, ed. 1997. *Gugong cidian* (A dictionary of the Old Palace-Forbidden City). Shanghai: Wenhuai.
故宮辭典。

Weidner, Marsha. 1986. "Ho Ch'eng and Early Yuan Dynasty Painting in Northern China." *Archives of Asian Art,* no. 39: 6–22.

Weidner, Marsha, ed. 1990. *Flowering in the Shadows: Women in the History of Chinese and Japanese Painting*. Honolulu: University of Hawaii Press.

Wenwu (Cultural relics; journal). Beijing: Wenwu chubanshe.

Wenyuan ge siku quanshu (Complete books of the four libraries in Hall of Literary Profundity). (1775–84) 1983–86. Taipei: Taiwan shangwu chubanshe.
景印文淵閣四庫全書。臺北：臺灣商務出版社，1983 – 86。

Xia Yuchen. 1982. "Gao Qipei shengnian kao" (A study of Gao Qipei). In *Wenwu*, no. 1: 84.
夏玉琛：高其佩生年考。文物。北京文物出版社。1982.1，頁 84。

Xuanhe huapu (Painting catalogue of Xuanhe). (1119–25) 1993. Vol. 2 of *Complete Collections of Chinese Calligraphy and Painting*. Shanghai: Shanghai shuhua chubanshe.
宋。徽宗敕撰：宣和畫譜。收入<u>中國書畫全書</u>，冊 2。

Xu Qin (active 1670–1700). 1993. *Minghua lu* (Records of paintings of the Ming dynasty). Vol. 10 of *Complete Collections of Chinese Calligraphy and Painting*. Shanghai: Shanghai shuhua chubanshe.
明。徐沁：<u>明畫錄</u>，收入<u>中國書畫全集</u>，冊 10。上海書畫出版社 1993。

Yang Boda. 1983. "Qingdai boli gaishu" (Summary of Qing-period glass). *Gugong bowuyuan yuankan (The Palace Museum Journal)*, no. 4: 3–16.
楊伯達：<u>清代玻璃概述</u>。故宮博物院院刊 1983.4。

Yubi shiquan ji (The emperor's record on the ten perfections). (1792) 1971. Taipei: National Palace Museum.
<u>御筆十全記</u>。台北故宮博物院 1971。

Yunlu et al. 1766. *Huangchao liyi tushi* (Illustrated ritual implements of the imperial dynasty). In *Wenyuan ge siku quanshu*, history section, chap. 13.
允錄 1766 乾隆 28 年 撰：皇朝禮器圖式。<u>景印文淵閣四庫全書</u>，史部十三。

Yu Pei-chin. 2014. "Lang Shining yu ciqi" (Giuseppe Castiglione and porcelain). *Gugong xueshu jikan* 32 (2): 1–23.
余佩瑾：<u>朗士寧與瓷器</u>。故宮學術季刊，2014 年 32 卷 -2期。

Zhang Bai. 2008. *Zhongguo chutu qici quanji* (*Complete Collection of Ceramic Art Unearthed in China*). 16 vols. Beijing: Science Press.
張柏：<u>中國出土瓷器全集</u>，16 集。科學出版社 2008 年。

Zhang, Fan Jeremy. 2015. "The Art of Ming Dynasty Princely Courts in Hubei." *Orientations* 46 (6): 70–77.

Zhang Naiwei. (1941) 1990. *Qinggong shuwen* (The legacy of the Qing imperial palace). Reprint. Beijing: Zijincheng chubanshe.
章乃煒主編 1941：<u>清宮述聞</u>。北京：紫禁城出版社 1990。

Zhang Tingyu et al. (1739) 1969. *Mingshi* (History of the Ming dynasty). Vol. 9 of *The*

Histories of Twenty-Five Dynasties. Reprint. Taipei: Kaiming shudian.
清。张廷玉等撰：<u>明史</u>。收入<u>二十五史</u>，9 冊。台灣开明书店铸版本 1969。

Zhang Xiaoyue. 2007. "Qinggong ciqi huayang de xingshuai" (From growth to decline: drawing samples of official porcelain of the Qing dynasty). In *Guanyang yuci* (The imperial style of official porcelain), by the Palace Museum, Beijing, 32–55. Beijing: Zijincheng.
張小銳：<u>清宮瓷器畫樣的兴衰</u>。故宮博物院：官樣御瓷。北京：紫禁城出版社。

Zhao Gou. (1150–70) 1966. *Hanmozhi* (The history of brush and ink). In *Yishu congbian* (Series of books on arts), edited by Yang Jialuo, vol. 2, article 8, chap. 29, pp. 1–6. Taipei: Shijie shuju.
趙構：翰墨志。收在楊家駱編：藝術叢編，一集二冊，臺北世界書局 1966。

Zhao Ji. (1107–10) 1646. *Daguan chalun* (A discussion about tea in the Daguan reign), chapter Shuofu, Gong 95. Zhejiang. Reprint based on the edition by Weiwanshan.
趙佶：<u>大觀茶論</u>。順至三年 (1646) 浙江委宛山堂本，說郛，弓 93。

Zheng Dedi et al. 2005. "Yesu huishi he zhongguo gongting huashi Wang Zhicheng xiushi zhi Dasuo xiansheng de xin" (Letters from Jesuit Wang Zhicheng and Chinese court painters to Mr. d'Assant). In *Yesu huishi zhongguo shujian ji: Zhongguo huiyi lu* (Letters edifying and curious), edited by Jean-Baptiste Du Halde, vol. 4, pp. 287–305. Zhengzhou: Daxiang chubanshe.
鄭德弟、呂一民、沈堅等譯，杜赫德編：耶穌會士和中國宮廷畫師王致誠修士致達索先生的信。收入耶穌會士中國書簡集：中國回憶錄。鄭州：大象出版社 2005 年。

Zhongguo diyi lishi dang'an guan (First State Archives Library). 2005. *Qinggong Neiwufu zaobanchu dang'an zonghui* (Complete Archives from the Imperial Household Department of the Qing Dynasty). 55 vols. Beijing: Renmin chubanshe; Hong Kong: Art Gallery, Chinese University of Hong Kong.
中國第一歷史檔案館、香港中文大學文物館合編：<u>清宮內務府造辦處檔案總匯</u>，55 冊。人民出版社 2005。

Zhongguo shuhua quanji (Complete collection of Chinese paintings). 1999. 30 vols. Hangzhou: Zhejiang renmin meishu chubanshe; Wenwu chubanshe.
<u>中國書畫全集</u>。浙江人民美術出版社、文物出版社 1999。

Zhuang Jifa. 1992. "Longzhang fengzao, tiehua yingou—Kangxi huangdi lun shufa" (Emperor Kangxi's critiques on calligraphy). *Gugong wenwu yuekan,* no. 111: 112–27.
莊吉發：龍章鳳藻，鐵畫銀鉤－康熙皇帝論書法。故宮文物月刊 1992，111期，頁 112–127。

Zhu Changwen (1039–98). 1970. *Mochi bian* (A series of ink ponds), chap. 3, pp. 429–32. Taipei: Hanhua wenhua gongsi.
宋。朱長文：<u>墨池編</u>，卷 3，頁 429–432。台北：漢華文化公司 1970。

Zhu Jiajin. 1995. "Ming Dai Qiqi Gaishu" (An overview of Ming lacquers). In *Zhongguo qiqi quanji* (Complete collections of Chinese lacquerware), vol. 5, pp. 1–12. Fuzhou: Fujian meishu chubanshe.
朱家溍：明代漆器概述。<u>中國漆器全集</u> 5，福建美術出版 1995。

Zhu Mouyin (active late 16th–early 17th century). 1983–86. *Shushi huiyao* (Selective collections of historical books). In *Wenyuan ge siku quanshu*, vol. 1153, chap. 68, p. 140.
明。朱謀垩：書史會要續編。收入<u>景印文淵閣四庫全書</u>，第 1153 冊，卷 68 頁 140。

INDEX

Kangxi, Emperor (Xuan Ye; r. 1662–1722): achievements of reign, 135–36; birthday celebration of, 154; calligraphy skills of, 4–5, 142, *142*, 147, *147*, 166; and farming, 148; finial of hat for (cat. 161), 225, *225*; and Four Wangs, 143, 146; and glassware, 136, 161, 176; and gourd molds, 160; and inkstones, 164, 165, 185; and Jesuits, 27, 135–36, 151, 155, 157, 158, 162, 190; and painter Tang Dai, 168–69; portrait of, *136*; and Qing collecting habits, 16; seals and inscriptions of, 142, 147, 148, 151, 156–59, 162–65; and West Lake, 194

Ke Jiusi, 76, *76*

kesi (cut-silk) tapestries: "Buddha Shakyamuni" (cat. 18), *32*, 53, *53*; Ding potters inspired by, 34–35; "Eight Immortals greeting God of Longevity" (cat. 17), 52, *52*; "Nine goats bring peace to New Year" (cat. 134), 196, *196*; paradise scene as source for, 189

Kublai Khan (r. 1271–94), 25, 69–71

Kumārajīva (Yao Qin), 119

lacquerware: box, bispherical, carved polychrome (cat. 149), 213, *213*; box, rectangular, with objects (cat. 138), 202, *202*; boxes, round, carved red (cats. 61, 75, 77), 109, *109*, 125, *125*, 128, *128*; and cloud motif, 67; and "hare's fur glaze," 60; Ming admiration for red wares, 97; porcelain imitations of, 209; table screen (cat. 148), 212, *212*; vase, carved red (cat. 60), 108, *108*

Lang Shining. *See* Castiglione, Giuseppe

Lang Tingji, 151, *151*

Lantern Festival, 236

Laureati, Jean (Li Guo'an), 136

Leng Mei, 9, 148, *148*, *149*, *150*, 154, *154*, 189

Li Cheng, 74, 78

Li Di, 113

Li Fang, 4

Li Gonglin, 24, 96

Li Guo'an (Jean Laureati), 136

Li Longji. *See* Xuanzong, Emperor

Li Tang, 38, 41, 42

Li Zai, 8, 114, *114*

Liang Jiugong, 136

Liang Shizheng, 168

Liangzhu culture, 13, 132

Liao dynasty, 57, 65, 92

Lin'an. *See* Hangzhou

literati. *See* scholars (literati)

Liu Fei, King of Jiangdu, 12–13

Liu Sheng, King of Zhongshan, 13

Lizong, Emperor (r. 1225–64), 44

Lou Yao, 50, *50*

Lu Dalin, 15

Lu You, 45, *45*, 46

Ma Guoquan (Matteo Ripa), 136, 190

Ma Lin, 7–8, 23, 44, *44*

Ma Yuan, 7, 8, 23, 43, *43*, 115

Ma Yunqing, 24

Manchus: and belt attachments, 231; and birds of prey, 190; and Emperor Kangxi's ancestry, 135; and Han Chinese culture, 4, 16; headgear styles, 225, 228; and imperial collecting habits, 16, 26–27; and pearls, 225; and Songhua stone, 164;

and Tibetan Buddhism, 27, 138; and turquoise, 236. *See also* Qing dynasty

mandala, three-dimensional, 28, *29*

Manjushri (bodhisattva), 25, 98, *98*

meat-shaped stone (cat. 177), 240, *240*

Meng, Empress (1077–1135), 22

Mi Fu, 3, 36, 46, 74, 142

Mi Youren, 74

Miao Jiahui, 141, 220

Ming dynasty: achievements, overview of, 95–97; blue-and-white porcelains, 103–5, *103–5*, 123, *123*; bowl, 124, *124*; boxes, 109, *109*, 125, *125*, 128, *128*; calligraphy, 4, 96, 101, *101*, 102, *102*, 111–12, *111*, *112*, 119, *119*; celadon porcelains, 107, *107*; cup, 126–27, *126–27*; ewer, 120, *120*; imperial collecting habits, 25–26, 97; imperial portraits, *96*, *97*, 110, *110*; jades, 97, 130–34, *130–34*; lacquerware, 97, 108, *108*, 109, *109*, 125, *125*, 128, *128*; paintings, 6, 96, 98–100, *98–100*, *111*, 113–18, *113–18*; plates and dishes, *25*, 122, *122*; Qing-era works influenced by, 146, 166, 174, 175, 183, 189, 212; teapots, 106, *106*, 121, *121*; vases, 103, *103*, 104, *104*, 108, *108*, 129, *129*, 133, *133*

Mongols: and birds of prey, 190; and Emperor Kangxi's ancestry, 135; and Han Chinese culture, 24, 69, 75, 95; and hunting of fowl, 92; and Islamic world, 88; religious tolerance of, 25, 70; and Tibetan Buddhism, 27–28, 70, 138; Torgut tribe of, 191; Zunghar tribe of, 27, 191, 217. *See also* Yuan dynasty

Mughal Empire, 217

music: bell, bronze (cat. 19), 54, *54*; in Emperor Huizong's reign, 33–34; *qin* (zither), 75, 78, 99, 142, 144

Muslims. *See* Islam

Nan Huairen (Ferdinand Verbiest), 135, 155

Nanjing, 8, 25, 26, 93, 95, 96, 99, 101

nephrite. *See* jade

New Year festival, 8, 195, 196

Ni Duan, 115, *115*

Nian Xiyao, 138, 172, 173

Ningzong, Emperor (Zhao Kuo; r. 1195–1224), 7–8, 43, 44

Northern and Southern dynasties, 90

Northern Song dynasty: *Antiquities Catalogue of Xuanhe*, 14–15, *15*, 21, 55, *55*, 62, 172; bowl, 60, *60*; bronzes, 54, *54*, 55, *55*; calligraphy, *xviii*, 3, *15*, *21*, 36, *36*, 37, *37*, 46; Huizong era, overview of, 33–35; imperial collecting habits, 11–12, 13–15, 19–22, 65; imperial portraits, *34*; jades, 34, 65, *65*; paintings, *5*, *6*, *7*, *8*, *21*, 38, 43, 44; pillow, ceramic, 59, *59*; vases, *56*, 57, *57*, 58, *58*

Ottoman Empire, 217

Ouyang Xiu, 20, 37, *37*

Ouyang Xuan, 87, *87*

painting: bird-and-flower tradition, 5–6, 80, 111, 118, 147; "boneless" (*mogu*) technique, 81, 111, 147; "coiling dragon" arrangement, 77, 146; European influence on, 27, 136, 139, 148, 152, 186, 189, 190, 191; female court artists, 141, 220; "flying-white" technique, 147; and Four Wangs, 143, 144, 146, 169; imperial academy, overview of, 6–9; in

imperial catalogues, 14–15, 16, 21; and imperial court tastes, 20–21, 22–24, 27; as imperial pursuit, overview of, 5–6; literati styles and themes, 9, 20, 81, 113, 116, 144, 212, 219; wages for court painters, 137–38. *See also specific works under* album leaves; handscrolls; hanging scrolls; *and* portraits, imperial

Parrenin, Dominque (Ba Duoming), 136

pearls, 225–30, 233, 235, 236

perfumer, porcelain (cat. 73), 123, *123*

Phags-pa, Tibetan Lama, 70

pillows, ceramic (cats. 23, 25), 59, *59*, 61, *61*

plaque with enamel inlays (cat. 109), 169, *169*

plates and dishes: enamel-painted copper, square (cat. 96), 159, *159*; jade, flower-shaped (cat. 153), 217, *217*; porcelain, with peach blossoms (cat. 122), 182, *182*; porcelain, with plum blossoms (cat. 120), 180, *180*; porcelain, with red glaze, 25, *25*; porcelain, with yellow glaze (cat. 72), 122, *122*

poetry: ancient-style verse in semistandard scripts (Ouyang Xuan; cat. 44), 87, *87*; *The Book of Odes*, 22–23; on ceramics, 57, 179–82; by Emperor Huizong, 3, 21, 34; by Emperor Kangxi, 147; by Emperor Ningzong, 43, *43*; by Emperor Qianlong, 57, 59, 61, 62, 75, 113, 120, 138, 160, 190, 194, 215, 217–19; by Emperor Xuande, 96, 111–12; for Emperor Yongle (Shen Can; cat. 54), 102, *102*; by Empress Yang Meizi, 23, *23*; on fans, *23*, 166, *166*; on inkstone (cat. 154), 218, *218*; *Ode on Pied Wagtails* (Li Longji), 2, *2*; painting by Ma Lin inspired by, 7–8, 44; on painting by Wu Li, 144; poem in cursive script (Bai Yuchan; cat. 16), 51, *51*; poem in standard script (Qian Shunxuan; cat. 41), 82, *82*; of Tang dynasty, 5, 41, 142, 160, 163, 180, 215

porcelain: basin, blue-and-white (cat. 57), 105, *105*; "bean-red"-glazed vessels (cats. 99–103), 162, *162*, 163, *163*; bowl, lidded, with design of red dragons and blue clouds (cat. 74), 124, *124*; bowl with green enamel glaze (cat. 117), 177, *177*; bowl with hidden design (cat. 116), 176, *176*; box, round, with flowers (cat. 158), 222, *222*; box with Western shepherd girl (cat. 147), 211, *211*; cup and saucer, cobalt-blue (cat. 45), 88, *88*, *89*; cup with chicken design (cat. 76), 126–27, *126–27*; dish, red-glazed, 25, *25*; *doucai* technique, 127; Empress Dowager's Cixi's line of, 140–41, 221, 222; enameling on, 139, 173, 177, 179, 181, 182, 210, 211; European imitations of Chinese, 151, 158; ewers (cats. 70, 115), 120, *120*, 175, *175*; flowerpot imitating wood (cat. 118), 178, *178*; flowerpots, floral (cats. 159, 160), 223, *223*, 224, *224*; hat stand (cat. 145), 209, *209*; jar, celadon (cat. 59), 107, *107*; Ming administration of production, 97; perfumer (cat. 73), 123, *123*; plate, yellow-glazed (cat. 72), 122, *122*; plate with plum blossoms (cat. 120), 180, *180*; spittoon (cat. 157), 221, *221*; teapot, sweet-white (cat. 58), 106, *106*; teapots, pair of (cat. 71), 121, *121*; vase, five-spouted (cat. 113), 173, *173*; vase, revolving (cat. 144), 140, 208, *208*; vases, blue-and-white (cats. 55, 56), 103, *103*, 104, *104*

portraits, imperial: of Chabi, Empress (cat. 33), 73, *73*; of Cixi, Empress Dowager, *140*, *237*;

Wei, Empress (1080–1159), 35

Wei, Lady (d. 1451), 26

Wei and Jin Wei dynasties (220–420), 3

Wei Guangcheng, 2

Wenzong, Emperor (r. 1328–29; 1330–32), 71, 76

Western Han dynasty, 12, 13, 66, 131, 216

Western influence. *See* European influence

wish-granting wand (*ruyi*), 160, 241, *241*

wood: agarwood-scented bracelet, 239; box, lac-
 quered, with objects (cat. 138), 202, *202*; box
 for gold bowl, 200, *200*; bronze vessels with
 sandalwood bases, 201; carved mountain scene
 (Yang Weizhan; cat. 155), 219, *219*; jade belt
 plaque with wood stand (cat. 49), 93, *93*; plaque
 with enamel inlays (cat. 109), 169, *169*; porcelain
 imitations of, 178

woodblock prints, *15*, 24, *55*, 148, 154, *154*

Wu, Emperor (r. 141–86 BCE), 13

Wu, Empress (1115–97), *18*, 40, *40*

Wu Li, 144, *144–45*

Wu Yuantai, 52

Wu Yuanyu, 5–6, 7, 36

Wuzong, Emperor (r. 1308–11), 24, 30n20

Xia dynasty, 13, 54, 55

Xia Gui, 8, 98, 115

Xi'an (ancient Chang'an), 3, 119

Xian of Zhou, Prince, 4

Xianfeng, Emperor (r. 1851–61), 201

Xiang, Empress Dowager (1046–1101), 33

Xiang Yuanbian (Zijing), 46

Xianyu Shu, 83, *83, 84*, 85, *85*

Xiaogong Zhang, Empress (Sun; 1399–1462), 110,
 110

Xiaoxian, Empress (1712–48), 28

Xiaozong, Emperor (r. 1163–89), 40, 41

Xinjiang, 34, 76, 183, 200, 217

Xu Daoning, 41

Xu Qin, 6

Xuan Ye. *See* Kangxi, Emperor

Xuande, Emperor (Zhu Zhanji; r. 1426–35): callig-
 raphy skills of, 4, 96, 111–12, *111–12*; and cobalt
 blue, 103, 123; and *doucai* porcelain, 127; and
 lacquerware, 97, 109; and painting academy, 8,
 113; painting skills of, 4, 6, 96, 111, *111–12*, 113,
 113, 186; portraits of, *97*, 110, *110*; and red-
 colored objects, 25, 97, 120, 121, 125

Xuantong, Emperor (r. 1908–11), 45, 75, 98

Xuanzong, Emperor (Li Longji; r. 712–56), 1–3, *2*

Xue Ji, 3, 36

Yan (now Beijing), 26, 95

Yan Xiu, 49

Yan Zhenqing, 20, 37, 50

Yang Meizi, Empress (1162–1232), 8, 23, *23*, 44

Yang Weizhan, 219, *219*

Yanjing (now Beijing), 69

Yi, Prince (Yunxiang, d. 1730), 100, 170, 100, 100

Yin Hongxu (François Xavier d'Entrecolles), 151,
 162

Yin Zhen. *See* Yongzheng, Emperor

Yingzong, Emperor (r. 1321–23), 71, 78

Yingzong, Emperor (1436–49; 1457–64), 110, 122

Yongle, Emperor (r. 1403–24): achievements of
 reign, 95–96; as Buddhist, 101; calligraphy

skills of, 4, 96; and cobalt blue, 103, 123; and
 Forbidden City's construction, 26, 95, 102; and
 lacquerware, 97, 108, 109; and mariner Zheng
 He, 95, 100, 123; and painter Wang Fu, 99;
 portrait of, *96*; and white ceramics, 106; and
 Xuande's empress, 110

Yongzheng, Emperor (Yin Zhen; r. 1723–35):
 achievements of reign, 136–38; calligraphy
 skills of, 4, 5, 166, *166*; and ceramics from
 earlier eras, 120, 172–74; and design of imperial
 objects, 136–37, 170, 172, 176, 178, 180, 181; and
 inkstones, 185; and official Jiang Tingxi, 147; and
 official Zhang Tingyu, 167; and painter Tang Dai,
 168–69; painting series on months of, 187; and
 plaques with moral edicts, 169; portrait of, *137*;
 and Qing collecting habits, 16; seals of, 170–85

Yuan dynasty: achievements, overview of, 69–71;
 calligraphy, 82–87, *82–87*; ceramics, 25, 70, 88,
 88, 89, 90, *90*; and cloisonné's introduction, 129;
 imperial collecting habits, 24–25; imperial por-
 traits, 72, *72*, 73, *73*; jades, 65, 91–93, *91–93*, 131;
 paintings, 6, *24*, 74–81, *74–81*, 115; territorial
 expansion during, 88, 95

Yun Shouping, 156

Yunxiang. *See* Yi, Prince

Zang Yingxuan, 135

Zhang Degang, 108

Zhang Tingyu, 167

Zhang Xiaoxiang, 47

Zhang Zhihe, 41

Zhao Gou. *See* Gaozong, Emperor

Zhao Ji. *See* Huizong, Emperor

Zhao Kuangyin. *See* Taizu, Emperor

Zhao Kuo. *See* Ningzong, Emperor

Zhao Lian, 118

Zhao Lingrang, 5

Zhao Mengfu: Buddhist sutras transcribed by, 24;
 calligraphic works (cats. 42, 43), 83, *83, 84*, 85,
 85, 86, *86*; imperial calligraphers influenced by,
 4, 5, 142; painters influenced by, 8–9, 74, 76, 77,
 78, 143

Zheng He, 95, 100, 123, 175

Zhezong, Emperor (r. 1086–1100), 3, 33

Zhong Yao, 3

Zhongshan kingdom, 13

Zhou dynasty, 12, 13, 54, 55, 131, 170, 201

Zhou Mi, 44

Zhu Derun, 78, *78*

Zhu Gang, Prince of Jin, 26

Zhu Gui, 154, *154*

Zhu Kan, 98, *98*

Zhu Suiliang, 3

Zhu Xi, 49, *49*, 50, 95

Zhu Yuanzhang. *See* Hongwu, Emperor

Zhu Zhanji. *See* Xuande, Emperor

Zhuang of Liang, Prince, 26, 131

Zou Yigui, 100

Zunghar Mongols, 27, 191, 217